NEW YORK
DESIGN
AT HOME

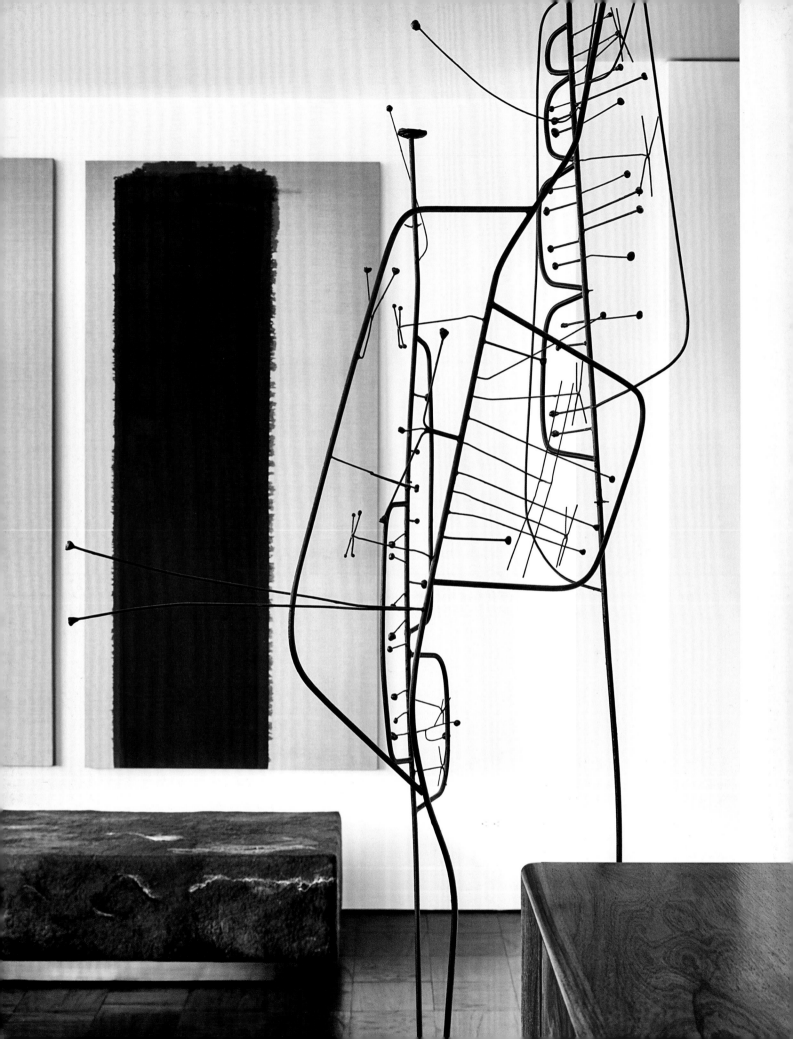

NEW YORK
DESIGN
AT HOME

ANTHONY IANNACCI
PHOTOGRAPHY BY NOE DEWITT

Abrams, New York

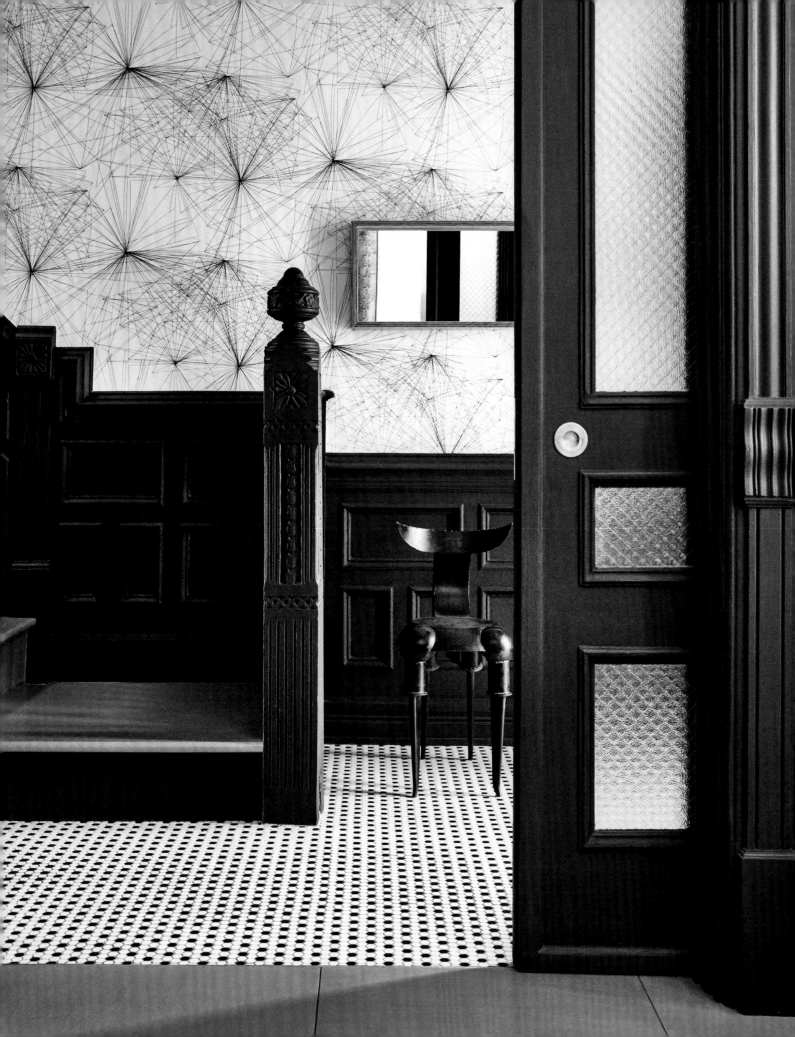

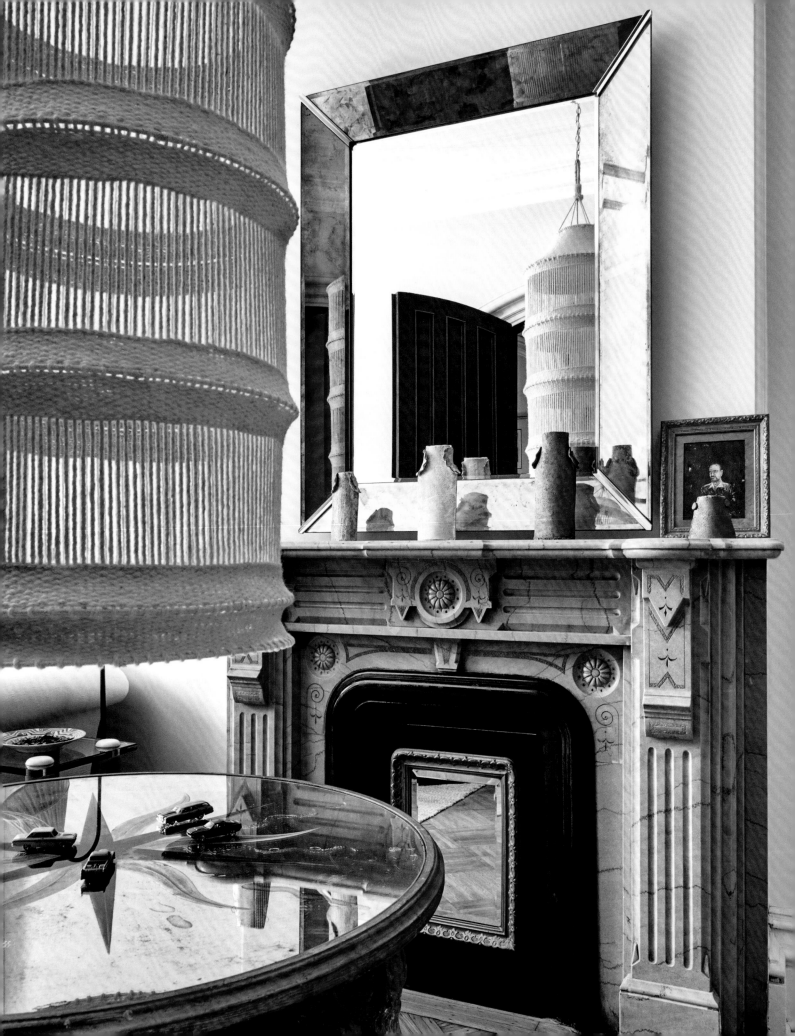

INTRODUCTION

Designers' own homes are often laboratories where they are free to take risks and experiment and are unrestricted from the demands of clients and the constraints of the business of architecture and interior design. These homes set trends, as opposed to follow them, and often host objects, furnishings, and finishes that are not yet valued or appreciated by the general public. Unlike the residences they create for clients, their homes tend to be more layered—more concentrated expressions of the designer's style, interests, and personal identity. While every object and surface might not be perfectly restored or of great value, these homes are just as carefully considered as the pristine, high-value spaces they create for their clients.

At the time they were constructed, the homes of architects as varied as Rudolph Schindler, Eileen Gray, Paul Rudolph, and Frank Gehry were among the most exuberant, creative, and forward-thinking forms of residential architecture. This phenomenon is not limited to architects. Designers such as Jean-Michel Frank, Elsie de Wolfe, Tony Duquette, Charles and Ray Eames, and Ward Bennett transformed their own homes into living laboratories of interior decoration and design that are now iconic cornerstones.

This book features the homes of thirty-four New York City–based architects and interior designers, some of whom are recognized and highly regarded in design circles, others of whom are just becoming known and appreciated. They are responsible for some of the most creative residential-design work being done today. Focusing on New York, one of the most complex and difficult real estate markets in the country and home to a vast array of architects and design professionals, provides a particularly interesting test sample. In the last decade or so, we have seen the size, scale, and value of much of the published interior design in New York grow to unprecedented heights. This book features environments that are, typically, much more modest and shows homes that were created with much smaller budgets than what the designers tend to work with. This too, I hope, will make the work included here more accessible and have greater interest to those both inside and outside the design and architecture fields.

New York, because of its limited housing stock and famously sky-high prices, adds a layer of complexity to the equation, but in reality, these conditions are just an amplification of the many issues being faced by those designing homes for themselves or others in all parts of the country—whether they're in urban, suburban, or rural areas. The city offers a vast array of residential housing options, and this book includes the homes architects and designers have created from these diverse offerings: nineteenth- and twentieth-century

townhomes, converted industrial buildings from those same periods, and tenement, turn-of-the-century, modern, and contemporary apartment buildings.

For decades, artists, designers, and architects have played an important role in the shifting attitudes toward neighborhoods, building types, and even entire boroughs of the city by staking claim to undervalued or undesirable areas, often with unconventional spaces, and setting up homes there. In the 1970s, we saw how parts of New York's creative class moved into the city's light manufacturing buildings, abandoned by the industries that these buildings were intended to serve, and kicked off a wave of loft living that has both spread to other urban and post-industrial environments and continued to foster innovative dwelling solutions some forty years later.

One clear shift in recent years is that there is no longer a single neighborhood associated with New York's creative classes. The centers of artistic, architectural, and design activities have, over the last century, traditionally moved from one neighborhood to the next. That formula seems to have been abandoned. Today's internet-infused, hyperconnected New York appears bigger than ever before, as the outer boroughs are more accessible and, simultaneously, more homogenous. For many of the architects and designers whose homes are featured here, the importance of "neighborhood" has taken a back seat to the quality of the spaces they call home. As a result, architects and designers are setting up homes across the city, from Harlem to Tribeca and from Bedford-Stuyvesant to Beekman Place.

In this book, you will see an array of architectural and decorative styles, an abundance of color and the absence of color, and maximalist and minimalist approaches. You will also see how some of these designers have managed to create inviting and functional homes in everything from studio apartments to entire townhomes, but the one thing that remains constant is that none of these homes follows a predetermined path that has not been thoroughly examined, analyzed, and considered. These creative environments are where designers are exploring and reimagining the notions of space, luxury, comfort, and personal identity.

In some cases, this manifests itself in the simple reassignment of room functions. When Michael Haverland, for example, was considering the traditional one-bedroom apartment that would eventually become home for him and his partner (page 142), he was concerned that the space might not be large enough. The formal layout of their apartment dedicated a good amount of the space to the dining room, which Haverland quickly realized they did not need. Armed with the freedom to abandon the conventional function of the room,

Haverland used the space as an intimate extension of the living room and installed a television and sofa there. This may seem like a simple gesture, but most folks follow the lead the architecture they inhabit provides as opposed to letting their own personal needs mandate how the architecture is used. Similarly, interior designer Bill Sofield's apartment (page 324) communicates his complete disregard for rigid distinctions and delineations of space and their expected functions. His living space is a fantastic collage of exquisite furnishings, many of his own design; art and decorative objects; and exercise and gym paraphernalia literally peppered about. In Sofield's world, one can sit on the rowing machine and reach for the dining table.

In a city like New York, space has long been in short supply, so naturally the designers here experiment with just how much space is really necessary. The architect Charles Renfro, for example, felt that the abundance of windows and multiple exposures of his loft-style apartment (page 268) far outweighed any concerns over the space's limited square footage; designer Neal Beckstedt resolved the absence of a true bedroom with a beautifully designed Murphy bed (page 36); and Reinaldo Leandro and Patrick McGrath visually amplified the space of their intimately scaled one-bedroom apartment (page 184) by establishing a limited, nearly monochromatic design vocabulary and using it throughout the space.

Others, like designer Franklin Salasky, use their homes (page 280) as laboratories to experiment with materials. Salasky added plywood so unexpectedly and creatively—from the living room ceiling to the bathroom walls—that it is impossible to be in the space and not be inspired by the beauty he has created with this humble material. The architects Lan My Do and Cary Tamarkin also incorporated plywood into their loft (page 68). But while the magic of Salasky's use of the material lies in the creative and the unexpected, Do and Tamarkin create a sort of alchemy with it. Here, labor-intensive joinery, typically reserved for precious woods, has been applied, and the material is exalted, literally redefining luxury. Ellen Hanson also experimented with notions of luxury and how they evolve over time (page 110). She was inspired by the masterful use of marble and inlaid woods in her building's exuberant, early twentieth-century lobby. In the entry of her own apartment, deep baseboards and door moldings were carved from gleaming black marble, and while calling to mind the elegance of the lobby, her use of the stone introduces a bolder, more aggressive sense of drama that is unmistakably modern.

Every one of the designers featured here allowed the architecture and history of their base building to inspire the design choices they made on the

interior of their homes. Signature and style are no longer being applied like a blanket over any and all vessels, but rather, these designers are fusing the identity of their base buildings with their own architectural and design sensibilities. The architect and designer Brian Sawyer, for example, scoured his late nineteenth-century building to study the original moldings and trim profiles before designing those solutions in his own apartment (page 296), which had suffered a fire and lost much of its original detail. While this may seem like an exercise in historical restoration, Sawyer was, in reality, attempting to understand and respect the true nature of the space and determine what would both be appropriate and feel authentic. When redesigning the interior of his apartment in a modernist high-rise built in 1966, David Mann hoped his work would seamlessly integrate with the building's history (page 204). He wanted to create a space that would amplify that history without creating a static monument to it. Designer Juniper Tedhams wanted to modernize parts of the nineteenth-century townhouse that hosts her duplex (page 350) but would not position the kitchen range anywhere but where the original hearth had been. This notion of listening to the clues the spaces provide, of extracting lessons from the base building architecture, is not limited to buildings with particularly interesting pedigrees. Reinaldo Leandro and Patrick McGrath turned to the interior design trends of the late mid-century for inspiration because that is the period in which their no-frills building was constructed. Their choice to run wall-to-wall carpet throughout the space was inspired by the building itself and not some preconceived design vocabulary they would have been willing to apply anywhere. Designer Michelle R. Smith (page 310) was so taken by the patina on parts of her Brooklyn brownstone that she left entire surfaces as she had found them and had to constantly stop the contractor from "finishing" them.

With this collection of homes, we see the structural foundation of professional design shift radically, specifically the establishment of a dialogue between the client, designer, and chosen space. What occurs in its place is not simply the extraction of the client but also the amplified importance of the chosen space as seen through the individual designer's lens. Here the space—with its assets and flaws, history and cultural position, architectural pedigree or lack thereof—replaces the client in the architect or designer's professional practice. In turn, the designers can focus their attention on making the best of their chosen spaces with whatever vocabulary they can imagine. The end result is highly personal—a comingling of their identities as designers with that of the spaces they inhabit. Home is, after all, where the heart is.

JEREMY ANDERSON
& GABRIEL HENDIFAR

The parlor floor of this charming Park Slope brownstone, built in 1829, was exactly what Gabriel Hendifar and Jeremy Anderson of Apparatus had in mind when they moved to Brooklyn from Los Angeles. The apartment had been well maintained by the landlord, who had purchased the property in the early 1970s, when Park Slope was still a bit of a no-man's-land. Luckily for the design duo, the landlord was very protective of what he considered to be important historical details such as the parquet floors and plasterwork; however, some functional, no-frills rental choices had been made in the kitchen and bathroom and with the lighting that the designers were eager to reimagine.

In addition to the floors and plasterwork, the Brooklyn parlor apartment offered a sensible arrangement of rooms, twelve-foot ceilings, a bay window, and original crystal doorknobs. The couple thought the apartment's proportions hinted at something more elevated than the pragmatic choices that had been made over the years. In order to accentuate the grandeur of the space, they treated the walls differently in each of the rooms. Wallpaper was installed in the dining room, and in an attempt to underscore the sheer volume of the living room, the walls, moldings, and ceiling were painted in the same off-white color. This decision to emphasize the volumes of the home left them with spaces they feared would feel empty or cold, but they mitigated this by incorporating a variety of window and floor coverings and adding a rich layer of art, lighting, and objects, some vintage but many of their own design or by their colleagues.

While the living room was painted in a chalk white, the other spaces embrace a rhythm of colors. The entry hall, for example, was inspired by Sol LeWitt's isometric drawings. Here an array of bold, geometric shapes in custom shades of gray and nudes create the illusion of an expansive, art-filled space. Hendifar said that considering the rhythm of colors as one moves through the various spaces was very important in designing a dynamic experience. Leaving the chalk-white living room, one moves through the graphic hall and into the master bedroom, which is painted in blue-gray. The guest bedroom, just across the hall, is much darker and painted in two shades of dark blue in rectilinear fields, the proportions of which reference Rothko paintings. The kitchen is painted the vibrant color of new growth, perhaps as a reminder of their seemingly endless creativity. Outside this area, a small rooftop was transformed into an intimate terrace that has become one of Anderson and Hendifar's favorite spaces.

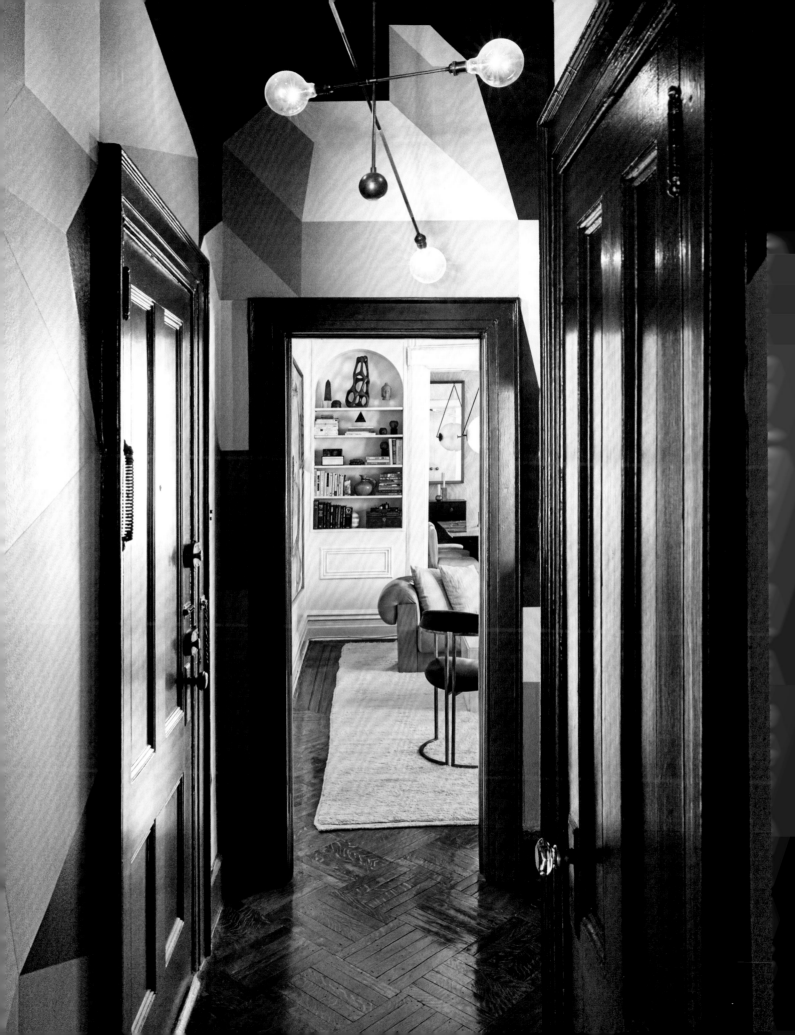

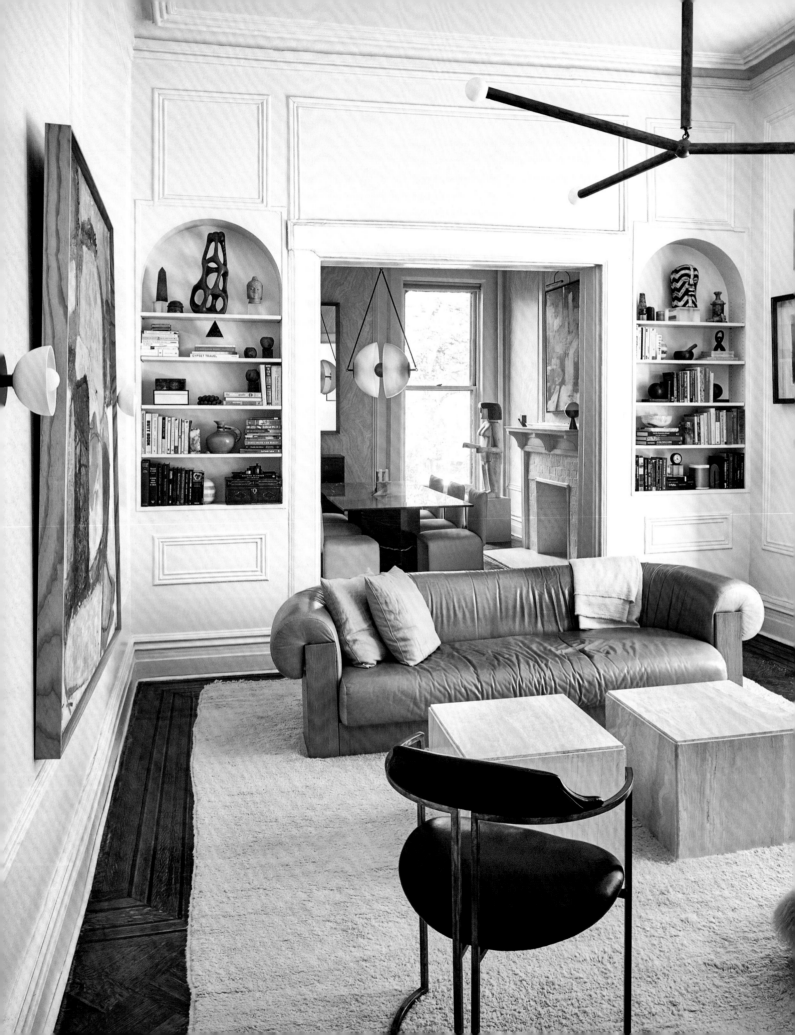

Anderson and Hendifar own the lighting company Apparatus, and its products are used throughout the apartment. Many of these pieces, including the Synapse in the dining room (following spread), Arrow in the living room, and Triad 15 in the master bedroom (page 22), were designed specifically with this apartment in mind. They also made the living room's custom media cabinet.

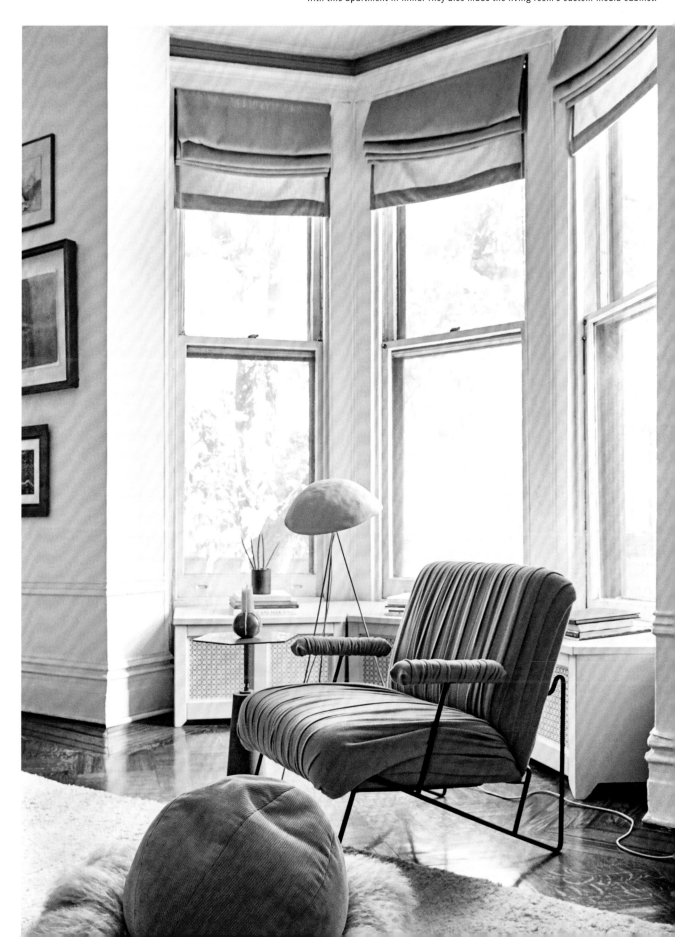

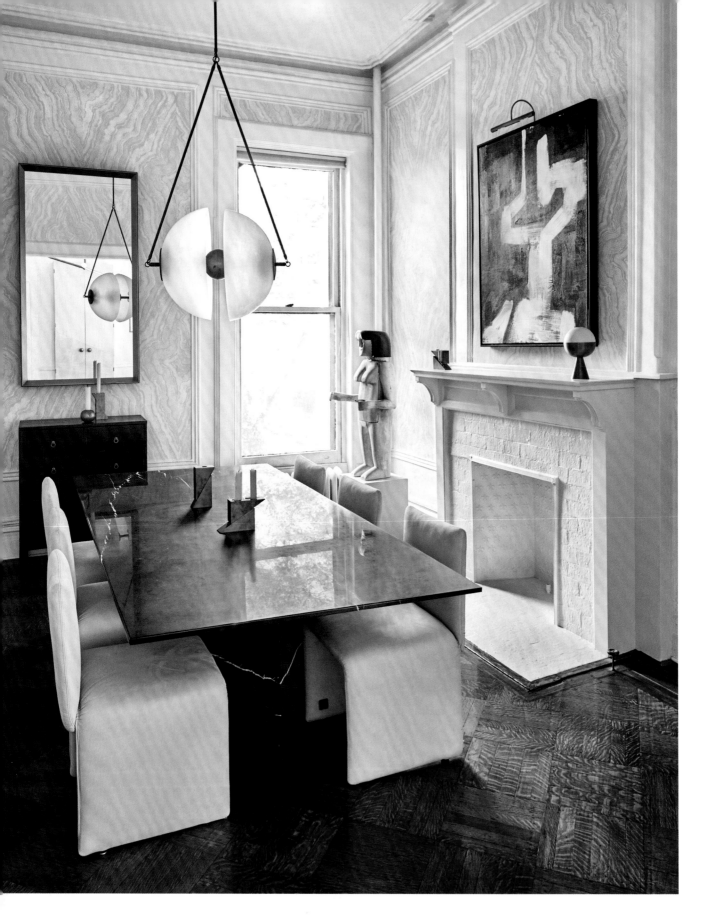

The dining room includes a table designed by Anderson and Hendifar. A painting by
Jamie Bush hangs over the mantel, and a pair of vintage carved-wood liquor cabinets,
one depicting a man and one a woman, flank the fireplace. The couple also designed
the candleholders and the incense burner on the mantel.

Anderson made the canisters that sit on the kitchen counter. The dinnerware on the credenza is by Apparatus.
Following spread: In this bedroom, Anderson and Hendifar designed the graphic application of the two custom shades of blue based on the proportions of Mark Rothko's paintings. Hanging above the bed is the Cloud 37 lighting fixture from their own collection. It is made of hand-frosted glass and brass.

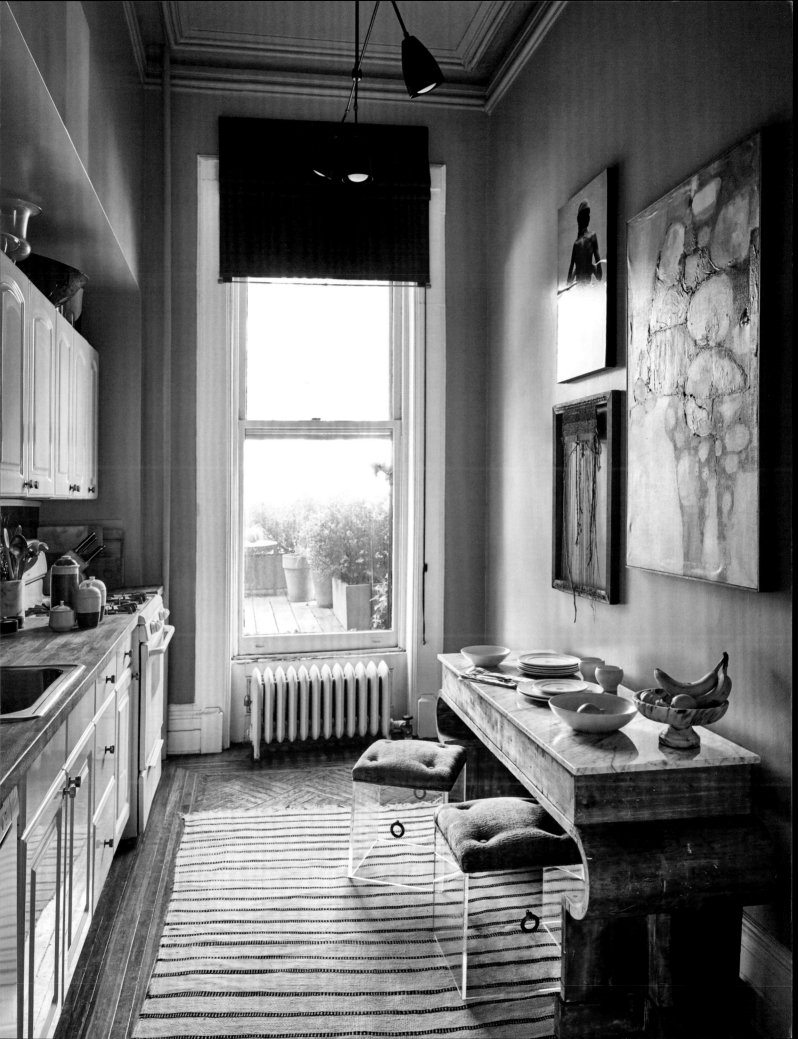

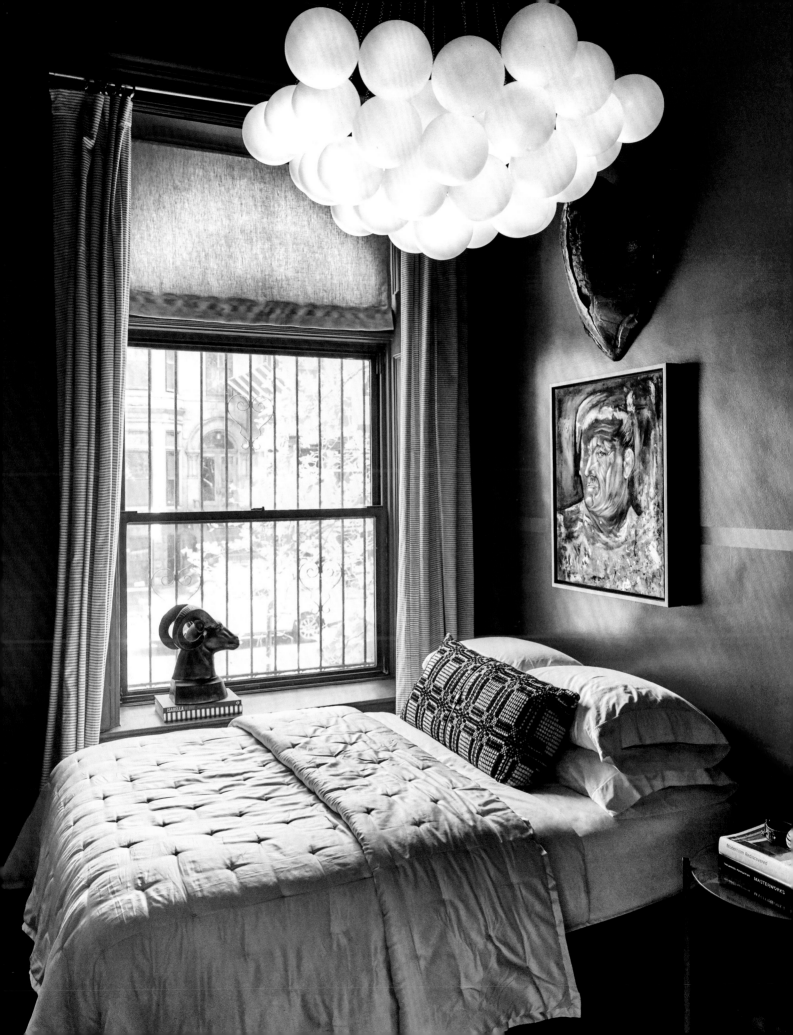

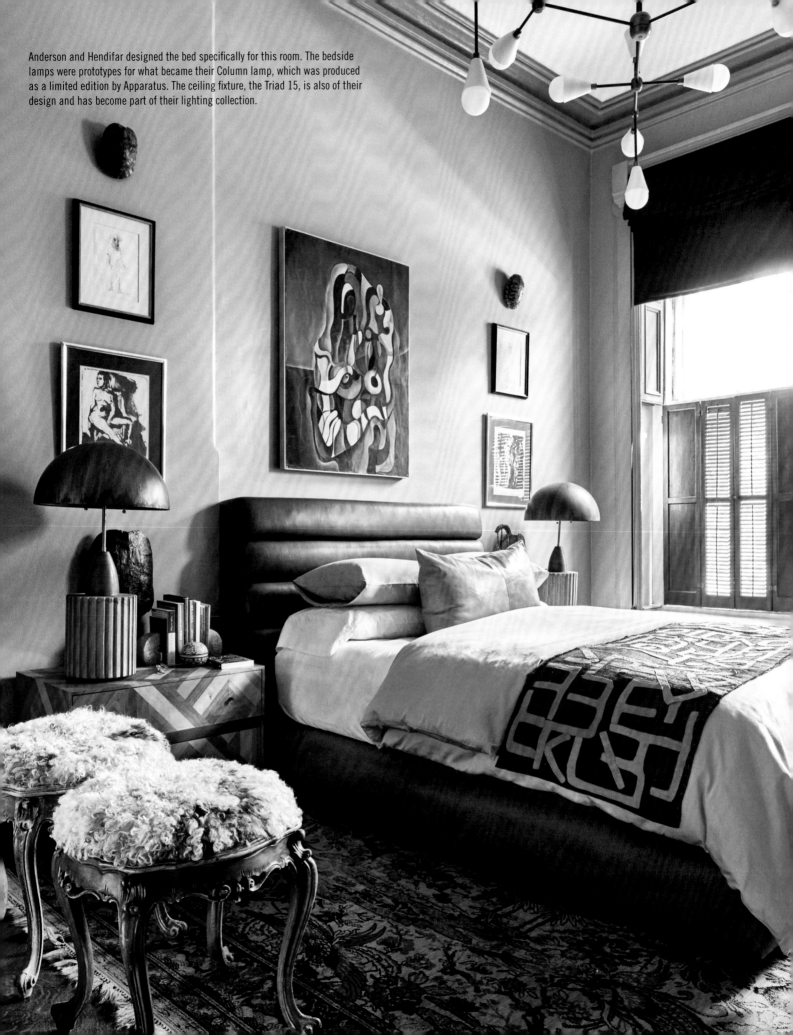

Anderson and Hendifar designed the bed specifically for this room. The bedside lamps were prototypes for what became their Column lamp, which was produced as a limited edition by Apparatus. The ceiling fixture, the Triad 15, is also of their design and has become part of their lighting collection.

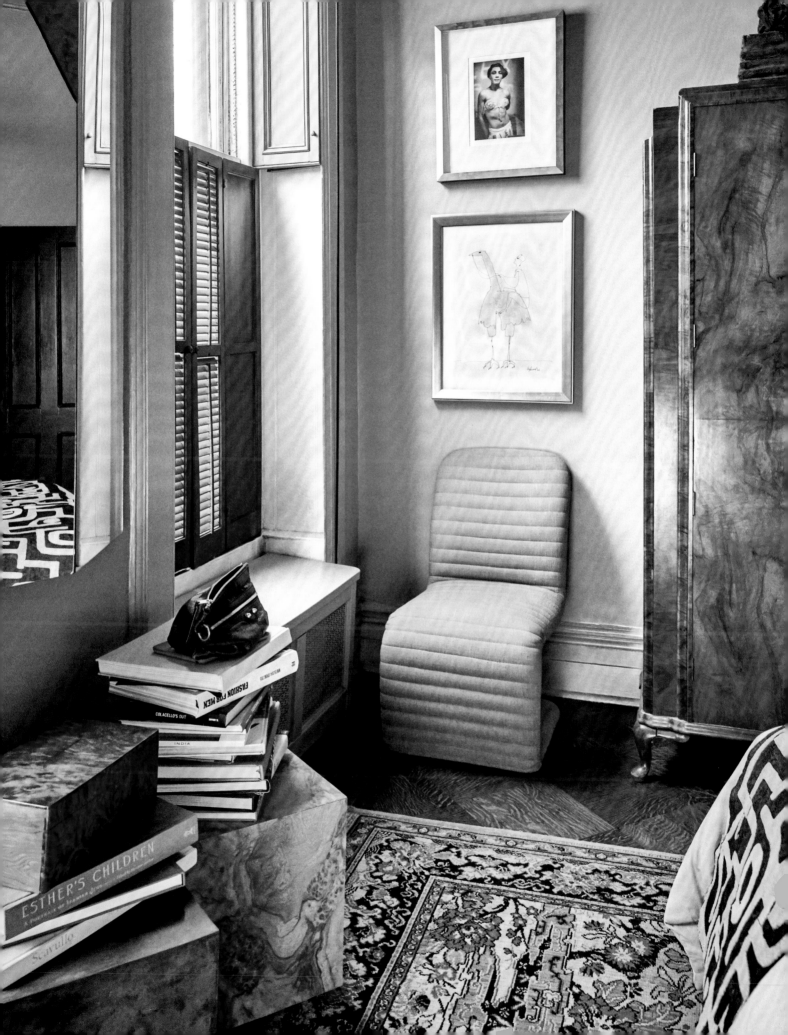

The painting treatment in the entry hall, seen here from the master bedroom, was inspired by Sol LeWitt's isometric drawings. After working with copies of LeWitt's drawings, Anderson and Hendifar drew on the walls, masked the shapes, and mixed custom shades of grays and nudes to create a dynamic environment in what would have otherwise been an overlooked space.

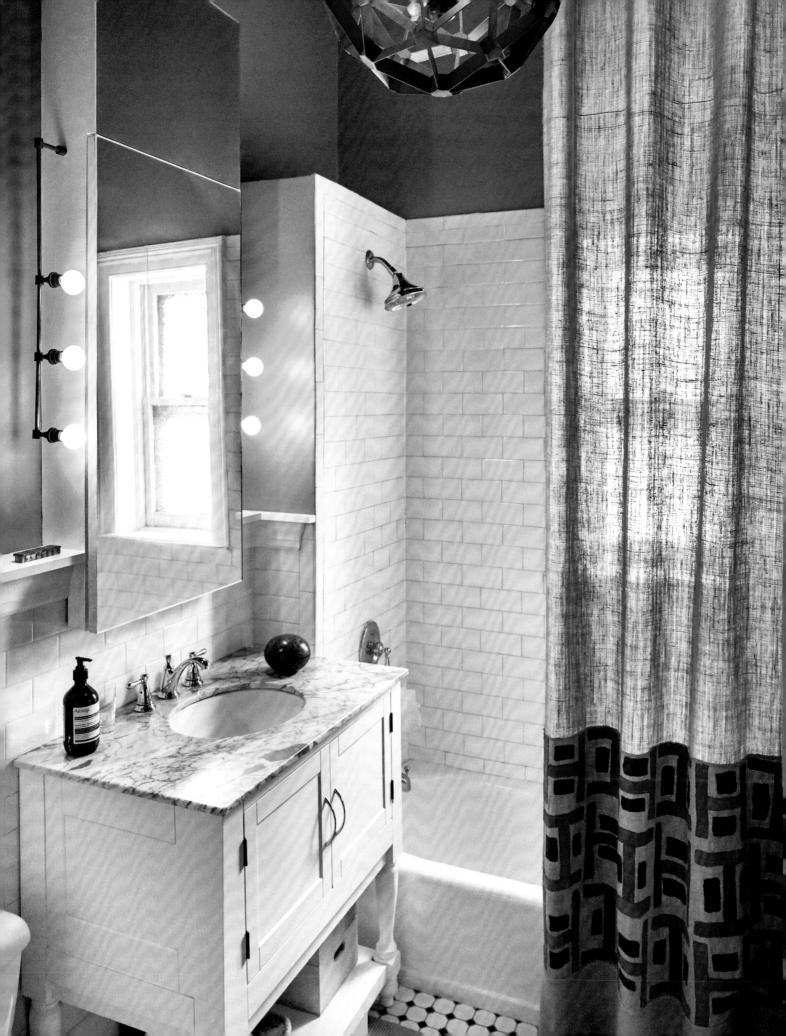

ARIEL ASHE

When Ariel Ashe first saw this apartment, which occupies the top floor of a quintessential Greenwich Village townhome built circa 1899, she was immediately attracted to the light and quirky qualities of the century-plus-old space. With three skylights, three windows across the south-facing front, and an additional three in the north-facing back, the apartment had near-perfect exposure and light, which, for this New Mexico native, was a major selling point. Because the apartment is on the top floor, the ceiling reflects the slope of the roof, and therefore, the front, street-facing living room maintains the tallest height; as the roof slopes toward the back of the apartment, it creates a cozier, lower-ceilinged space for the intimate bedroom and dressing room. In addition to the light-filled and various-sized rooms, the apartment hosts two fireplaces, rare finds in Manhattan.

After living in an impersonal high-rise, Ashe wanted her design for the new space to fully embrace the privacy and grandeur of town house living, but without abandoning her desire for an intimate and cozy home. In order to emphasize and celebrate the loftiness of the living room, Ashe installed floor-to-ceiling curtains on a single rod that spans the width of the living room wall. This gesture makes the windows appear bigger and underscores the dramatic ceiling heights. She also hung art salon-style, nearly to the ceiling, which also accentuates the walls and ceiling height. Typical of a New York rental, the wood floors were very yellow and shiny, so Ashe incorporated an abundance of rugs, like the large handwoven Moroccan Tuareg rug in the living room. Ashe chose the rug because it reminded her of the Navajo designs of her native New Mexico while setting a decidedly bohemian vibe in the apartment.

For the living room furnishings, Ashe limited the palette to natural materials in various earth tones, a choice she believes fosters a certain degree of serenity and that she often applies in her design practice. She shifted gears slightly in the bedroom, where a large, peach-colored bed dominates the space. Ashe designed the velvet bed with oversize buttons on the headboard and a modern shape but incorporated ball-and-claw feet as a nod to the age of the house. Ashe said she spends a lot of time in her bedroom and believes that no sofa is as comfortable as a bed—so she made hers with this in mind.

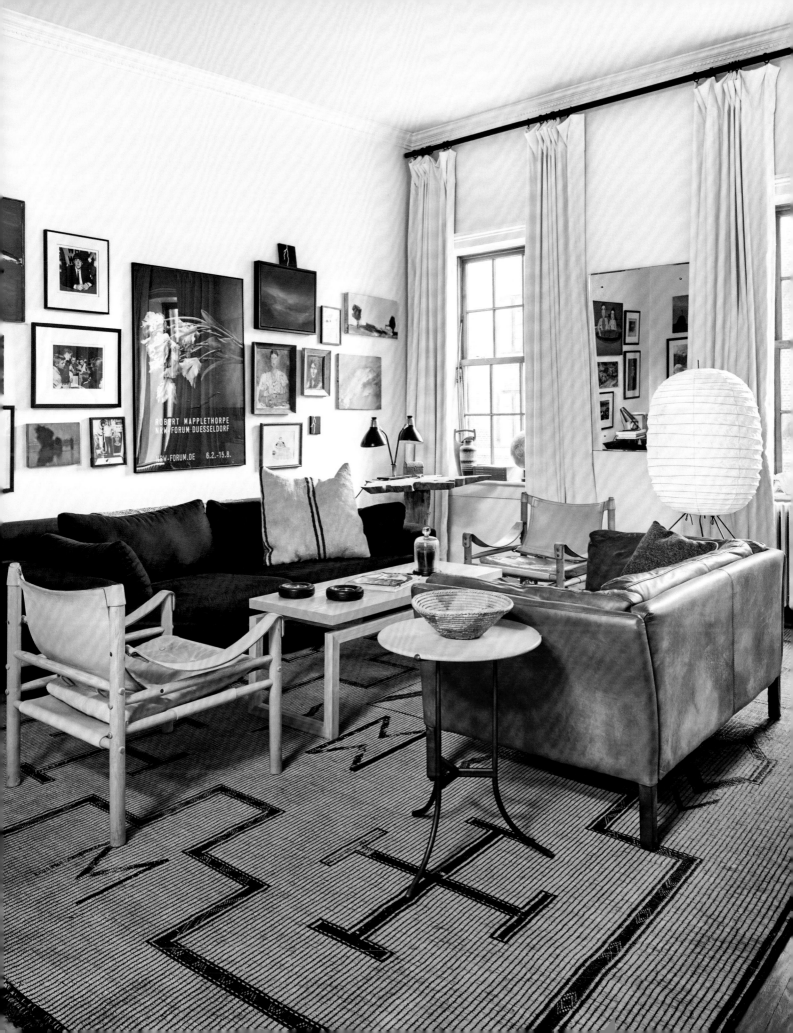

Ashe wanted to accentuate the tall ceilings in the living room while making the windows appear larger, so she hung dramatic floor-to-ceiling curtains on a single rod across the entire width of the living room. She also hung the art nearly to the ceiling for a similar effect. A handwoven Moroccan Tuareg rug, which she chose for its durability and beauty, anchors the seating area.

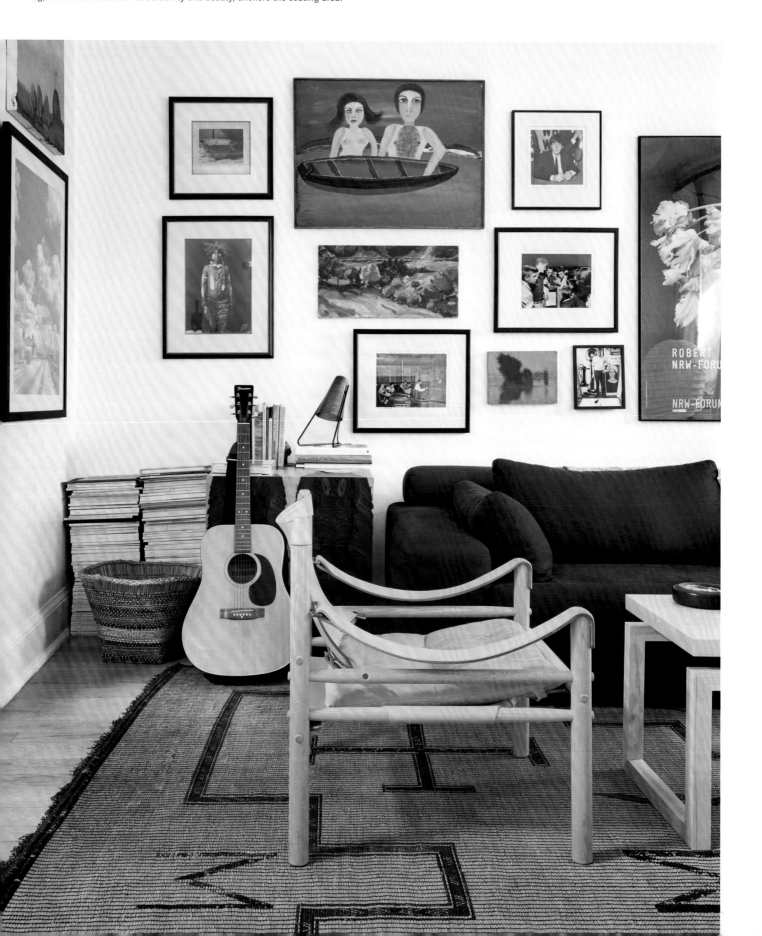

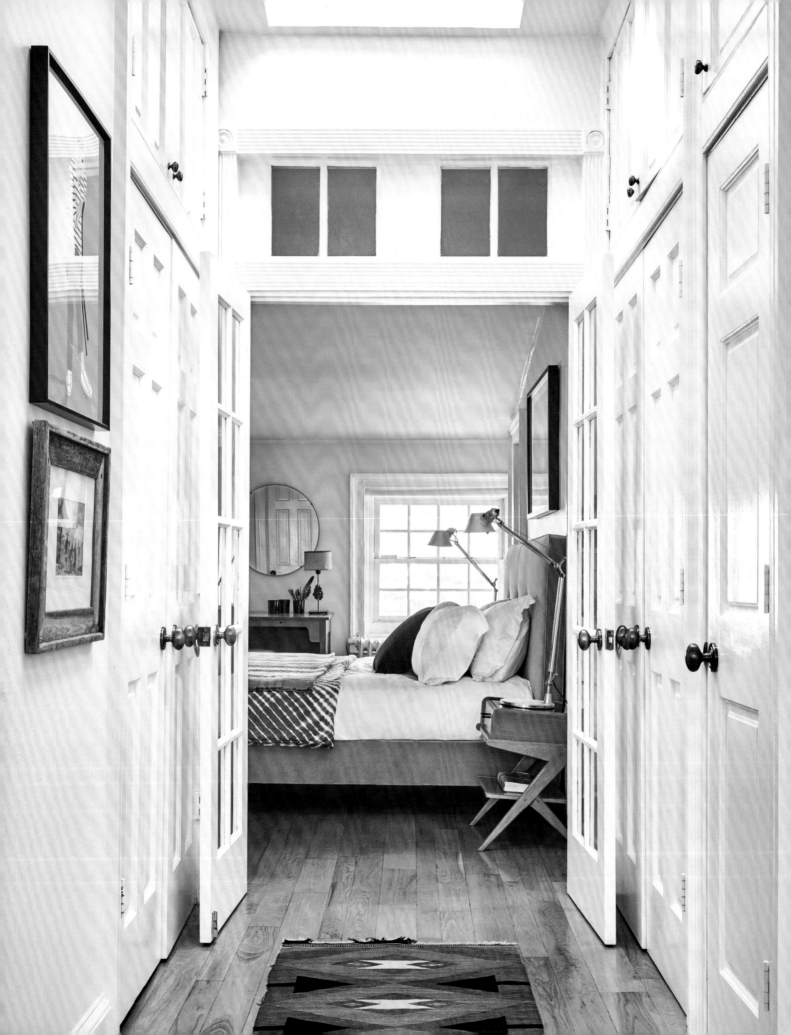

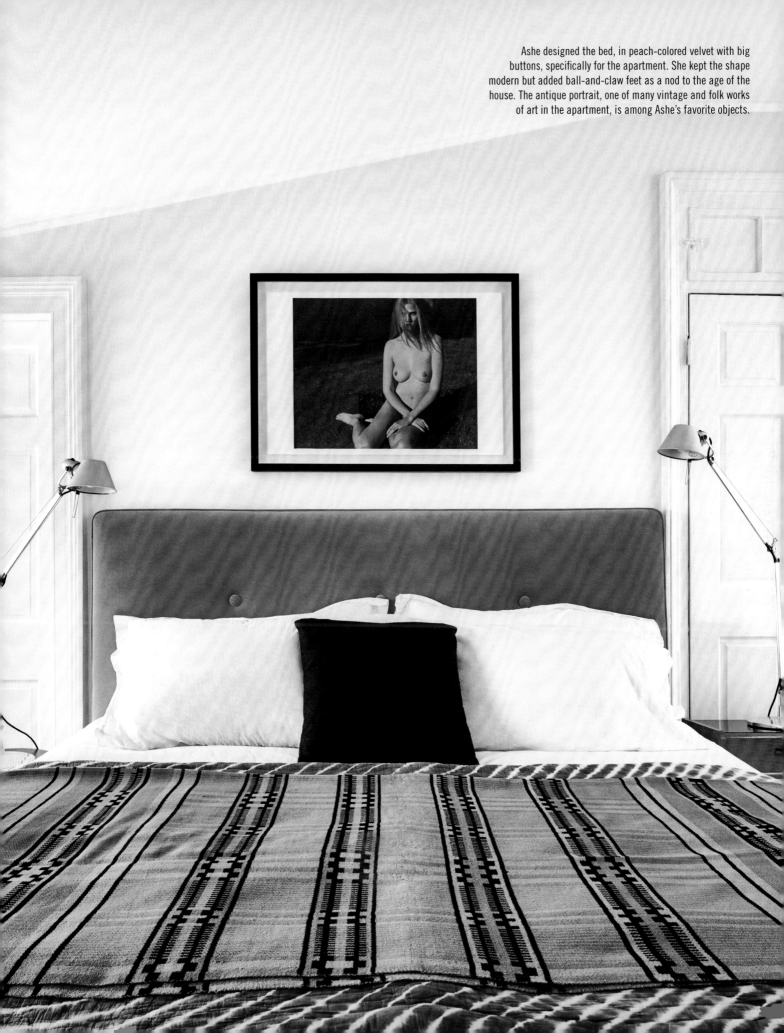

Ashe designed the bed, in peach-colored velvet with big buttons, specifically for the apartment. She kept the shape modern but added ball-and-claw feet as a nod to the age of the house. The antique portrait, one of many vintage and folk works of art in the apartment, is among Ashe's favorite objects.

In a sunny corner of the bedroom, Ashe placed an inviting
wingback chair—a vintage find she boldly reupholstered.

NEAL BECKSTEDT

When Neal Beckstedt first saw this apartment, it was a standard New York City rental: a simple white space with wood floors and a serviceable kitchen. What attracted him, though, was the bright and open southern exposure across the kitchen, living room, and bath—and the West Chelsea location. More importantly, the apartment had some classic prewar elements that Beckstedt believed gave the small space an authentic feel—original Bakelite plumbing fittings in the shower; often-mimicked, classic crackled subway tile on the bathroom walls; and doors with beautiful layers of paint and original brass hardware. The apartment, however, was not large, and Beckstedt moved in thinking his stay would be temporary.

Composed of an entryway; living room; small, windowless room sandwiched between the entry and the bathroom; and a long, narrow kitchen, the apartment did not offer a true bedroom. Beckstedt decided to create a sleeping nook out of the awkward, windowless space between the entry and the bath, and designed a Murphy bed based on a cabinet by Le Corbusier. Beckstedt's cabinet features carved wood handles and asymmetrical doors, which all come from Le Corbusier's design. Instead of lacquered doors, however, Beckstedt experimented with heavily brushed cypress, a finish that he has since incorporated into his other design projects. The bed disappears every morning and transforms the space into a dressing room, with the underside of the bed affixed with a mirror.

Beckstedt painted the doors throughout the apartment a dark black to give them more heft and substance. He painted the living room a soft gray and the kitchen and bath a matte black, which has since become his "go-to" black. He said that painting these rooms black instantly gave them a specific identity while visually expanding the space. To further differentiate the small rooms, he painted the entry a warm gray and lined the walls of the sleeping area with a gray wool plaid.

Beckstedt is surprised by how long he has lived in the apartment. Since it is a small space, he thought he would outgrow it and move on; instead, Beckstedt has built a collection of works by designers he has always admired, furnishing the apartment with an assortment of antique rugs, traditional and industrial finds, and Danish and French mid-century objects. Beckstedt said that the small space has made him edit and curate to a degree he never had to before. He loves the rigor of it, but sees no reason to become a monk doing it.

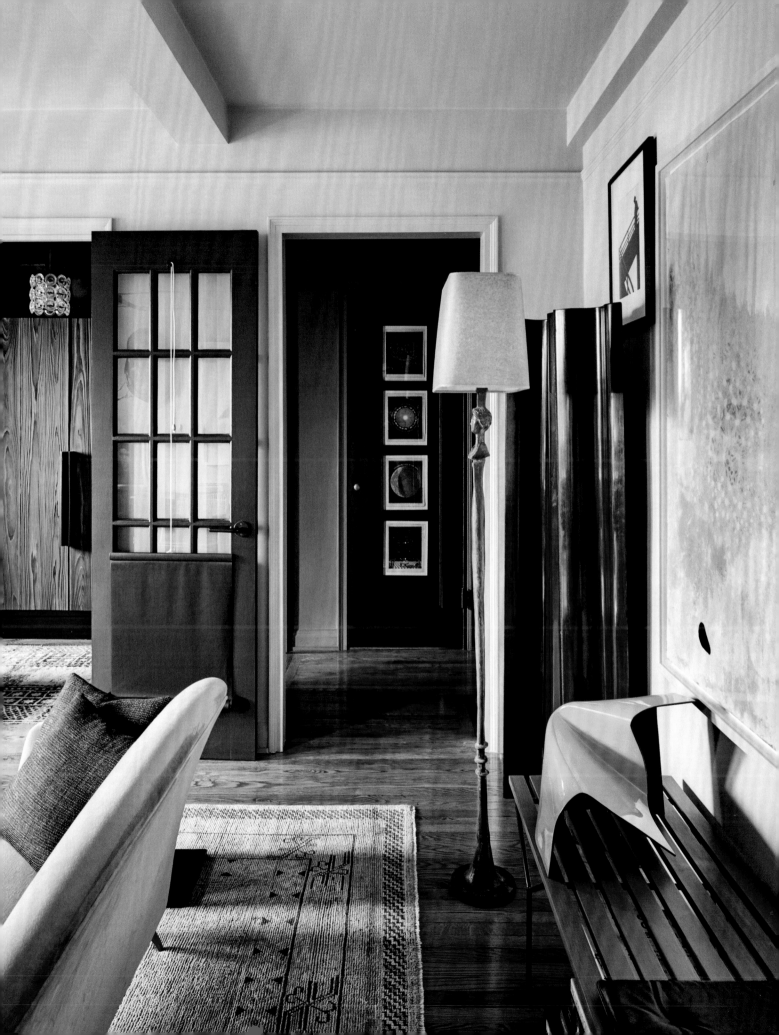

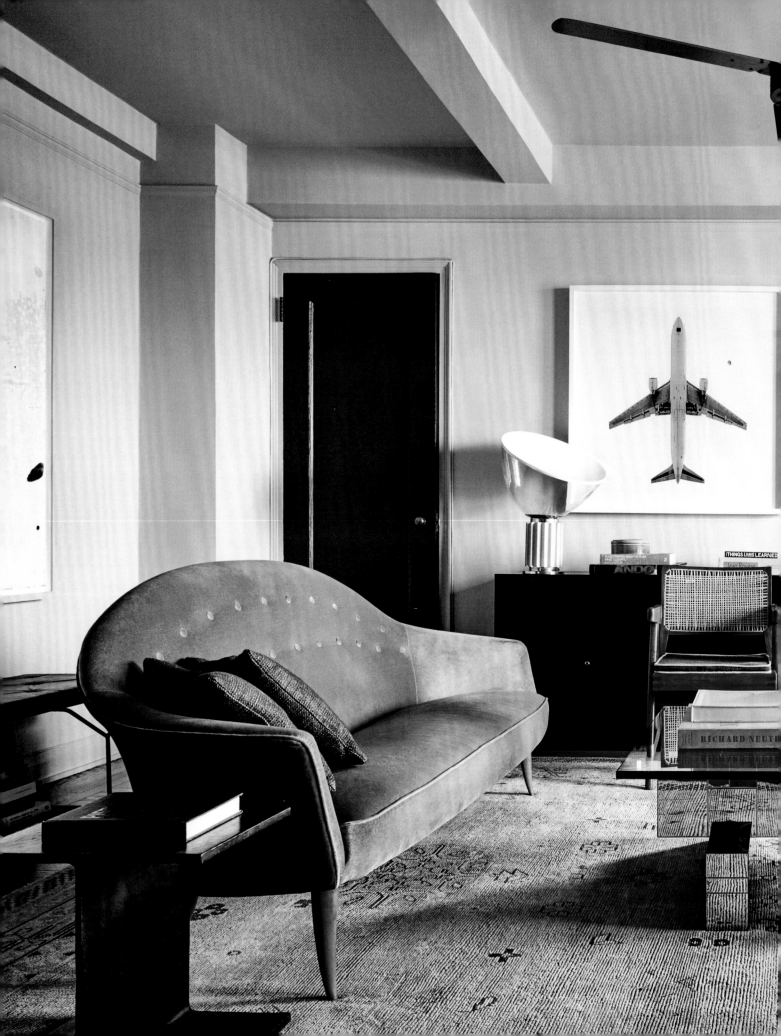

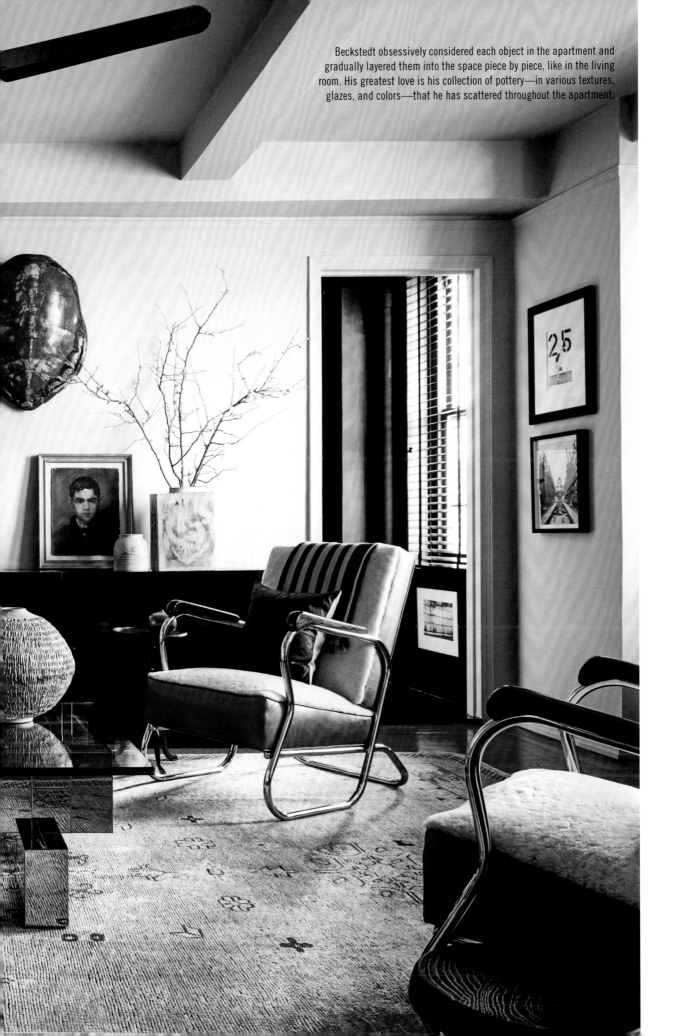

Beckstedt obsessively considered each object in the apartment and gradually layered them into the space piece by piece, like in the living room. His greatest love is his collection of pottery—in various textures, glazes, and colors—that he has scattered throughout the apartment.

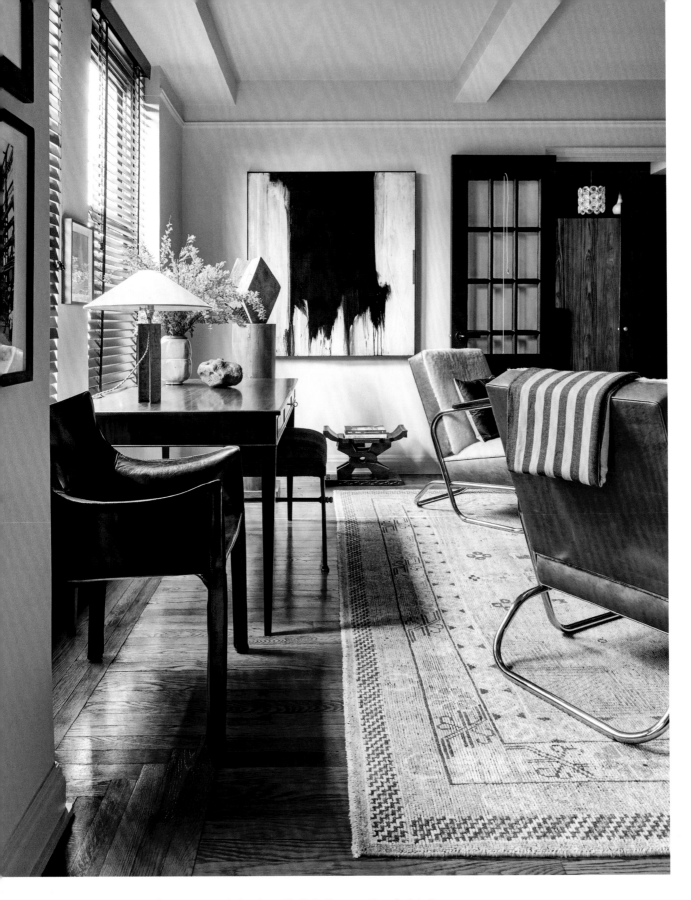

The Murphy bed, just past the living room, was designed specifically for the space. Here, Beckstedt transformed an awkward room into a sleeping area when the bed is down and a dressing area when up. A cabinet by Le Corbusier inspired details such as the carved wood handles and asymmetrical doors, but Beckstedt used heavily brushed cypress for the bed's doors.

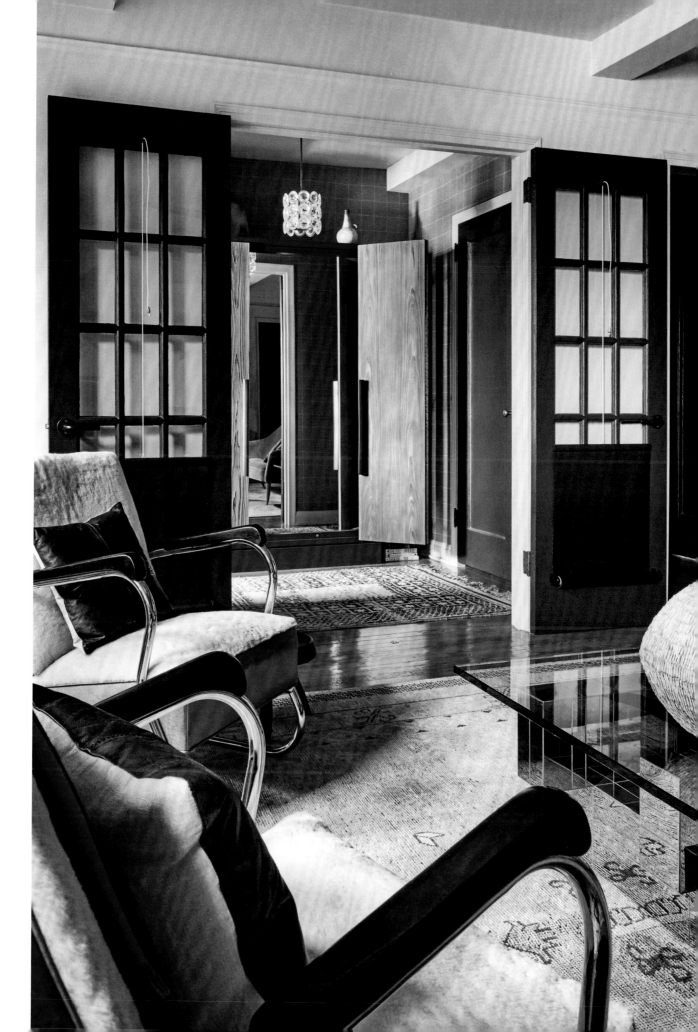

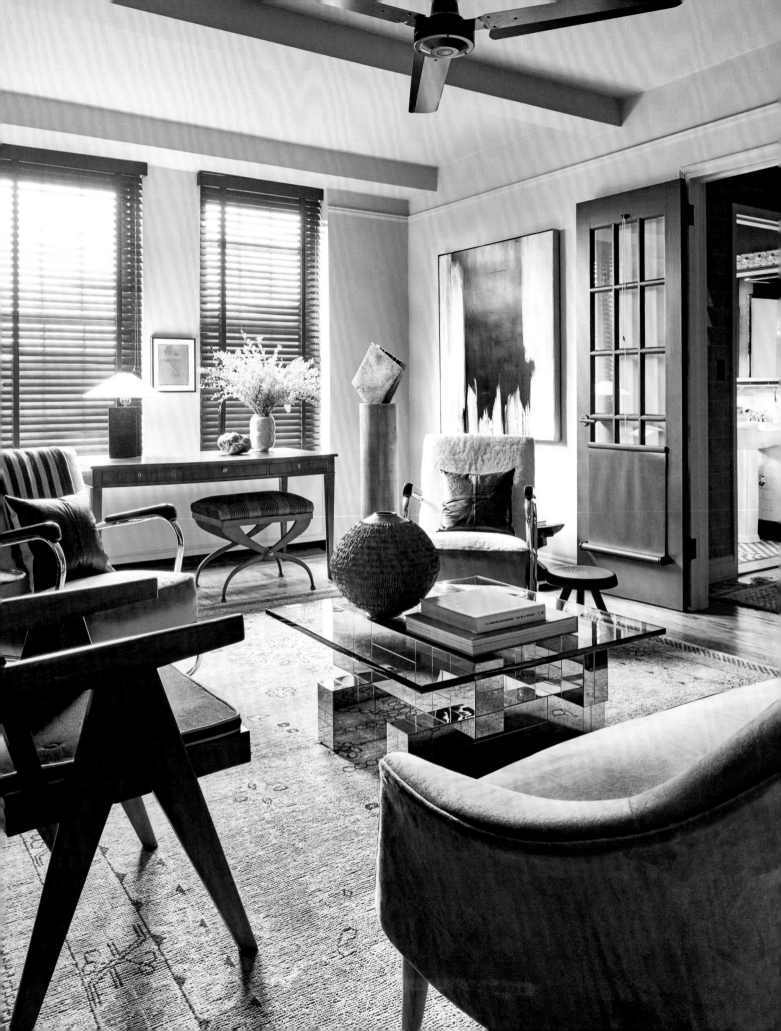

The bathroom had classic New York prewar elements—like the original Bakelite plumbing fittings in the shower and the classic crackled subway tile that lines the walls—that Beckstedt wanted to exalt. The black paint brings these elements to the foreground. Beckstedt was also fond of the doors because they had beautiful layers of built-up paint and original petite brass hardware that gave the space some soul.

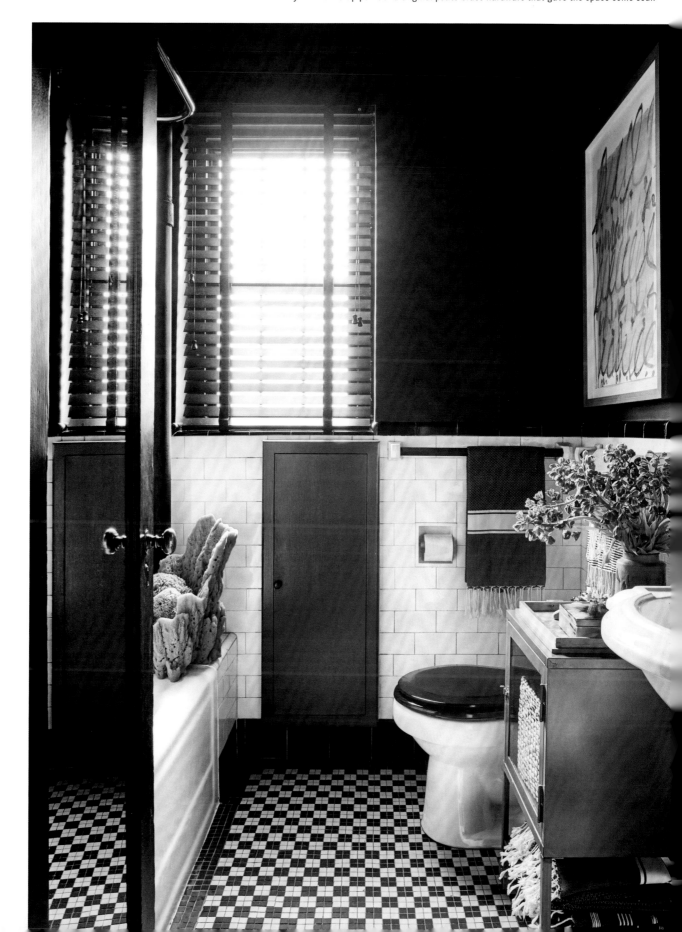

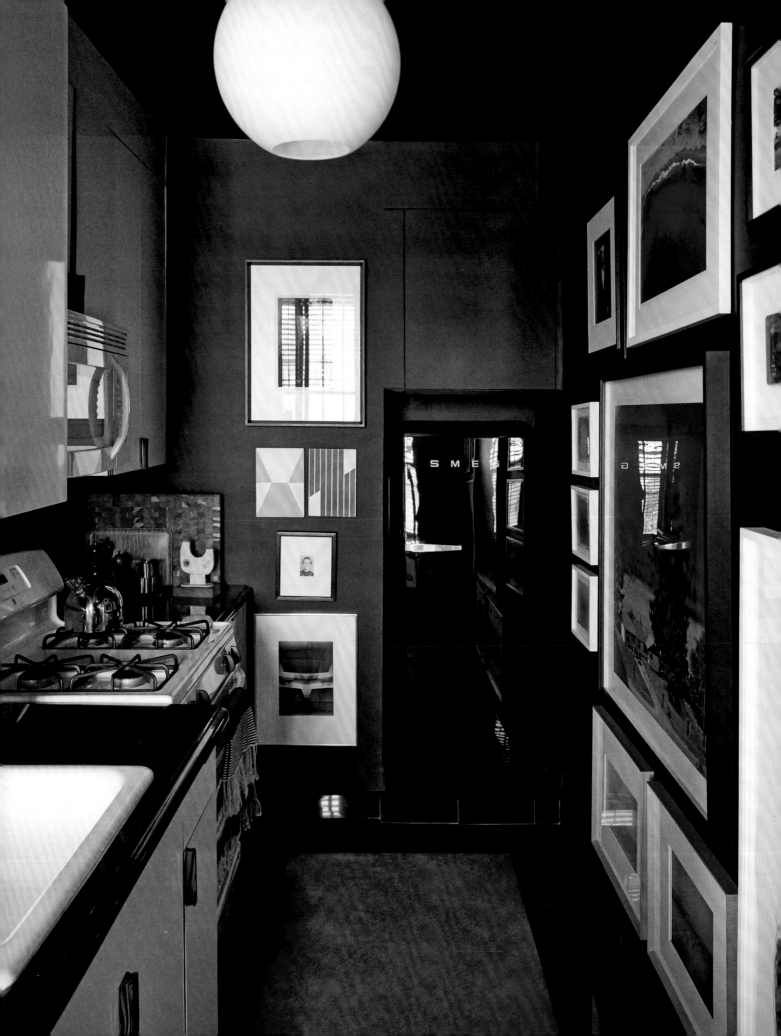

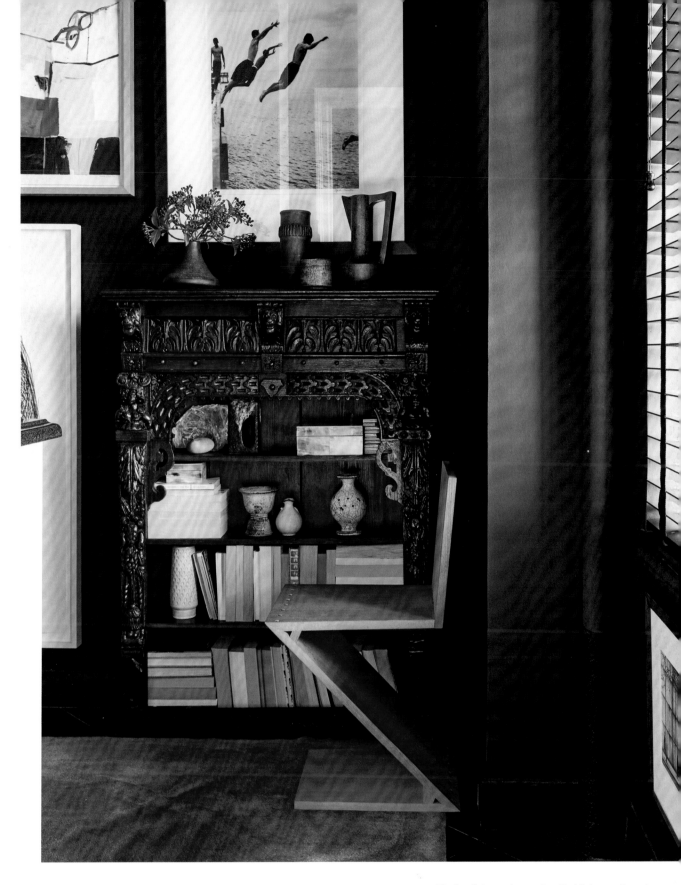

Black paint was also used on the kitchen walls and ceilings to provide the narrow space with a sense of depth while focusing the attention on the art and other objects.

WILL COOPER

Will Cooper finds refuge from the never-ending pursuit of perfection at his design practice, which focuses on the design, development, and operation of hotels in rapidly transforming urban areas, in both the grit of his East Village neighborhood and the imperfections of his intimately scaled, renovated tenement apartment. Cooper has deliberately created a space that allows him to unwind and abandon any thoughts of finishes and textures that dominate his workday.

When Cooper first saw the apartment, he was immediately attracted to the tangible history of the space. The ceiling beams were exposed, and the plaster had been removed from the common wall, running the entire length of the apartment, to reveal the underlying bricks with their ghost doors and fireplaces. But Cooper found that the red brick, while providing much-appreciated character, absorbed the precious light in the small, railroad apartment. With this in mind, Cooper had the floors and walls, including the exposed brick, painted a bright white. His intention was to blur the spatial constraints of the space with a singular, dominant color, or a lack thereof. Cooper believed that this color would reflect the most amount of light, so whether it was day or night, it would always feel bright even in the center of the apartment, far from the front and back windows. Cooper considered white to be a visual "palette cleanser," and said, "everything looks good against a white background." The constraints of the small space also led Cooper to remove all the closet doors and replace them with white linen panels. This eliminated the door swing but added some softness to the space. Black high-gloss venetian blinds were installed to diffuse and further reflect light into the long, narrow space.

Perhaps the most impressive aspect of Cooper's home is how it has become a laboratory or testing ground for the furniture he designs. The sofa, rug, and stools in the living room are of Cooper's own design, as is the bed, which is a prototype of the WC7 from his own collection. Cooper has found that the compact space forces him to constantly edit and pare down furniture, objects, and art. And the exposed brick and beams, along with the crooked ceiling, function as reminders that a perfect and abundant space does not always lead to the most creative solutions or make for the happiest living environment.

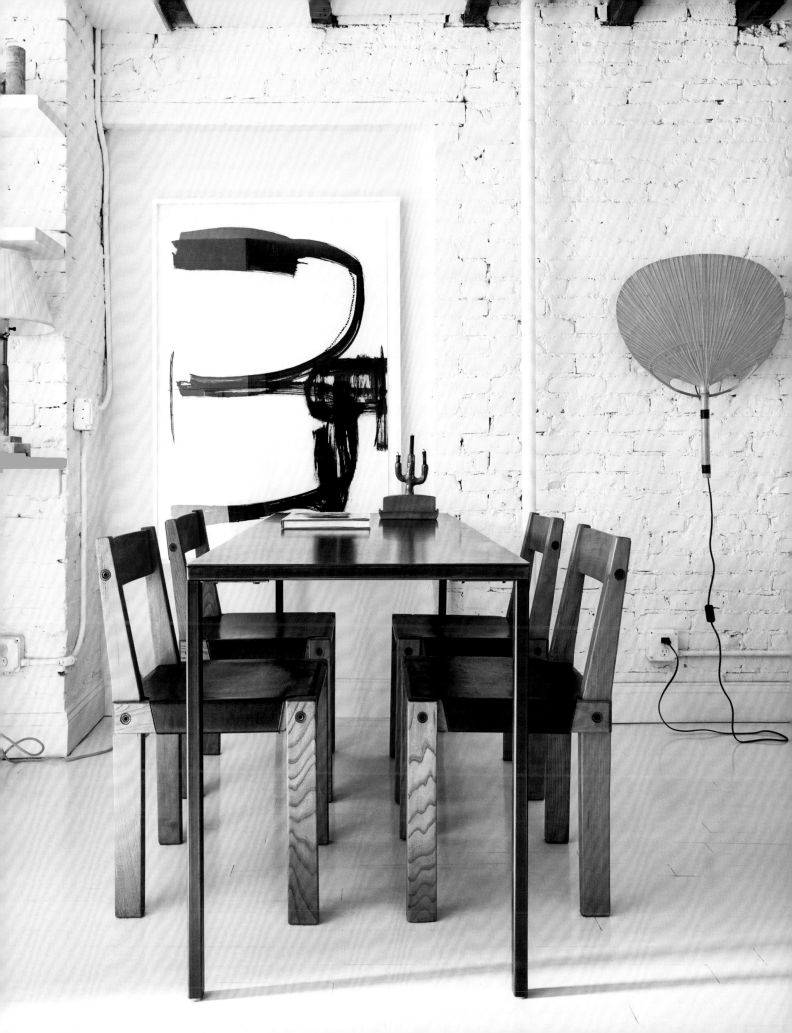

Cooper designed the sofa specifically for the space. He wanted a piece without a back
that could easily accommodate sleepover guests. The arched polished-stainless bench,
area rug, and three-legged cocktail table are also by Cooper.

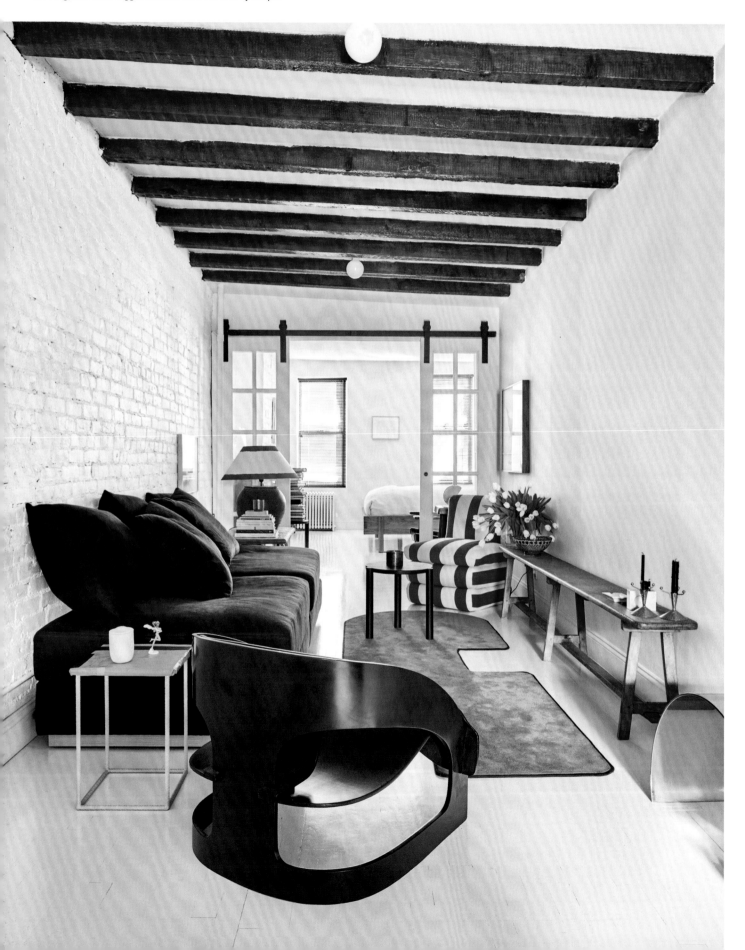

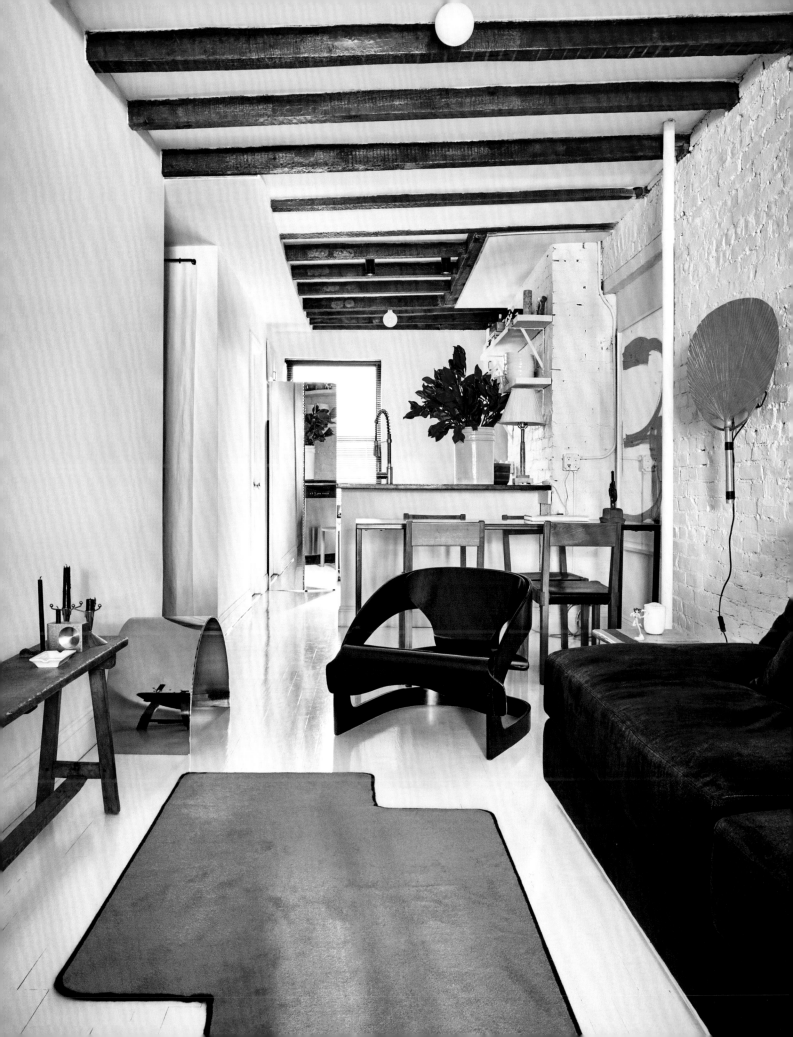

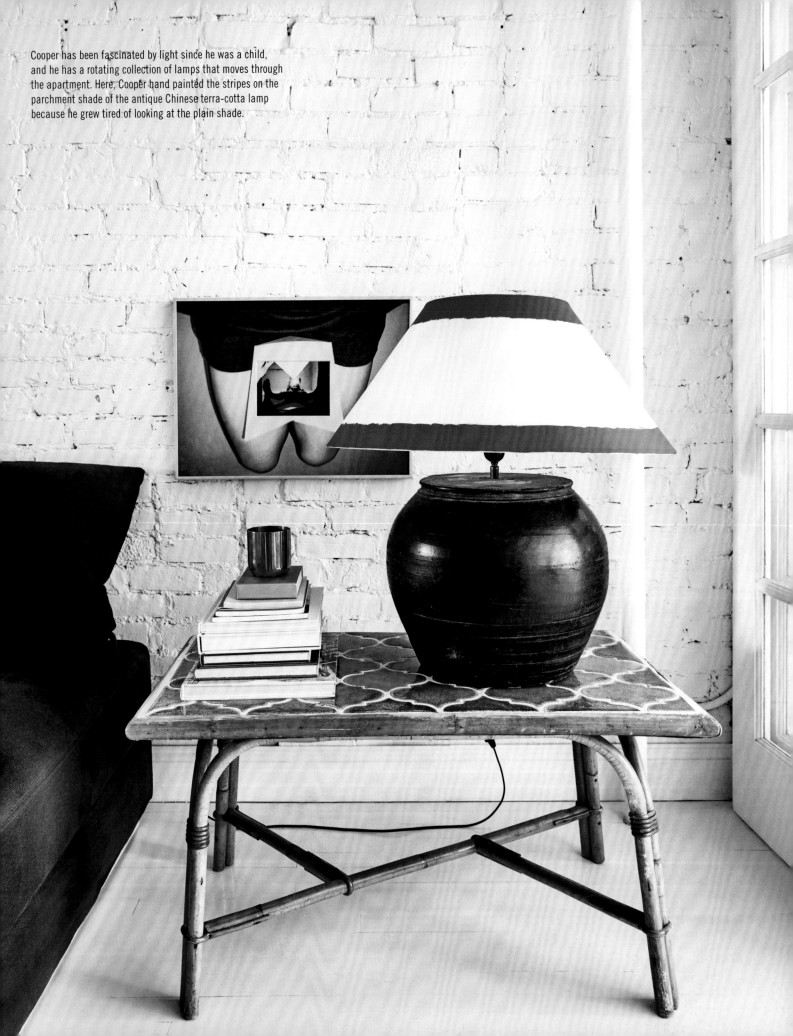

Cooper has been fascinated by light since he was a child, and he has a rotating collection of lamps that moves through the apartment. Here, Cooper hand painted the stripes on the parchment shade of the antique Chinese terra-cotta lamp because he grew tired of looking at the plain shade.

Cooper designed the bed for the apartment, and it is a prototype for the WC7 bed from his furniture collection. He needed something that could be disassembled and reassembled in the space while maintaining the integrity of the joinery that exists within the collection. The three-legged side tables, in marble and painted wood, are also part of his furniture collection. Cooper thinks that closet doors are overrated, so he replaced them with white linen panels to add softness and eliminate the door swing.

This chair is one of Cooper's designs. It, like the nonworking fireplace,
has become a receptacle for Cooper's collection of art and design books.
A pair of matching vintage dressers flank the fireplace.

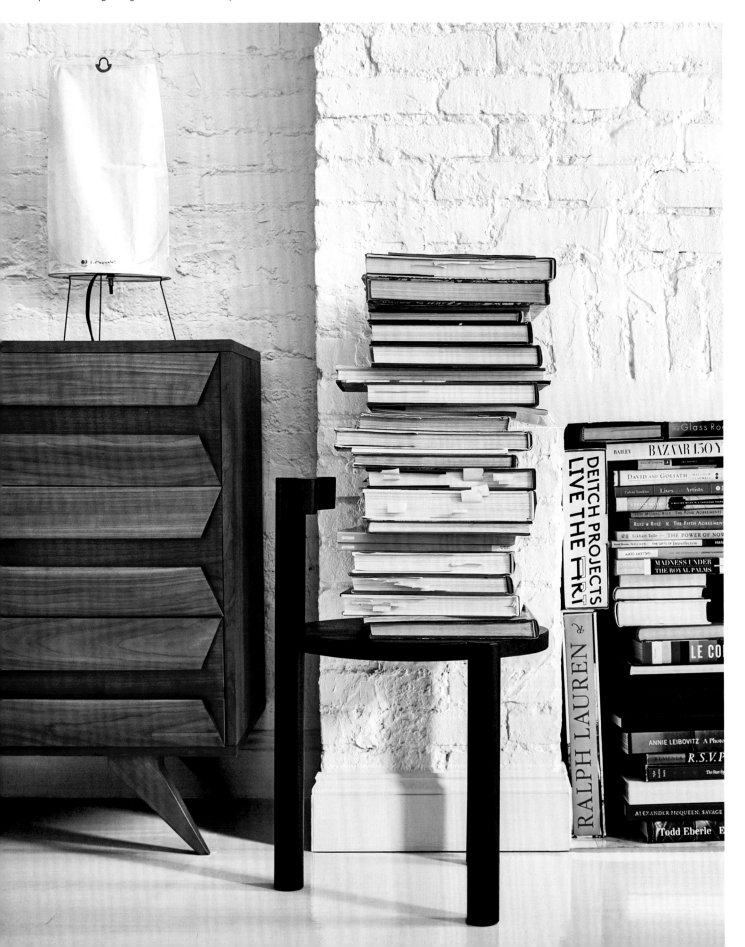

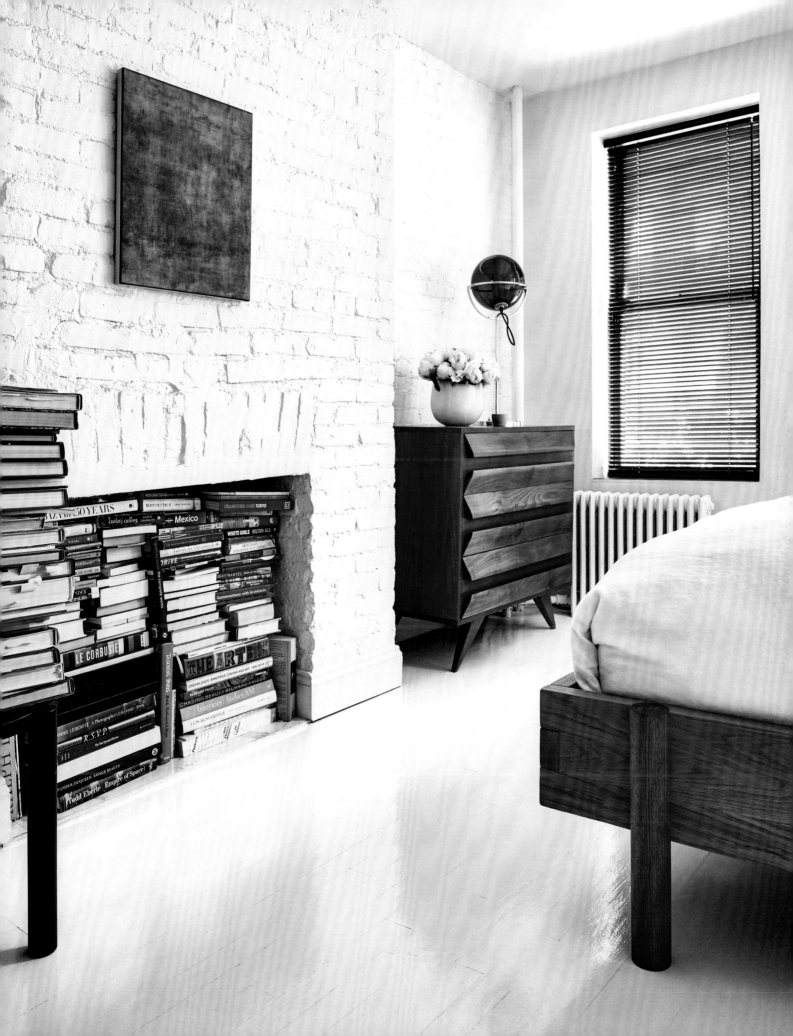

BILLY COTTON

When Billy Cotton first saw this apartment, the list of pros and cons was clearly unbalanced: The space had been cursorily rebuilt after a fire; the architecture was not special in any way beyond its testimony to a specific kind of railroad flat common in New York City's tenement buildings; and the layout—a series of rooms accessed from a hallway running the length of the apartment—meant that all the windows, with the exception of those in the living room, opened onto an interior airshaft, rendering much of the space void of direct sunlight. The apartment was, however, in Cotton's preferred West Chelsea neighborhood and offered relatively high ceilings. This outweighed the negatives.

Cotton set out to correct as many of the flaws as he could with a limited budget and the fact that the preexisting floor plan could not be changed. He reorganized the kitchen and bathroom for greater functionality and kept the furnishings throughout the apartment to a minimum. His boldest decision, though, was to create a monochromatic environment that would make the space feel brighter and more considered. Because there was not a great deal of natural light coming into the apartment, Cotton chose a warm, almost buttery, color that, without being yellow, mimics the effect of a sunlit space. In order to maximize the limited space, Cotton designed most of the furniture, including the custom sofa, buffet, and bookcase in the living room, the dresser in the bedroom, and the small cabinet with a mirror that he inserted into the wall of the entry. This gesture in the entry introduces the rigorous simplicity of the rest of the apartment and prepares visitors for Cotton's monochromatic vision.

With this renovation, Cotton seems to have been inspired by early-twentieth-century New York residential architecture. The kitchen and bath maintain a nostalgia that appears more grounded in the quality of design and construction associated with that period rather than stylistic concerns. Cotton, for example, has displayed his masterful ability to work with tile in many of his commissioned design projects; his own bathroom illustrates that dedication to perfection and is worth consideration. The kitchen, a sea of creamy walls and Art Deco–inspired cabinetry, exalts the Carrara marble backsplash, which literally glows with contrast in this sea of buttery hue.

It is Cotton's sense of the straightforward and the simple that taps into a nostalgia for a more streamlined past, a time of fewer objects and possessions, but each of greater importance and quality. This is communicated through everything in the apartment—with the simple but elegant bedspread, the custom sofa, and the simplicity of the two Paul Lee paintings cherished by Cotton. In the end, this exercise in design made Cotton realize that he needs much less than he ever thought.

Although it appears to be a vintage workbench, Cotton designed the table in the living room and had it constructed from reclaimed wood by a carpenter in Pennsylvania. Surrounding the table is a collection of formal, yet pedestrian nineteenth-century chairs. The room also features a ceiling fixture, called the Pick Up Stick, that was designed by Cotton and is part of his collection, as well as a sofa, buffet, and bookcases that were made by Cotton specifically for the apartment.

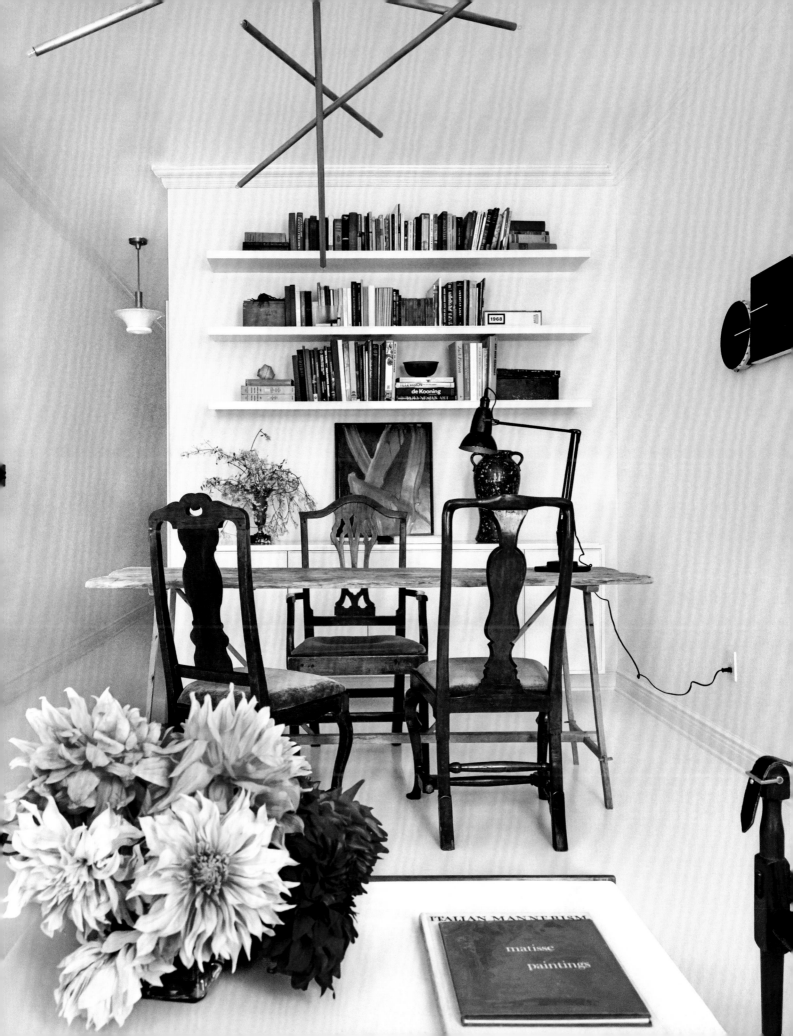

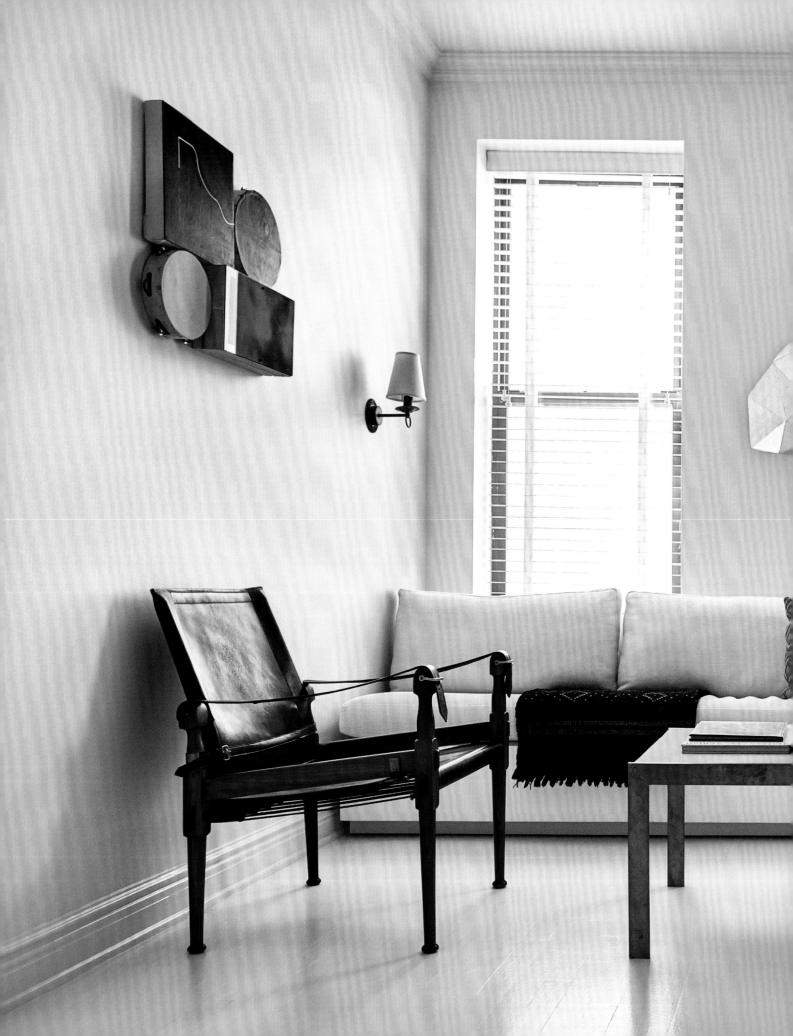

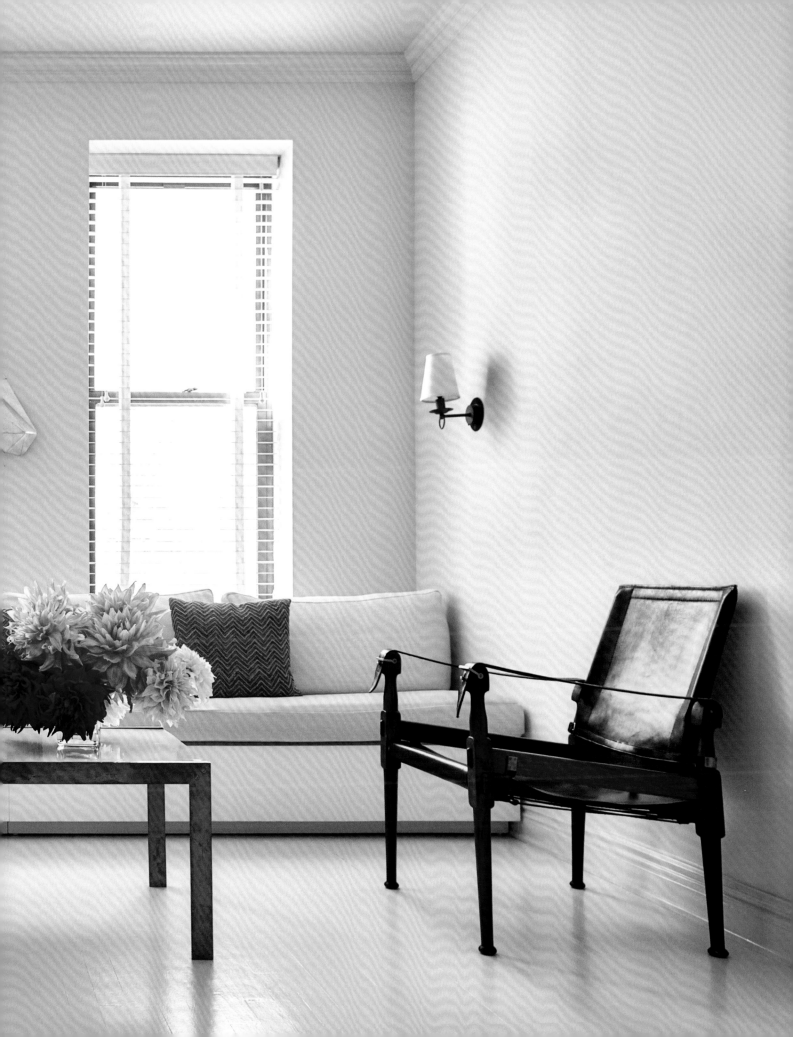

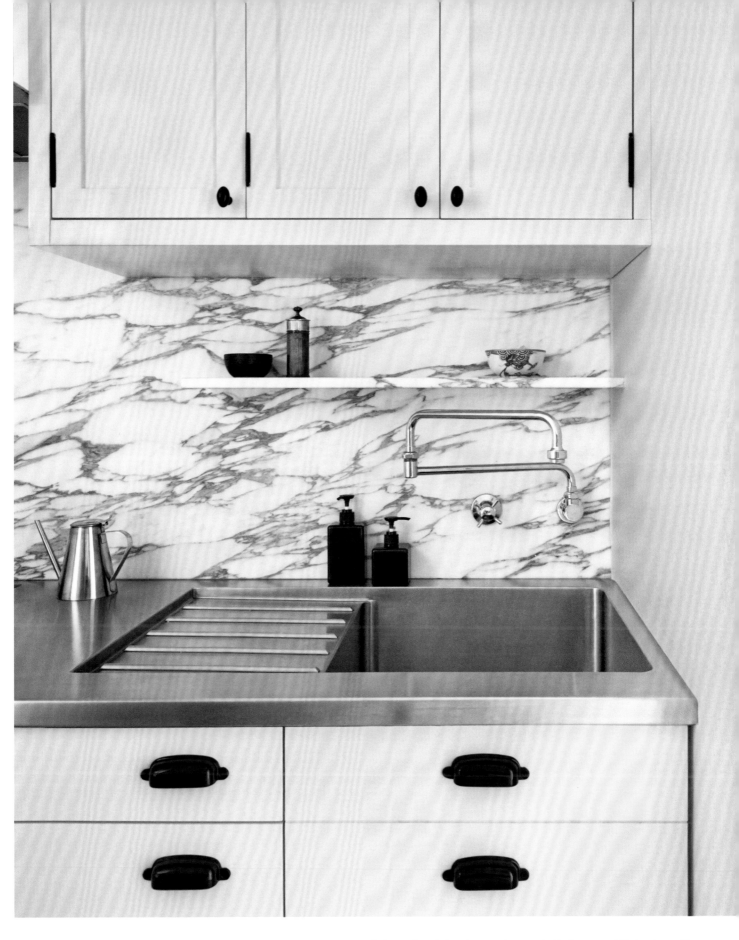

Undercounter referigerators were incorporated in the compact kitchen to provide as much counter space as possible. The cabinetry, like all the custom millwork in the apartment, was designed by Cotton and painted the same color as the walls and ceilings. The overall buttery hue of the kitchen highlights the beauty of the marble.

The dresser in the bedroom was also created for the apartment. Like he
did with the built-in mirror in the hallway, Cotton kept all the built-in and
custom millwork the same color as the walls, ceiling, and floors.

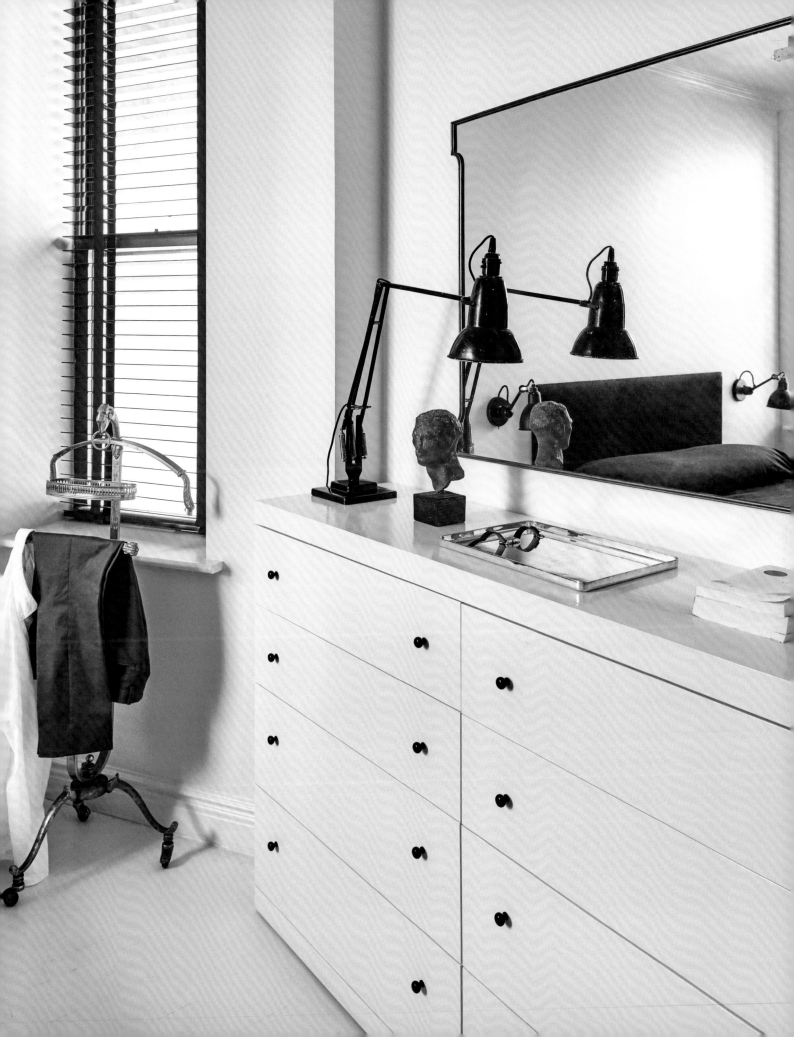

Cotton has developed a masterful ability to work with tile. The meticulous detailing here calls to mind the ways in which tile was used in the early decades of the twentieth century.

LAN MY DO
& CARY TAMARKIN

The architects Lan My Do and Cary Tamarkin had been living in a four-story town house for fifteen years when they decided they were ready to move into a classic loft. They yearned for big open spaces with an abundance of light and searched for a year before they found the right space: a full floor of a former manufacturing building in Greenwich Village. The building was constructed at the turn of the twentieth century and had been converted to housing in the late 1970s, and Do and Tamarkin were attracted to its solid, industrial quality and the massive windows across the north-, west, and south-facing façades. The ever-changing amount and quality of light throughout the day, along with another rarity, a twelve-foot ceiling height, drew the architects to the space.

Do and Tamarkin have designed many residential buildings across Manhattan, and much of that work would fall into the category of "luxury" housing; however, Tamarkin is somewhat allergic to that overused word. Concrete and plywood, two of Do and Tamarkin's favorite materials, are, after all, not what one associates with luxury. By using simple, utilitarian materials in a limited palette, Do and Tamarkin allow the space and light within their designs to take center stage. For their own home, they followed this philosophy; here, all the cabinetry and millwork was constructed from fir plywood, and the kitchen counters and bathroom floors and counters were made from concrete. Do and Tamarkin, however, elevate these utilitarian materials through meticulous detailing and, by doing so, redefine the notion of "luxury."

In order to both accentuate the light and shadows and pay homage to the building's industrial past, the architects replaced all the fenestration with multi-paned steel windows. The interior was designed to emphasize the loft's openness, but Do and Tamarkin were leery of creating a space that felt, according to Tamarkin, "over architected." They were interested in paring down the design until it achieved what Tamarkin described as "a simplicity that felt inevitable." This also involved deciding what "imperfections" to keep and what should be altered. The oak floors had been stained black, but once they were sanded, they revealed an imperfect yet beautiful surface. Do and Tamarkin felt the quality of the original wood provided an authentic feeling of history and infused the design with a record of its industrial past they very much wanted to celebrate. The ceilings were maintained for the same reasons. Incorporating white walls and mostly iconic, modern pieces of furniture further focused the attention of the light and space, elements both architects believe are their most important tools.

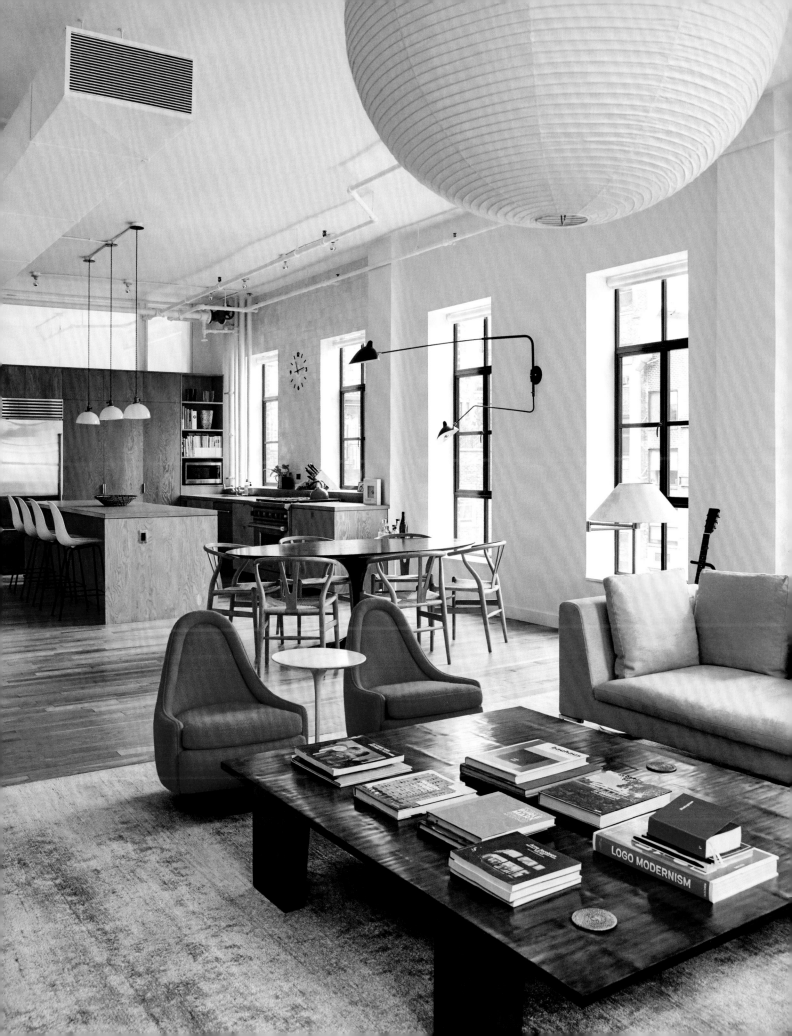

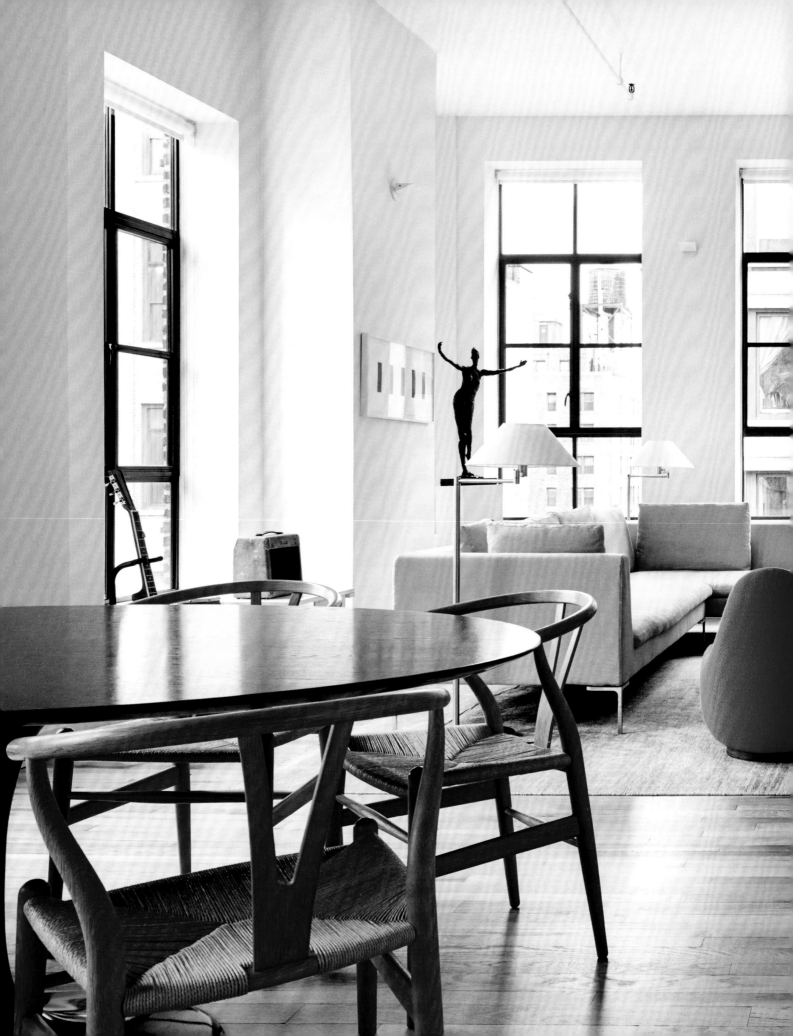

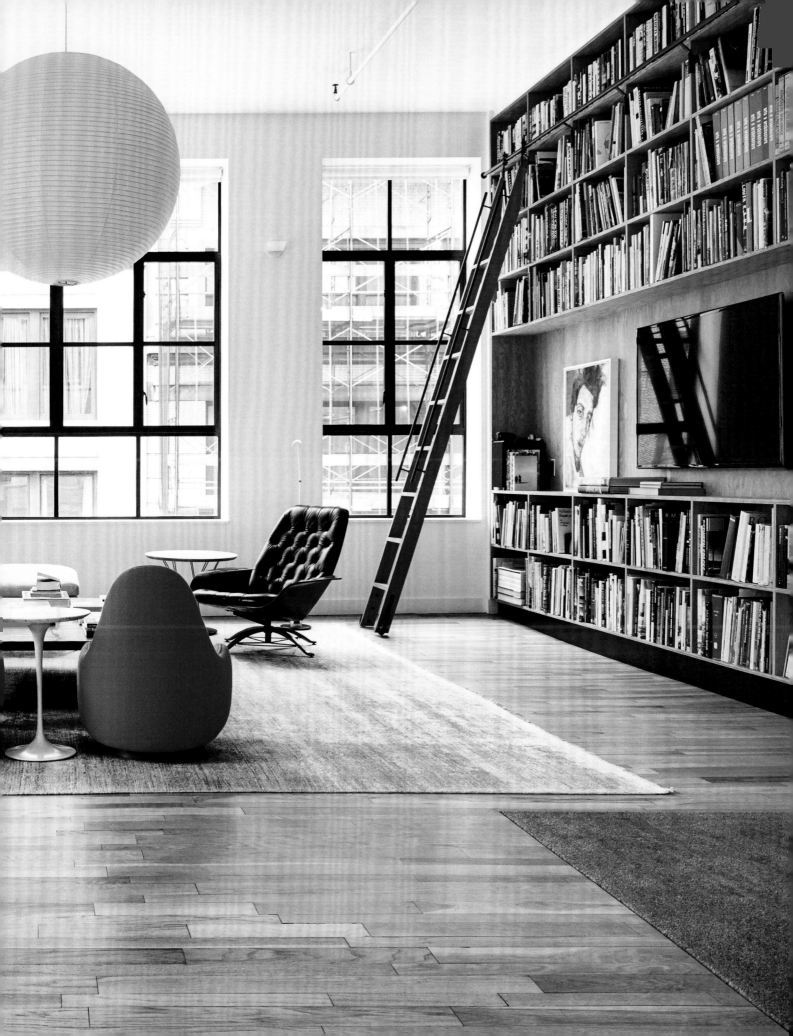

Previous spread: Rather than replace the floors, Do and Tamarkin simply refinished the original oak flooring. They felt the imperfect quality of the original wood provided an authentic feeling of history and strengthened their design objectives. The bookshelves and rolling ladder were designed and built specifically for the loft. A sculpture by Lynn Syms, a depiction of a woman with open arms, commands the corner of the living room and greets visitors.

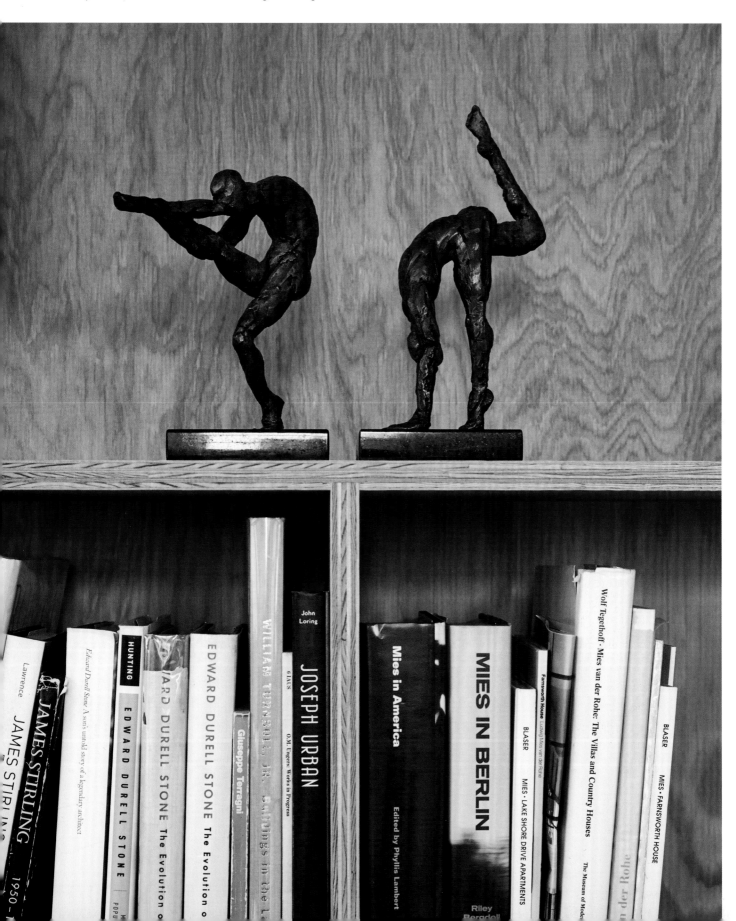

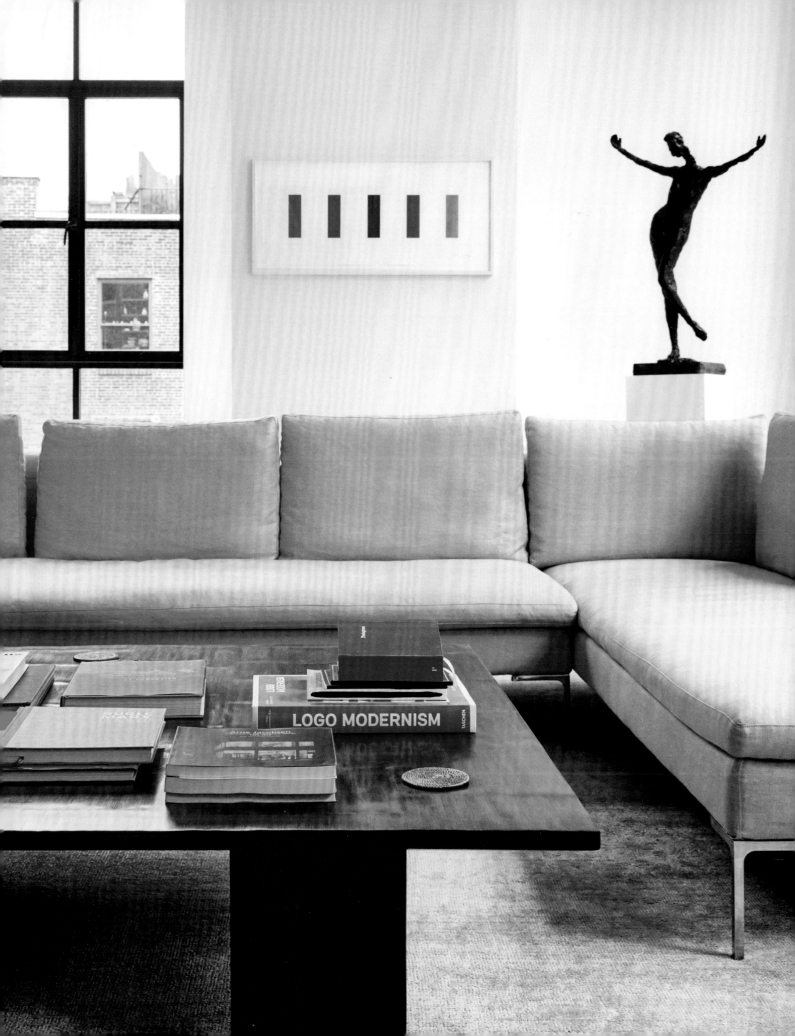

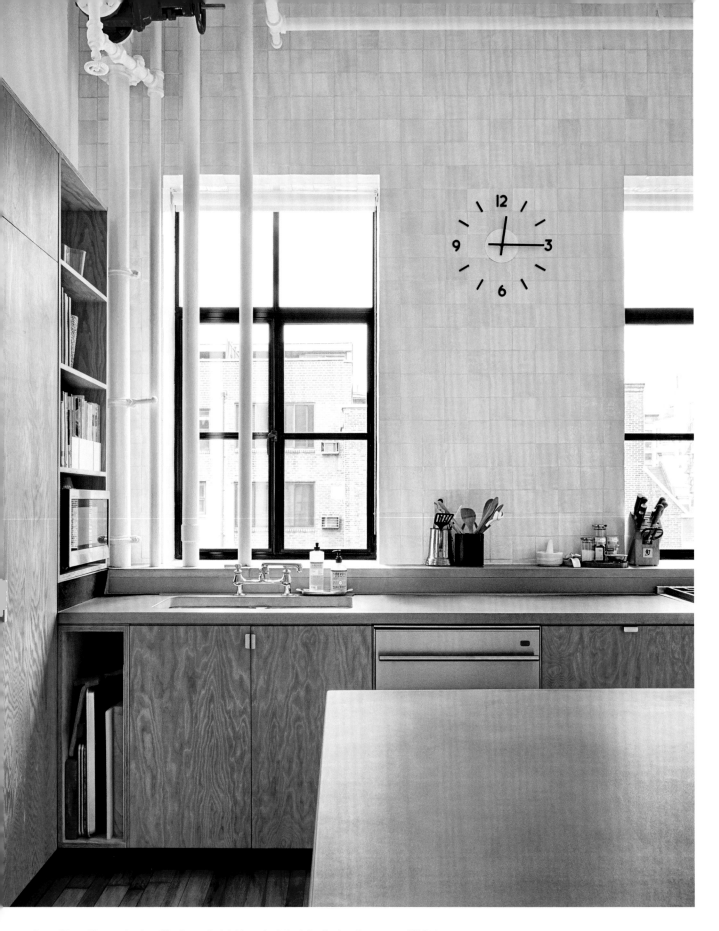

Do and Tamarkin use simple, utilitarian materials throughout the loft, allowing the space and light to remain the focal point. In the kitchen, all the cabinetry is constructed of fir plywood; the counters are concrete. A Le Corbusier tapestry hangs on the wall opposite the kitchen.

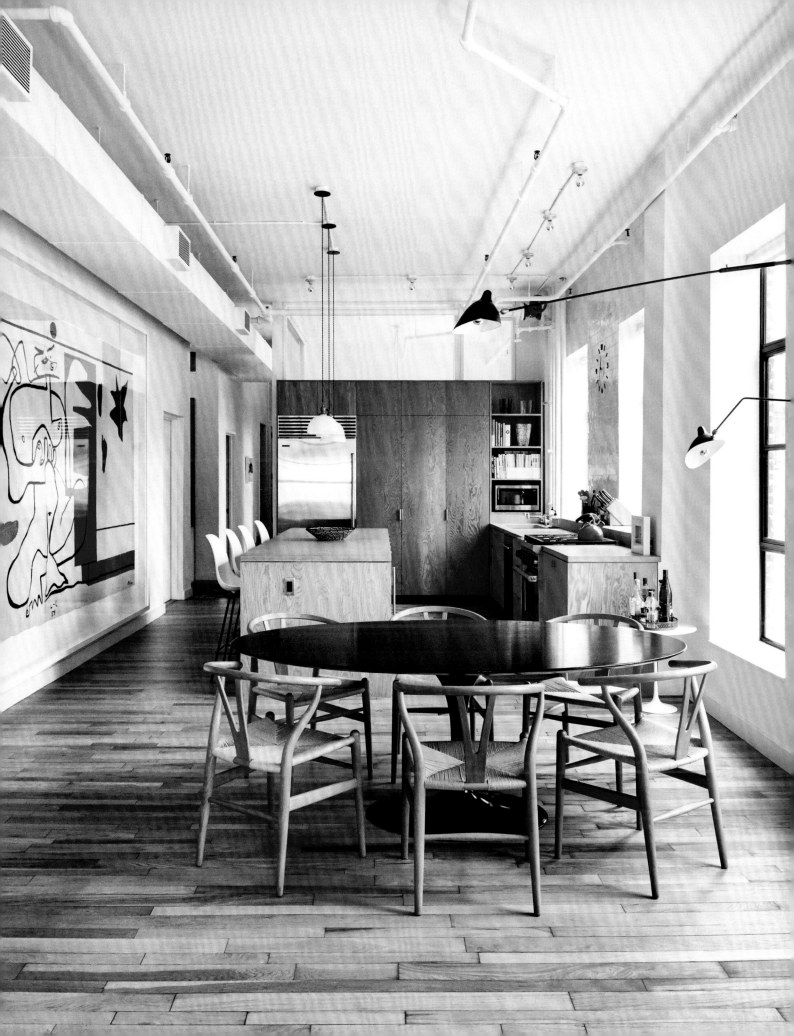

In the bedroom, the headboard and nightstands were constructed from solid slabs of wood that had originally been installed in the couple's previous home. Here they have been recycled, both a nod to sustainability and a keepsake. A compact office area, located off the kitchen, is home to Tamarkin's collection of guitars.

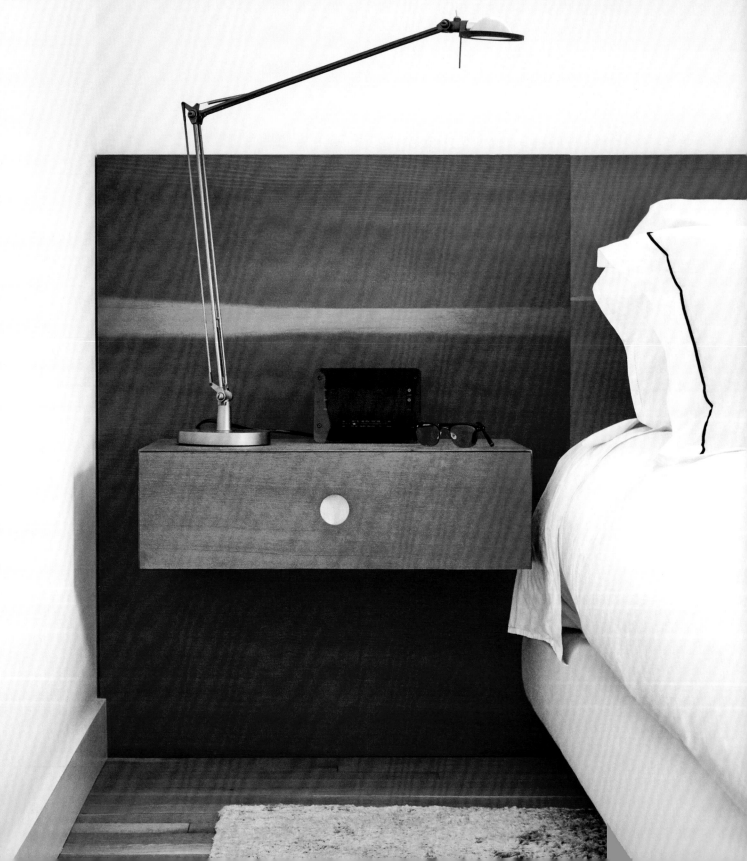

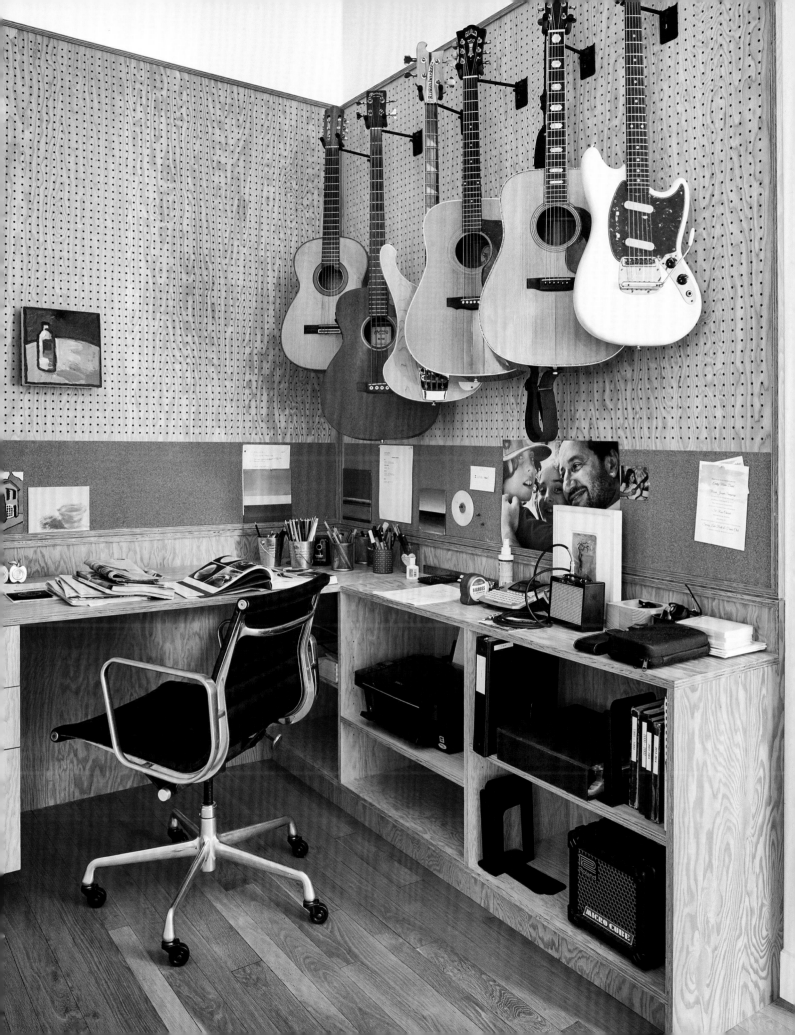

In the master bath, the floors and countertops were made from concrete.
The pattern on the floor was inspired by a Le Corbusier application.
The cabinetry, as in other parts of the loft, is made from fir plywood.

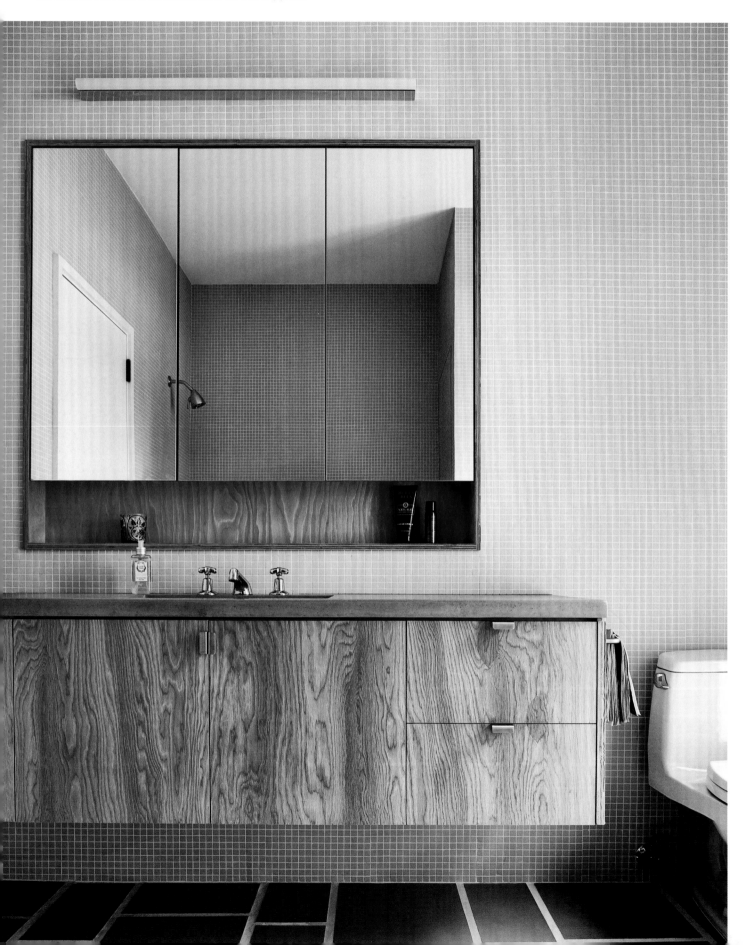

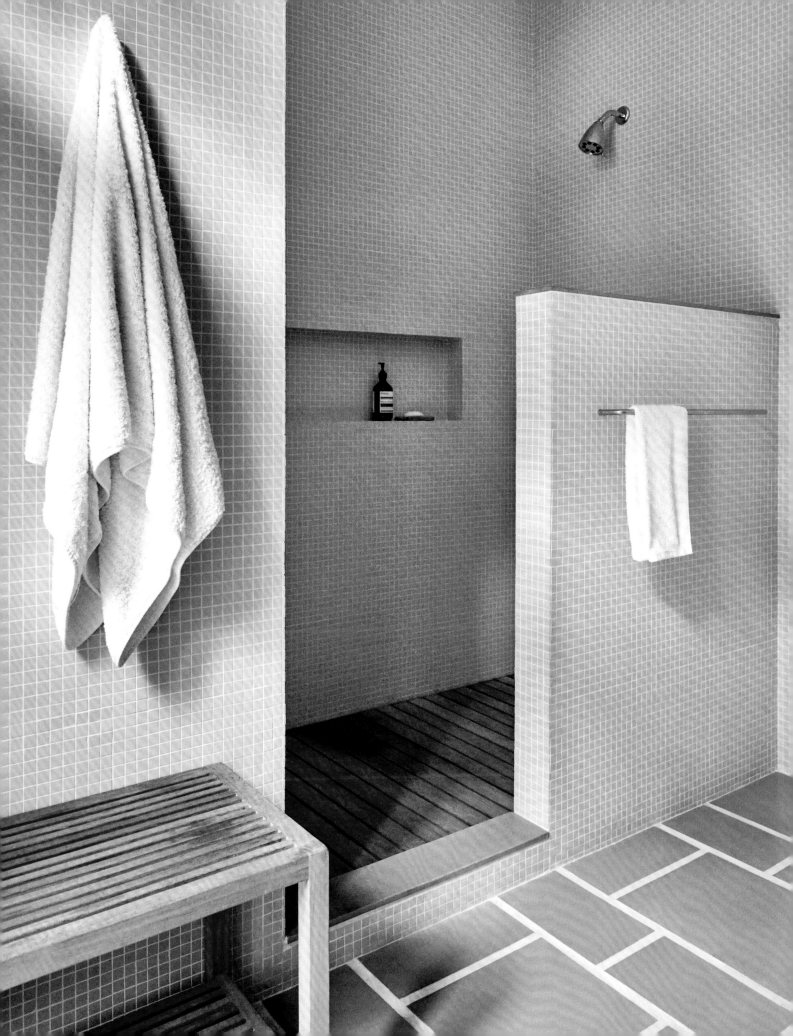

TOM FLYNN

When Tom Flynn found this apartment in his preferred neighborhood, Greenwich Village, he was immediately attracted to the building's charming original entrance and graciously sized public spaces. While the apartment itself needed a gut renovation, the rooms offered multiple exposures and were in pleasant proportions. Flynn knew that the layout would allow him to obtain the well-proportioned rooms and the various spaces he was looking for without excessive reorganization. He was also well aware of the apartment's limited square footage.

Flynn discovered that the building, constructed in the 1930s, was the first co-op in the Village and had been designed exclusively for single career women. Originally, each apartment had a separate entrance from the common hallway to an adjacent maid's room and bath. Flynn closed off this entrance and opened up the former maid's room to the interior of the apartment, creating the guest bedroom and bath. The new opening was fitted with sliding leather-and-mahogany shoji screens installed on top of a low built-in mahogany bookcase, all of Flynn's own design, for the living room. The screens allow the room to be closed off and used as a guest room with an ensuite bath. Flynn installed a queen-size mattress that he had upholstered in linen and leather, along with a collection of enormous linen and velvet pillows; the space can be made up as a guest bed or used as a wonderfully comfortable lounge when watching TV.

Flynn also opened up the wall between the living and dining rooms and the kitchen. By doing so, he allowed all three exposures—north, south, and east—to be experienced from the main living space and created an environment that feels far more open, inviting, and modern than the original plan. During the course of the renovation, Flynn replaced or restored everything in the apartment, including all the original 1930s double-hung windows and the French doors in the living area. The plaster walls were restored, the plumbing and electrical appliances were replaced, and the firebox and chimney flue were rebuilt. Flynn designed the gray-travertine fireplace surround in the living room, which is simultaneously contemporary and reminiscent of the building's past. The gesture creates a visually important bridge to his eclectic collection of furnishings and art, which span nearly all the decades of the latter part of the last century.

Flynn's design for the kitchen incorporates a combination of cerused teak cabinetry, bronzed steel, and basaltina volcanic stone counters. By using the same cerused-teak in the bedroom for a wall of storage, Flynn created a sense of continuity he hoped would both render the space more modern and increase the perception of continuous space.

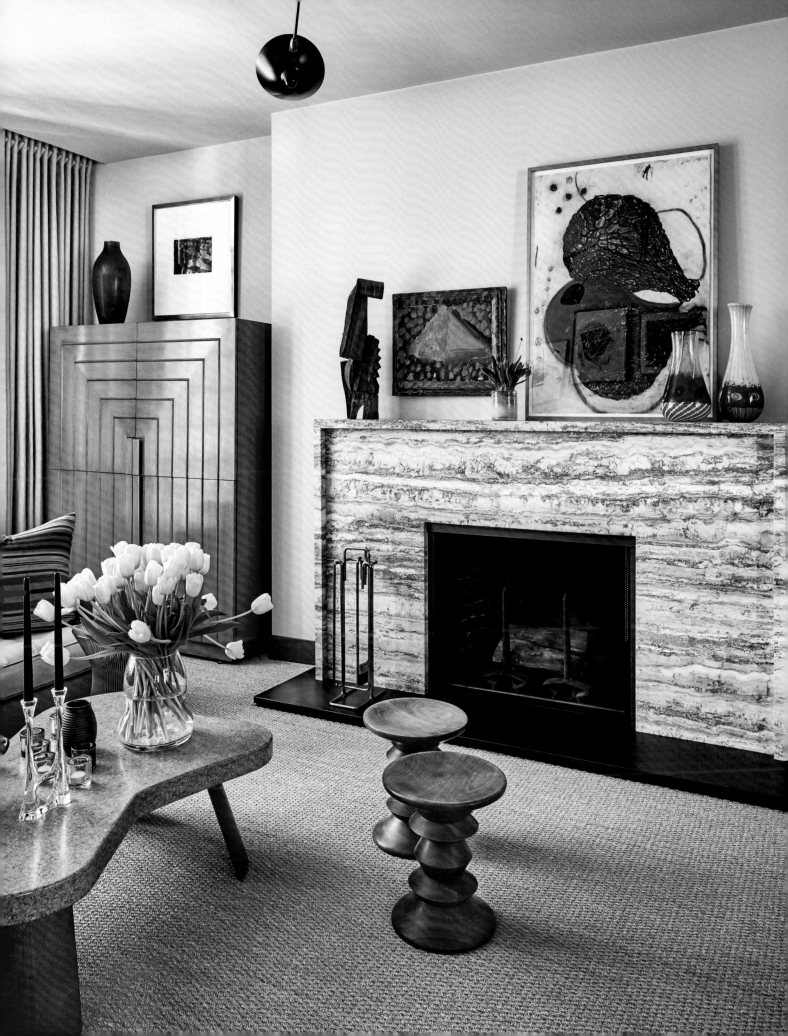

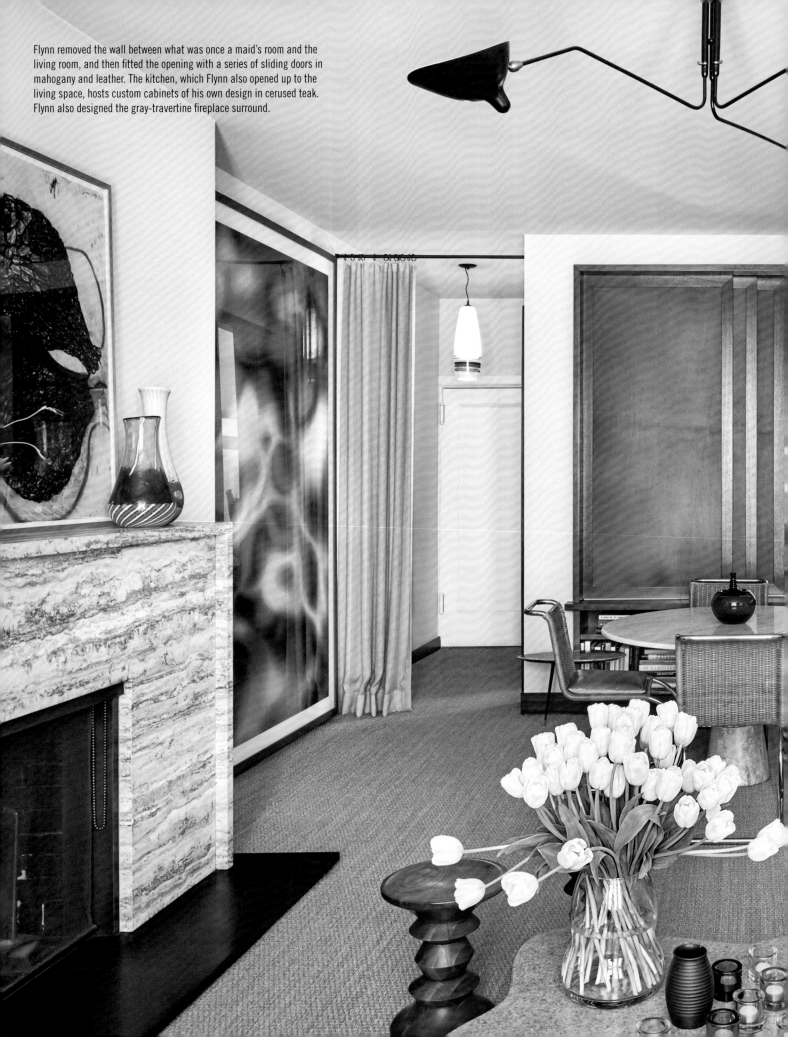

Flynn removed the wall between what was once a maid's room and the living room, and then fitted the opening with a series of sliding doors in mahogany and leather. The kitchen, which Flynn also opened up to the living space, hosts custom cabinets of his own design in cerused teak. Flynn also designed the gray-travertine fireplace surround.

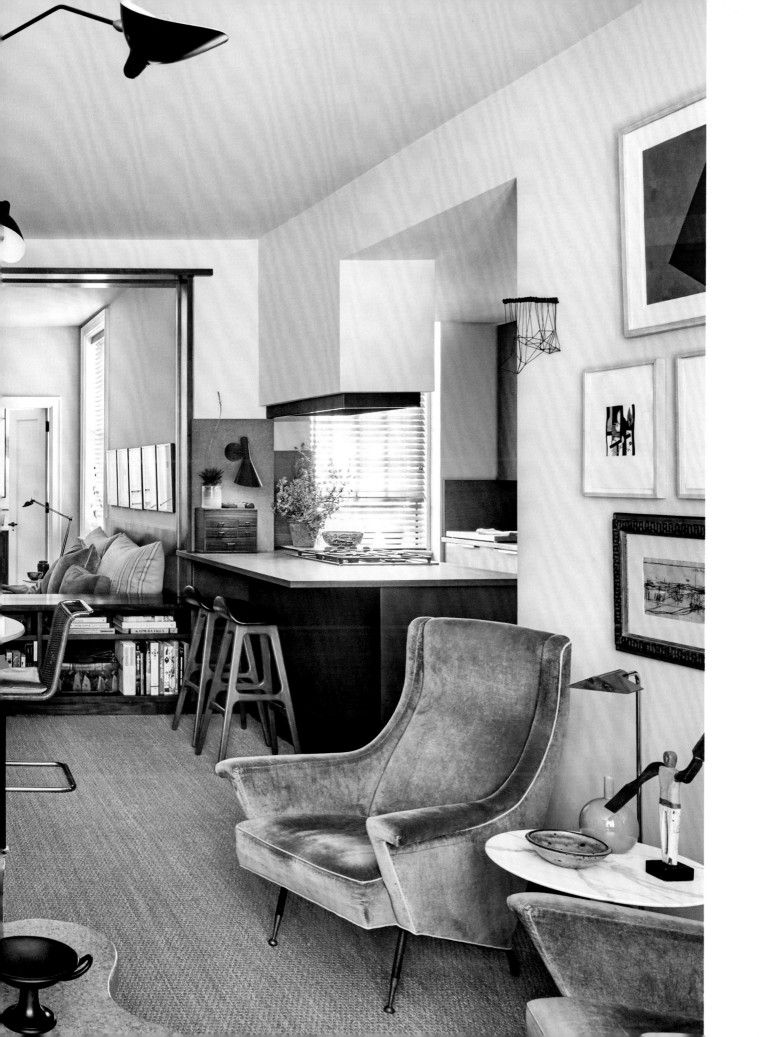

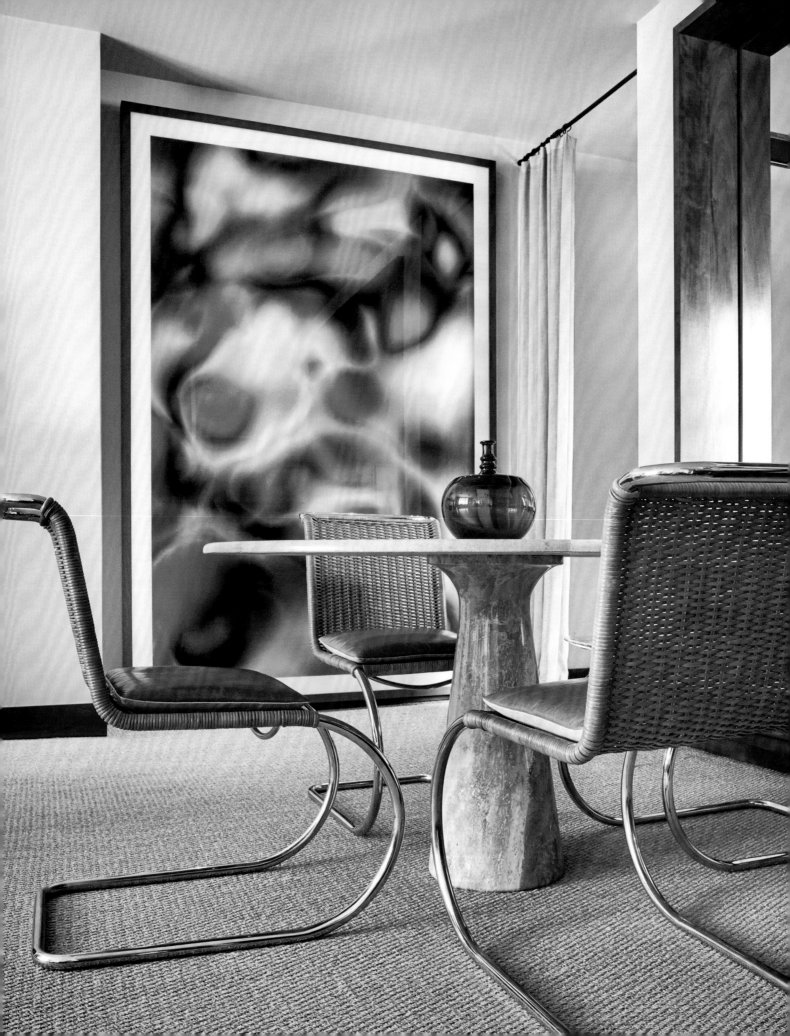

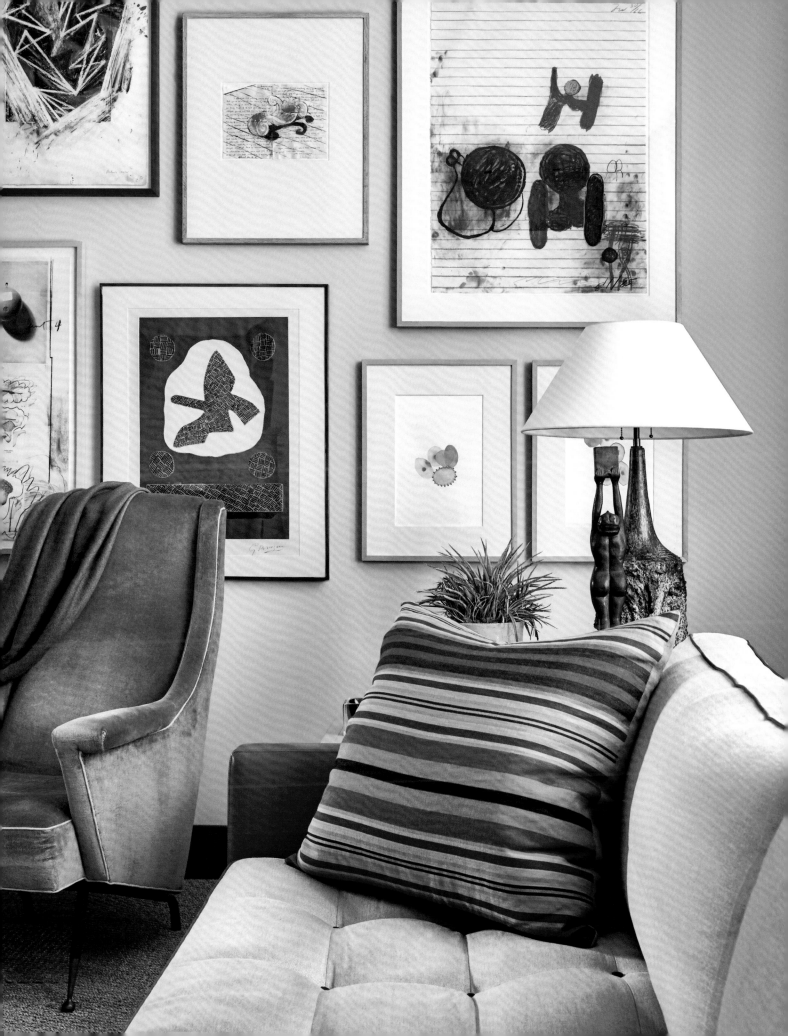

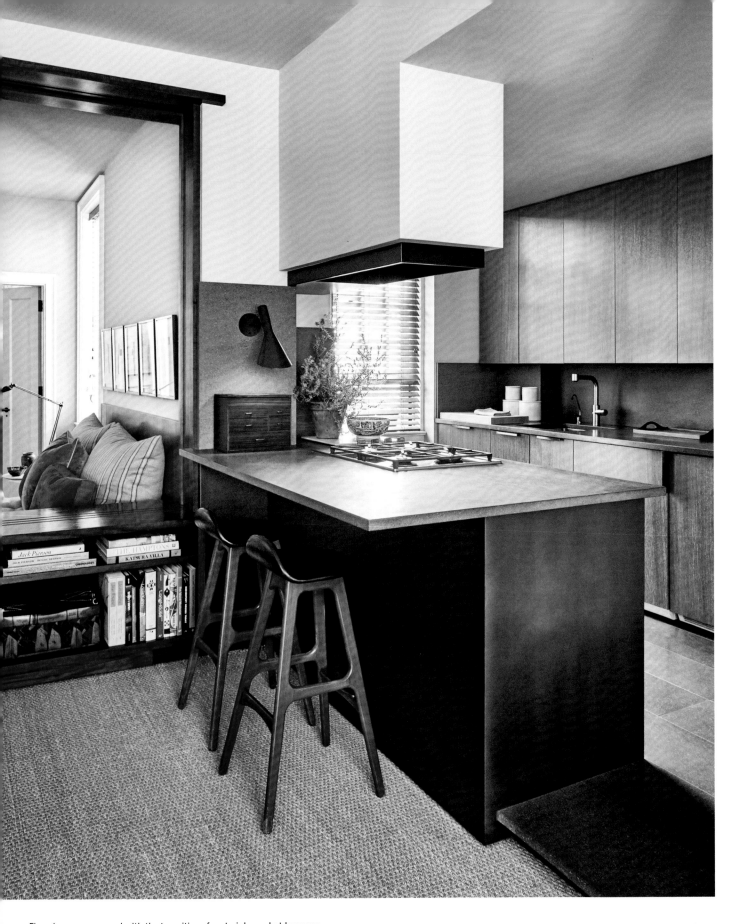

Flynn is very concerned with the transition of materials—what happens when one material ends and another starts—and never ignores these moments. Instead, he transforms what is often considered a "problem" into a moment of interest and integration.

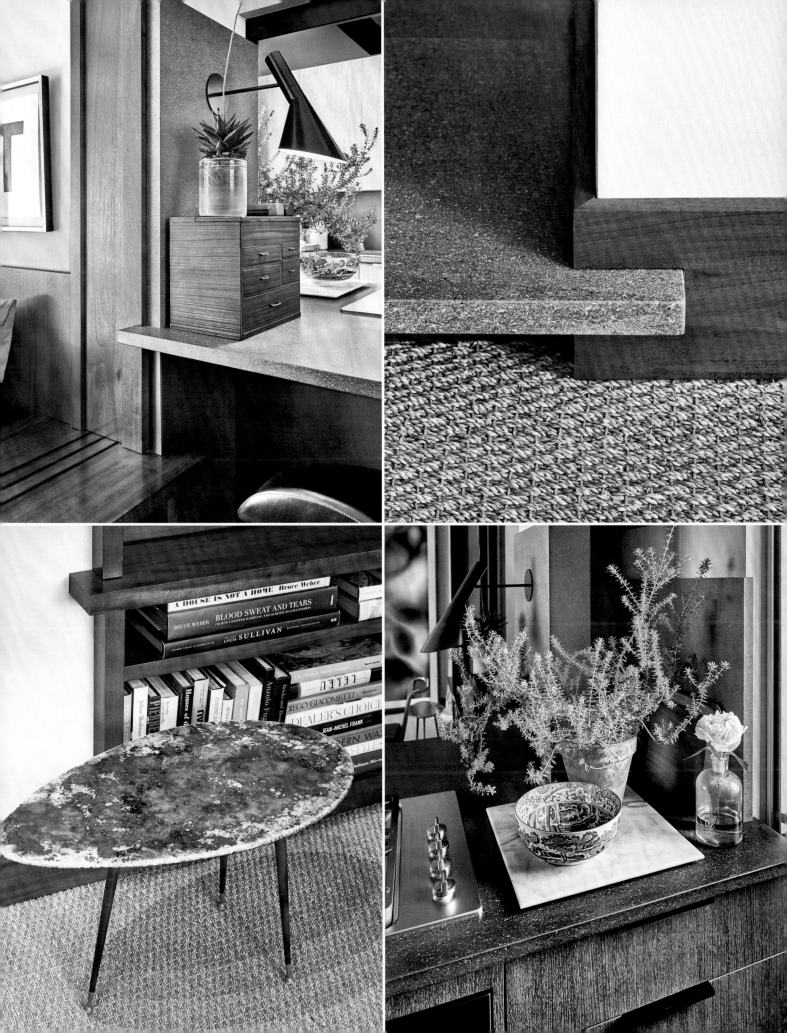

A HOUSE IS NOT A HOME Bruce Weber

BLOOD SWEAT AND TEARS

LOUIS SULLIVAN

DIEGO GIACOMETTI

DEALER'S CHOICE

JEAN-MICHEL FRANK

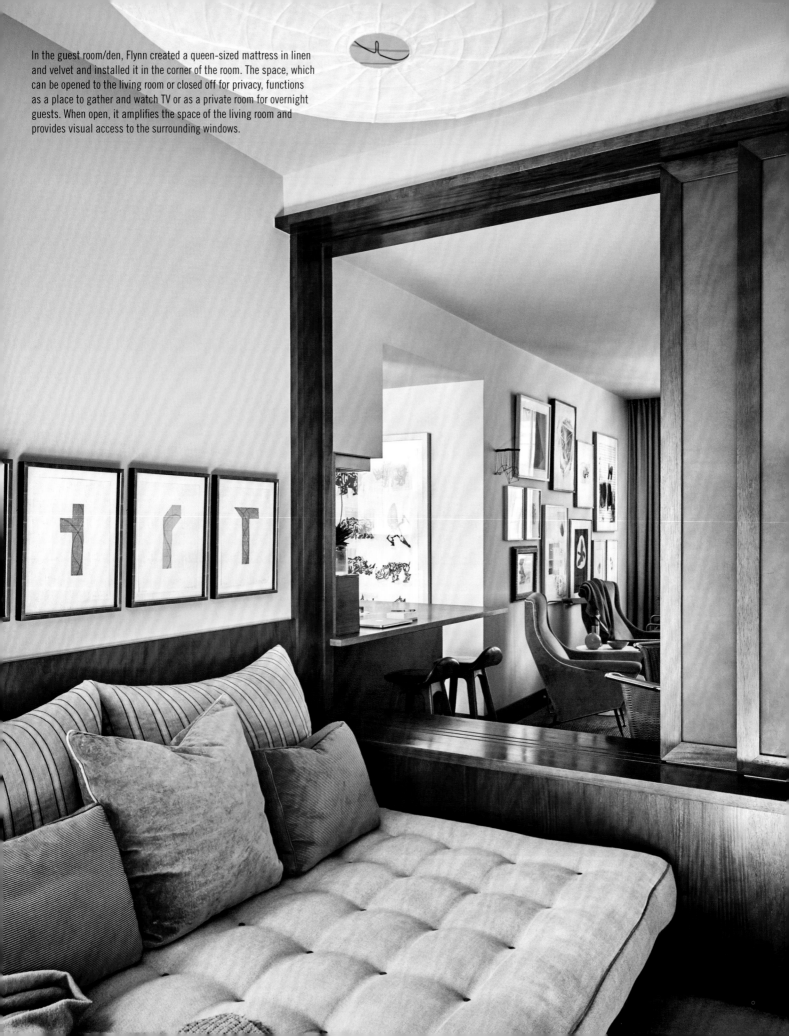

In the guest room/den, Flynn created a queen-sized mattress in linen and velvet and installed it in the corner of the room. The space, which can be opened to the living room or closed off for privacy, functions as a place to gather and watch TV or as a private room for overnight guests. When open, it amplifies the space of the living room and provides visual access to the surrounding windows.

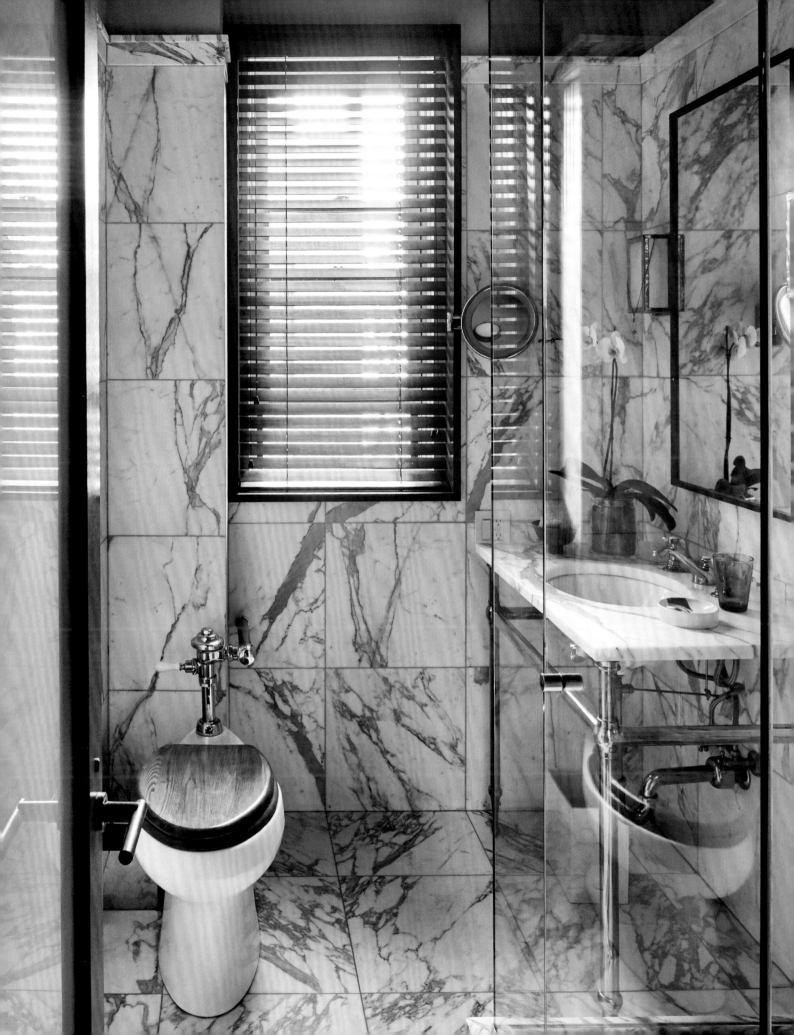

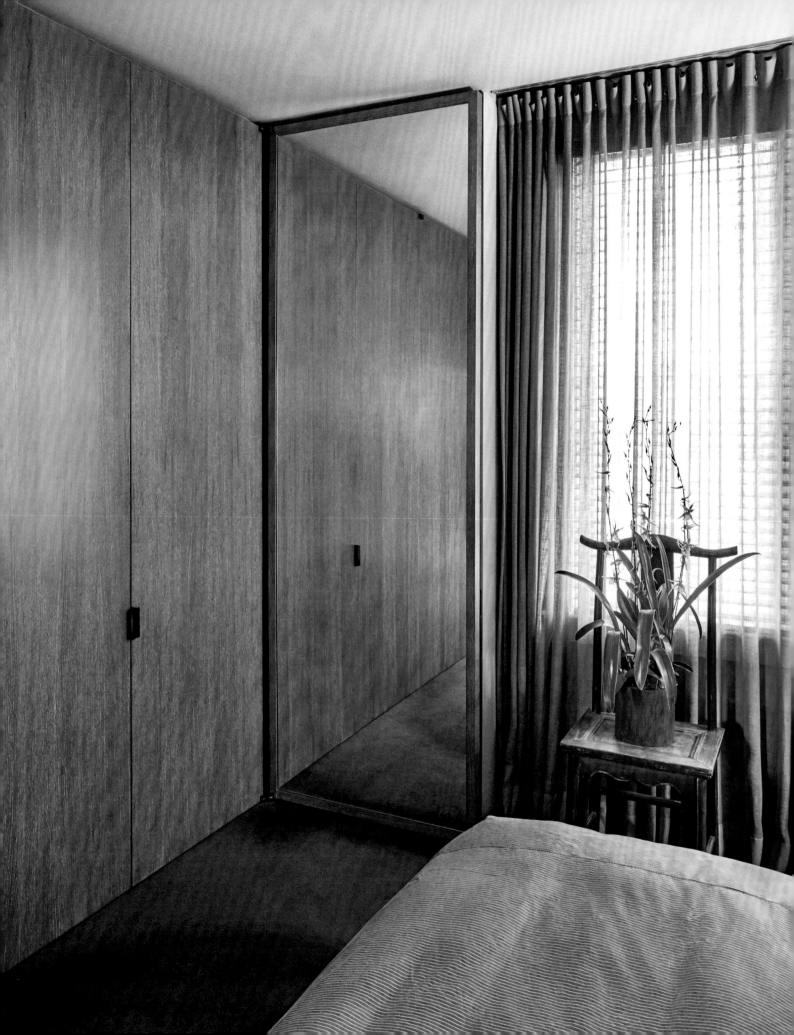

In the bedroom, Flynn continued the use of cerused teak cabinetry that was introduced in the kitchen. Here, an entire wall is lined with floor-to-ceiling storage and ends with a mirror of the same proportions, which also continues to the floor-to-ceiling drapery.

DAVID GRESHAM
& BENJAMIN PARDO

David Gresham and Benjamin Pardo wanted to live in a modern building with as close to floor-to-ceiling glass as possible. Back in 2003, though, there were not many residential buildings in Manhattan that met their simple requirement, so when they saw this unit at United Nations Plaza, built in 1966 and designed by Wallace Harrison and Max Abramovitz, the team behind the Metropolitan Opera House at the Lincoln Center for the Performing Arts, they were sold. The apartment was in the "as built" condition, complete with original fixtures in the baths and the original kitchen. The only changes the previous occupants had made were laying carpet over the parquet flooring and covering nearly every surface with wallpaper, including the doors and doorframes. In Gresham and Pardo's first renovation, many of the doors were removed to provide the space with a more open feel and both visually connect the rooms and accentuate the views. The wall dividing the living room from the kitchen, for example, was punctured along the window wall to vastly increase sight lines. They also painted the HVAC registers along the window wall nearly black so they would read as part of the curtain wall of glass and not as a mass in the space.

The couple are avid collectors of industrial design, and the apartment is a reflection of that lifelong interest. Many of the pieces either are prototypes or were made in collaboration with the manufacturers according to their exacting standards. The Florence Knoll credenzas in the living room, for example, were manufactured in a veneer that Gresham and Pardo chose and supplied to the manufacturer. The mural in the dining room was created from an electronic file of Pablo Picasso's *Guernica*, then printed at the size of their dining room wall and installed as wallpaper.

Gresham and Pardo just completed their second renovation of the apartment. This time, they eliminated the guest bedroom and transformed the space into an office and dining room. By opening this room up to the kitchen along the window wall, they further extended the feel of the space and increased the sight lines. Gresham believes the new configuration is much more in keeping with how they live. The former dining area, which was part of the living room, was never large enough nor provided a place for him to work. Now they live in the entire apartment. Perhaps the biggest challenge of the second renovation was the installation of the travertine floors; the floors were surprisingly uneven, and the many rules and regulations about noise, underlayments, soundproofing, and wet-cutting the stone on the site lengthened the process. As a result, Gresham has learned that patience plays an important role in a renovation; no matter what level of project you undertake, it takes time.

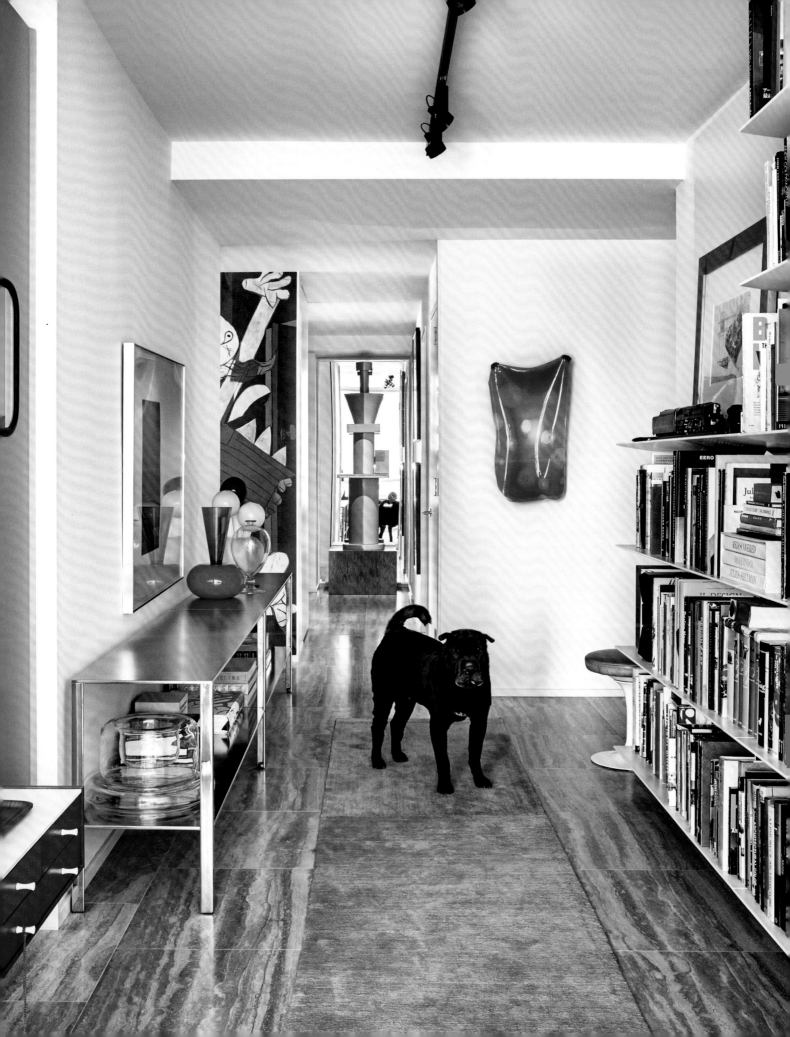

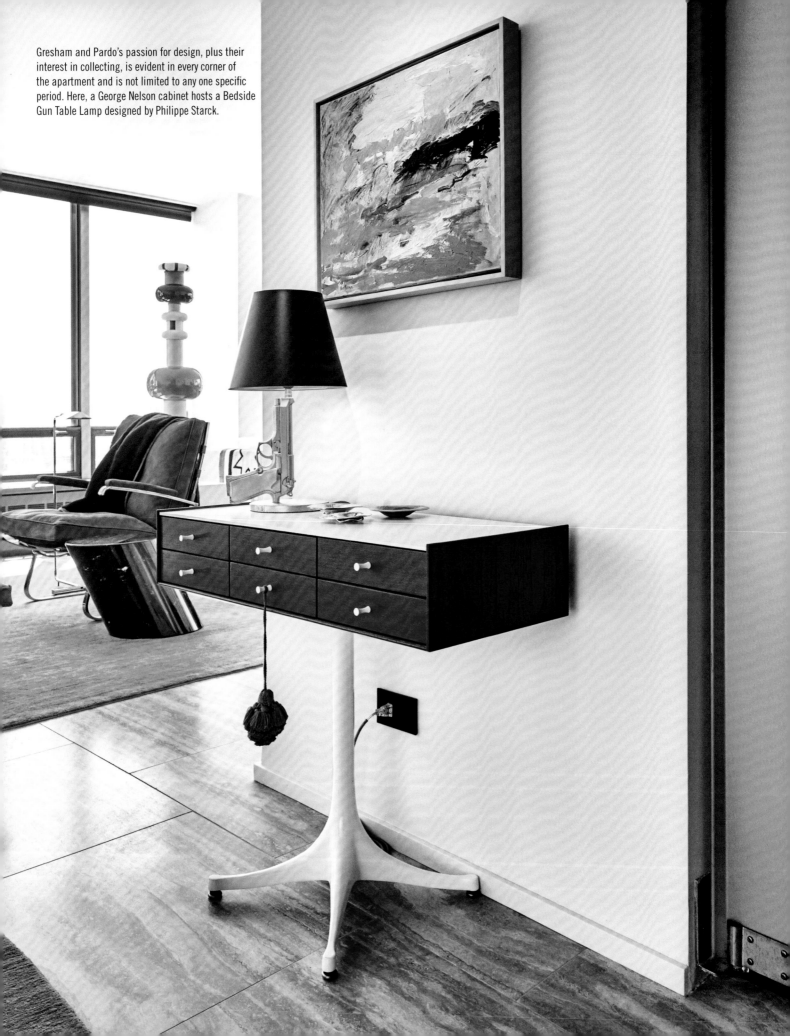

Gresham and Pardo's passion for design, plus their interest in collecting, is evident in every corner of the apartment and is not limited to any one specific period. Here, a George Nelson cabinet hosts a Bedside Gun Table Lamp designed by Philippe Starck.

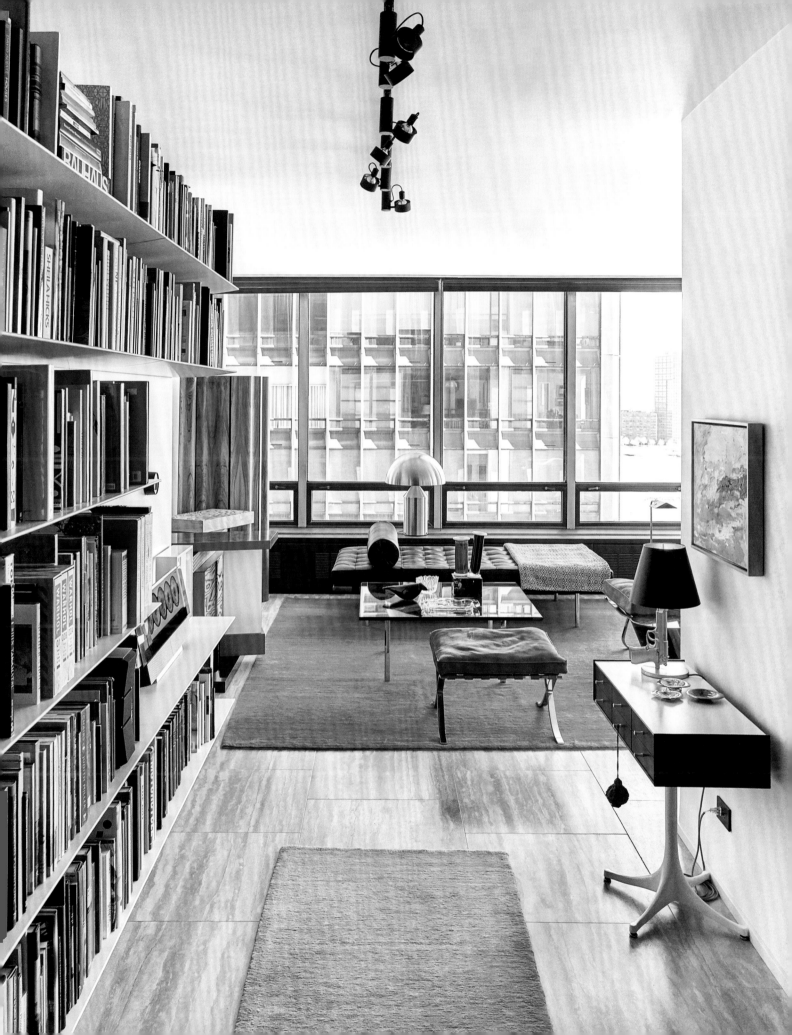

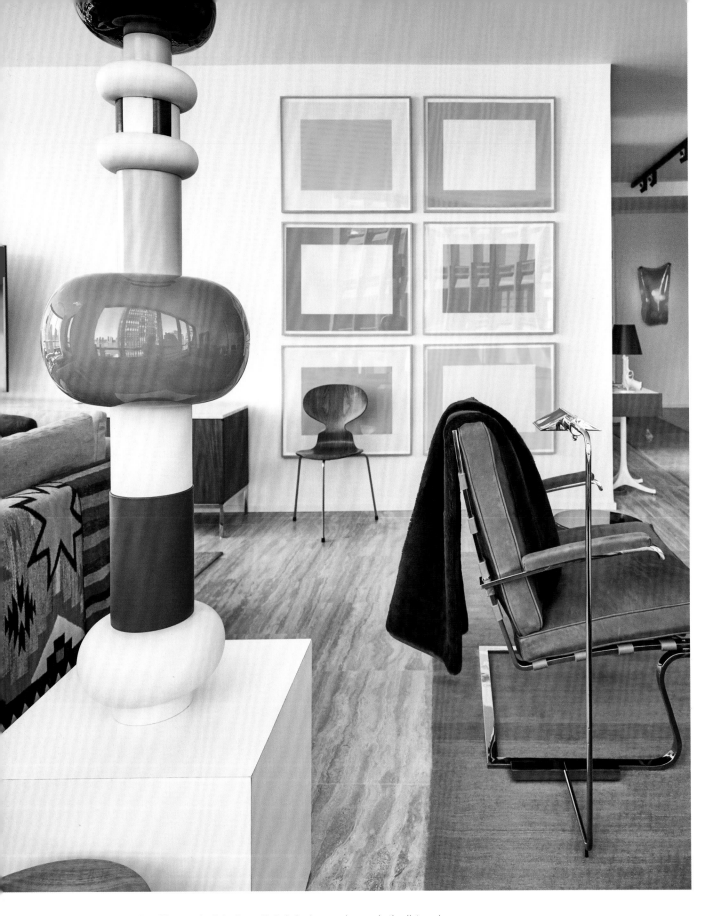

The apartment includes three Mies van der Rohe Tugendhat chairs (one can be seen in the distance), along with three Ettore Sottsass totems the couple has collected. **Following spread:** A "Charles" sofa, designed by Antonio Citterio and manufactured by B & B Italia, anchors the far end of the living room and provides an additional surface to display the couple's collection of textiles.

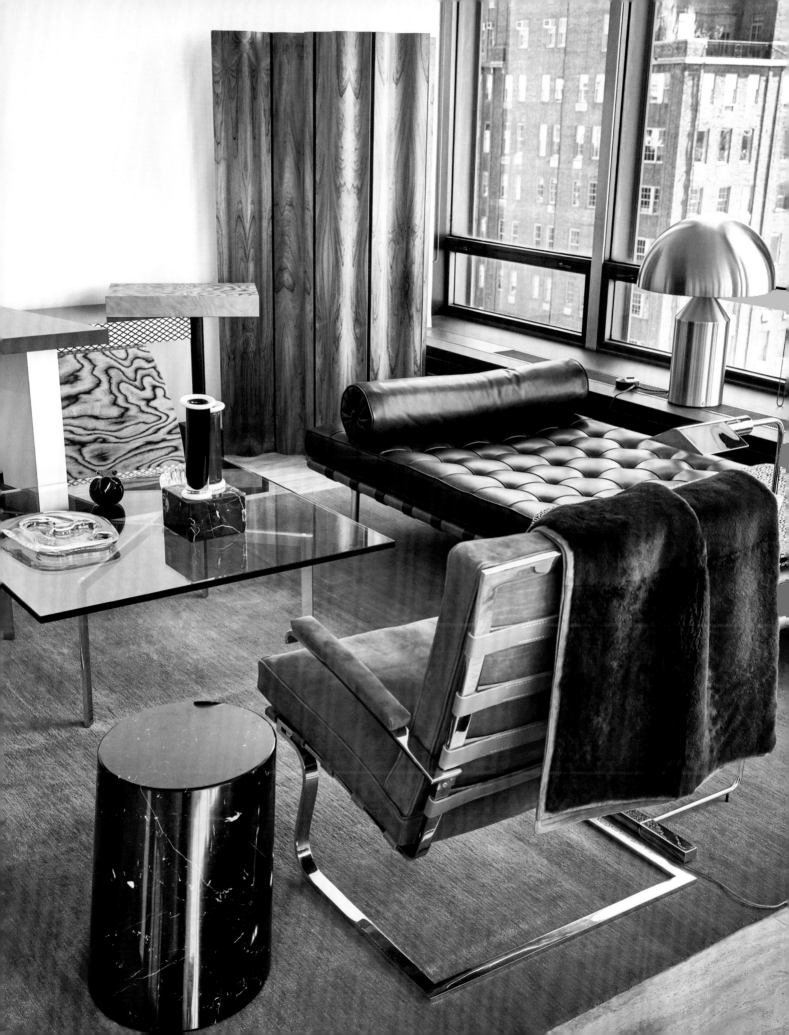

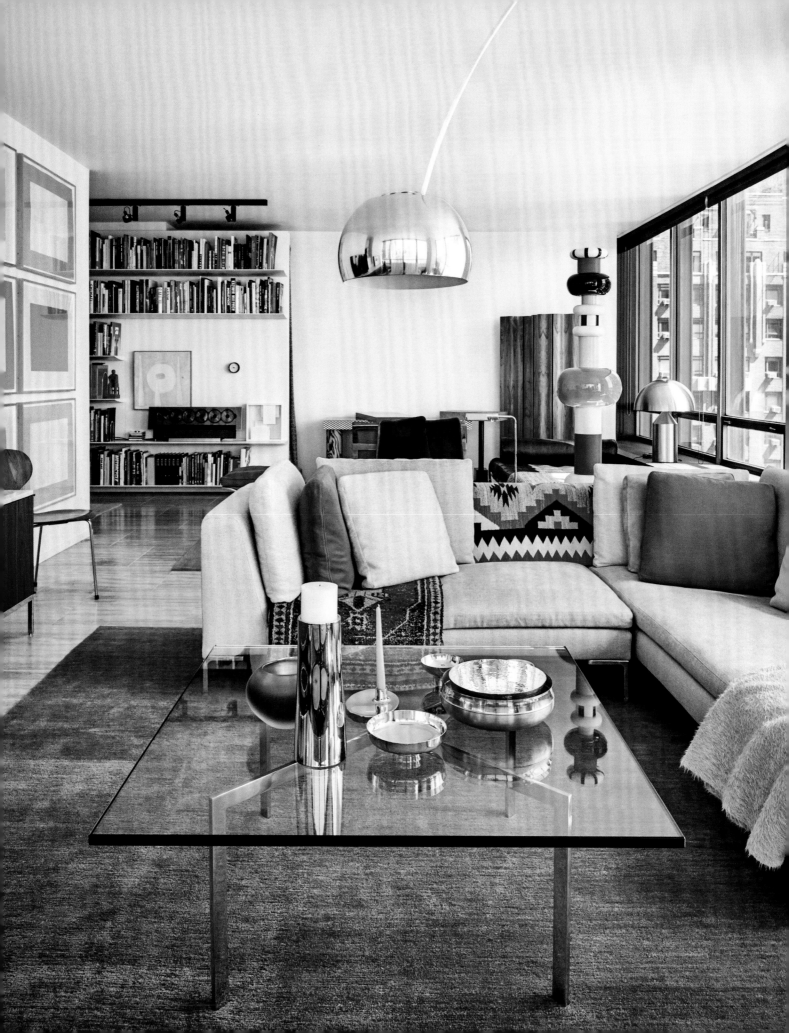

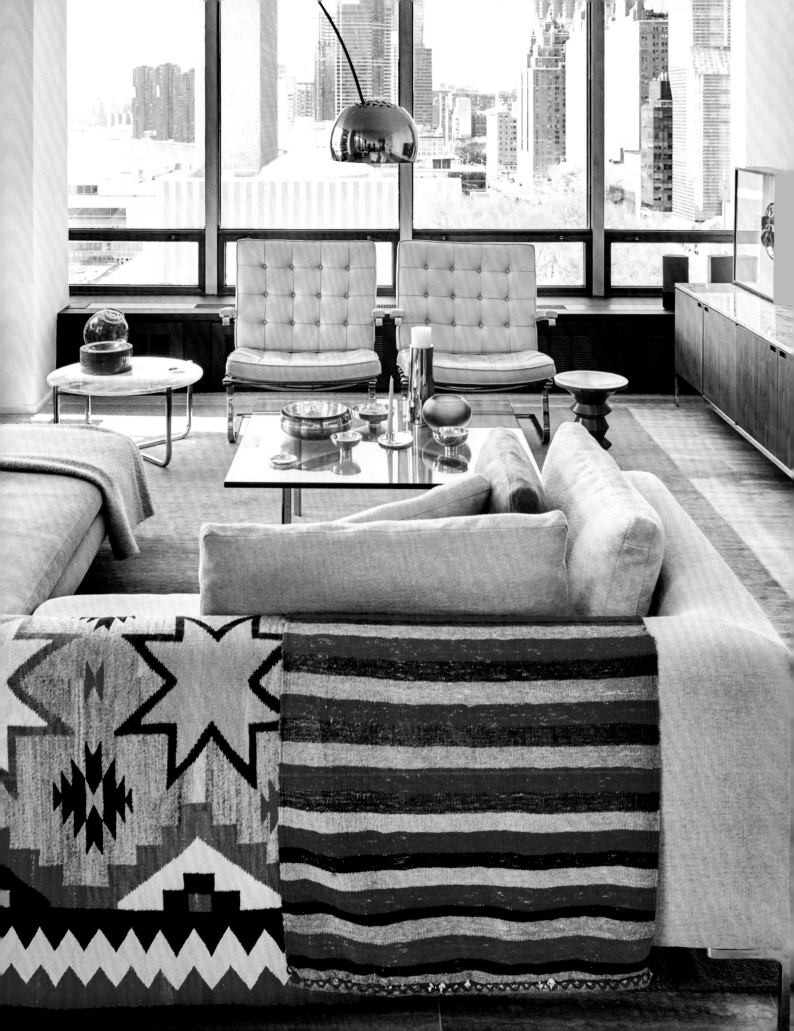

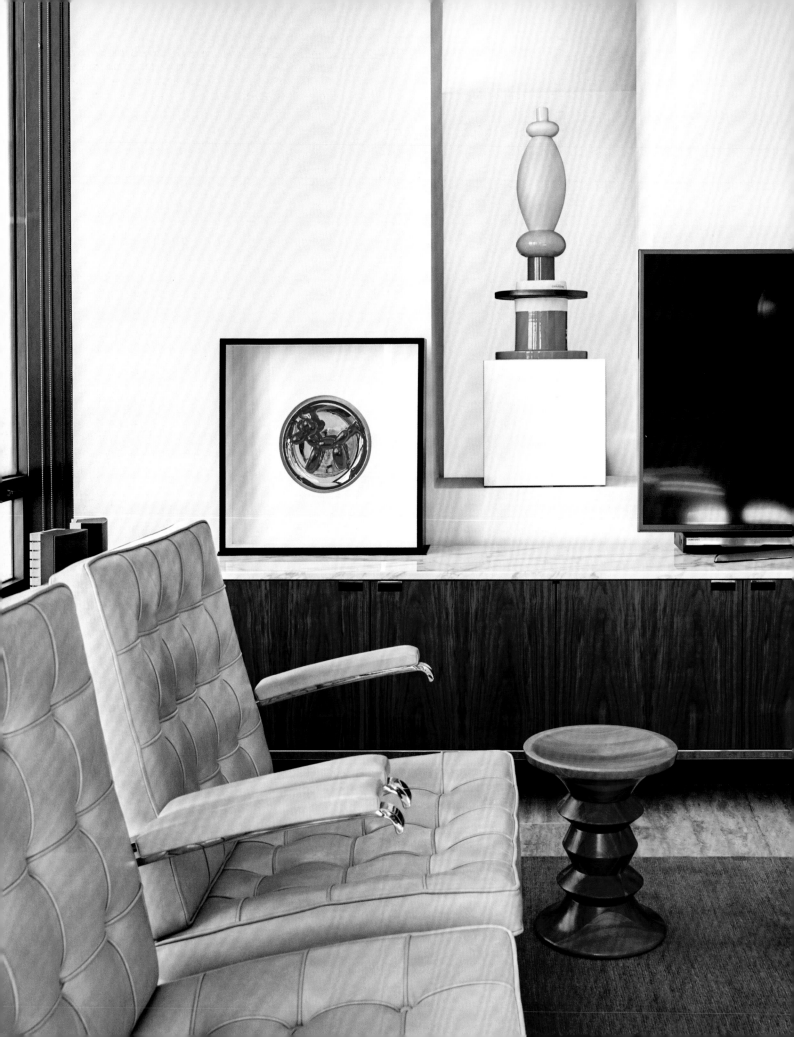

A pair of Mies van der Rohe Tugendhat chairs are located at the far end of the living room. The two Florence Knoll credenzas were custom-made to length and use a veneer that Gresham and Pardo selected and shipped to Italy for manufacture. An Ettore Sottsass totem fills a passage between the living room, kitchen, and dining room beyond.

An industrial kitchen door separates the kitchen workspace from the entry hall and introduces the utilitarian vibe of the room. Powerstrips were installed under the upper cabinets, and plug-in bulb sockets provide ample light while continuing the low-tech, industrial vocabulary.

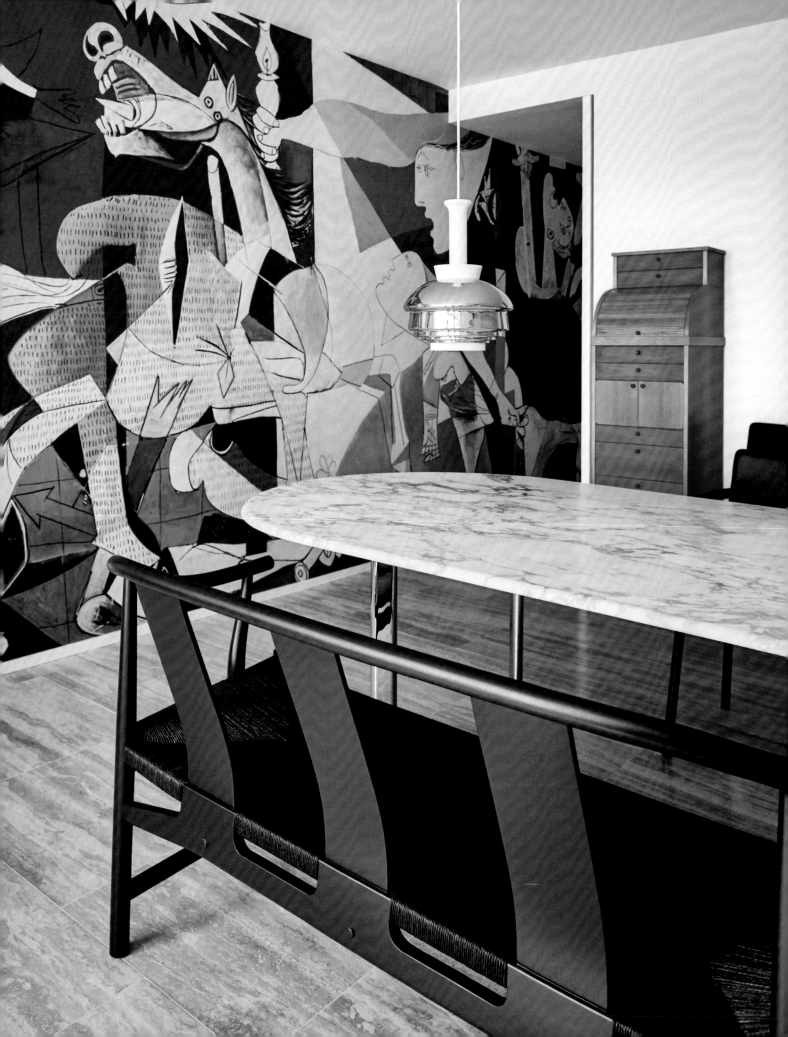

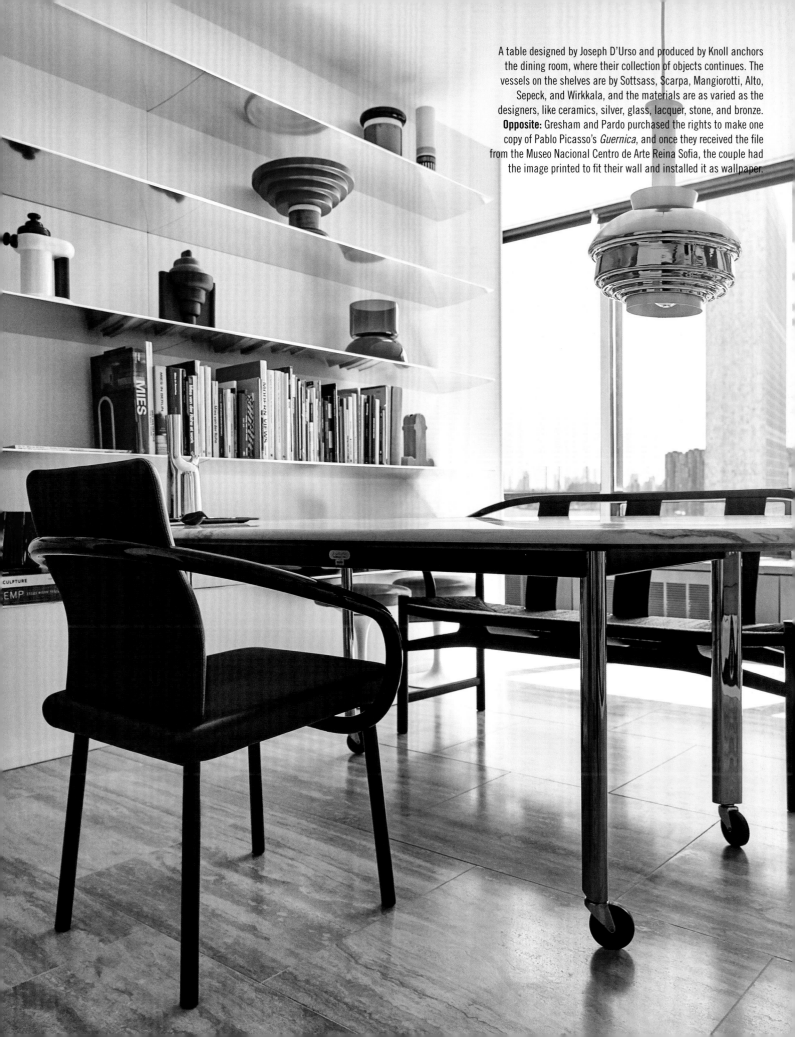

A table designed by Joseph D'Urso and produced by Knoll anchors the dining room, where their collection of objects continues. The vessels on the shelves are by Sottsass, Scarpa, Mangiorotti, Alto, Sepeck, and Wirkkala, and the materials are as varied as the designers, like ceramics, silver, glass, lacquer, stone, and bronze. **Opposite:** Gresham and Pardo purchased the rights to make one copy of Pablo Picasso's *Guernica*, and once they received the file from the Museo Nacional Centro de Arte Reina Sofia, the couple had the image printed to fit their wall and installed it as wallpaper.

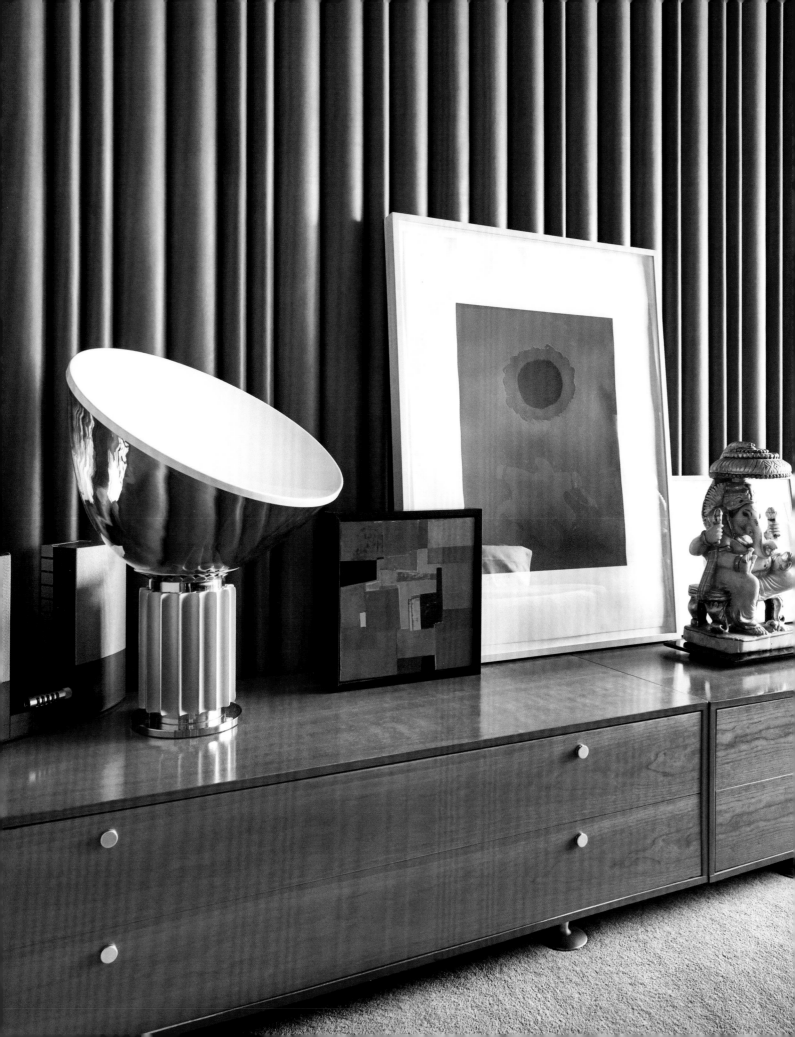

A wall of leather-wrapped spindles of varying dimensions (opposite) covers one of the bedroom walls. The bed was designed in the late 1980s by Paolo Piva and Antonio Citterio and produced by B + B Italia, and by its side are a polished stainless and glass table designed by Joe D'Urso and a Saarinen side table. The room is filled with objects collected by Gresham and Pardo. An intimately scaled painting by Steven Johanknecht is one of many artworks in the space.

At the far end of the bedroom, Gresham and Pardo have installed a vintage Bang & Olufsen TV monitor, a Hans Wegner Papa Bear chair, a Joe Colombo floor lamp, and an Eames molded-plywood folding screen, all further testimony to their interest in design collecting.

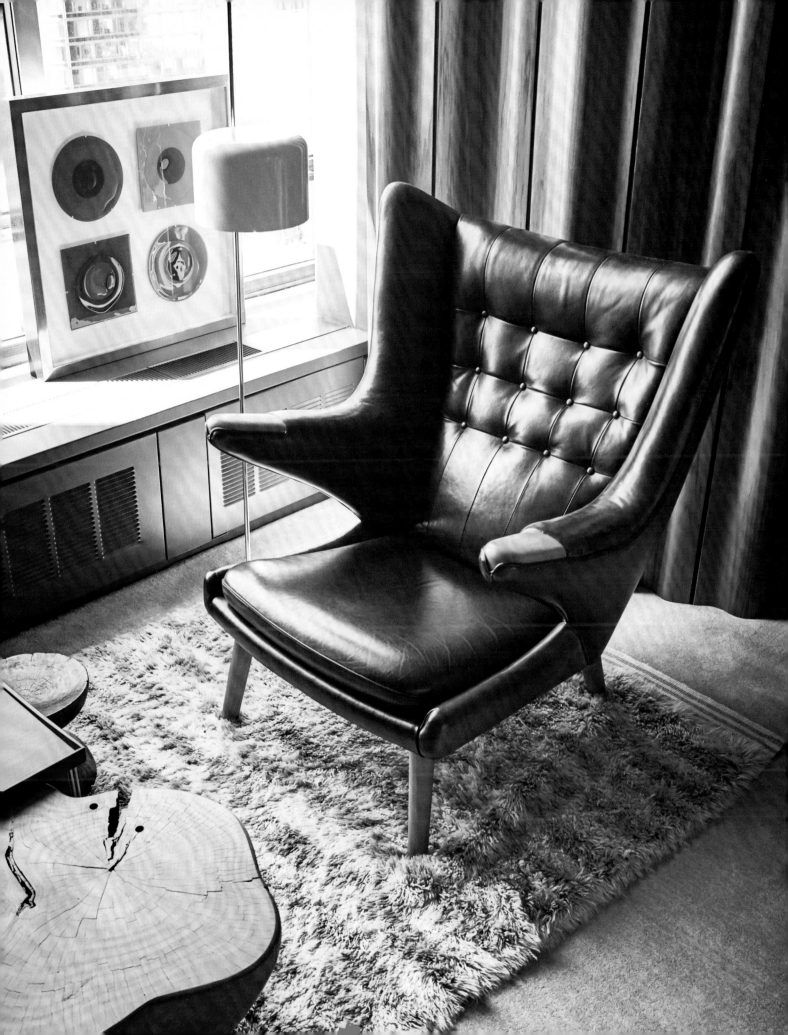

ELLEN HANSON

When Ellen Hanson purchased this apartment, it had been untouched for more than fifty years. The previous owner was one of the founders of the 21 Club and frequently entertained in what Hanson describes as a "faded glory" style that had become an Upper East Side time capsule of sorts. Hanson and her husband were attracted to the idea that they would do the same, but they wanted to enhance the glamour of the space and add modern amenities, sparkling surfaces, and additional storage.

The lobby of the grand Fifth Avenue building, completed in 1926, was a point of inspiration for Hanson. The space is clad from ceiling to floor with various exquisitely veined and figured marbles; the elevator cab is finished with floral patterns of inlaid woods; and gleaming brass details abound. Hanson has clearly carried inspiration from those details into much of her apartment. In the entry foyer, for example, black marble with white-and-gold veining is used as a deep baseboard, and doorframes and sets of double doors, leading on one side to the living room and on the other to the dining room, host a contemporary composition of inlaid woods. Hanson then packed the entry with small works of art installed over enormous antiqued mirrors. The salon-style installation of art here introduces yet another theme that she has carried throughout the apartment. Hanson's major objective was to maintain the feeling of old New York glamour while transforming the space into a functioning modern home; the challenge was to not let the whole home tip over into a glossy and charmless space devoid of a connection to the history that Hanson was initially drawn to.

Color and materials are as exuberantly used in the apartment as they are in the building's public spaces, but within her home they were chosen to take on bright, modern roles in enhancing experiences. The master bedroom, for example, is a soothing pale gray for relaxation, and the exquisitely clad marble master bath continues in this direction. In the kitchen, Hanson designed a vibrant, multicolored, patterned linoleum floor to support the multitudinous daily activities taking place there. A classical wall treatment of limed-oak paneling in the tiny den supports the need for a place of quiet reflection.

Throughout her design career, Hanson has been interested in how perceptions of space, light, and color affect our daily lives. For her, life in this apartment has confirmed her belief that imaginative use of color and an inventive display of art give great joy and pleasure on a never-ending basis.

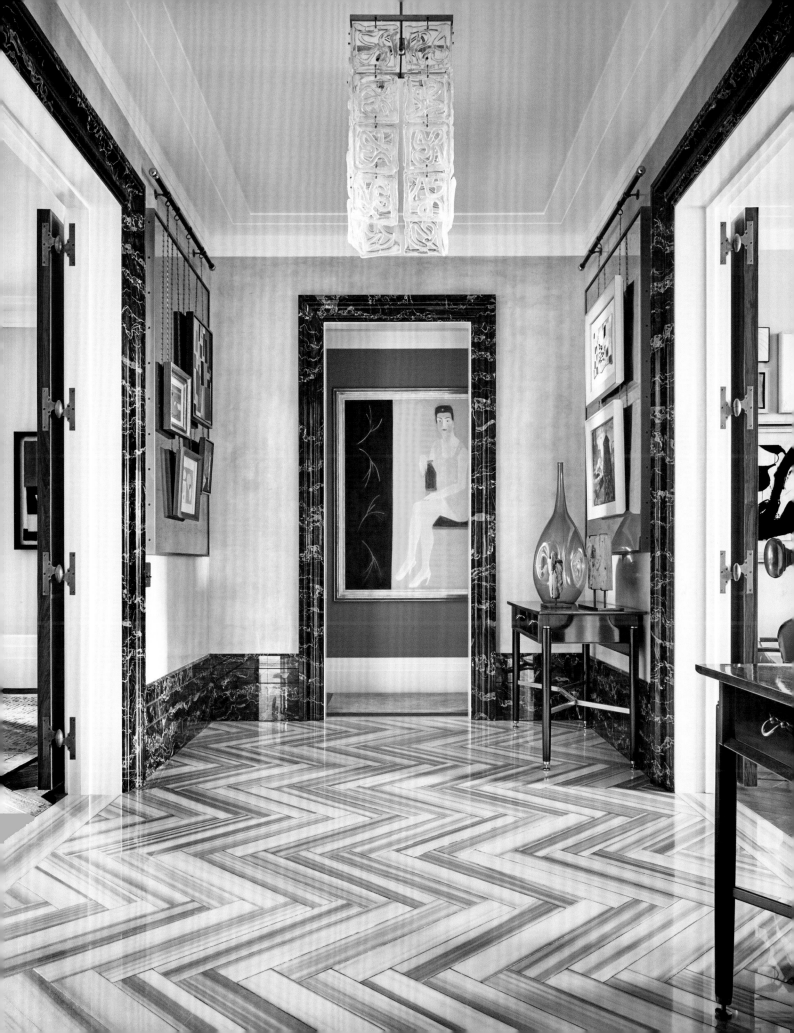

The entry (previous page) is packed with small works of art installed over enormous antiqued mirrors, which sets the stage for the salon-style clusters of artwork Hanson has added throughout the apartment. Larger works, displayed separately, add scale to the interior.

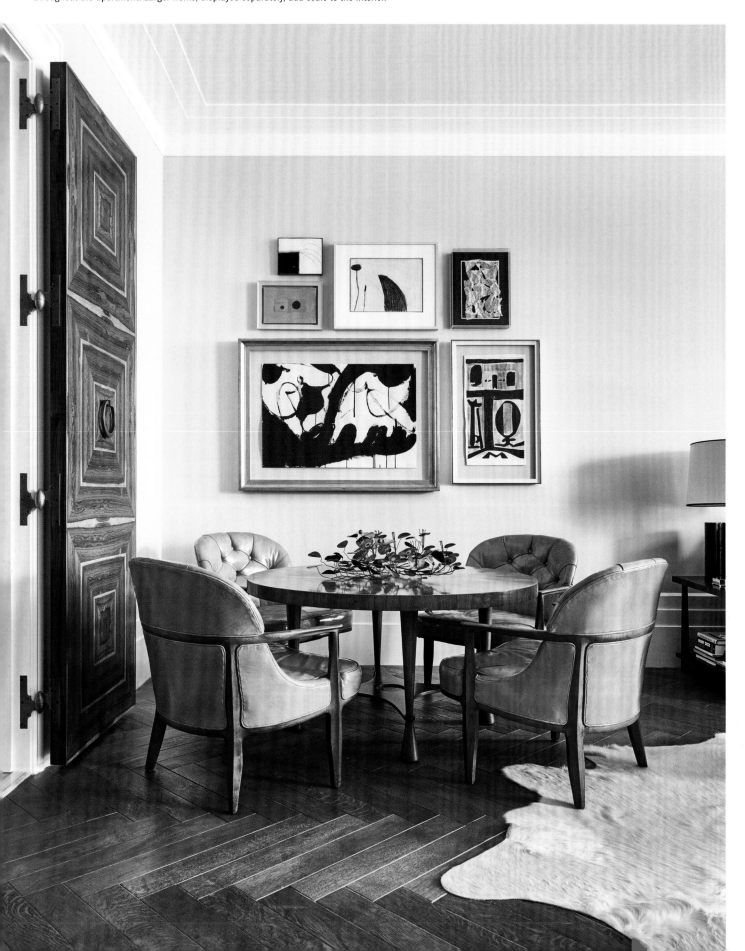

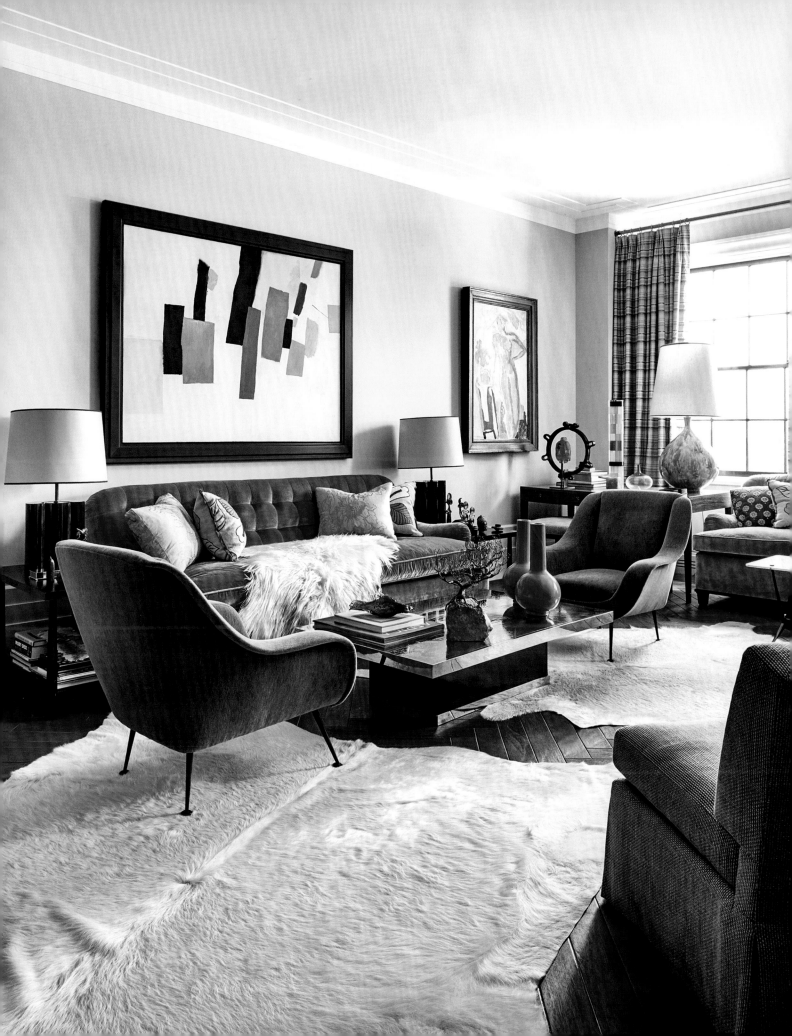

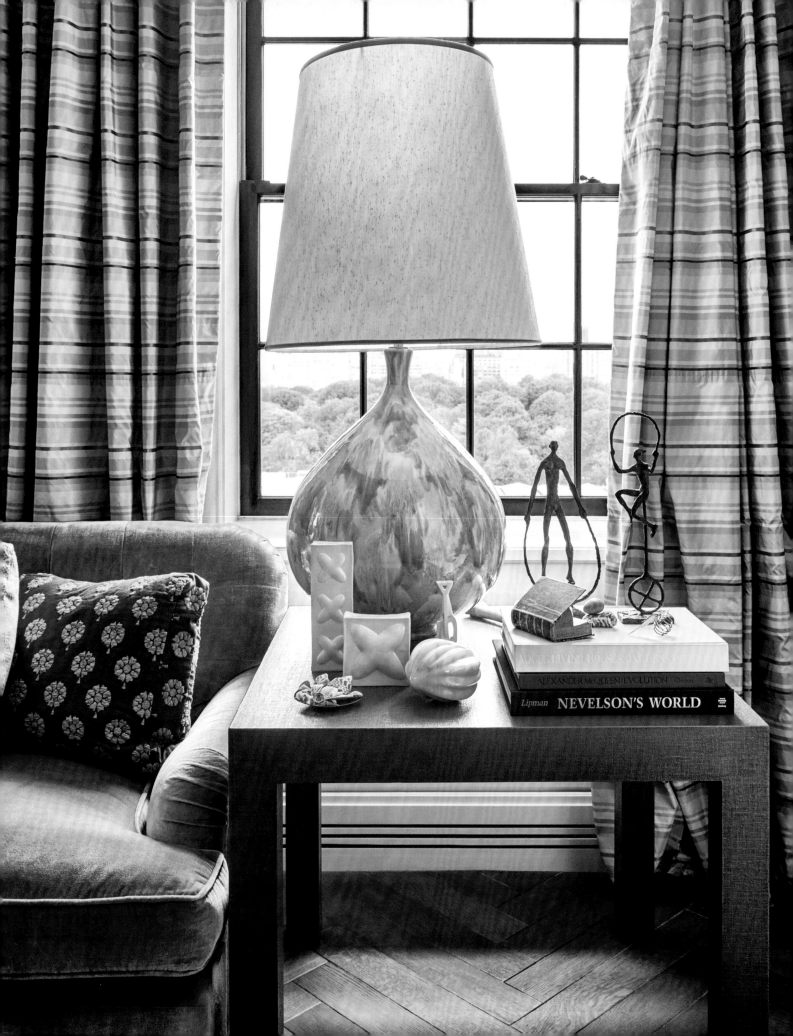

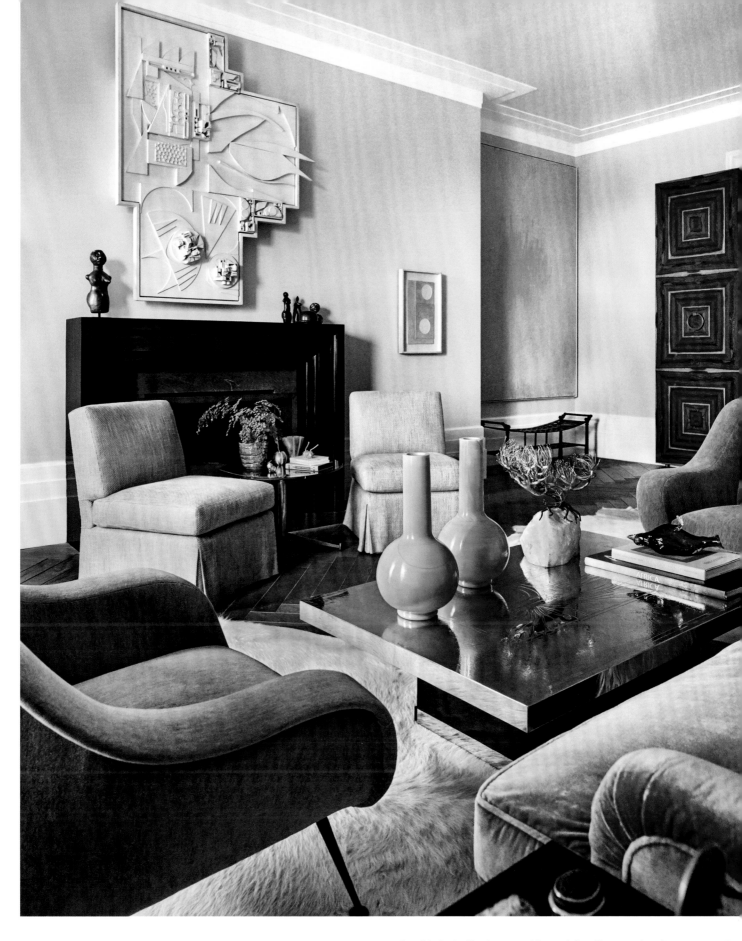

A work by Louise Nevelson, one of Hanson's favorite possessions, hangs over the fireplace. Its lack of color and asymmetrical presence make it stand out. The fire surround is of Hanson's design. Her friend Steven Gambrel designed the pair of brass-colored silk-velvet sofas in the living room.

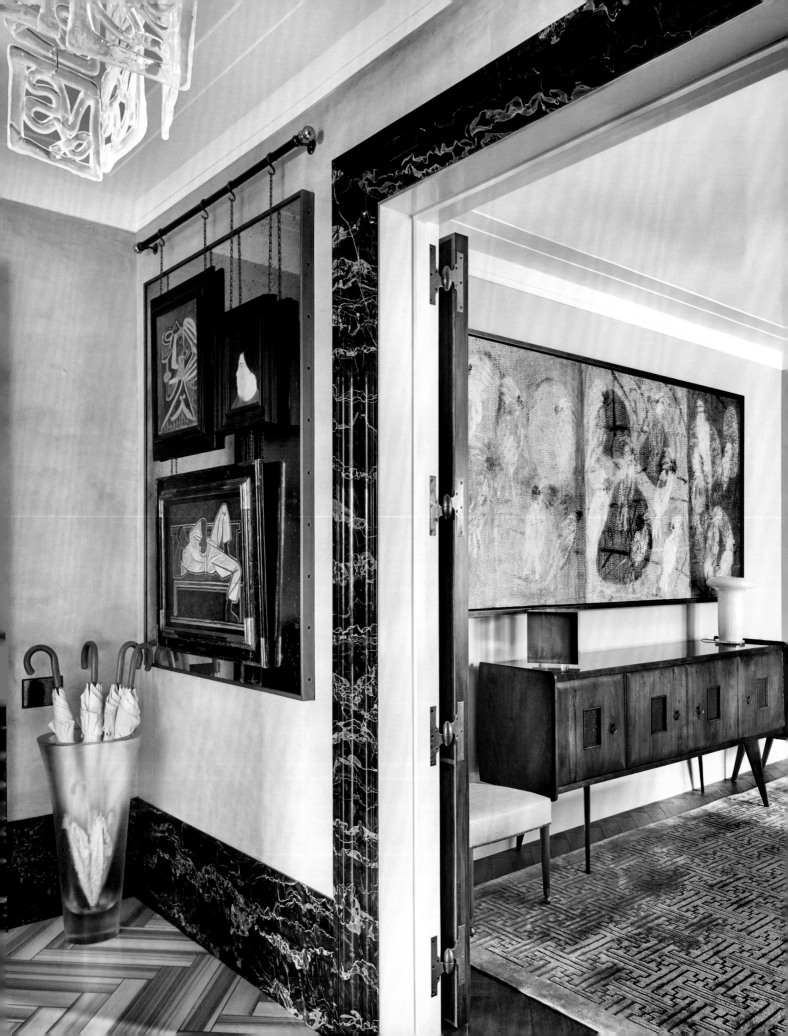

The dining room, just off the entry foyer, continues Hanson's interest in what she describes as "cozy elegance" and her passion for color. Here, mid-century art and furnishings seamlessly blend with the bold gestures, like the inlaid doors and deep stone baseboards and door trims, of her architectural intervention.
Following spread: Two small maid's rooms were combined to create a cozy den/library adjacent to the kitchen. A classic wall treatment of limed-oak paneling supports the feeling of a place for quiet reflection.

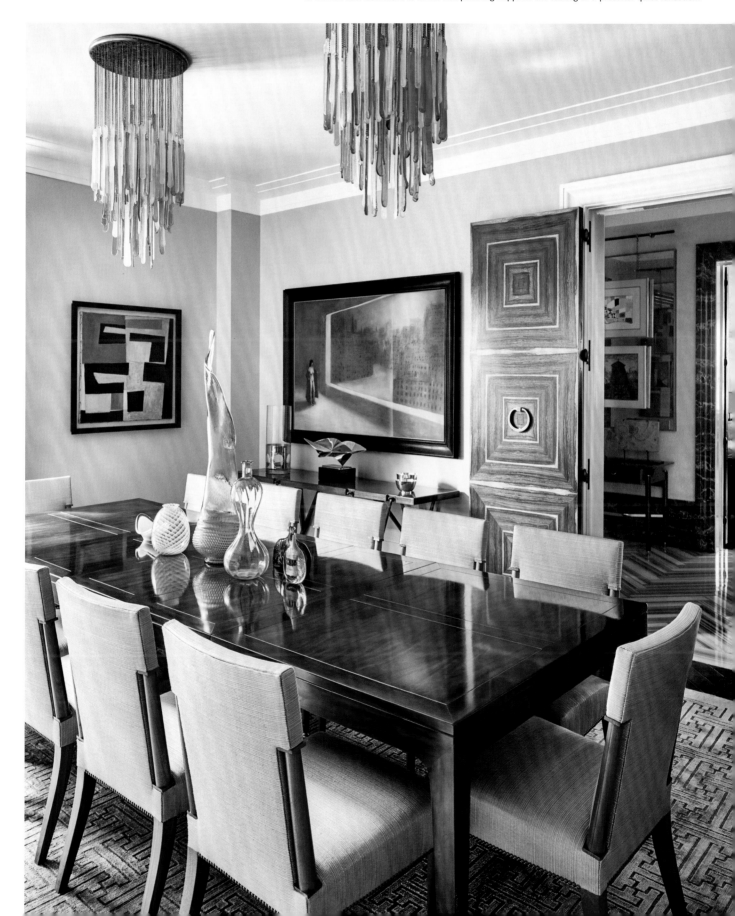

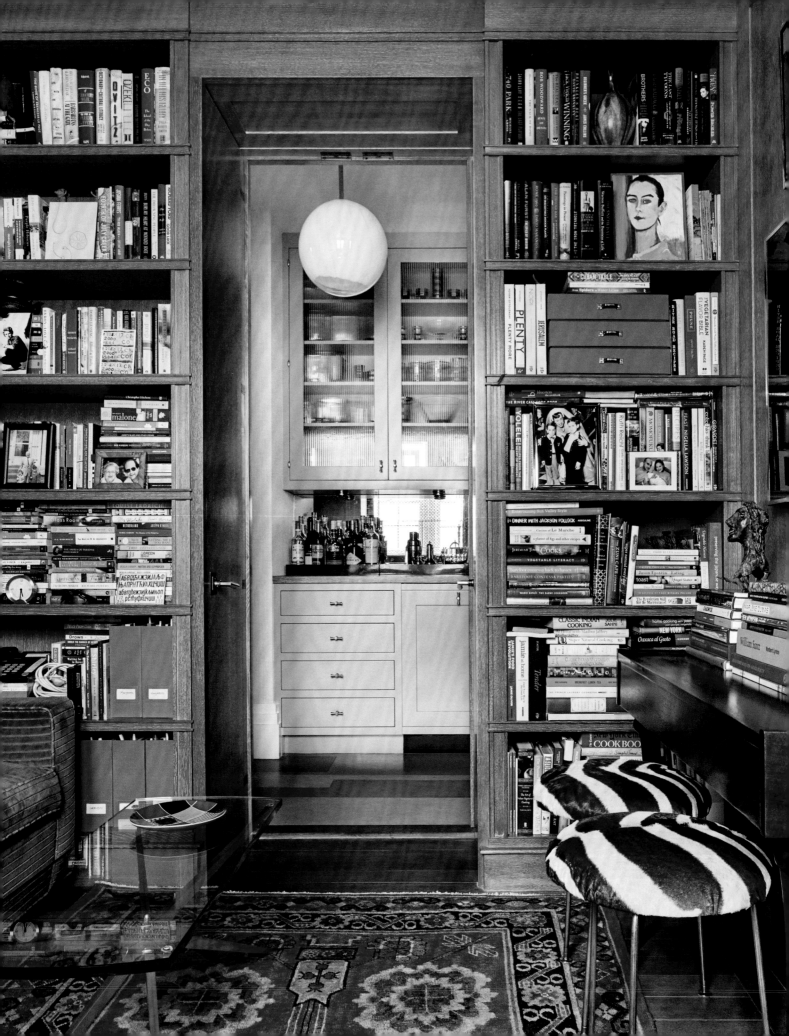

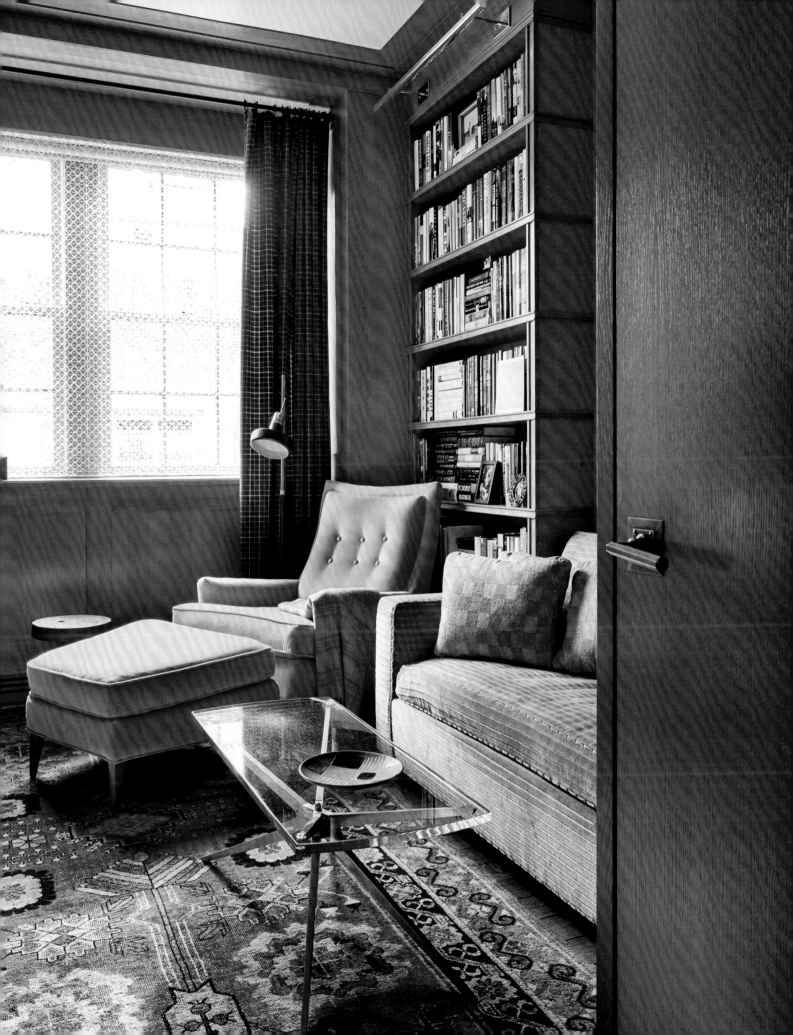

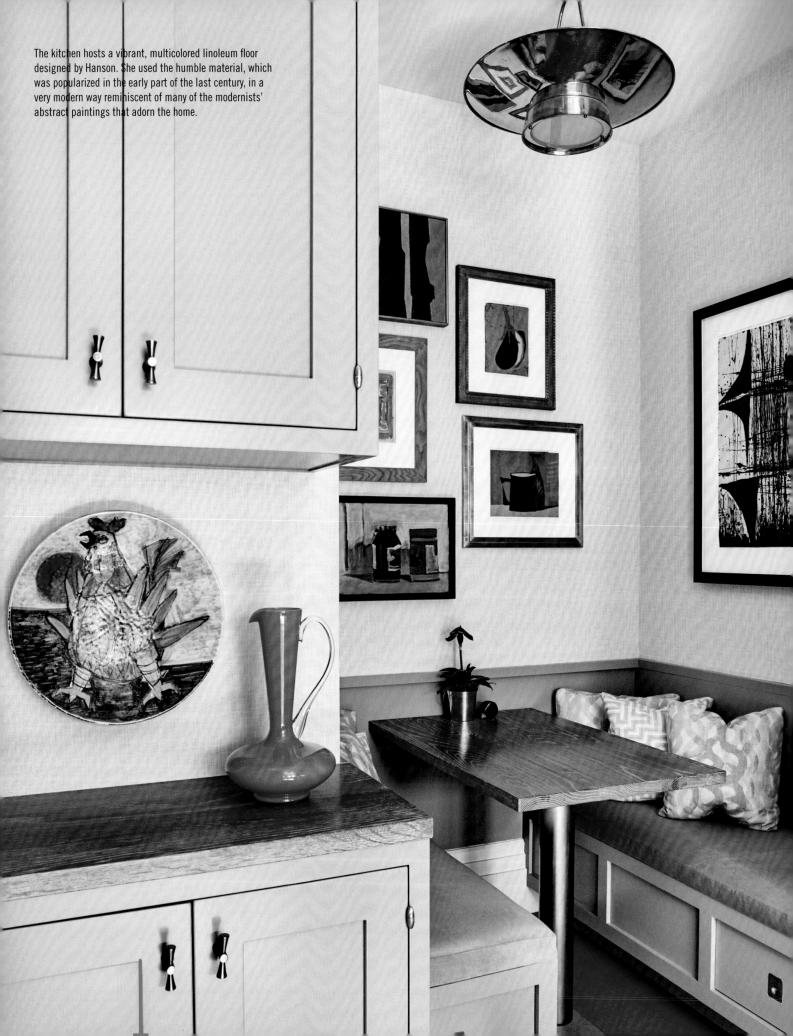

The kitchen hosts a vibrant, multicolored linoleum floor designed by Hanson. She used the humble material, which was popularized in the early part of the last century, in a very modern way reminiscent of many of the modernists' abstract paintings that adorn the home.

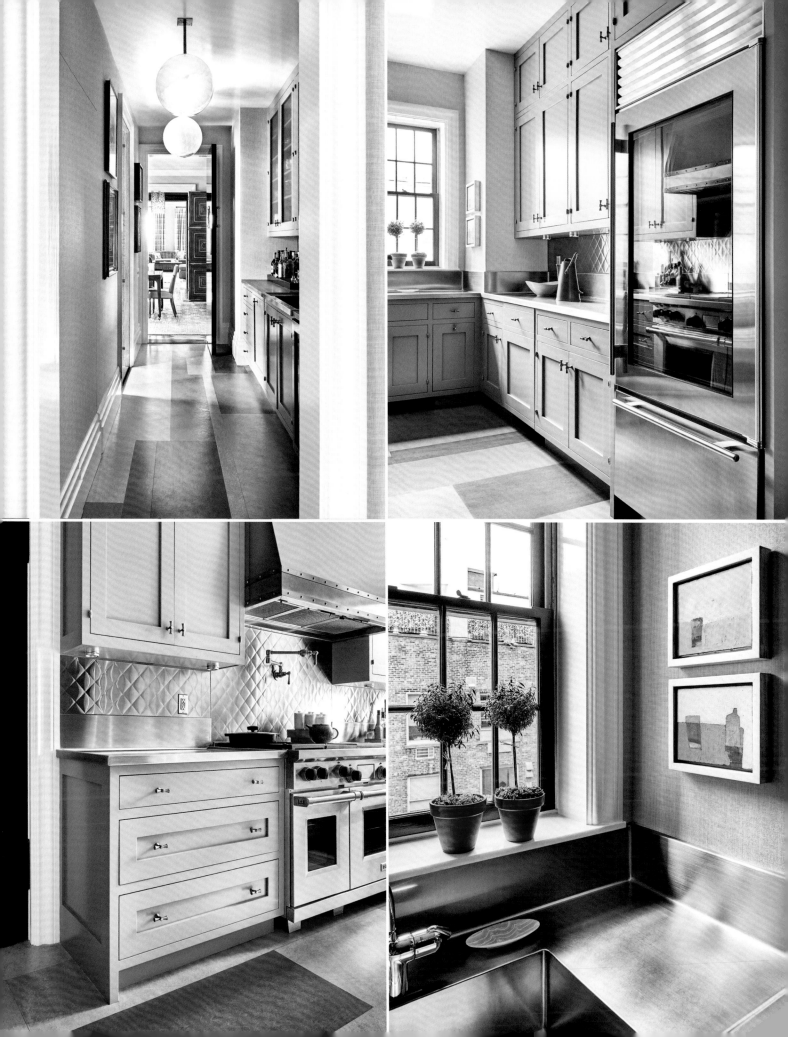

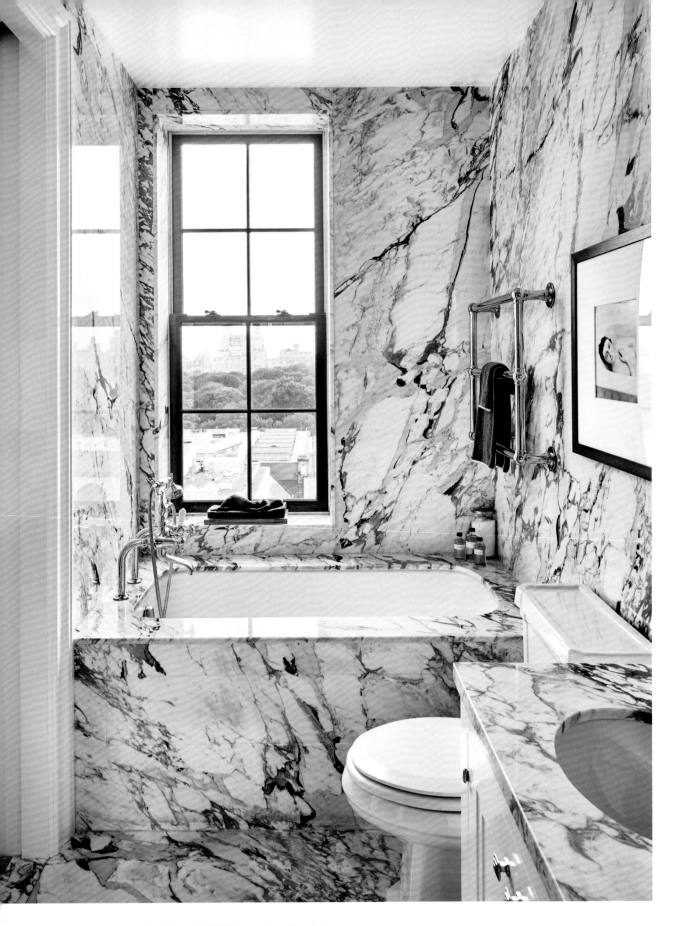

The master bath is an example of Hanson's ability to use stone. Here, full slabs cover the walls and floors, making the space feel like walking into an abstract painting.

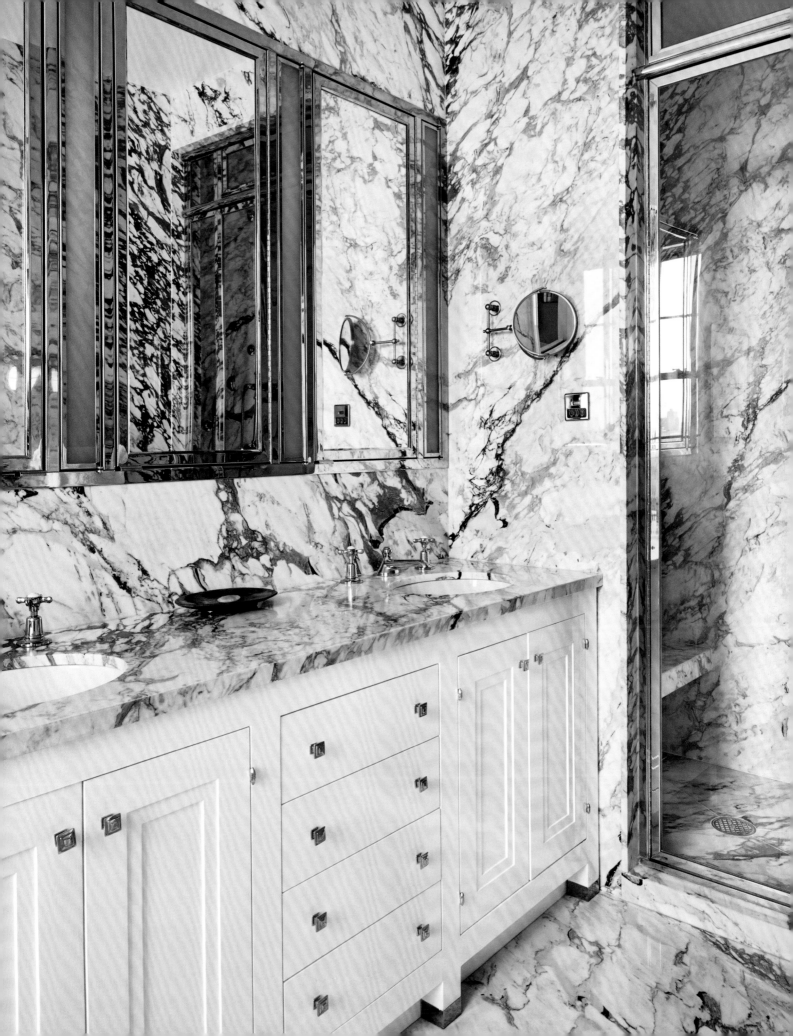

STEVEN HARRIS
& LUCIEN REES ROBERTS

Steven Harris and Lucien Rees Roberts share a home that they carved out of a classic Tribeca loft. When they took on the space, an artist had been living in it for more than thirty years; it was nearly raw with uneven floors, basic partitions, and only a sink and toilet at the back wall. The space, however, was on a beautiful Tribeca street lined with stone façades and flowering trees; it was also just a short walk from their workplace.

The architect-and-designer duo quickly set out to accentuate the eleven-foot ceilings and large windows. Luckily, they were able to advise the building on the restoration of the façade, which included returning the fenestration back to the original design. Three large north-facing windows create an evenly spaced rhythm across the front of the home, and the pair used the placement of these windows, which correspond to three windows across the back, as an overall organizing principle for the loft. A secondary wall, parallel to the window walls, was installed to divide the living room and entry from the dining room, library, and kitchen; there are also three openings that mirror the windows along the front façade. This gesture brings a heightened awareness of the windows into the dining room, library, and kitchen, along with views and light.

The architectural intervention left a beautifully proportioned rectangular living room and a slightly smaller, rectangular dining and kitchen area. The couple further distinguished the living room by covering the walls in rift-cut white-oak paneling that was wire brushed and bleached. The loft lacks a proper foyer, so the pair decided to hide the front door within the wood paneling; once inside, the door disappears to create a seamless paneled environment that gives the space a slightly European feel. A center corridor, positioned in line with the middle windows, leads from the dining room, library, and kitchen to the master bedroom suite, guest room, and guest bath. They lined this corridor with mirrored glass with beveled edges, which makes the hall feel generous in width, reflects light and views, and provides hidden storage.

Harris and Rees Roberts designed the sofa and TV cabinet in the living room, the dining table, and the bed, nightstands, and console in the bedroom, but perhaps their connection to the space is most strongly felt in the paintings that animate the rooms. Rees Roberts comes from a family of artists and is a painter himself. In fact, most of the art throughout the home is by Rees Roberts, his grandfather, father, mother, or brother. The shared family passion for the beautifully expressive is felt throughout this space and is not limited to the paintings.

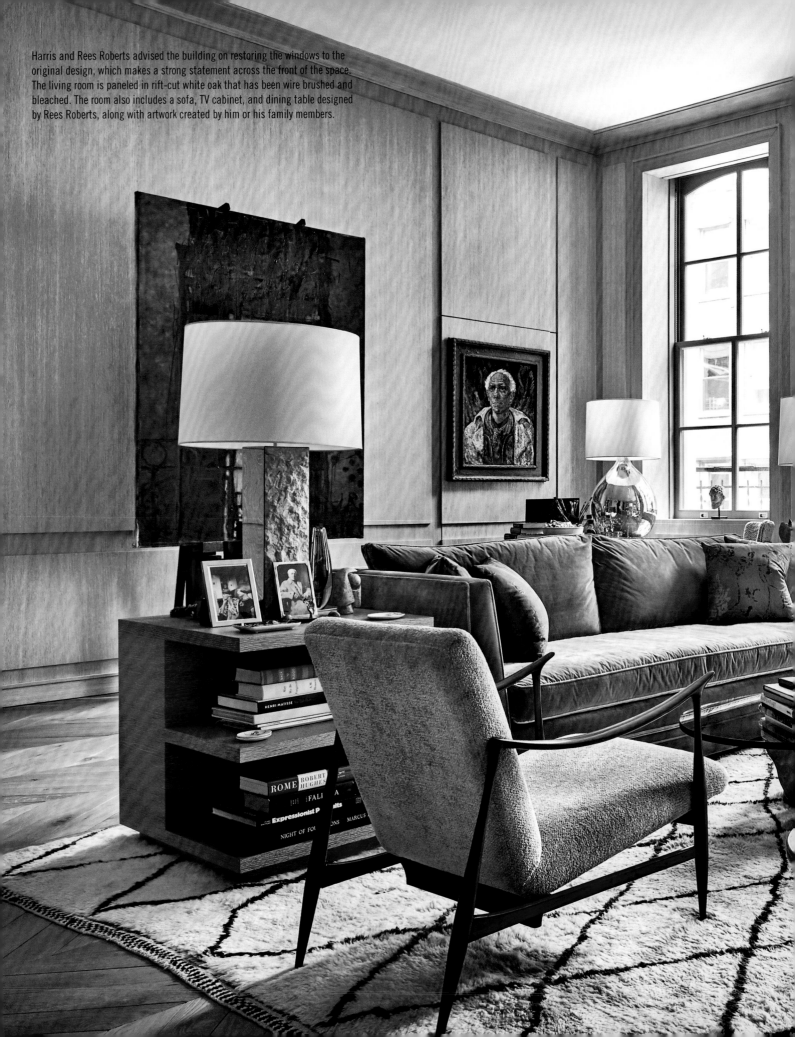

Harris and Rees Roberts advised the building on restoring the windows to the original design, which makes a strong statement across the front of the space. The living room is paneled in rift-cut white oak that has been wire brushed and bleached. The room also includes a sofa, TV cabinet, and dining table designed by Rees Roberts, along with artwork created by him or his family members.

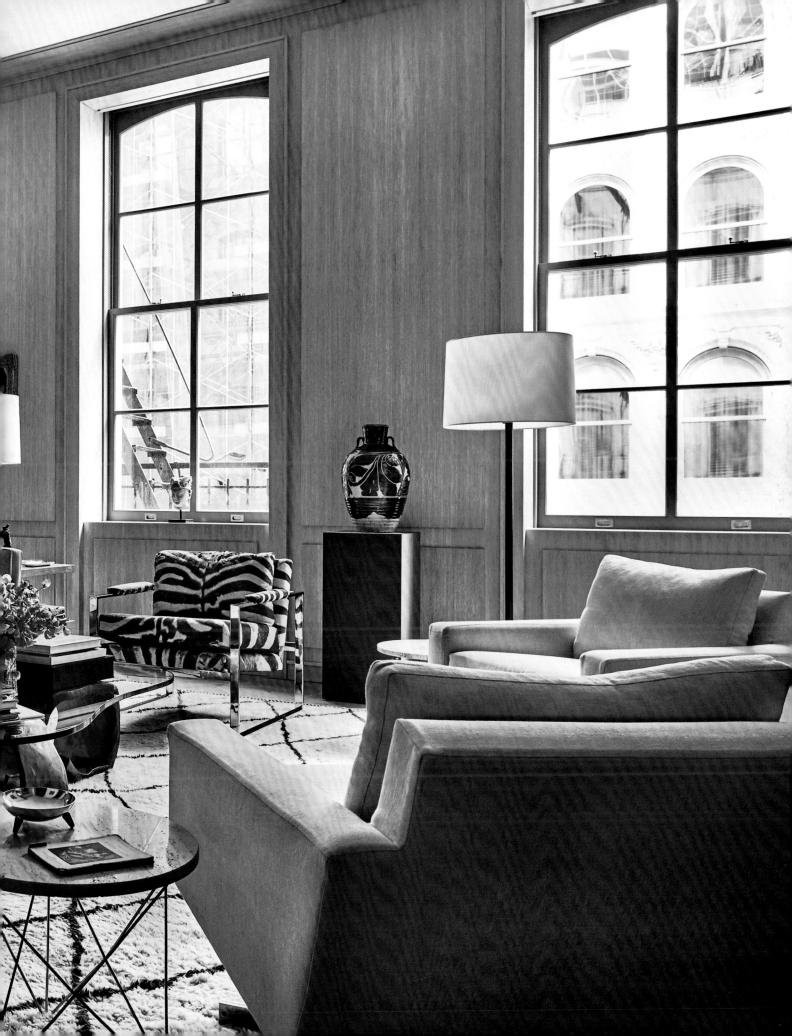

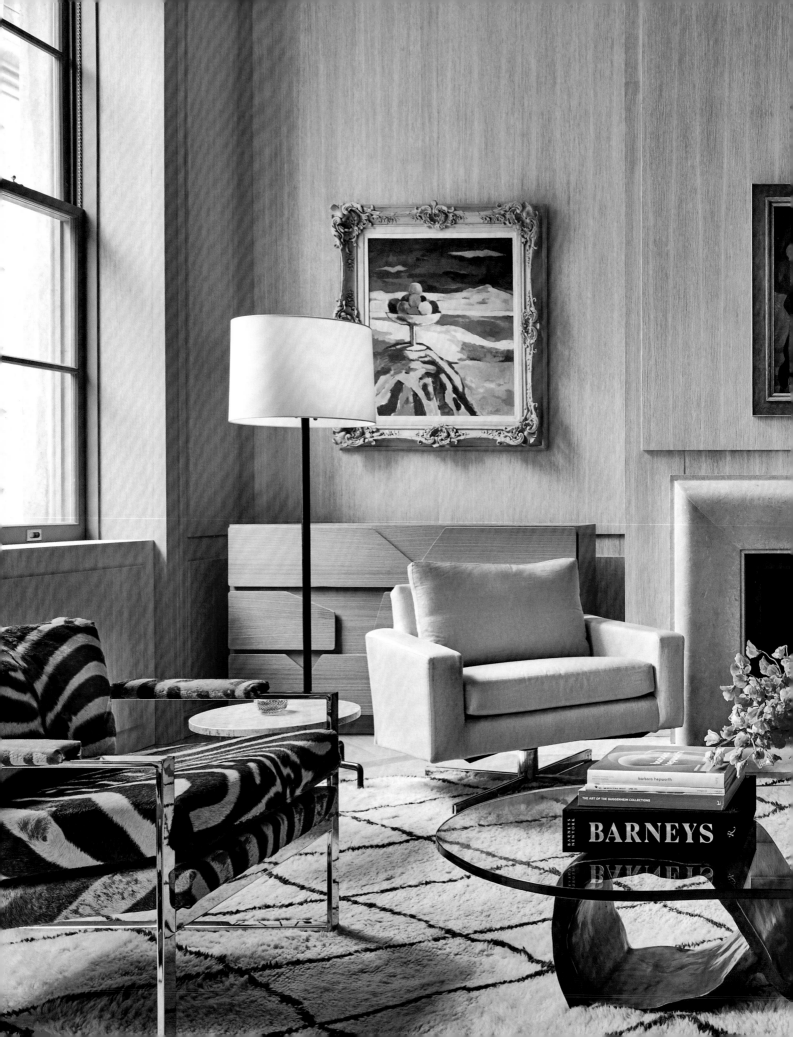

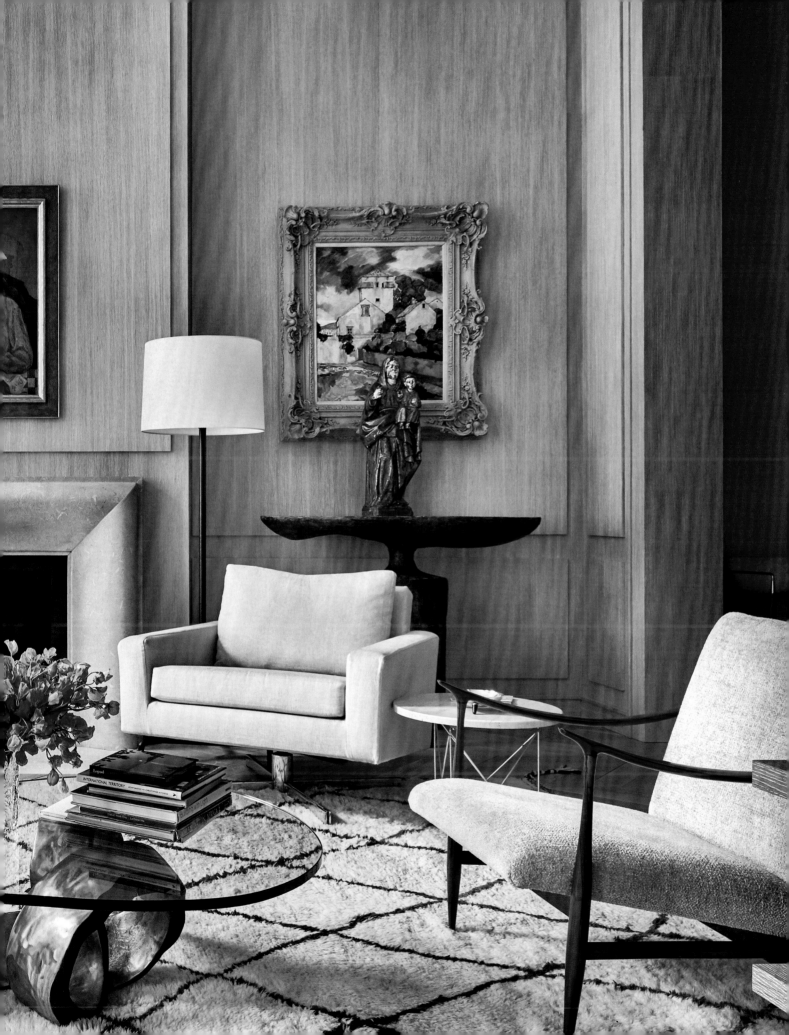

The dining area, accessible from three openings that align with the three windows across the front of the space, also functions as a library. The dining chairs are an adaptation of Dan Johnson's Viscount chair and were produced by Rees Roberts. The kitchen island, which also doubles as a buffet server, conceals an oven at one end. The remainder of the kitchen is tucked behind the far wall of bookshelves.

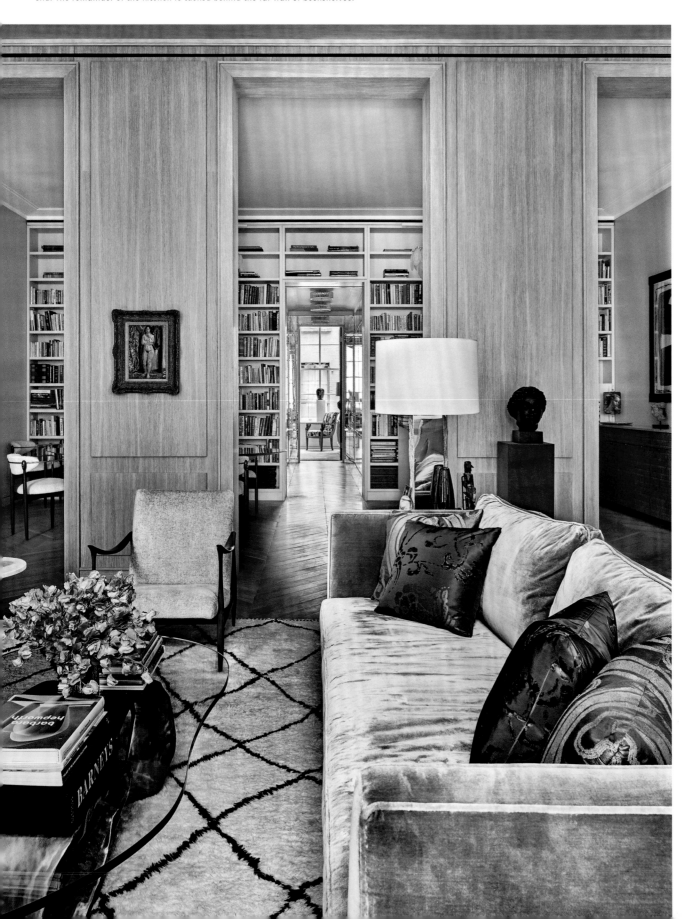

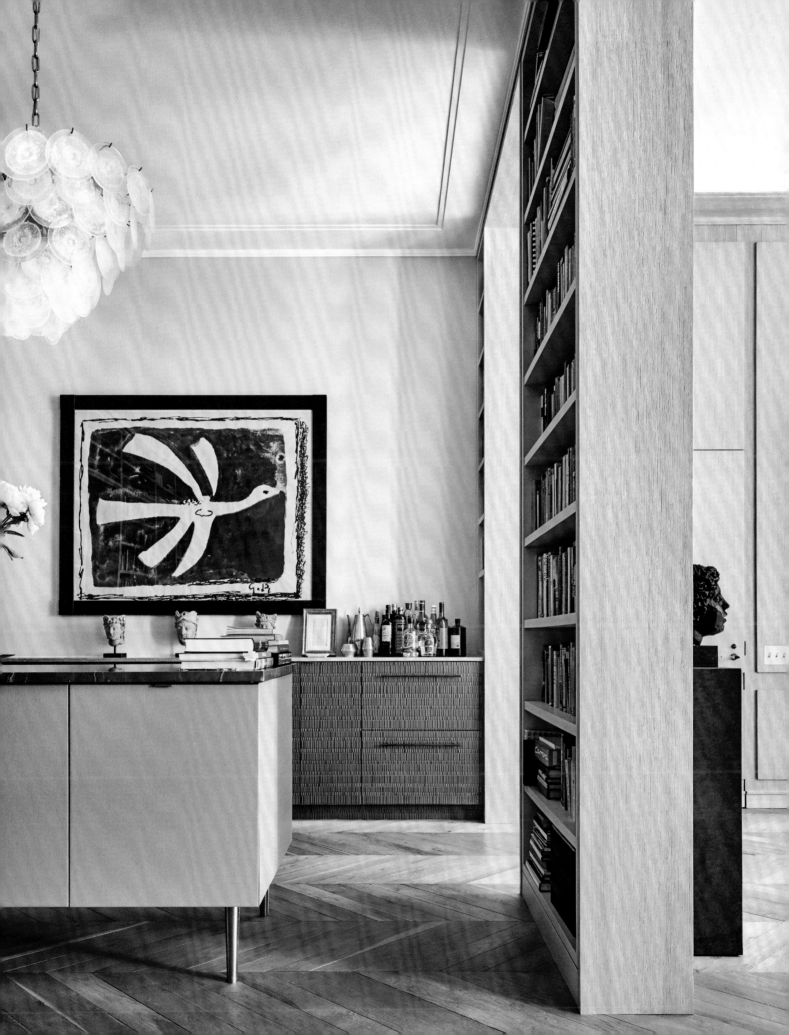

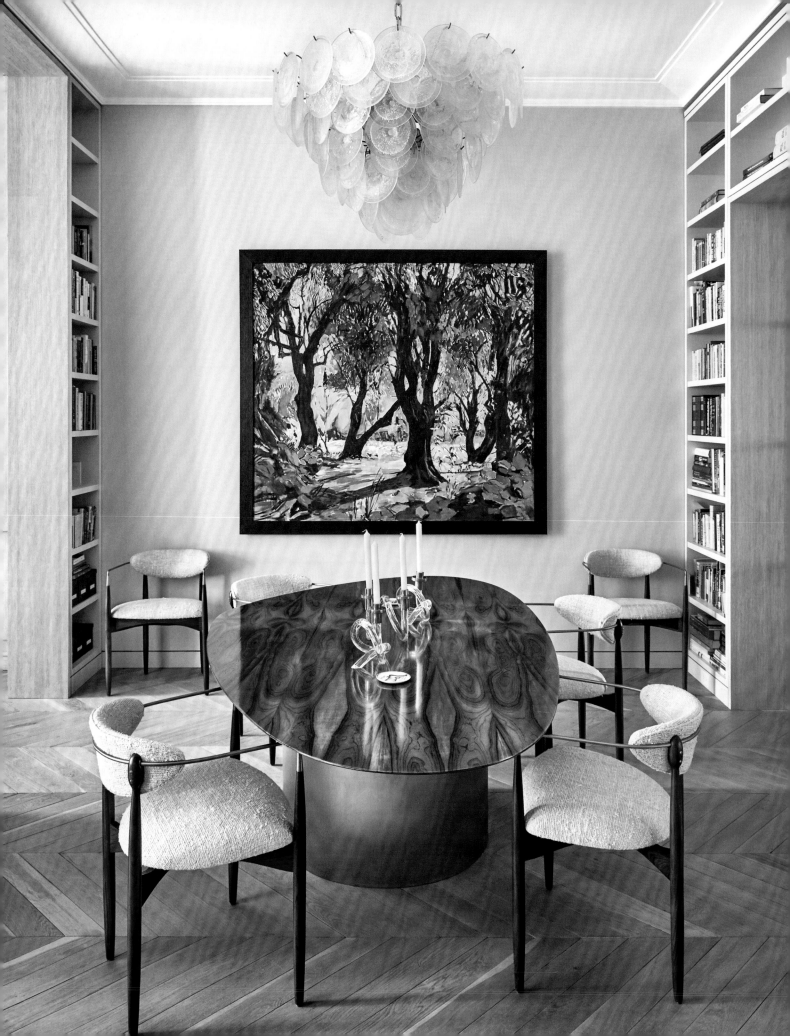

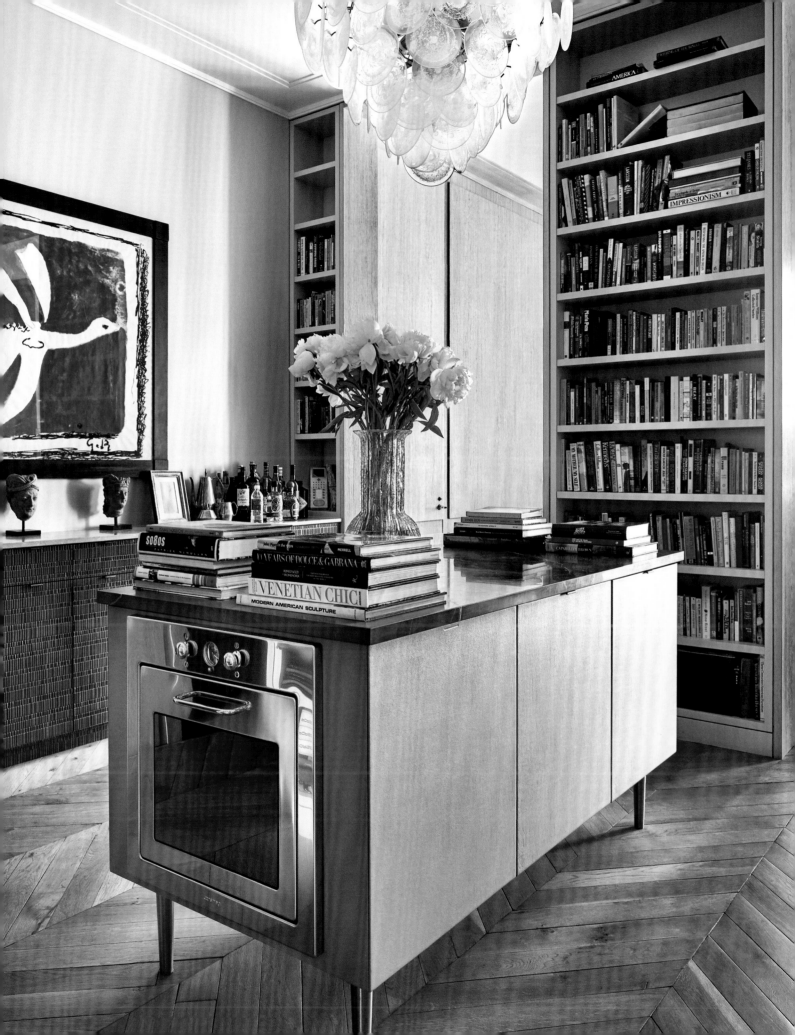

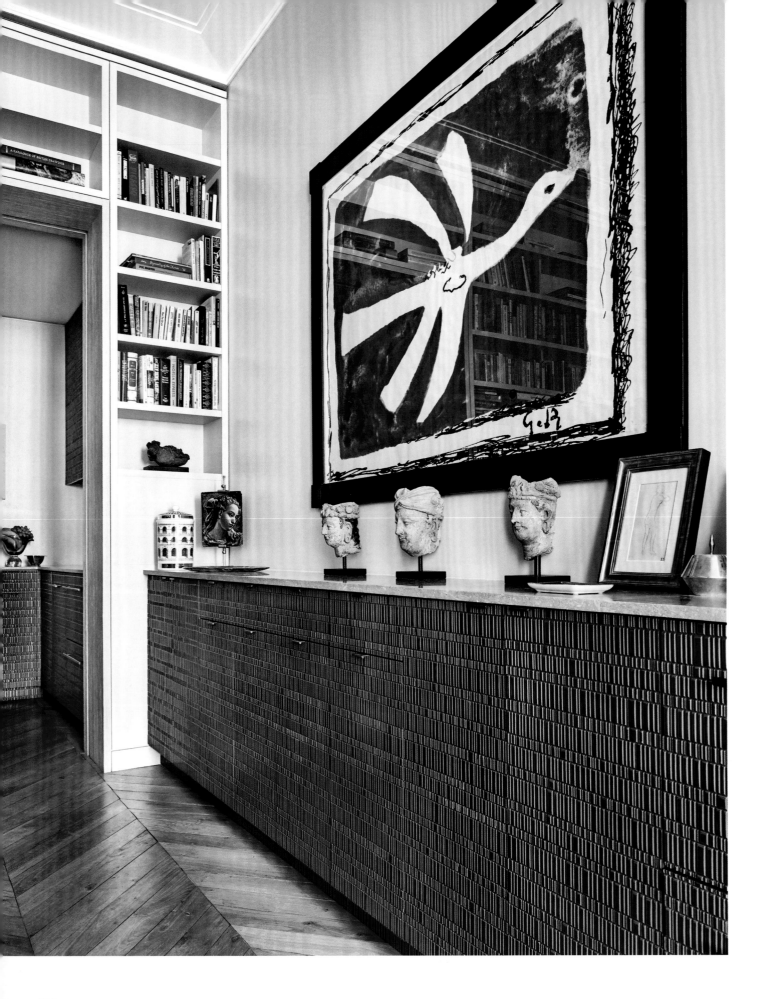

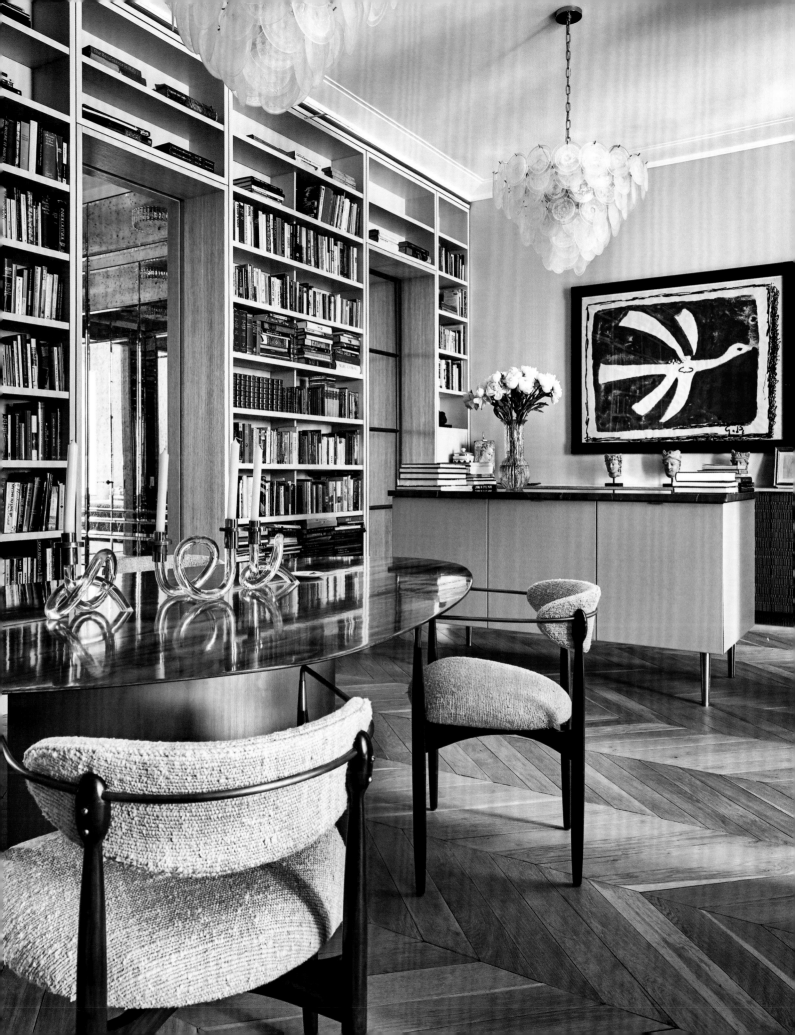

The limited amount of space was a concern for Harris and Rees Roberts, so they covered the hall to the bedrooms with mirrored glass. This makes the area feel more generous in width while also adding a great deal of hidden storage.

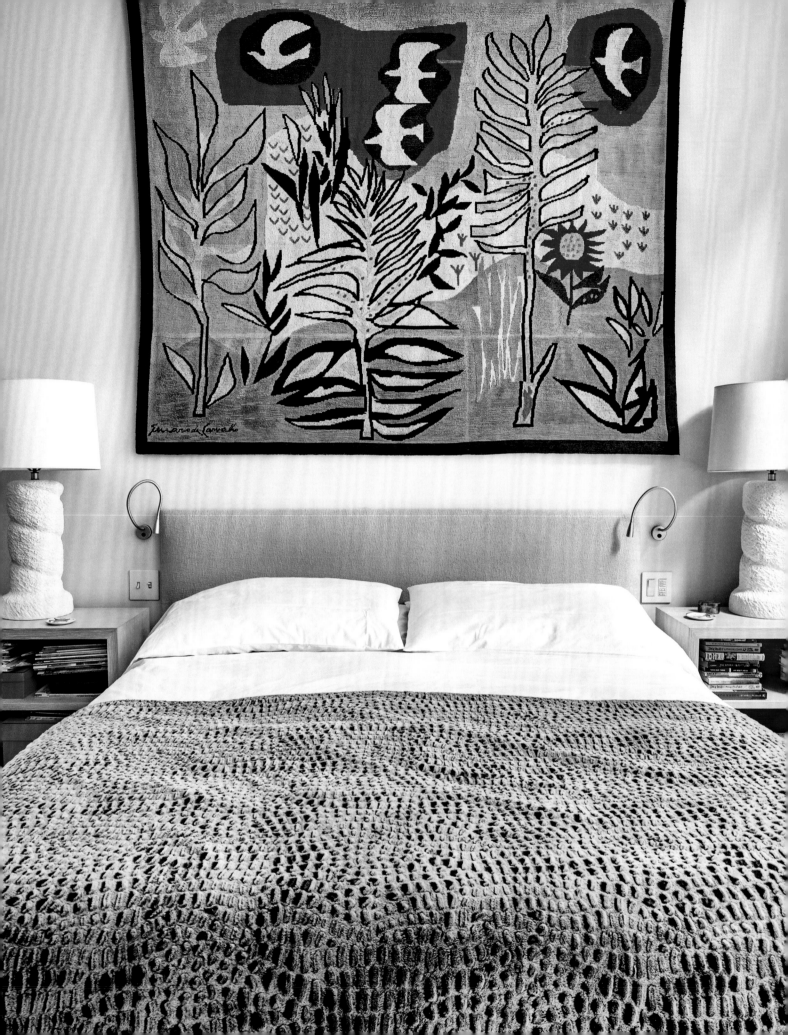

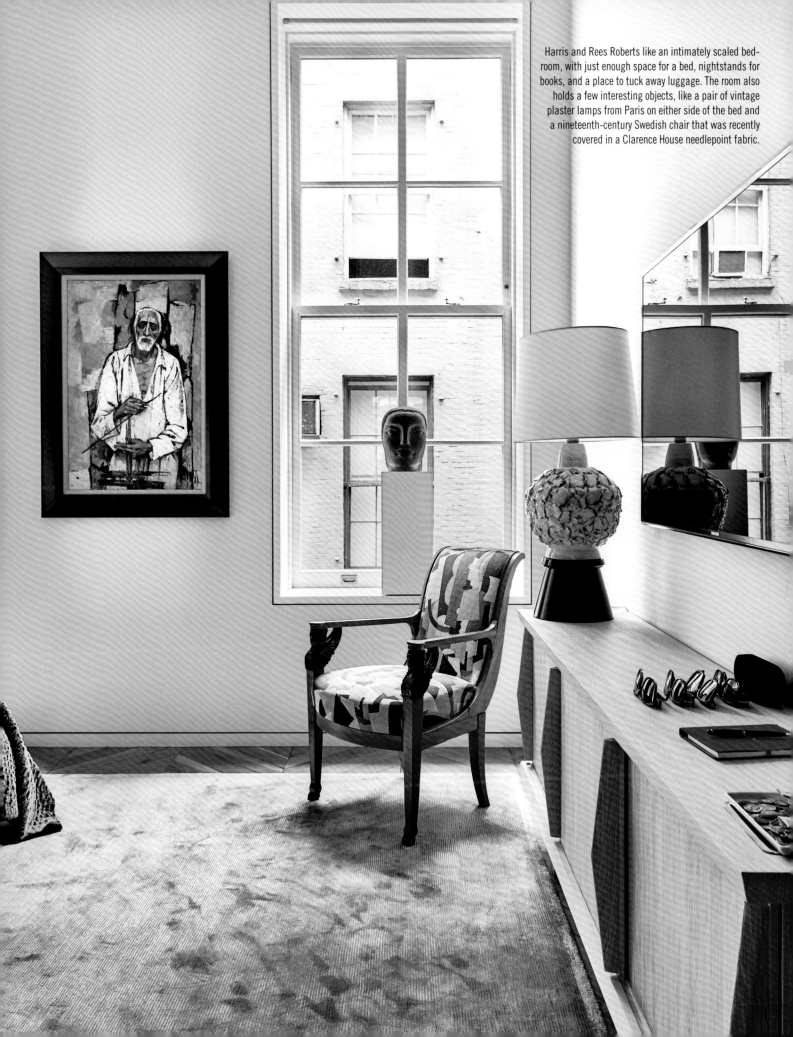

Harris and Rees Roberts like an intimately scaled bedroom, with just enough space for a bed, nightstands for books, and a place to tuck away luggage. The room also holds a few interesting objects, like a pair of vintage plaster lamps from Paris on either side of the bed and a nineteenth-century Swedish chair that was recently covered in a Clarence House needlepoint fabric.

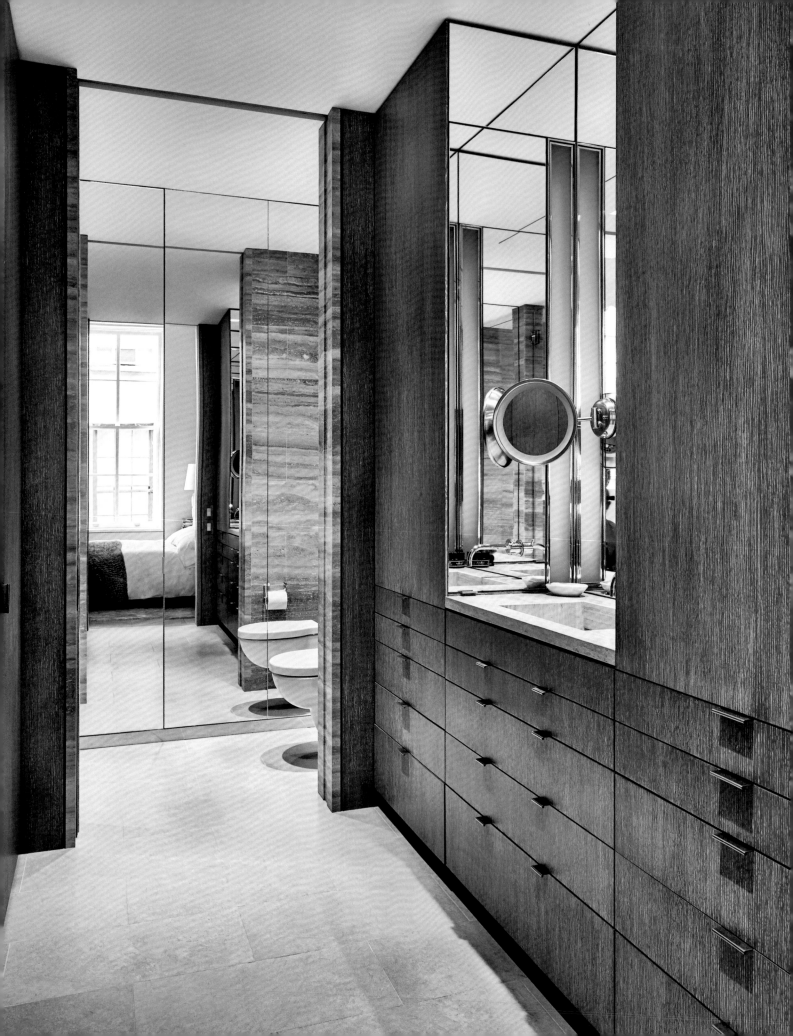

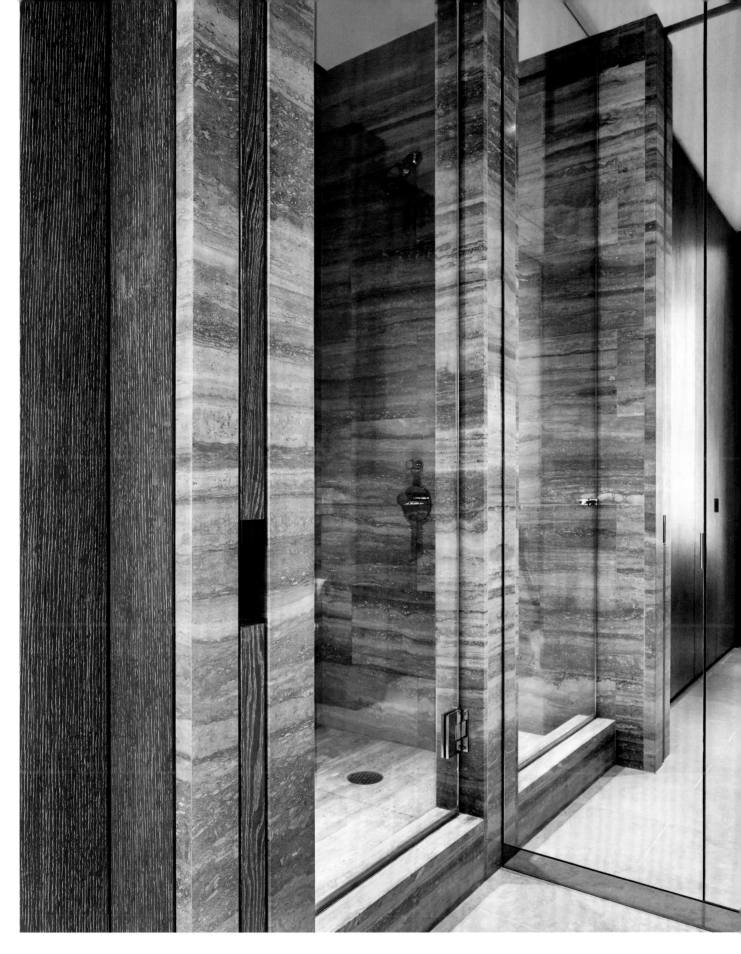

The master bathroom is divided into two sections—wet and dry. The wet section, for the toilet and shower, is lined with silver travertine, and the dry section, dedicated to the sink and wardrobe storage, is outfitted with stained-oak cabinetry.

MICHAEL HAVERLAND

Michael Haverland and his partner, Philip Galanes, had lived across the street from their current apartment's building for more than a decade, and it had always been a favorite of Haverland's. Haverland used the classic Greenwich Village building designed by Helme and Corbett in 1925 as a case study when he taught housing design at Yale. He found the cross-section of the building, with alternating duplexes, to be a brilliant solution and admired the floor plans, proportions, and fenestration. At the time of its construction, the building bucked the trend of taking advantage of the new building code that allowed for ceiling heights to descend to eight feet and became known for retaining many of the characteristics of homes from that period, including large parlors with double-height ceilings.

The apartment did not require a gut renovation, but Haverland felt it needed some work. They added central air-conditioning, a new powder room on the first floor, and new finishes, window treatments, and millwork. They also did work in the kitchen and bath. They made every effort to retain the remaining original details, such as the steel staircase and plaster ceiling medallions. The double-height living room was also his biggest design challenge. He felt that the sixteen-foot-tall stark-white walls in the room distracted from the elegance of the vaulted ceiling. Many decorative options were explored, but none felt fresh or appropriate. The solution was already part of the space; it just needed Haverland's creativity to extrapolate it. He decided to cover the walls with circular and octagonal medallions made of computer-milled and lacquered MDF, which were abstracted versions of the barrel-vaulted ceiling's original circular and octagonal plaster ornamentation. Haverland's solution allows these existing decorative elements to trickle down the walls. As they do, they decrease in size and spacing, mediating the scale between the large volume and the objects in the room.

Haverland has infused every corner of this home with a playful quality that seems to stem from the joy of design and his joy in collecting it. He is not afraid of the whimsical, cheerful, or colorful for interiors, and his sustained interest in mid-century design often embraces the place where these two notions come together. Bright colors are used to underscore the pedigree of some of the upholstered furnishings, while white walls seem to frame and exalt each object. Haverland thus stained the wood floors a dark hue and left the walls a matte white; this combination created the ideal grounds for the diverse colors and textures of the furniture and objects he would fill the space with. Haverland understands the objects he has created and their installation here, and while he is still respectful of function, he always shows them of in the most positive lights.

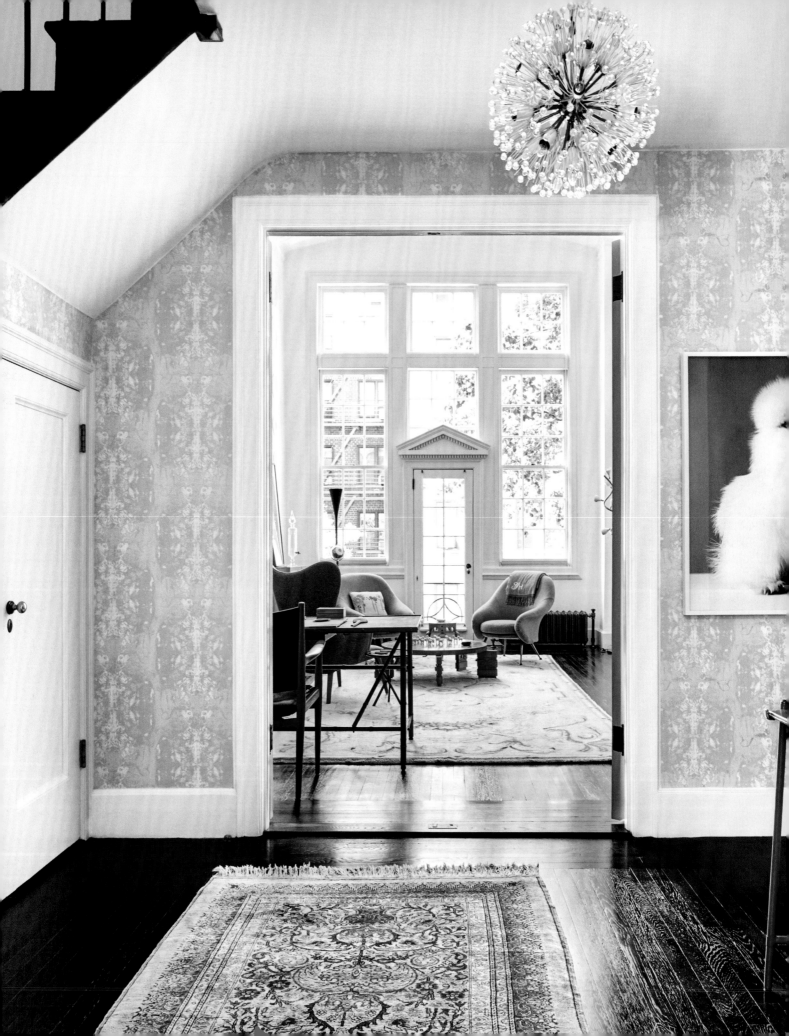

The entry foyer introduces visitors to Haverland's interest in vintage furnishings, color, and whimsical decorations used with restraint. The Jean Royère mirror, with cheerful inlaid dried flowers, hanging above the Jacques Adnet entry table illustrates this point.

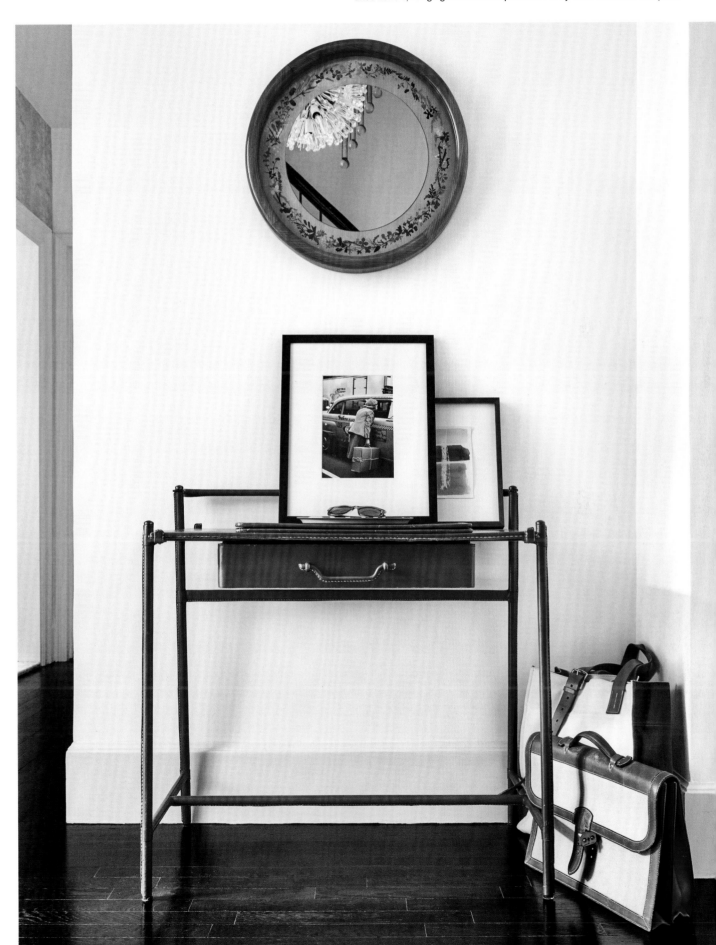

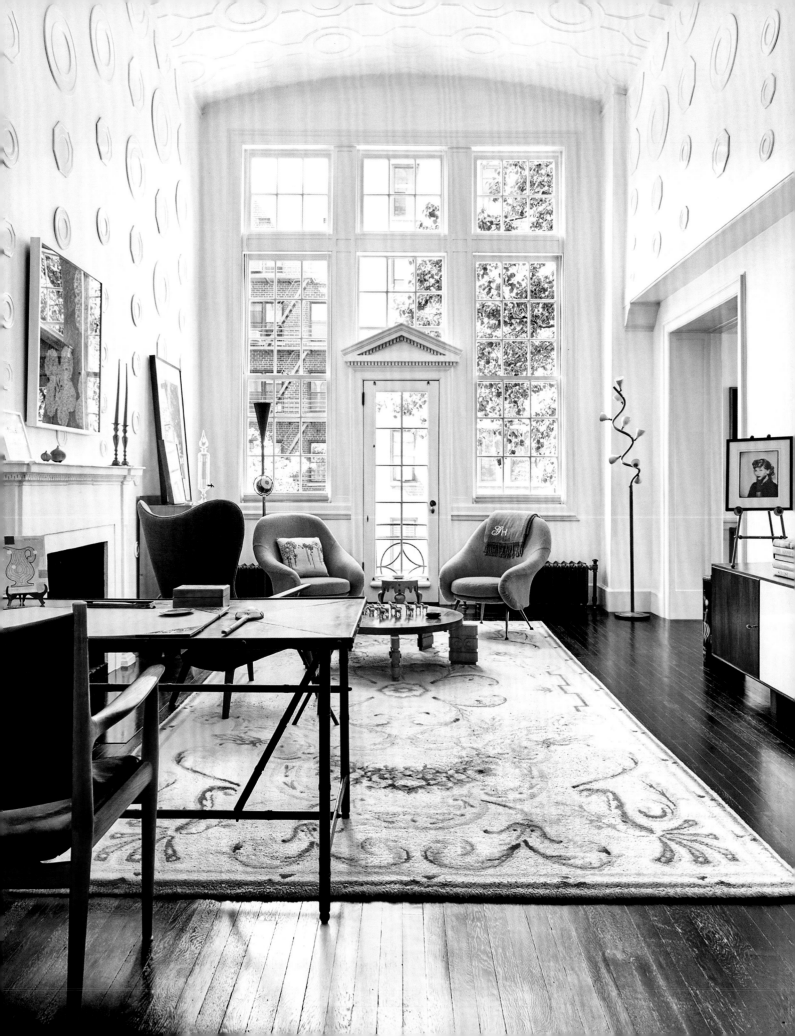

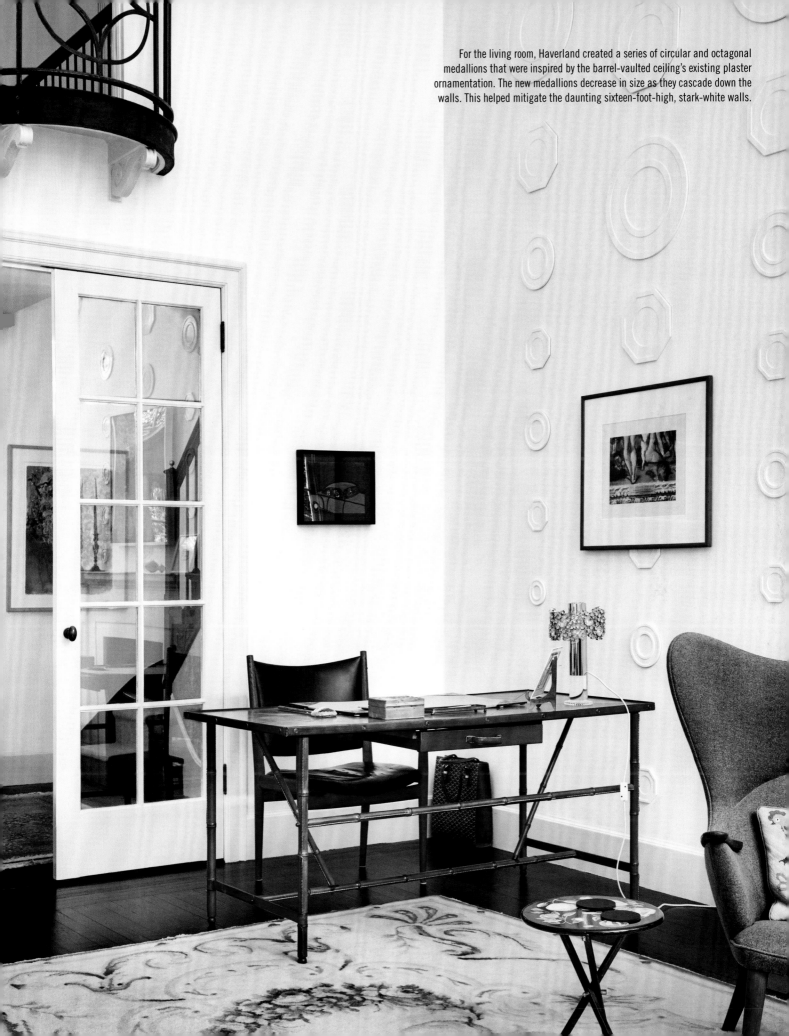

For the living room, Haverland created a series of circular and octagonal medallions that were inspired by the barrel-vaulted ceiling's existing plaster ornamentation. The new medallions decrease in size as they cascade down the walls. This helped mitigate the daunting sixteen-foot-high, stark-white walls.

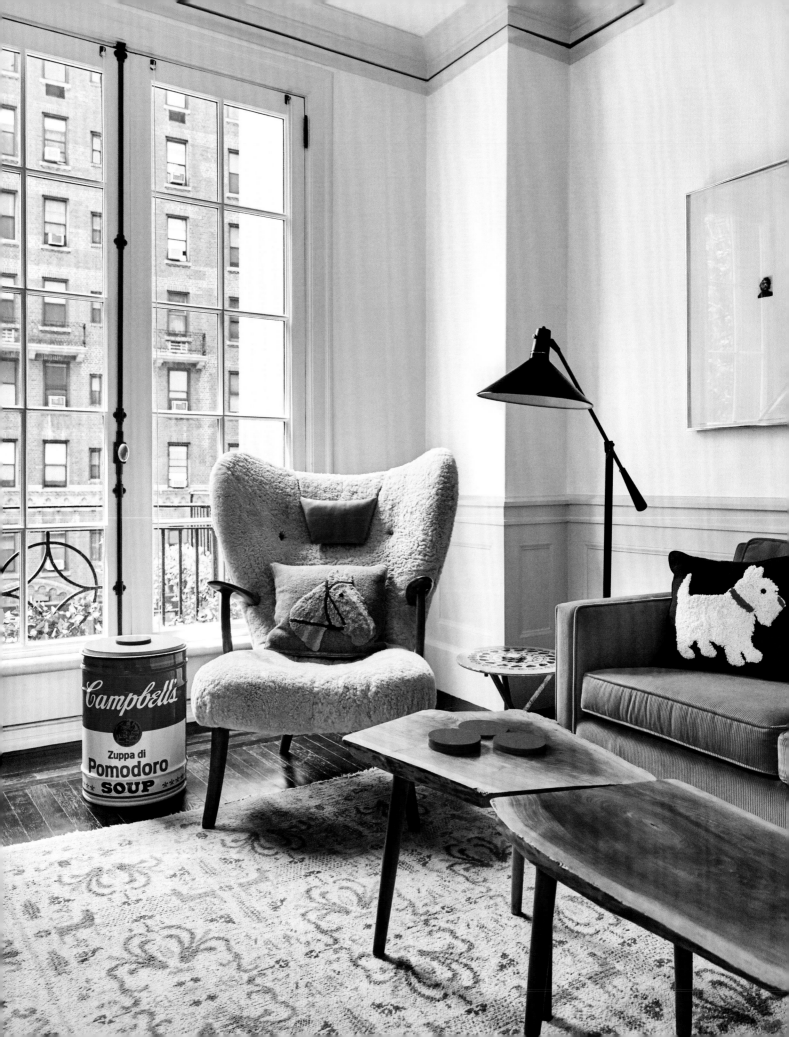

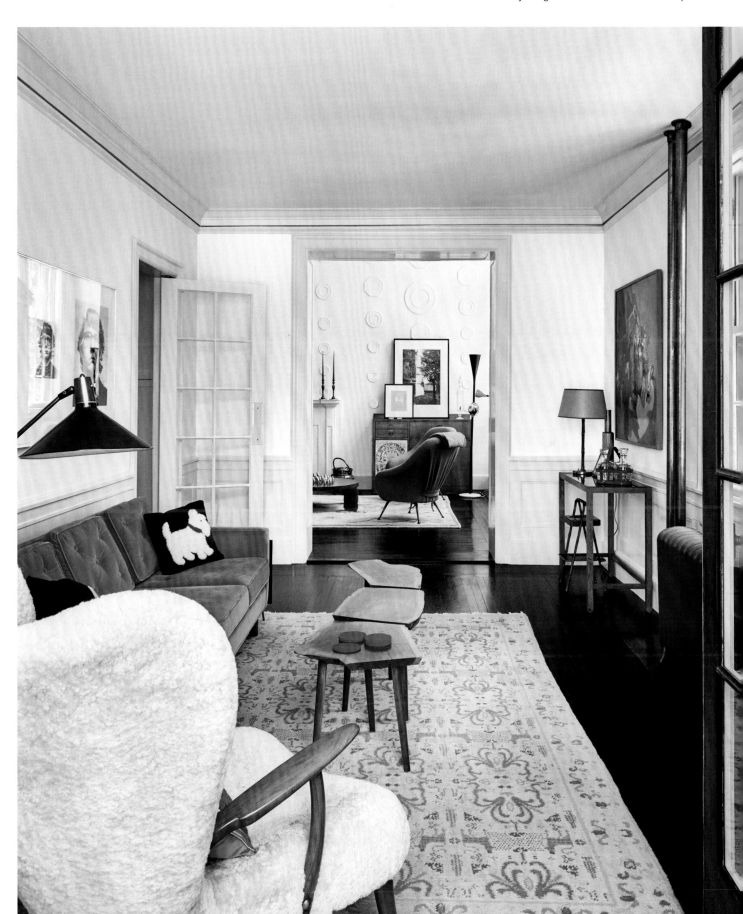

This space off the living room and kitchen was originally intended as a dining room, but because Haverland and his partner frequently dine out in New York, they decided to turn the intimate area into their TV room. A Madsen and Schubell "Pragh" lounge chair, circa 1950, occupies the far corner. The sofa, designed by Edward Wormley, and the collection of tables by George Nakashima are from the same period.

After searching for a fixture that could hang in the stairwell and illuminate both the upper landing and the foyer, Haverland decided to have one made. He purchased two Gino Sarfatti lamps and used the parts to create a long pendant.

The clothes, drawers, and shoe cubbies in the hallway fill the void created by the barrel vault of the living room ceiling below and the space created by the unique building section. Haverland reconfigured this area to function as a closet without cumbersome doors. While it mandates a certain level of tidiness, it is in ingenious use of otherwise awkward space.

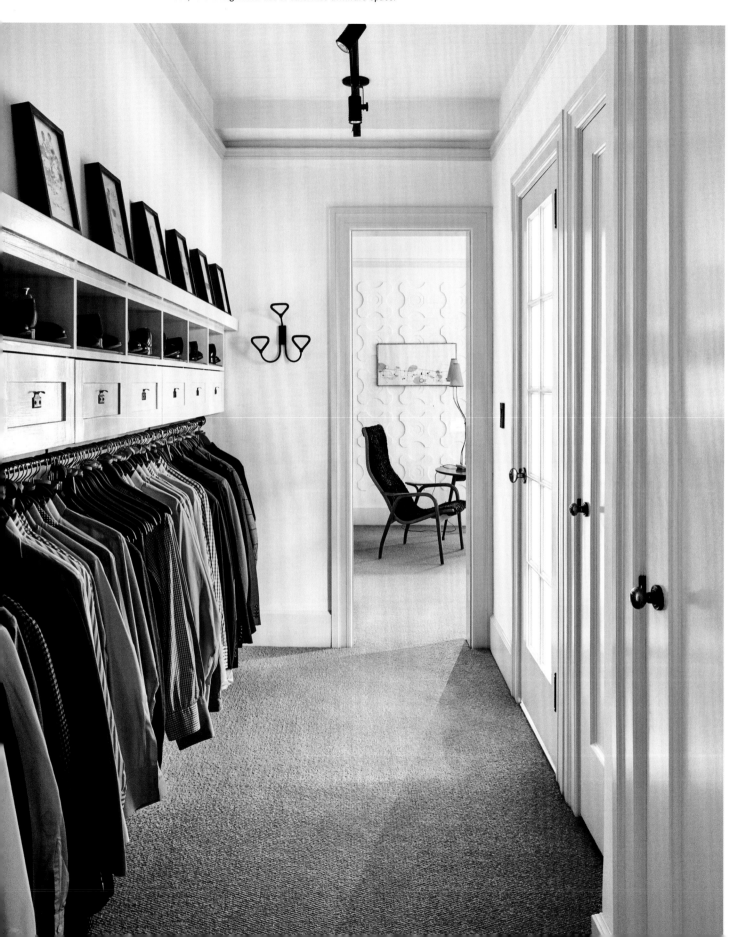

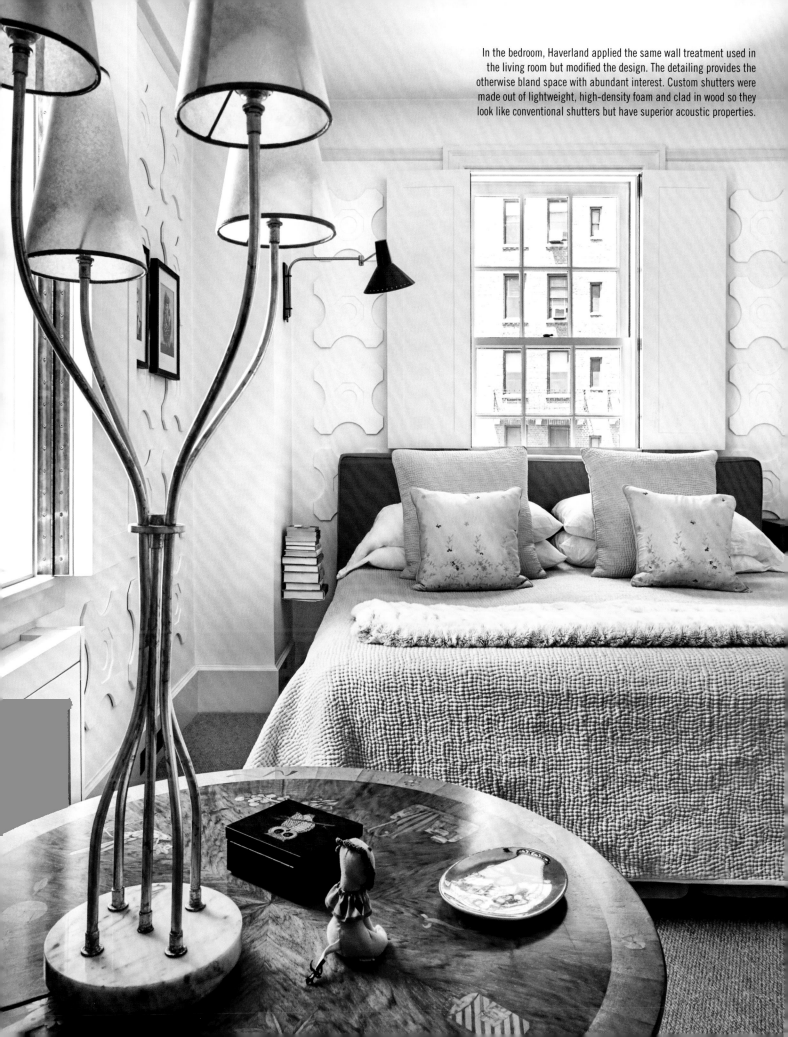

In the bedroom, Haverland applied the same wall treatment used in the living room but modified the design. The detailing provides the otherwise bland space with abundant interest. Custom shutters were made out of lightweight, high-density foam and clad in wood so they look like conventional shutters but have superior acoustic properties.

SHAWN HENDERSON

In discussions about interiors, we often sidestep notions of appropriateness and managing expectations, as we have grown accustomed to consuming design in isolated fragments via periodicals or social media. It is not really possible to discuss Shawn Henderson's home or work without considering this topic. When Henderson found this apartment, for example, the previous owners, clearly inspired by the stately townhomes in the area, had filled the space with extremely traditional, heavy moldings and lots and lots of wallpaper. The building, however, was built in 1915 to accommodate modest apartments, and none of what the previous occupants had done felt appropriate to Henderson.

The bulk of Henderson's decisions here, while contemporary in spirit, seem driven by a desire to create a sense of homogeneity between the building, the apartment, and the casual elegance of its West Village location. Henderson removed walls and archways and stripped away all the unnecessary moldings. He peeled the floor back to the underlying wide-plank pine boards and exposed brick walls and beams; in the main living space, ceiling beams were added; in the kitchen, brick tile was installed on the wall and then painted; and for the new flooring in the bedroom, Henderson used wide-plank pine. While never attempting to be historically accurate, Henderson created a balance between the modest past of the building and his desire for a warm and inviting space. To achieve this, Henderson installed a combination of antique and vintage furnishings in warm woods and metals combined with rich wools and leathers in earth tones.

The apartment runs the length of the building, with windows in the living room that face the street and a window in the bedroom that looks out on the rear garden. There are also windows that run along the side of the apartment and face an interior space that is not quite a courtyard but too big to be called an airshaft. Henderson added shutters to all the windows as a way of unifying the space and dealing with the variation in view and light from window to window.

Wanting an open plan, Henderson took down the wall separating the dining and living areas, but creating distinct areas within the space was still a priority. To manage this, he turned to bold, geometric forms. He installed a custom, circular rug in the living room, which defines that space, and a large, rectangular, woven wood screen on the wall, flanked by identical columnar cabinets to establish the dining area. The apartment is quite quiet—something that Henderson was pleasantly surprised about. This also applies to his design approach: He managed to infuse the space with a great deal of character and complexity while maintaining a sense of serenity.

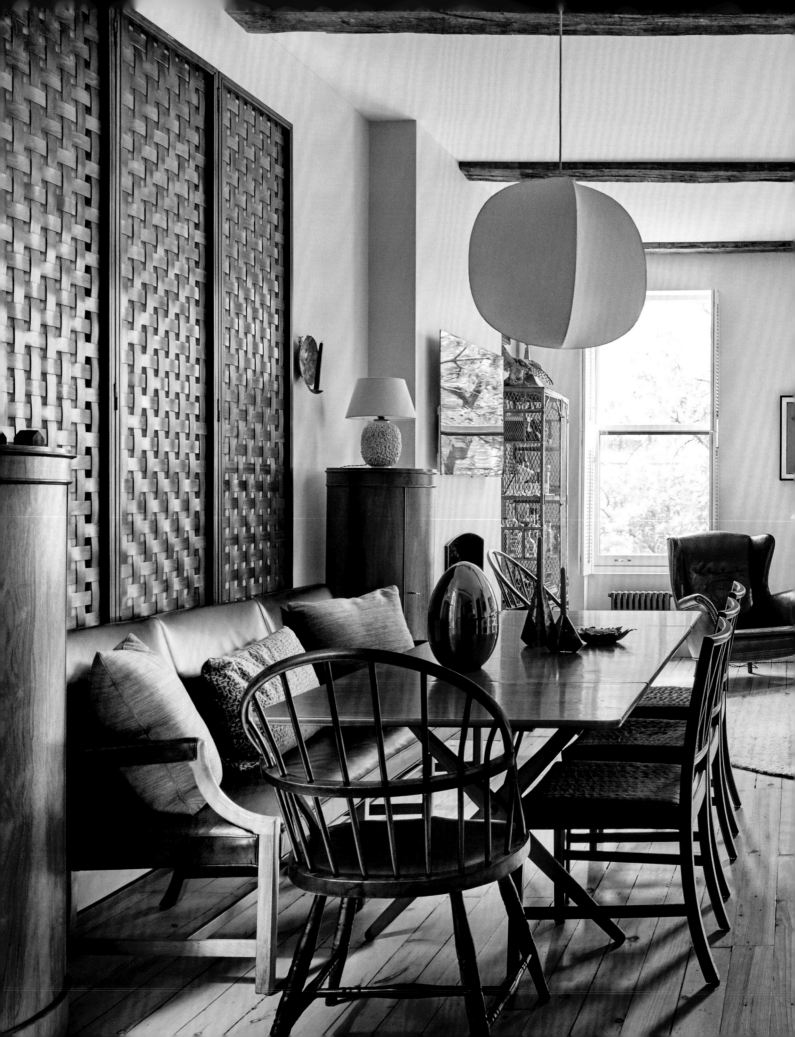

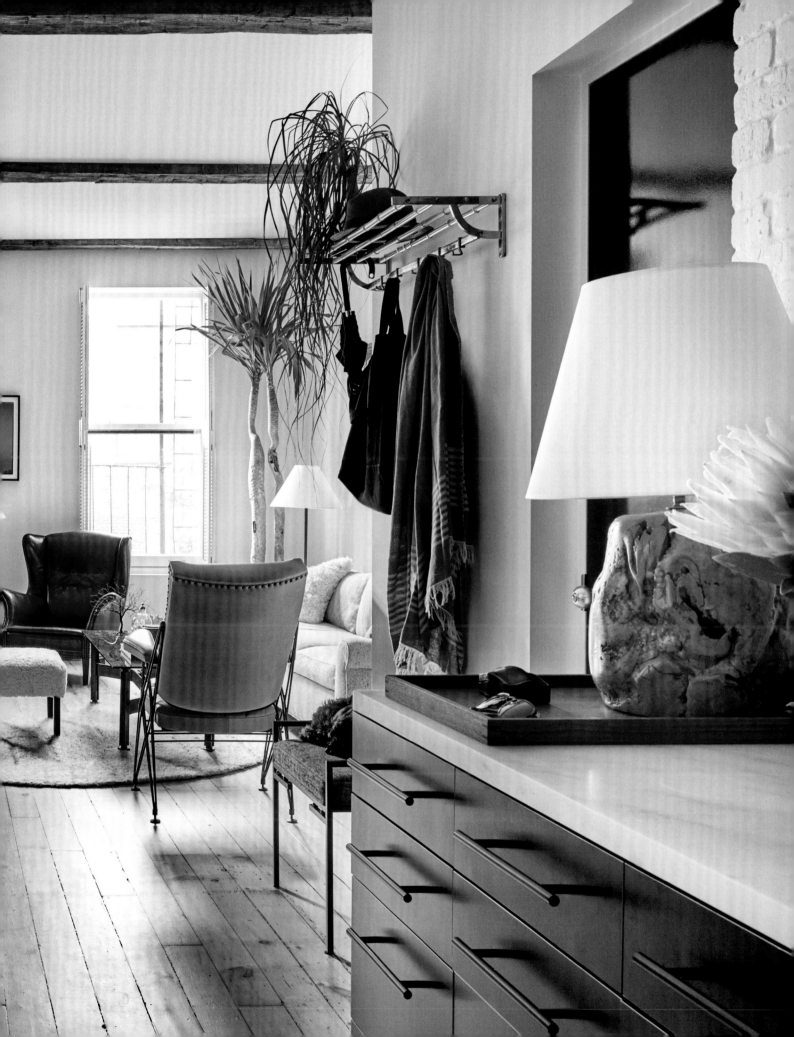

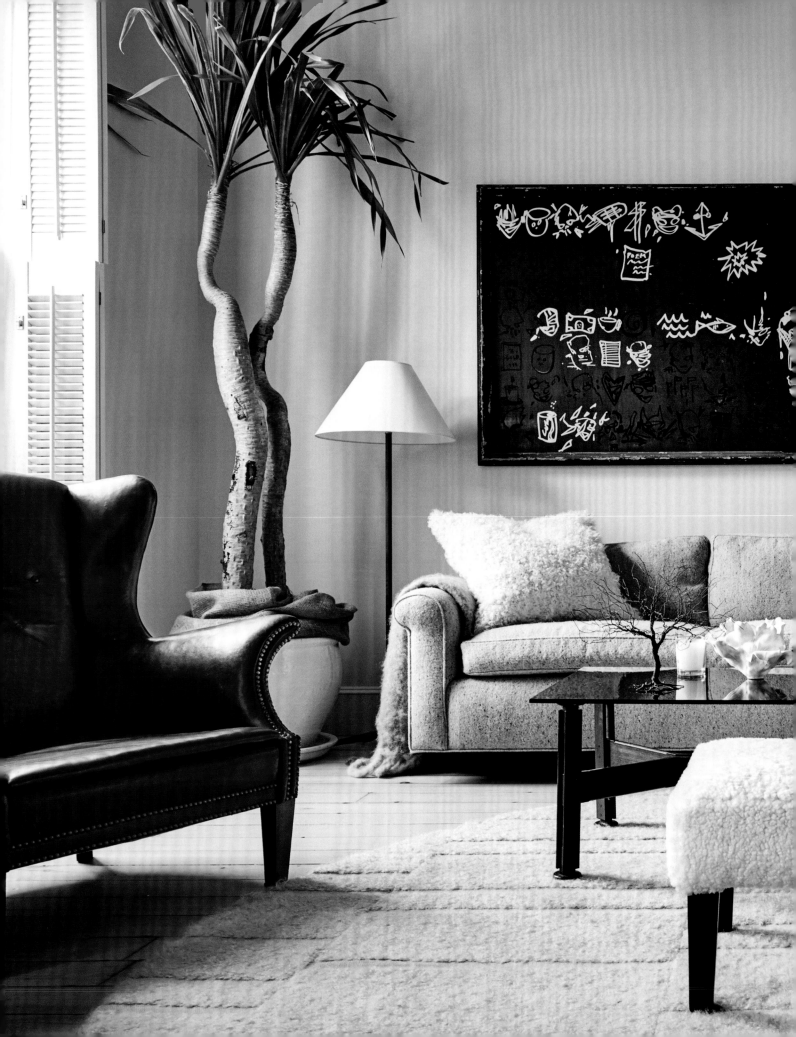

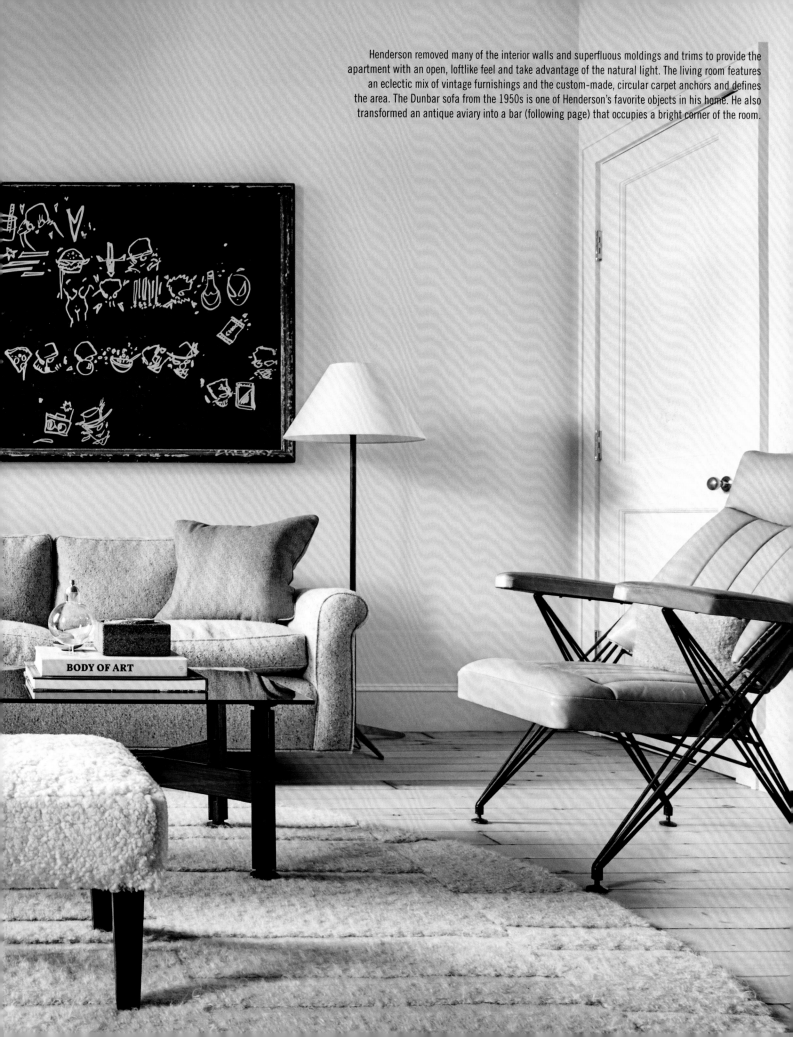

Henderson removed many of the interior walls and superfluous moldings and trims to provide the apartment with an open, loftlike feel and take advantage of the natural light. The living room features an eclectic mix of vintage furnishings and the custom-made, circular carpet anchors and defines the area. The Dunbar sofa from the 1950s is one of Henderson's favorite objects in his home. He also transformed an antique aviary into a bar (following page) that occupies a bright corner of the room.

BODY OF ART

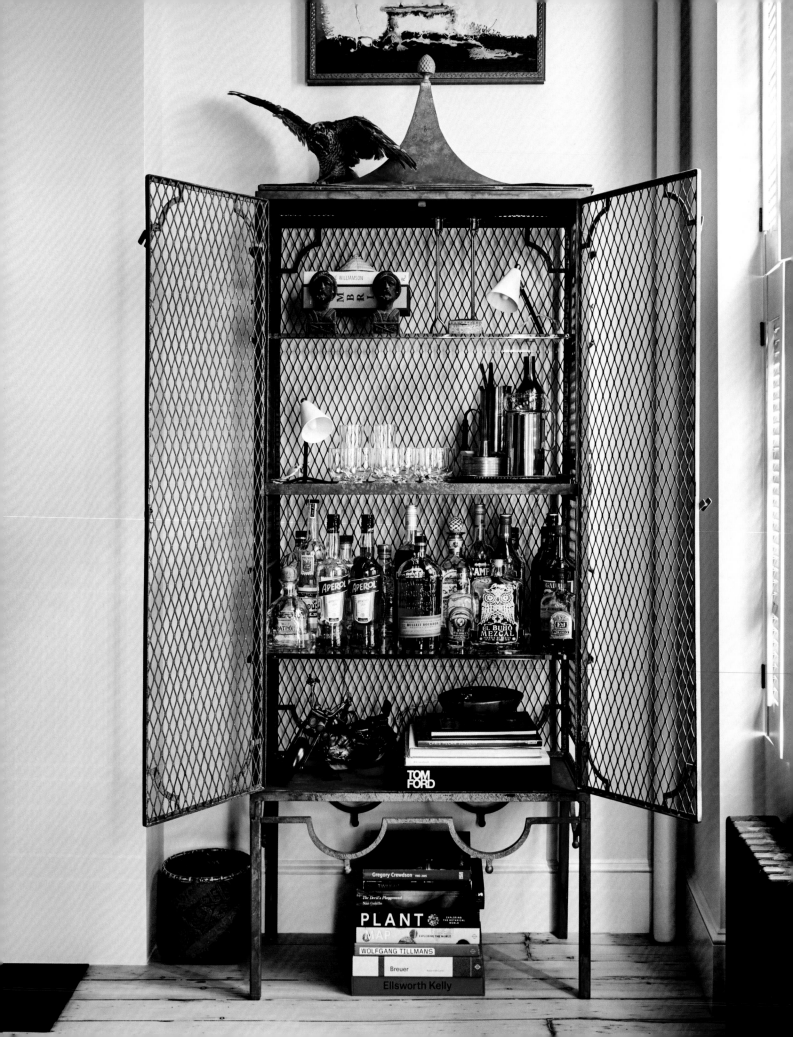

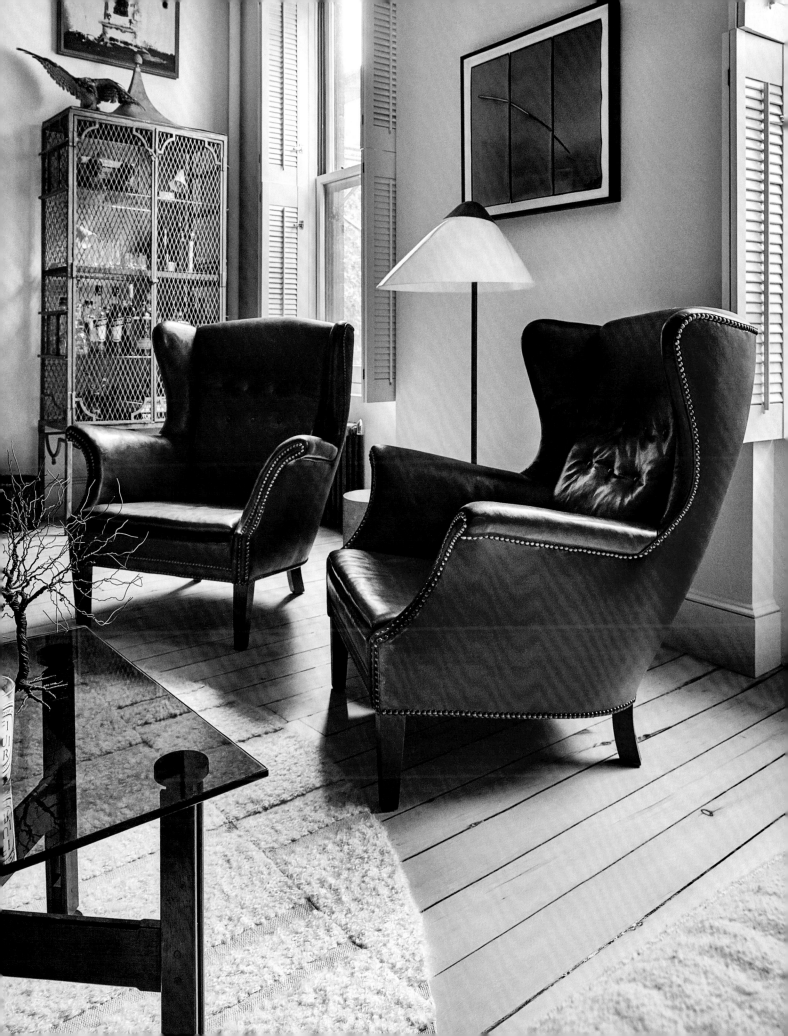

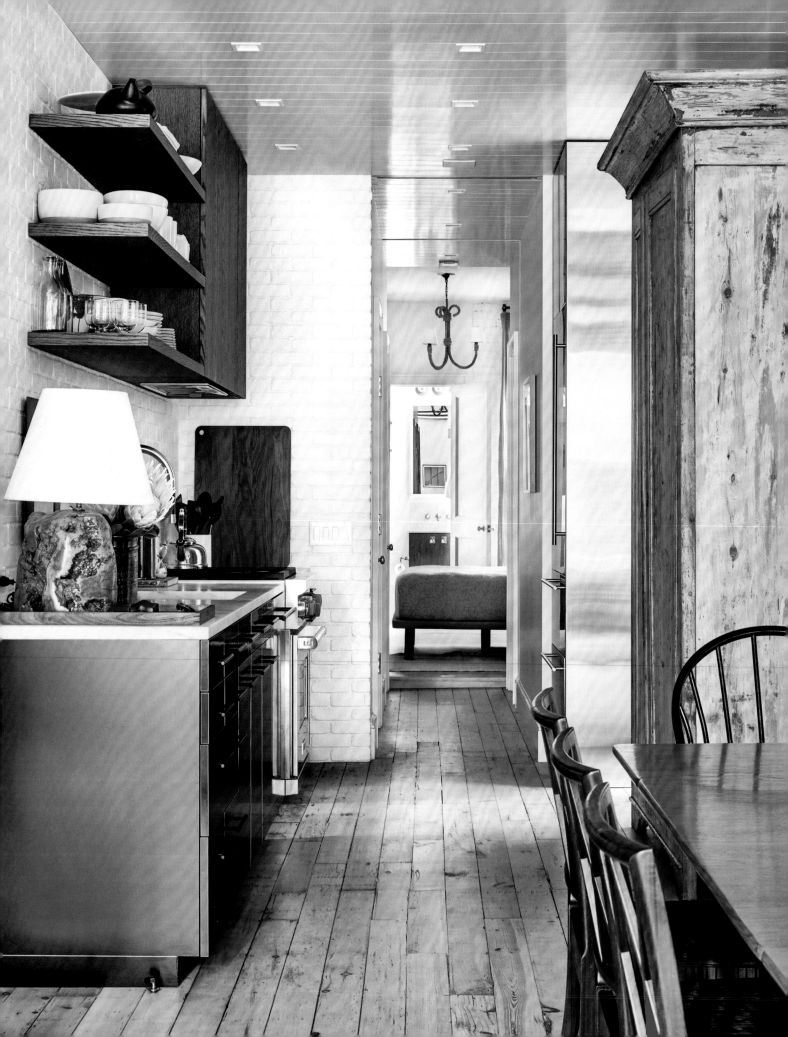

The open kitchen occupies one wall. By eliminating the backsplash, incorporating a table lamp and rustic armoire, and keeping some of the storage open, Henderson infused this area with a design vocabulary that is not exclusive to kitchens, allowing it to seamlessly blend with the rest of the lofty space.

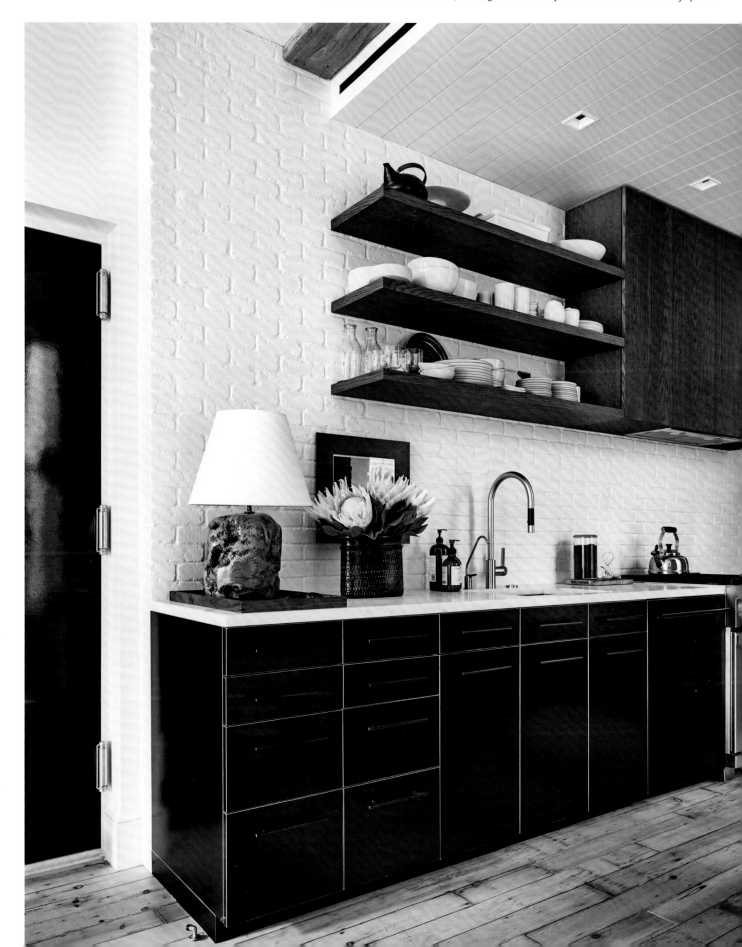

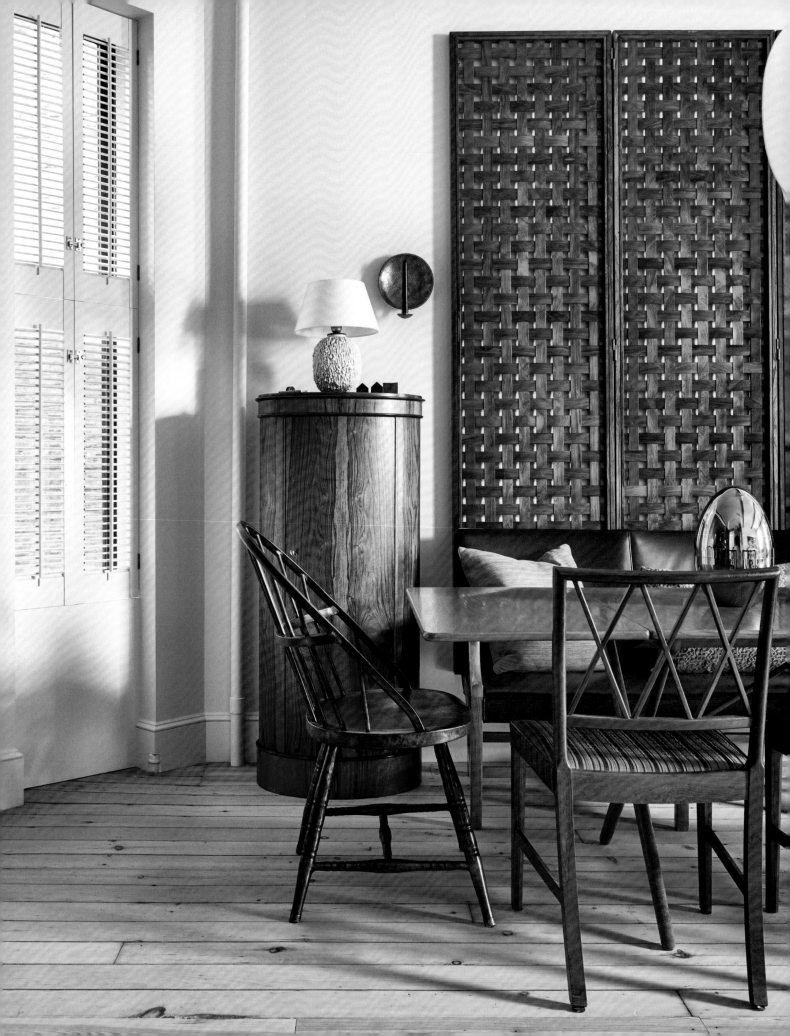

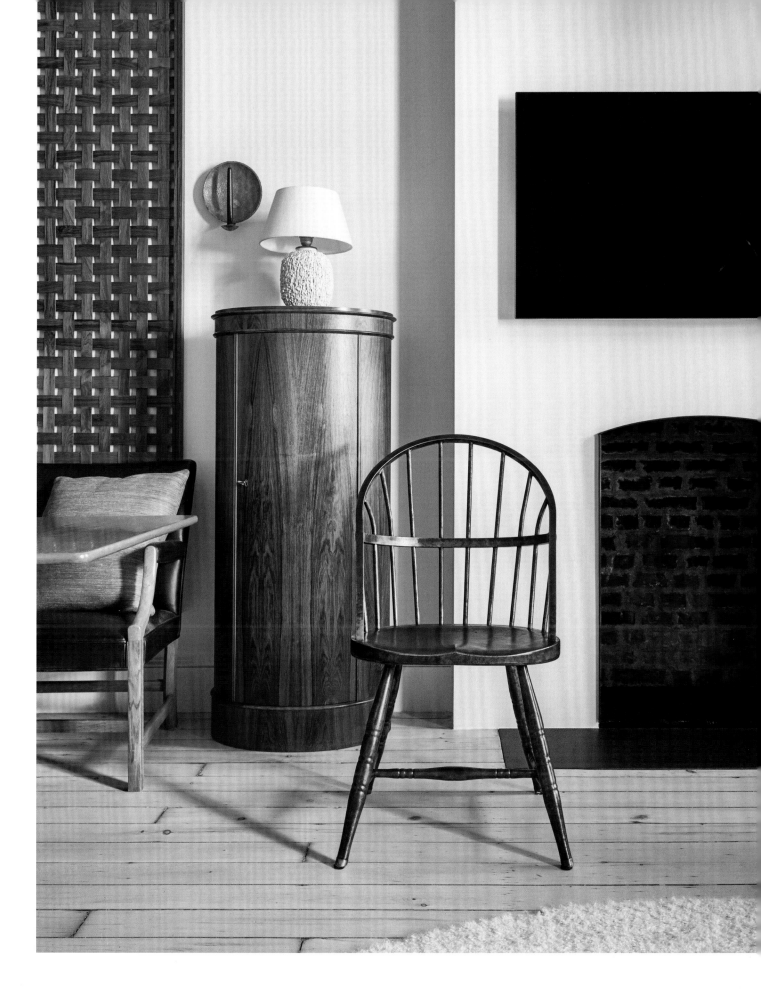

The bedroom hosts a mix of vintage finds and objects of Henderson's design. The bed, which Henderson created specifically for the space, is upholstered in wool felt, and the sconces on either side were designed by the prolific mid-century architect Kaare Kilnt. They hang above a pair of Meta nightstands by New Tendency. The series of artworks over the bed are by Sam Still. An American Studio chair commands attention in front of a tallboy cabinet designed by Ole Wanscher.

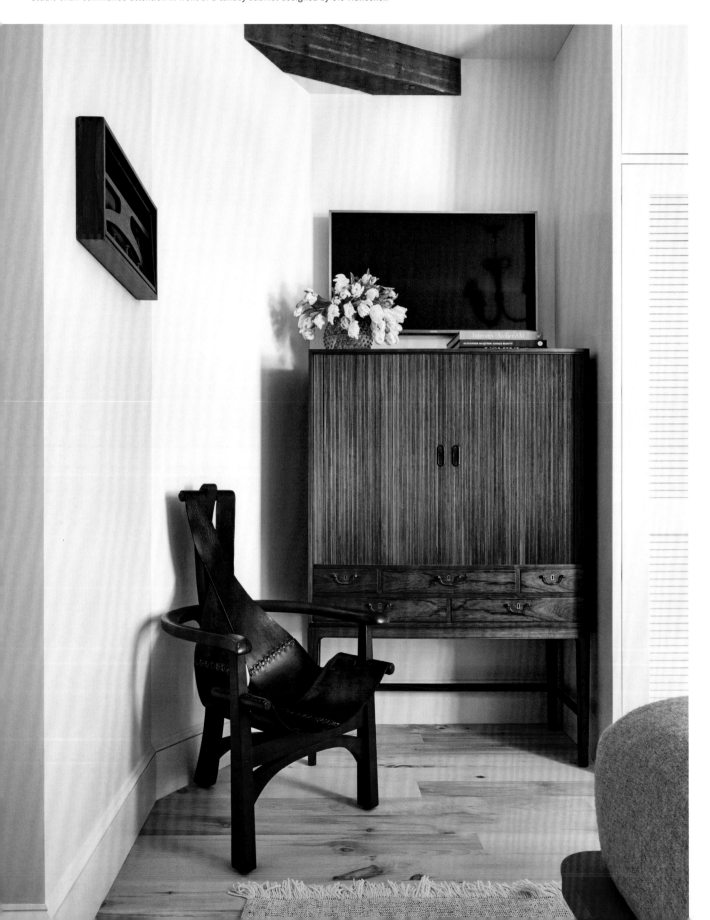

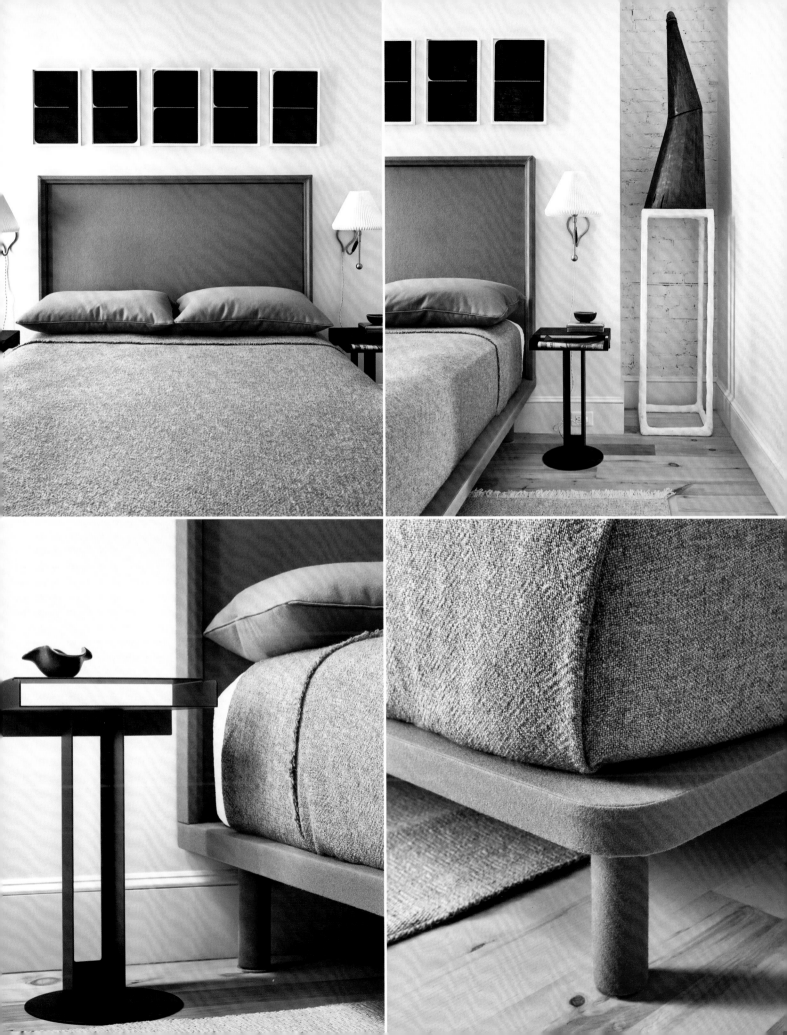

TONY INGRAO
& RANDY KEMPER

Perhaps a white-brick building from 1978 with relatively low ceilings and simple, no-frills finishes was not at the top of Tony Ingrao and Randy Kemper's wish list when they were searching for a home. But when they found this apartment, the location and sweeping views of Central Park along with the large, dramatic living room, sealed the deal.

The living room hosts a series of windows across its western façade. During the day, the foliage of the park seems within reach; in the evening, however, the windows reflect a sea of black as the park goes dark. The view and its changing relationship to the interior space inspired the pair to cover the living room walls in a custom black-wood veneer, installed like parquet flooring with squares of alternating grain patterns. The effect is like that of a black velvet wall covering, which mimics the black reflection in the windows at night. The floors were also stained a rich ebony to continue with the notion of all-over black backgrounds.

During the day, the dark floors and light-absorbing walls appear to frame the light and view. To further enhance the spectacular sights, triangular closets jut out into the space from between the windows and the opposite wall. These triangular forms delineate areas within the large rectangular space, but also host mirrors that reflect different angles of the view back into the room. For the dining room, Ingrao and Kemper created an oval-shaped space; the windowless room was then lined with small, darkly colored glass tiles that take their lead from the living room walls. The scale and material have shifted, though—instead of absorbing light, the room is all about reflection and glow. In order to mitigate the low ceilings, Ingrao and Kemper raised all the doors to just below the ceiling height and refined the moldings. They then sprayed the ceilings with an opalescent silver finish to add a glow that makes them disappear. The low ceilings were not conducive to overhead lighting, so the couple incorporated picture lighting and sconces, which were positioned to reflect off the ceiling.

Ingrao and Kemper felt that by modifying the wall finishes to get as far from Sheetrock as possible, they would give the apartment a more modern yet timeless elegance, creating a backdrop for their eclectic collection of modern and antique art and furnishings. Ingrao and Kemper are clearly attracted to dramatic, attention-grabbing objects and furnishings from a vast array of periods and styles. And the aggressive, muscular quality that many of their possessions have is seamlessly integrated with the dramatic quality of the apartment. The strategy clearly worked.

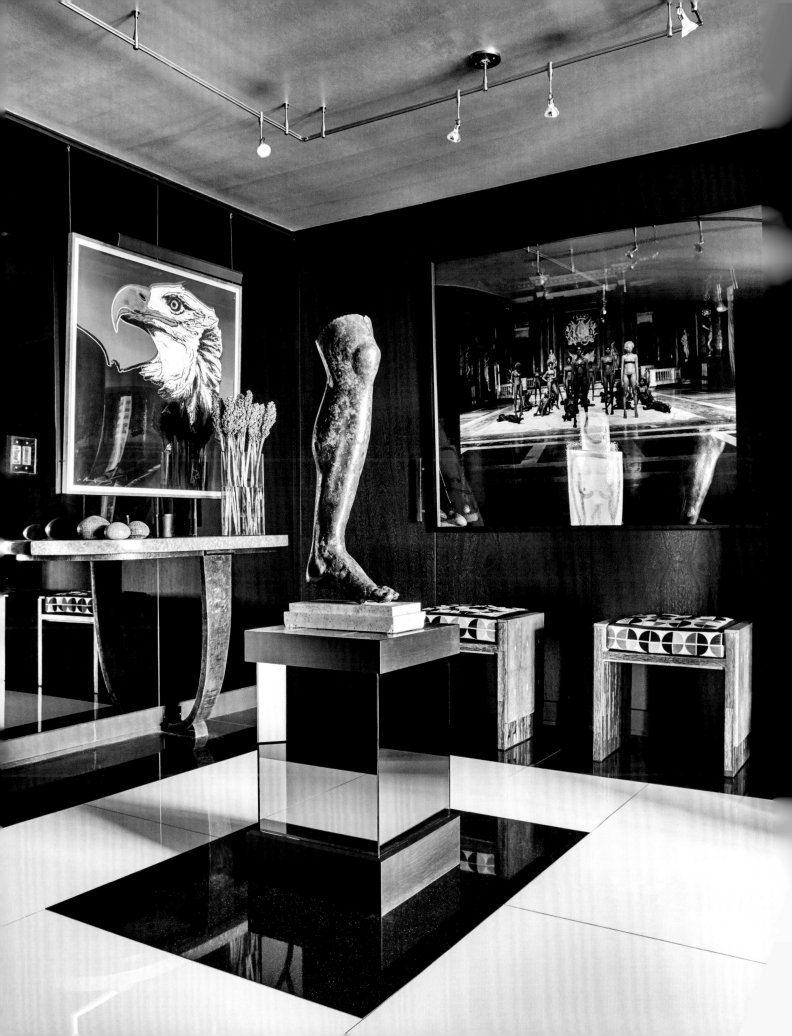

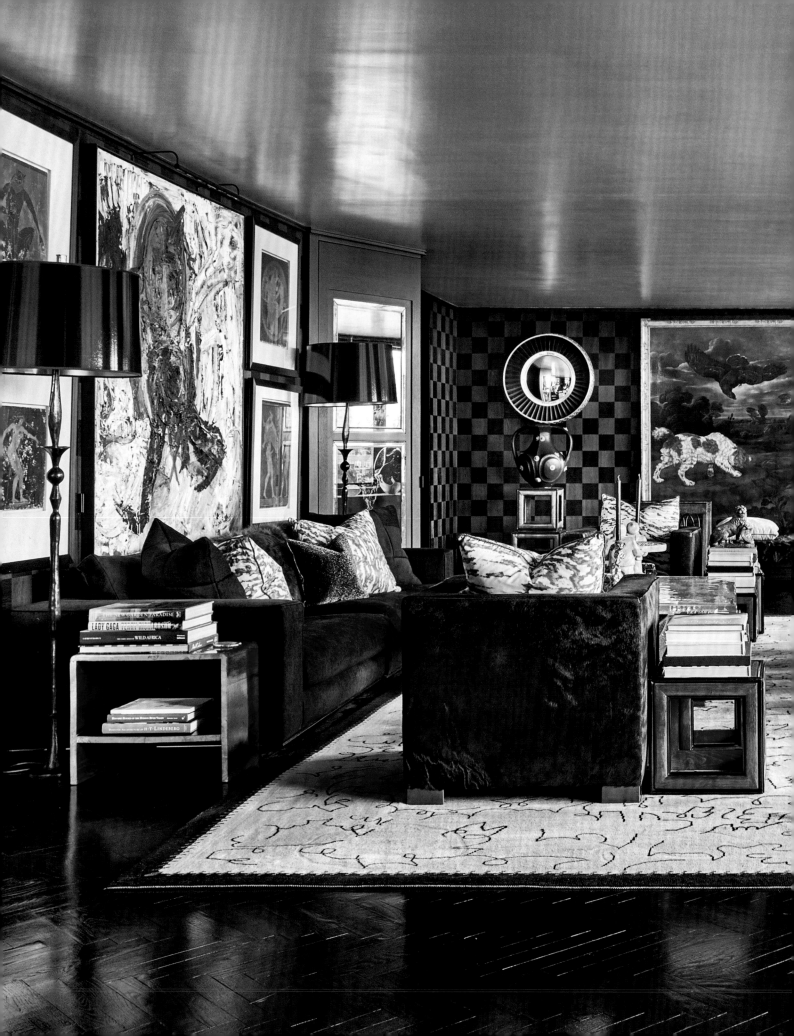

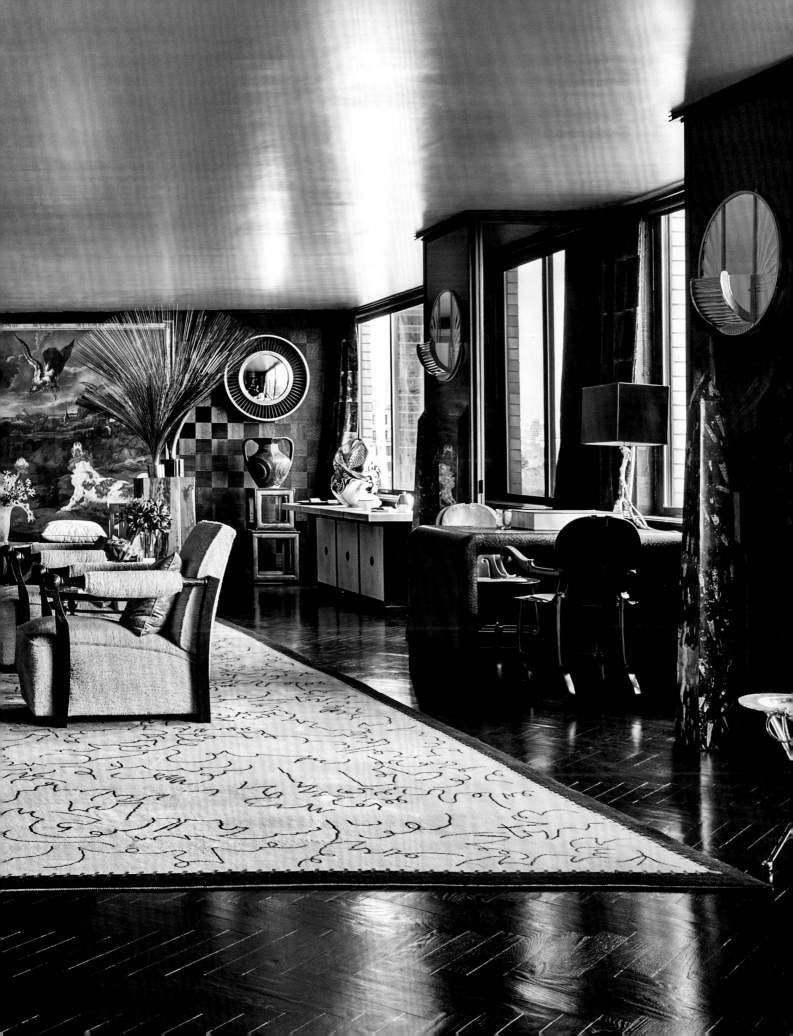

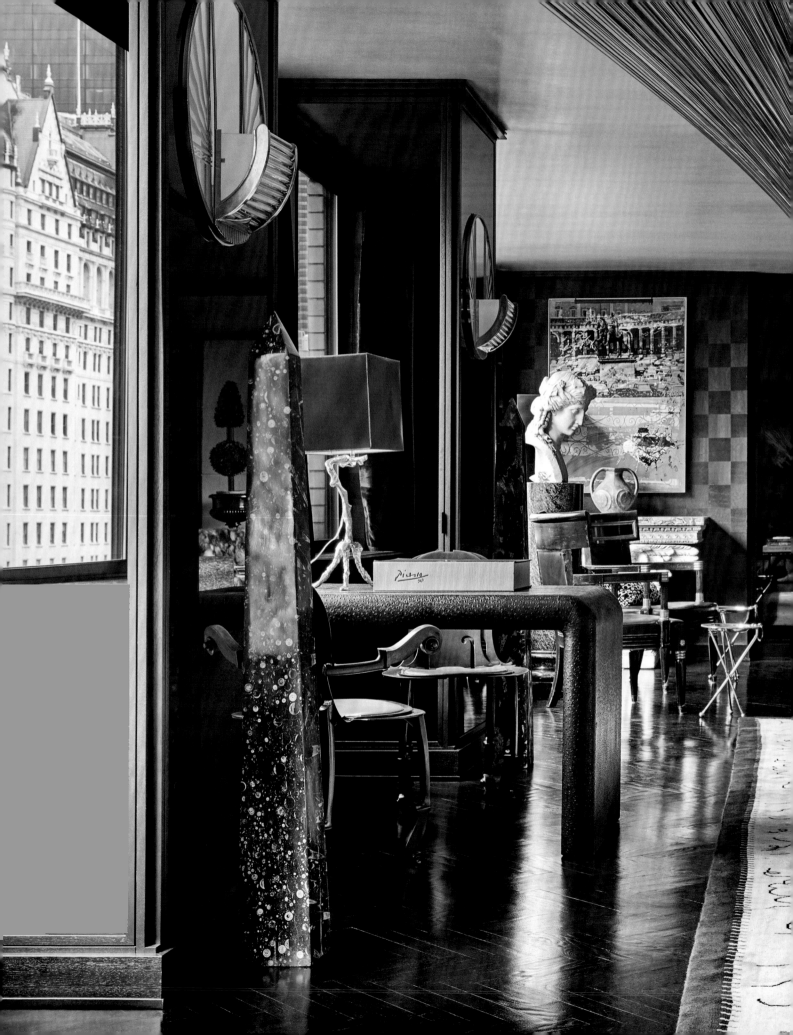

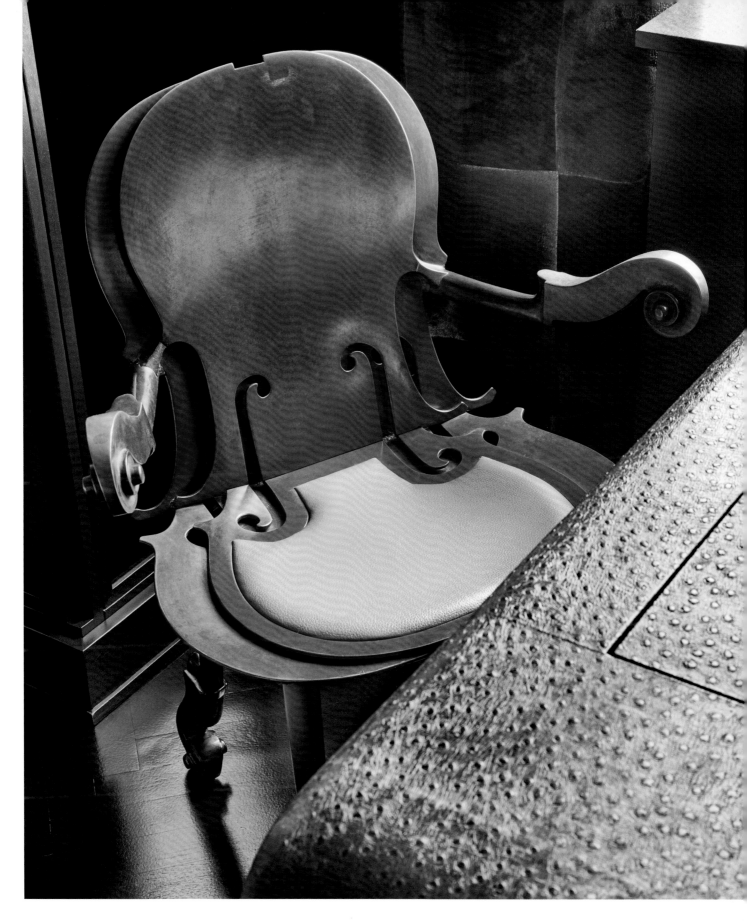

The large, dramatic living room has many windows that overlook Central Park. At night, the windows appear black with the skyline in the distance, so Ingrao and Kemper decided to cover all the walls in a custom black-wood veneer, which makes them recede in the evenings. The effect enhances the view and provides a dramatic background for their art and objects. A giant painting by Paul de Vos, a Flemish Baroque artist, of dogs chasing fowl (previous spread) dominates the space. The room also has a whimsical pair of Arman Cello chairs that flank a Pierre Cardin desk in ostrich skin.

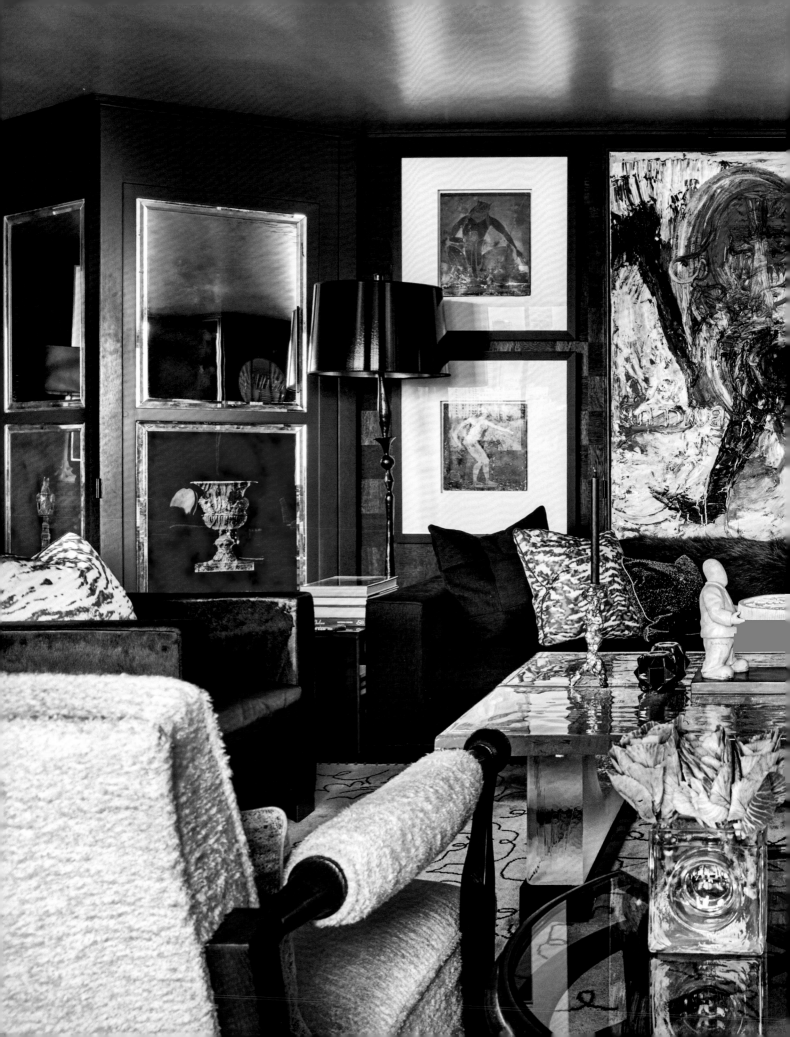

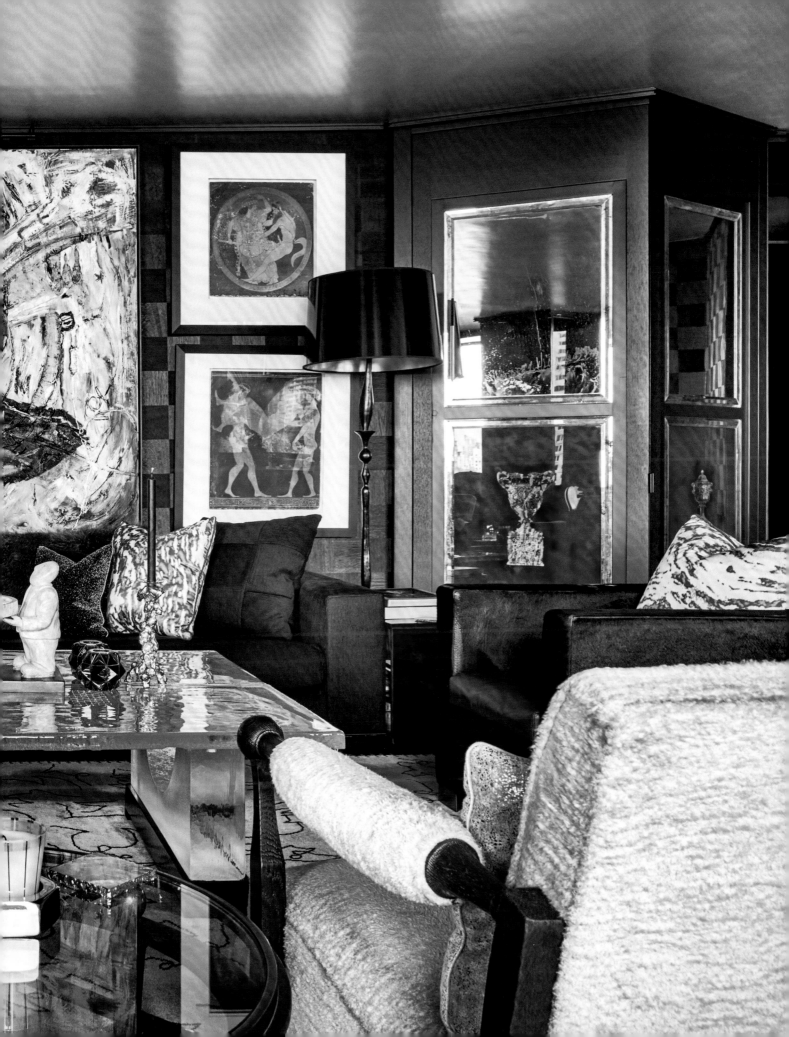

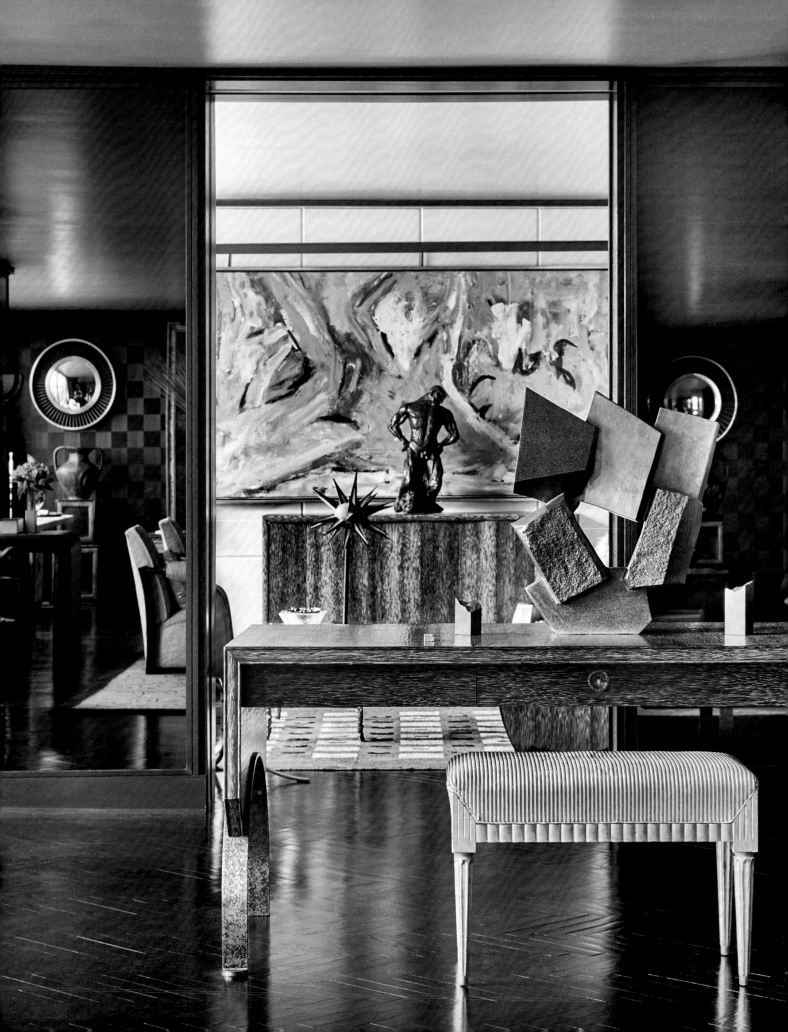

Previous spread and this spread: A pair of triangular cabinets flank the seating area. In addition to providing storage, the cabinets host artwork in the lower panels and mirrors in the upper panels. The mirror reflects the view back into the apartment at unexpected angles. The ceilings are low throughout the home. To counter this, Ingrao and Kemper raised all the door heights to just below the ceiling and refined the moldings. They then sprayed the ceilings with an opalescent silver finish to add a glow that makes the ceiling disappear. The small, intimate space off the living room provides a spot to watch television. Storage is hidden behind custom-designed cabinets that line the interior of the space.

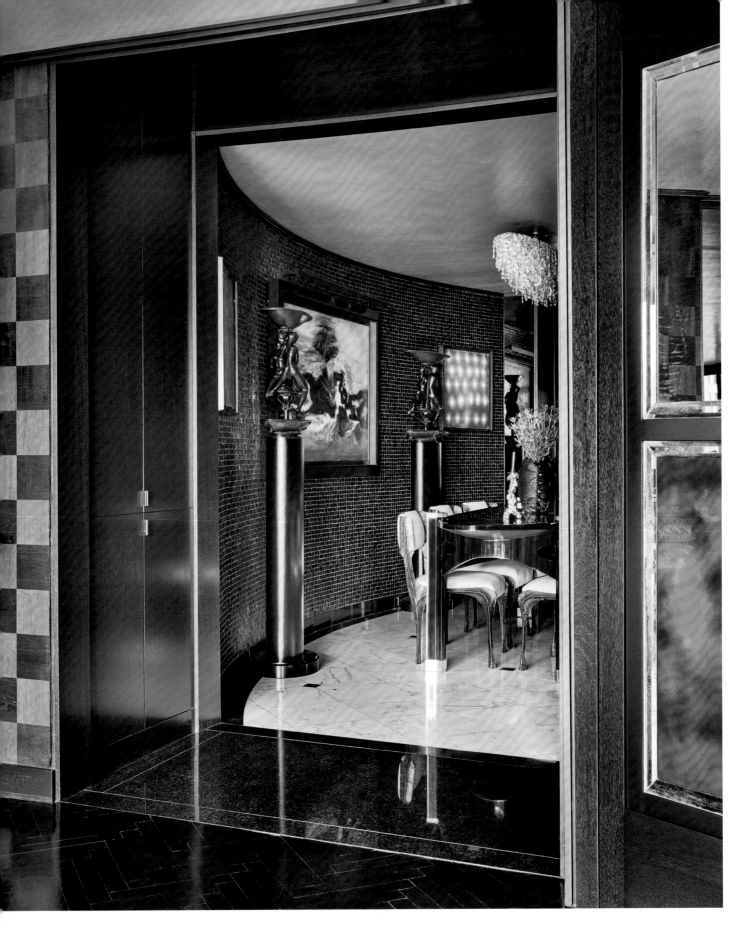

The elliptical dining room has no windows. Because of this, Ingrao and Kemper lined the walls with glass mosaic tiles that seem to glisten as they reflect light both during the day and in the evening. The shape of the room guarantees there is always some surface catching the light.

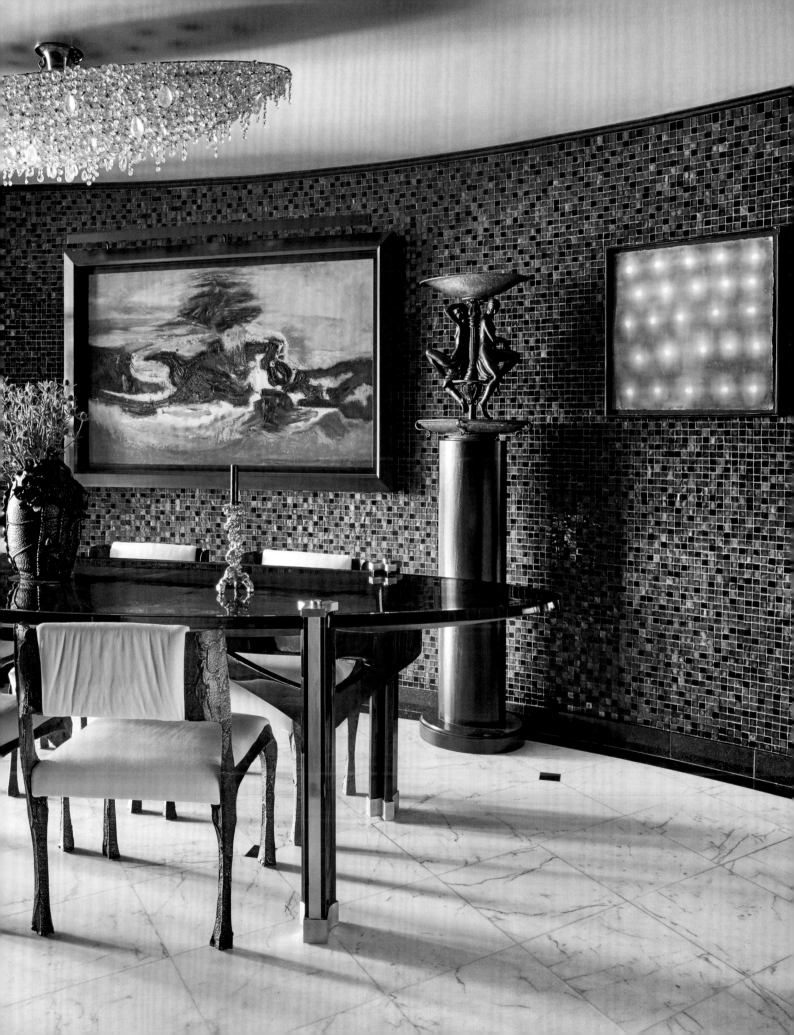

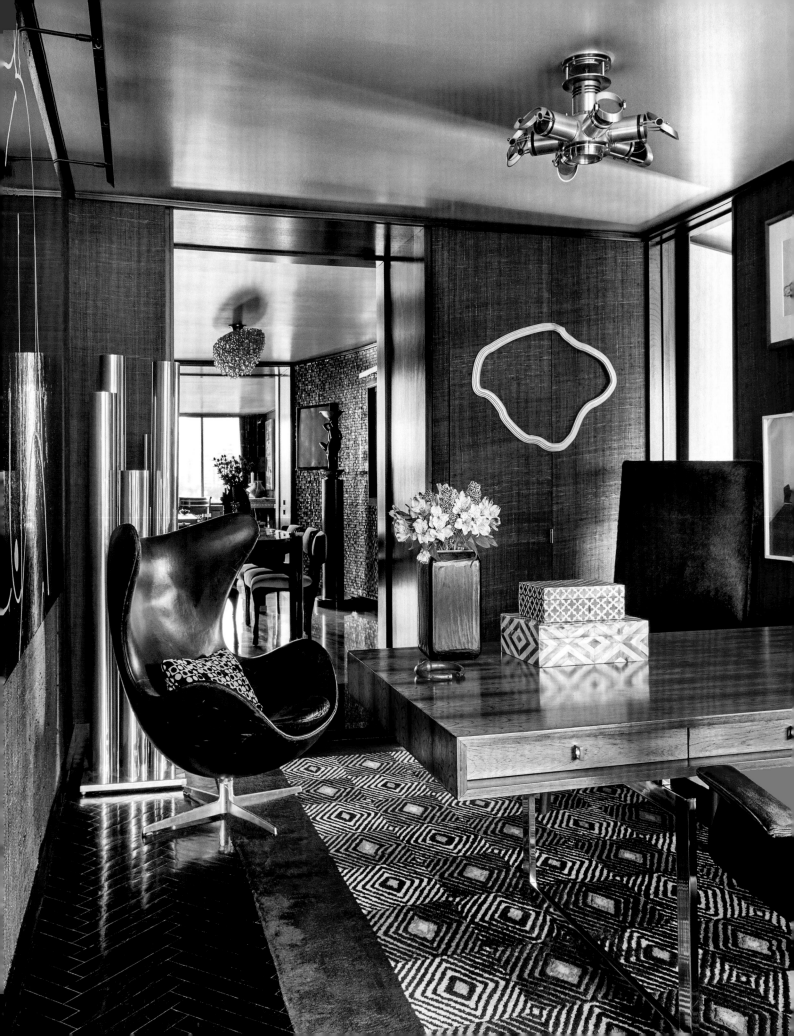

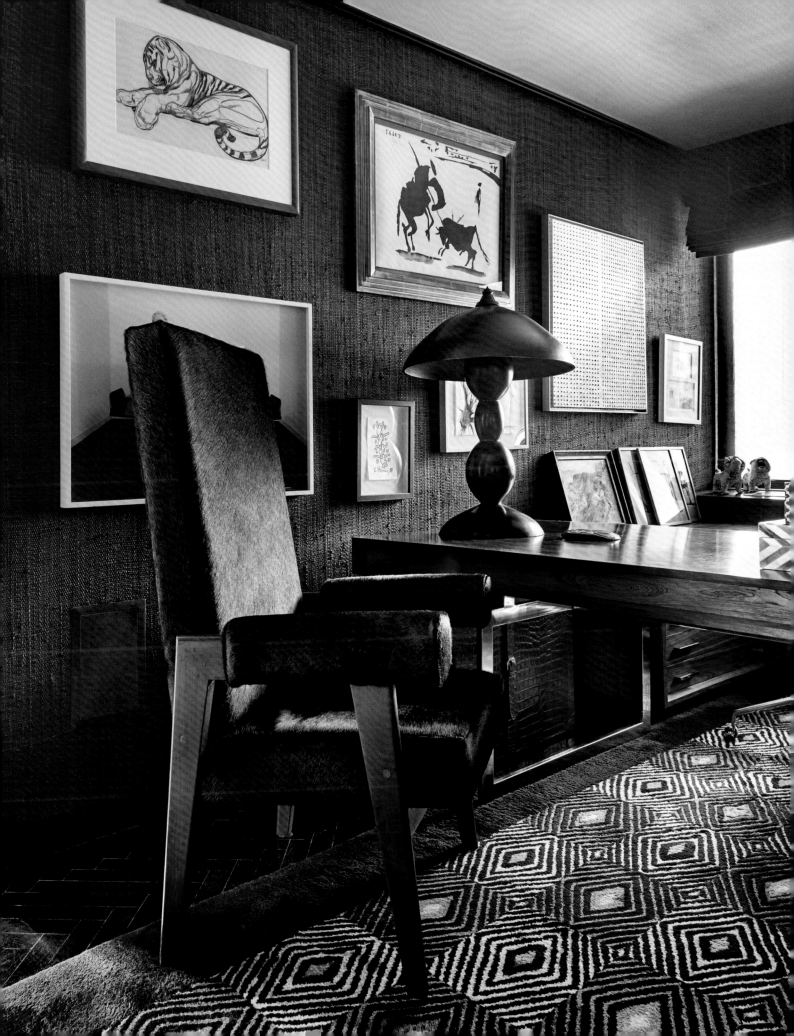

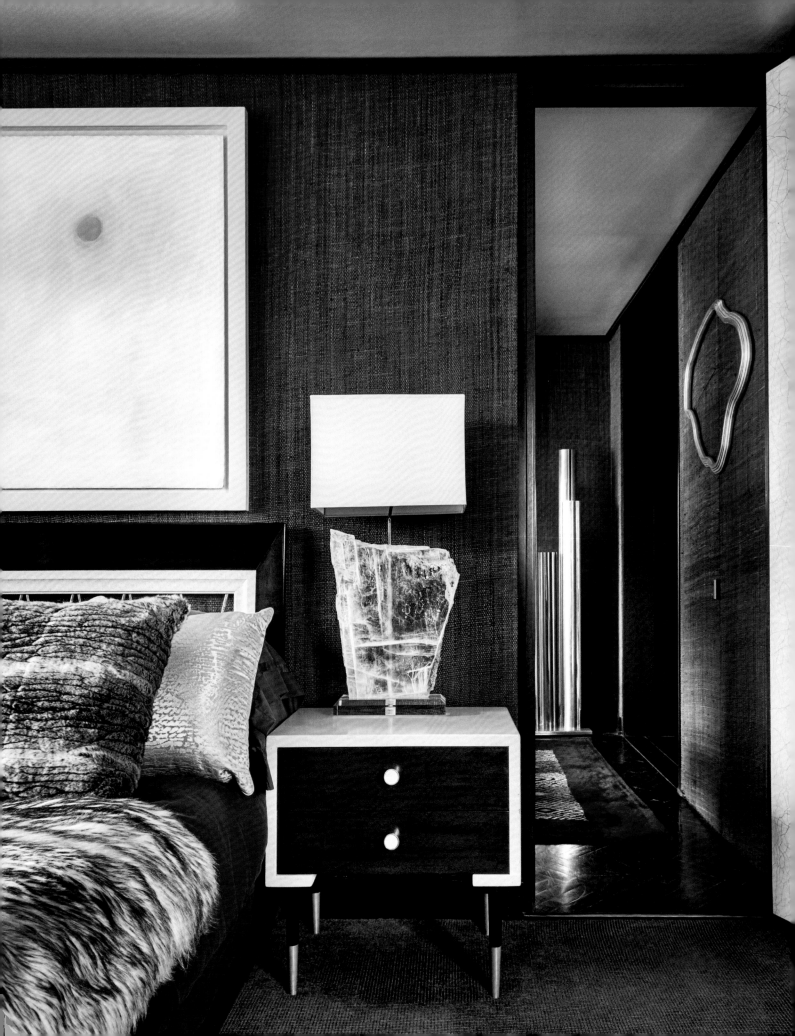

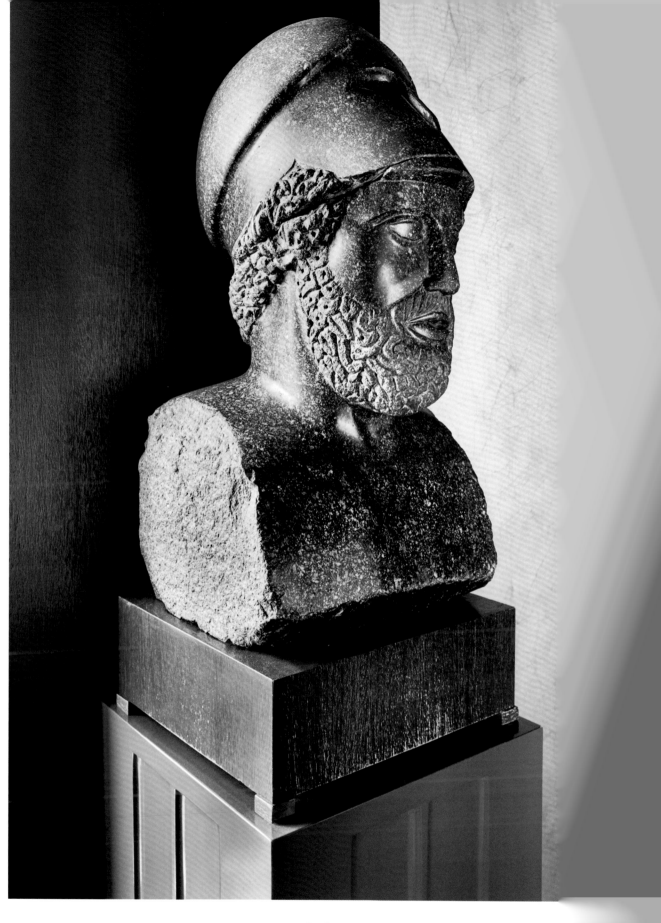

Previous spread and this spread: A study at the back of the a
home's one and only bedroom, can be closed off from the rest o
a private master suite. The space hosts a number of furnishings
Roman porphyry bust, circa 1st Century AD, a chair—known as th
by Pierre Jeanneret in the 1950s, and a French rug, circa

REINALDO LEANDRO
& PATRICK MCGRATH

When two designers share a home, the comingling of aesthetics can make for difficult terrain. The situation can become even more complex if one of the pair has already been living in the space. Reinaldo Leandro moved into this compact apartment located between the West Village and SoHo in a nondescript building from 1959, just as he was finishing his graduate studies in architecture. At that time, he tapped into his architectural skills and added a five-foot sliding panel that would integrate the bedroom space. He also designed and installed the kitchen, a walk-through closet, and the built-in desk and shelves. Leandro then painted everything white.

Leandro and McGrath met and initially shared another home, until co-op restrictions required the couple to take up residence in the apartment Leandro had occupied as a student. When Leandro did the original renovation, like all good architects, his objective was to increase functionality and take full advantage of the eastern and southern exposures. The notion of tapping into the building's mid-century origins as a point of decorative inspiration was simply not on his radar. However, when the couple started thinking of making the apartment their own, McGrath was inspired by all the built-ins Leandro had created, and he had a vision for the space that was grounded in a nostalgia for the 1970s.

The couple agreed that they wanted to maintain as open and reflective a space as possible. They also wanted the apartment to function like a welcoming hotel suite where they could lounge anywhere. With this in mind, they designed the low-slung platform bed. McGrath then proposed installing off-white wall-to-wall carpet. They moved forward with the idea, and the carpet not only gave the space the feeling of a luxurious hotel suite but also drove McGrath's vision of a seventies bachelor pad. The off-white color was also easier to maintain, and employing the same floor material throughout, with no thresholds, gave the illusion of expansion.

To further accentuate the period, an abundant 1960s sectional sofa became the focal point of the living space. The couple decorated the space with varied objects: Calder lithographs, low floor and table lighting, Lucite stands, a wall tapestry they found in Paris, African sculptures they purchased in Lamu, a runner they found in Istanbul, and metal blinds. The limited square footage of the apartment meant that every decision would be experienced by both partners and that every decision would shape their life together. Their design is simultaneously focused on comfort and simplicity, and nearly all the objects that are not functional are souvenirs of their collective journey. The apartment can be seen as a successful experiment in intimacy.

A massive vintage sofa from the 1960s, in a hue nearly identical to the carpet, provides seating for six and adds an unexpected level of luxury to the small space. The couple repurposed their Saarinen tabletop and turned it into a large coffee table, again of a scale one would associate with a larger, more luxurious space. Lucite stands, the wall tapestry, and metal blinds all add to the 1960s and 1970s vibe the couple hoped to accentuate.

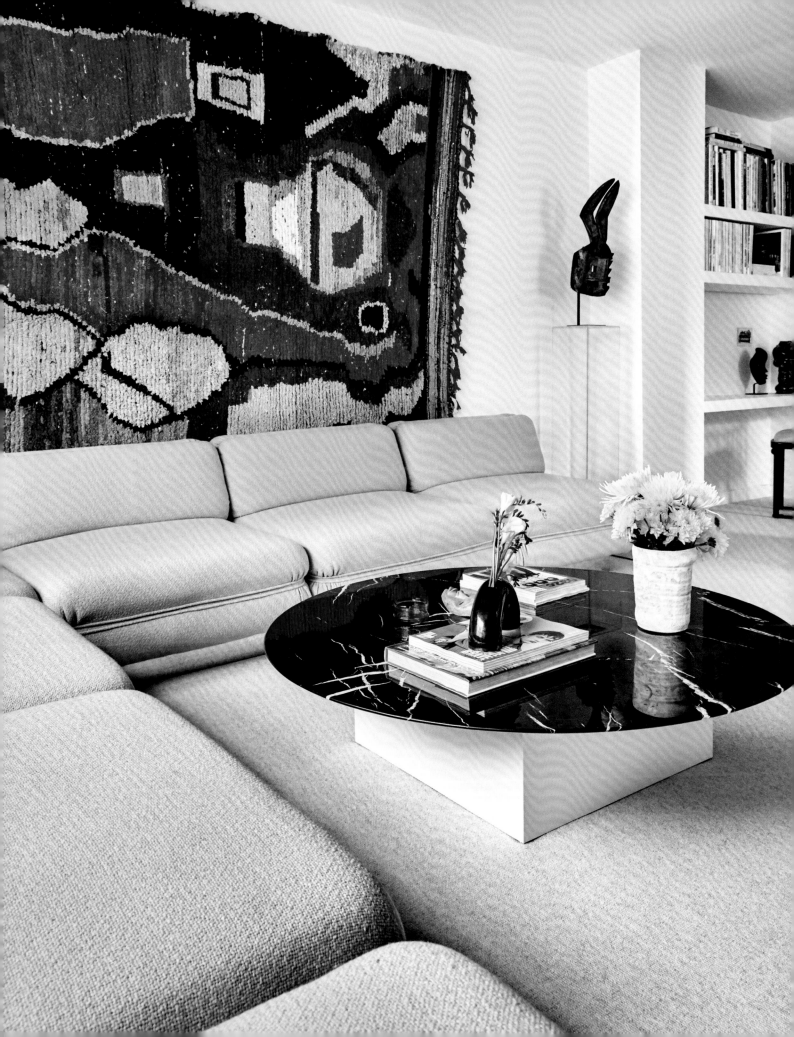

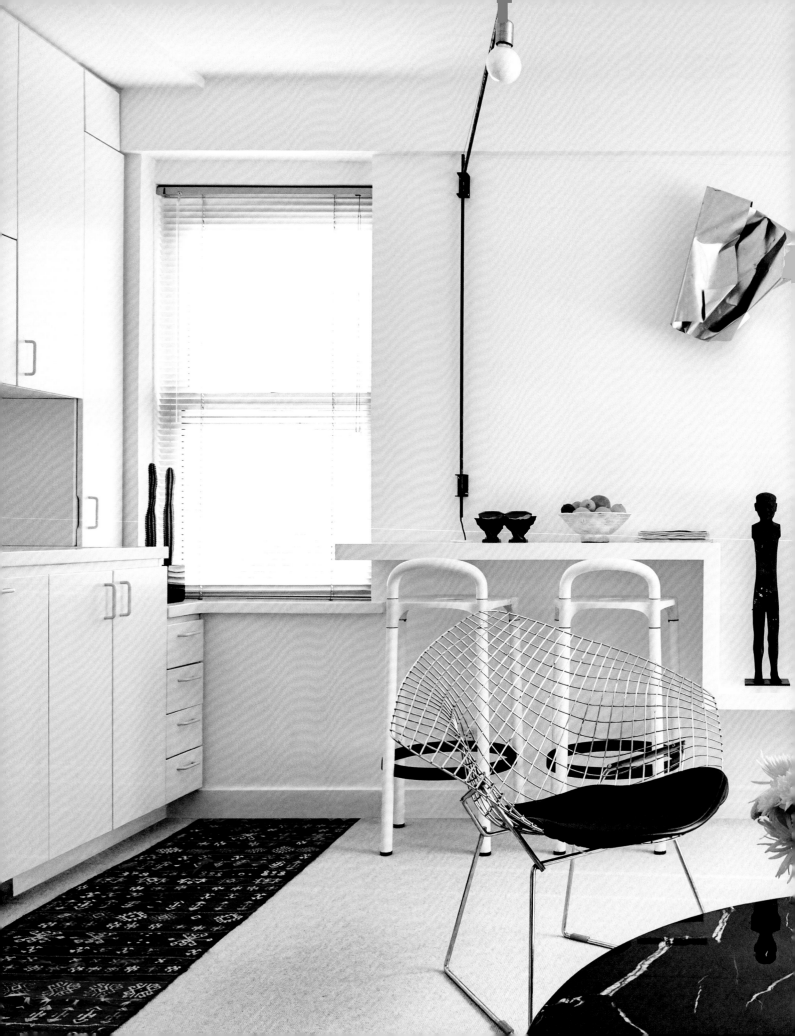

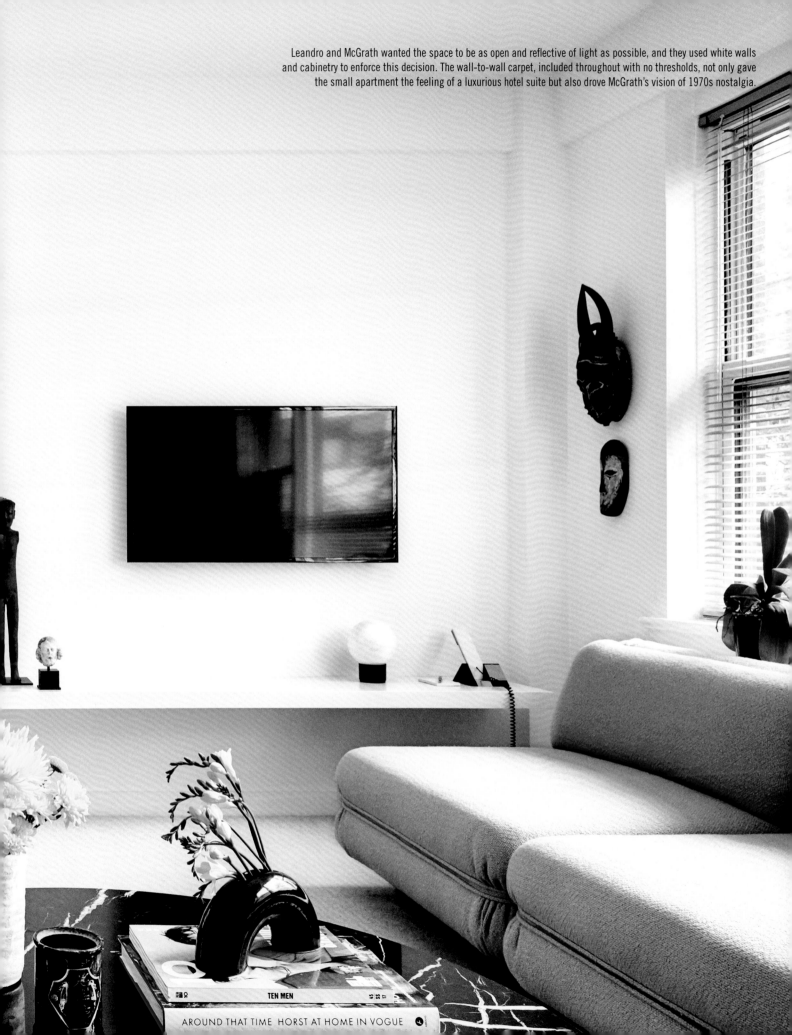

Leandro and McGrath wanted the space to be as open and reflective of light as possible, and they used white walls and cabinetry to enforce this decision. The wall-to-wall carpet, included throughout with no thresholds, not only gave the small apartment the feeling of a luxurious hotel suite but also drove McGrath's vision of 1970s nostalgia.

TEN MEN

AROUND THAT TIME HORST AT HOME IN VOGUE

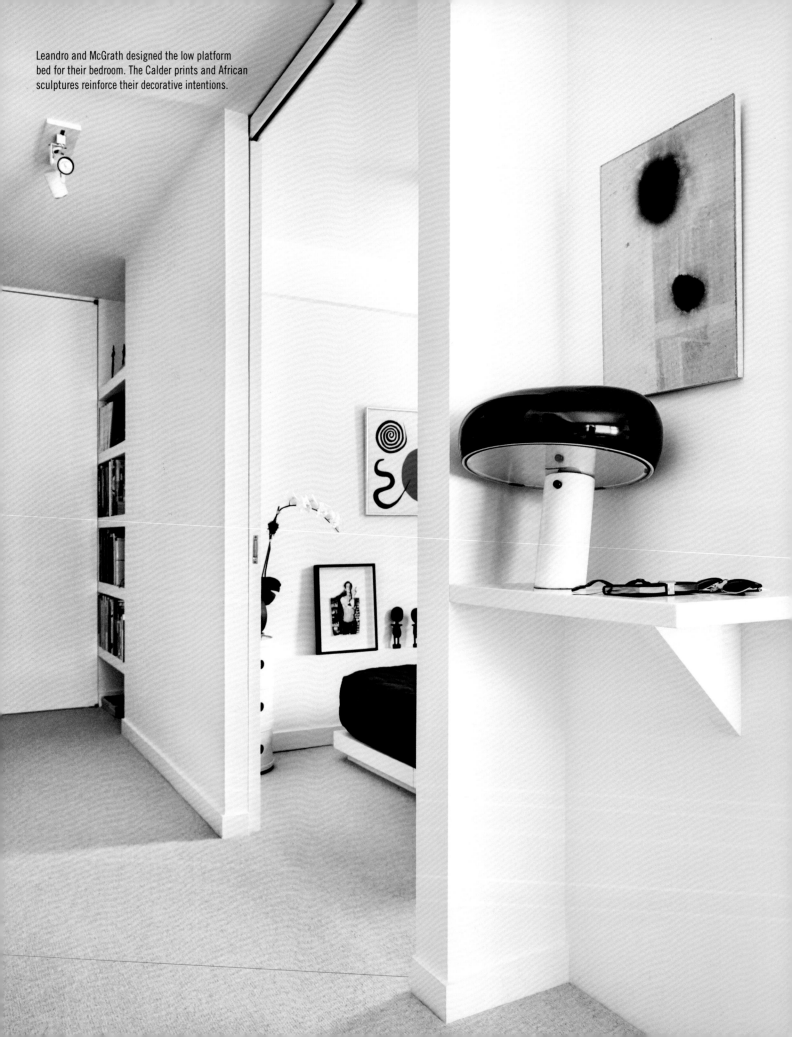

Leandro and McGrath designed the low platform bed for their bedroom. The Calder prints and African sculptures reinforce their decorative intentions.

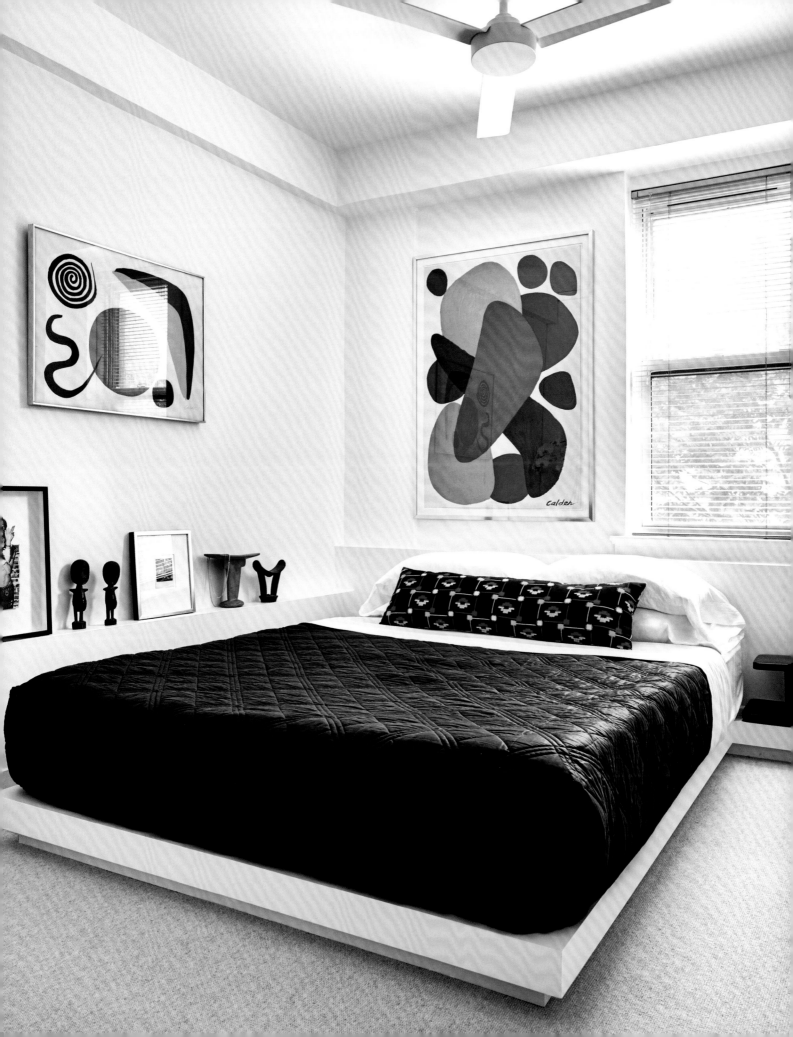

MASSIMILIANO LOCATELLI

For nearly fifty years, lower Manhattan's lofts have been inhabited; first by a wave of artists seeking large, open, light-filled spaces to live and work in, and, later, by a vast cross section of New Yorkers in search of ample space. Some of these buildings were originally used for light manufacturing and others, like the grand historic structure from 1907 that hosts Massimiliano Locatelli's loft, were originally designed to house offices. The distinction is an important one and provides a key to appreciating Locatelli's home.

While most loft buildings offer long, narrow spaces devoid of architectural detail, with windows only at the two narrow ends, Locatelli was fortunate enough to find a loft with three distinct exposures and three massive street-facing windows. The space also maintains many of its original details, like its simple yet elegant cove moldings, columns, and plaster ceilings and walls, as well as the ghost of a beautifully tiled corridor that currently dissects the open space but was once the pathway into the various workspaces. This was clearly a place designed for white-collar workers with a certain degree of privilege, existing in stark contrast to the sweatshops the neighborhood became known for. Locatelli has capitalized on the loft's elegant history while also celebrating what drew creative individuals to the area some fifty years earlier.

Locatelli was initially attracted to the space because he knew the rooms could be arranged to provide him with the flexibility of a loft and the comfort of a more traditional apartment. He created a large, open space along the street-facing window wall, built a private bedroom suite at the back, and encased the kitchen behind glass-and-steel partitions. The result is a home that can host up to 150 people and, at the same time, feel intimate and livable.

Locatelli lives and works in his native Milan, and his homeland inspired some of the design choices throughout his home. The green accents in the kitchen and the rust in the guest bedroom are similar to the colors of the iconic Riva motorboats. Lake Garda, the largest lake in Italy, is also the name Locatelli gave the set of tables he designed, which are produced in various materials and meander through the space. When combined, the assemblage of tables takes on the shape of the iconic lake; broken apart, they can be used individually, thus offering both a sense of Locatelli's history and providing the space with the sought-after flexibility. Loft living is not often associated with the sense of history and elegance one might find in a turn-of-the-century brownstone, but Locatelli has managed to create that balance here without scrubbing all the history and patina away.

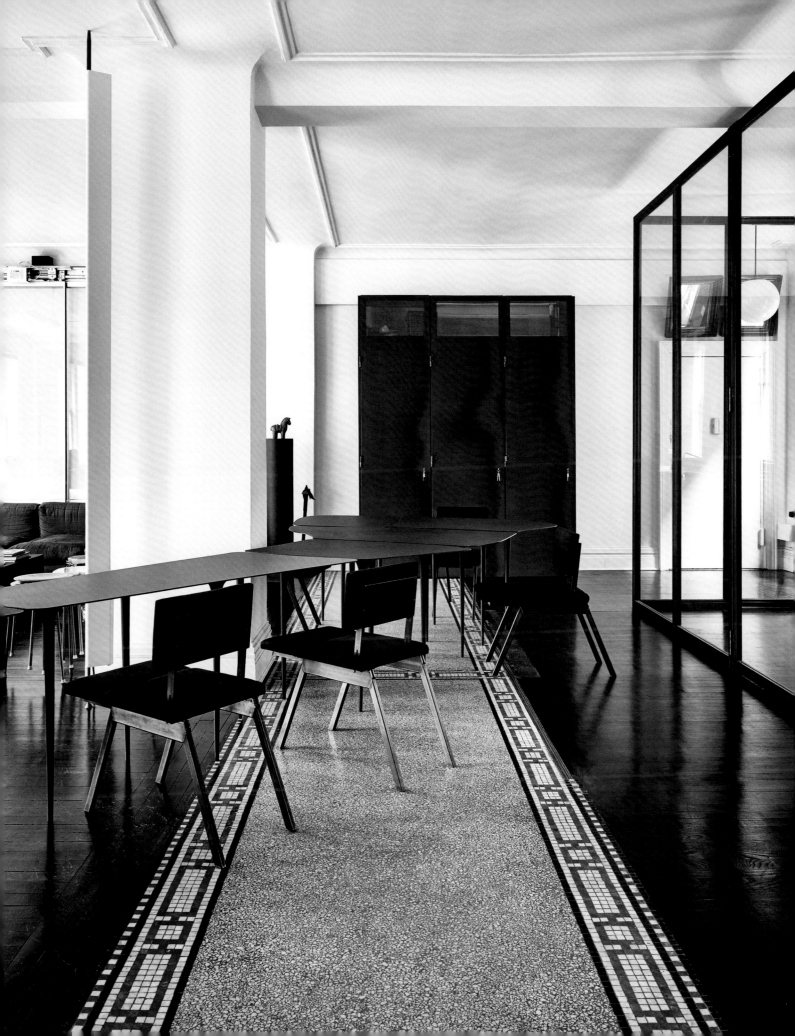

Locatelli designed the Garda table, and the ML 01 dining chairs, also his design, are scattered throughout the apartment. The table, which snakes through the space, is composed of a collection of smaller tables that when assembled take on the shape of Italy's Lake Garda. The space also includes a painting by Alexander May and armchairs created by Osvaldo Borsani in 1951.

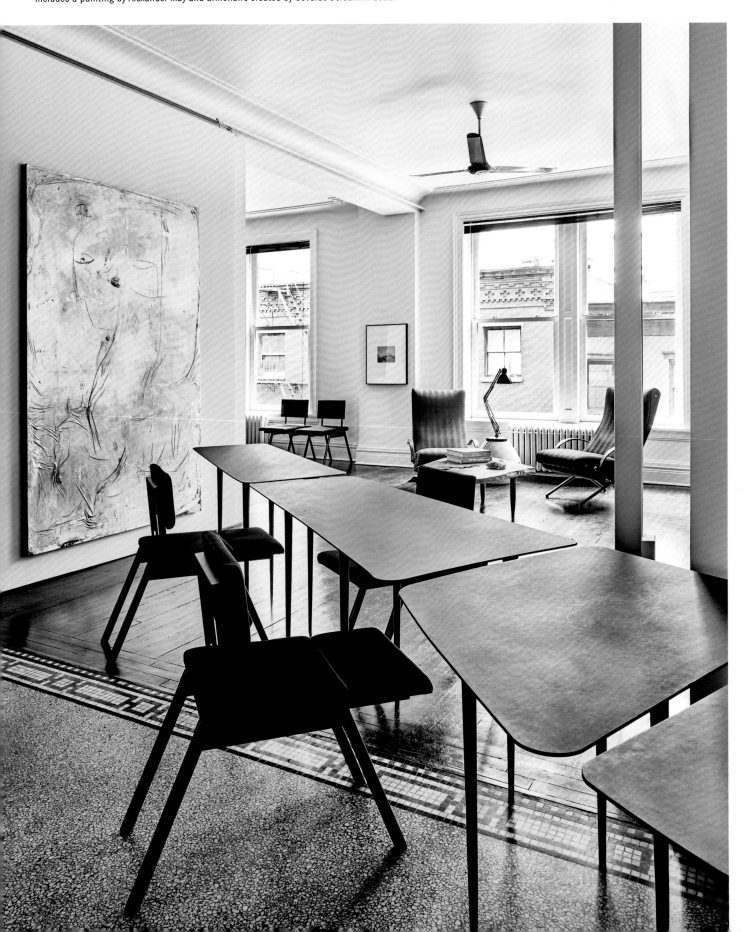

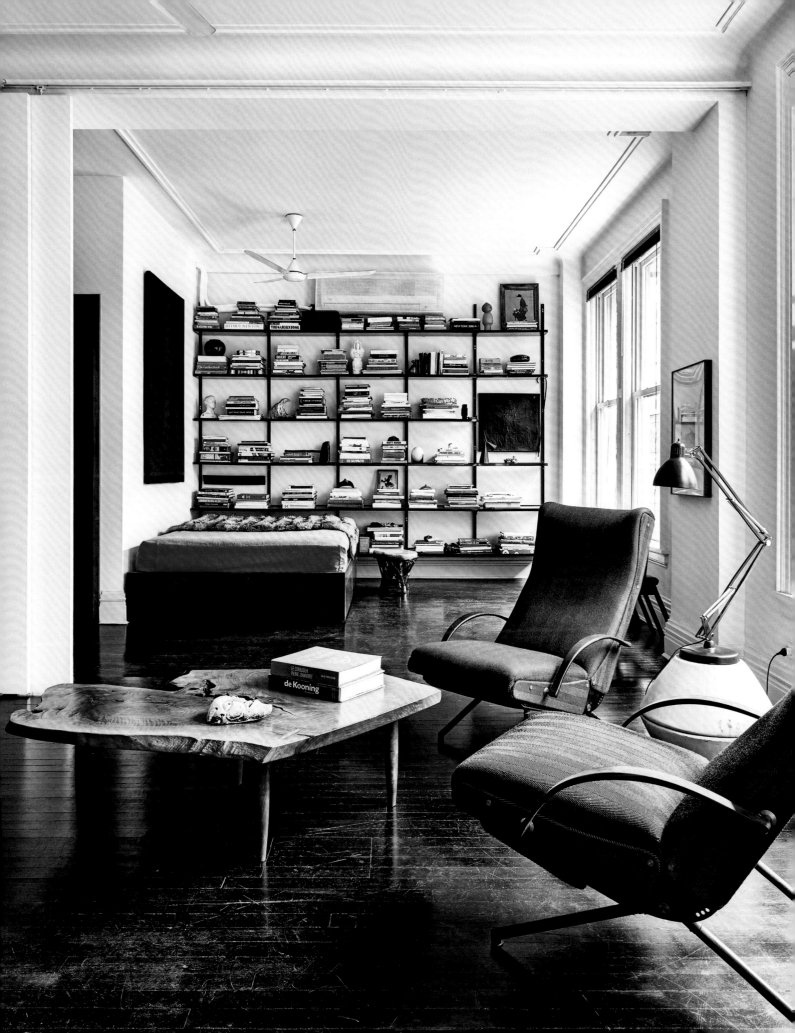

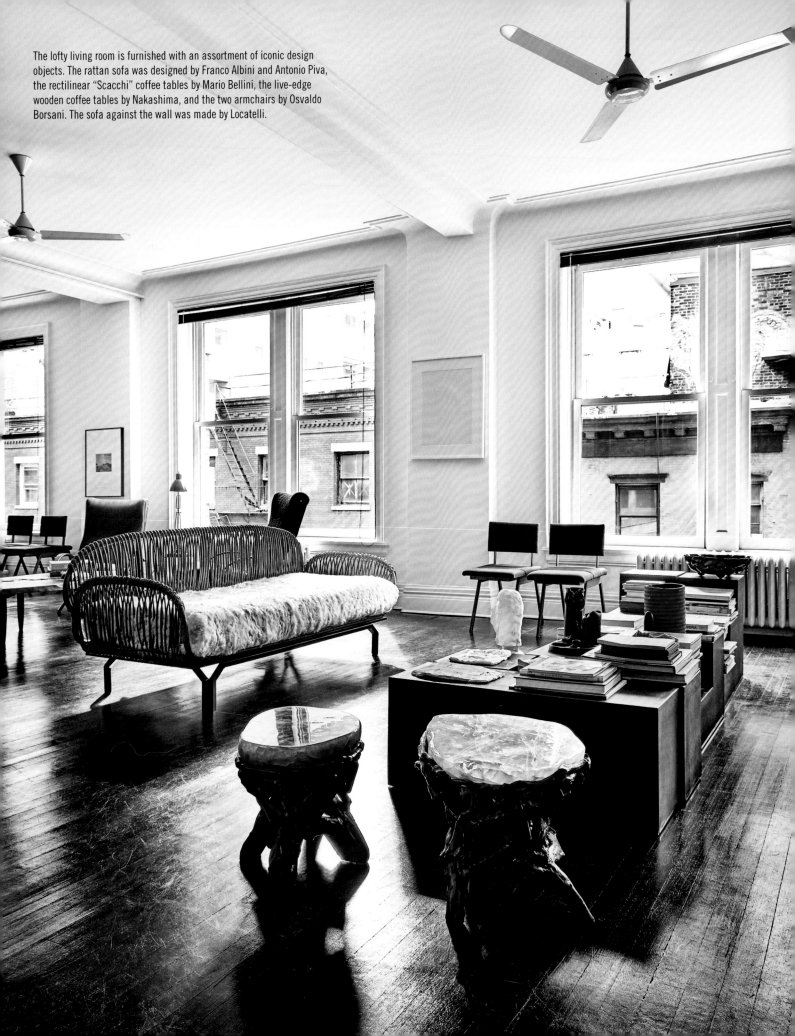

The lofty living room is furnished with an assortment of iconic design objects. The rattan sofa was designed by Franco Albini and Antonio Piva, the rectilinear "Scacchi" coffee tables by Mario Bellini, the live-edge wooden coffee tables by Nakashima, and the two armchairs by Osvaldo Borsani. The sofa against the wall was made by Locatelli.

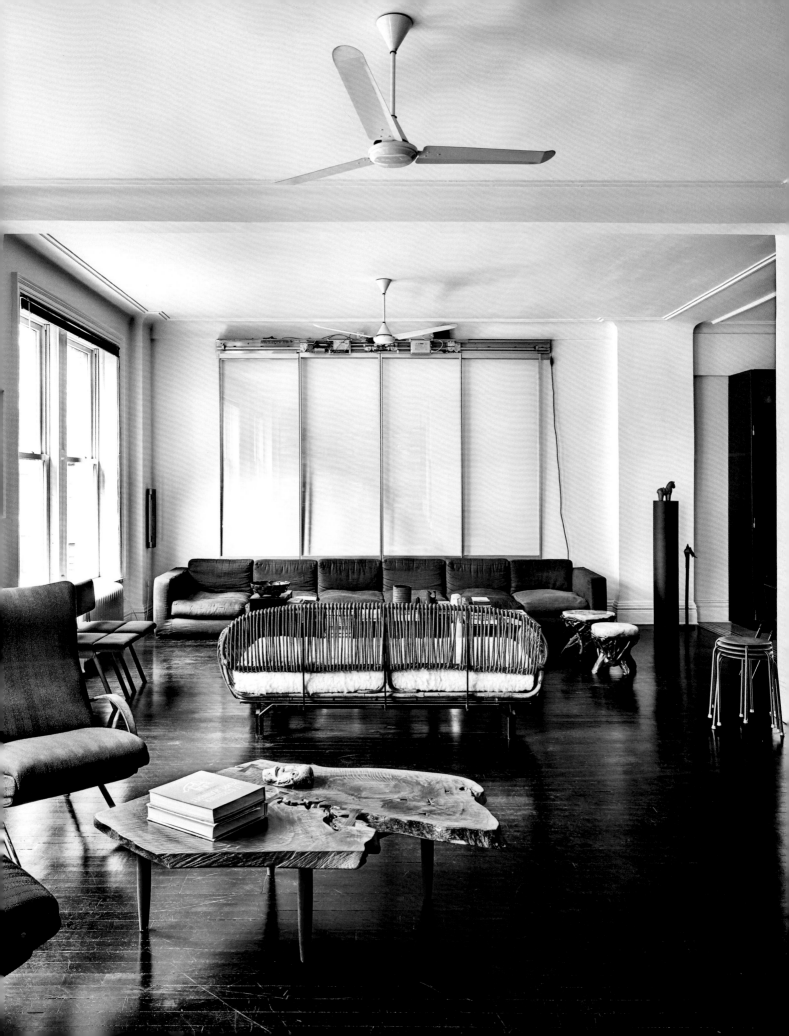

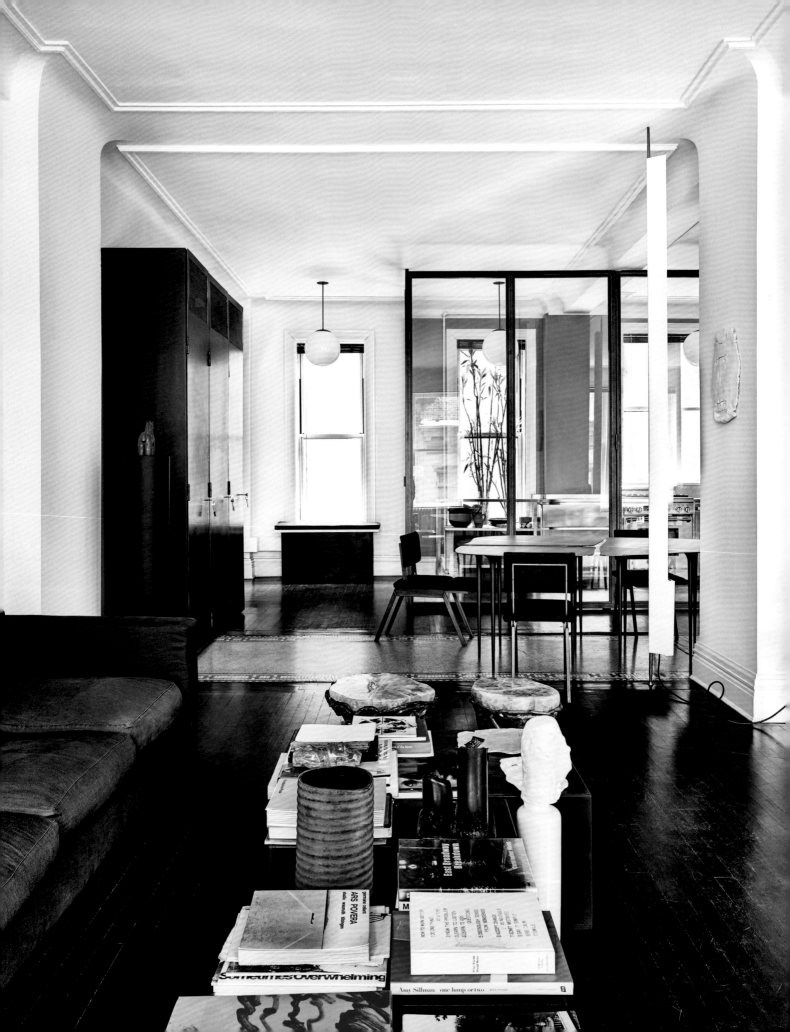

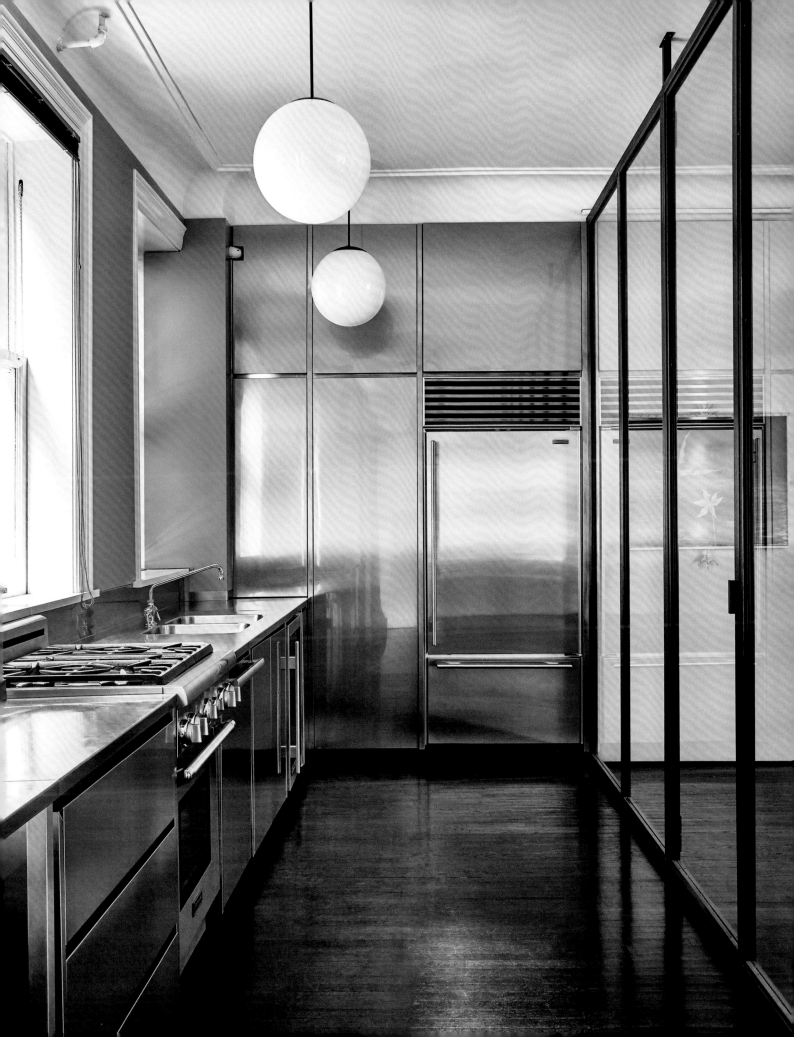

Locatelli designed the wall-mounted fixture, which calls to mind an abstract work of art while providing light, thus playing with distinctions between art and design. Another similar fixture by Locatelli hangs in the hall.

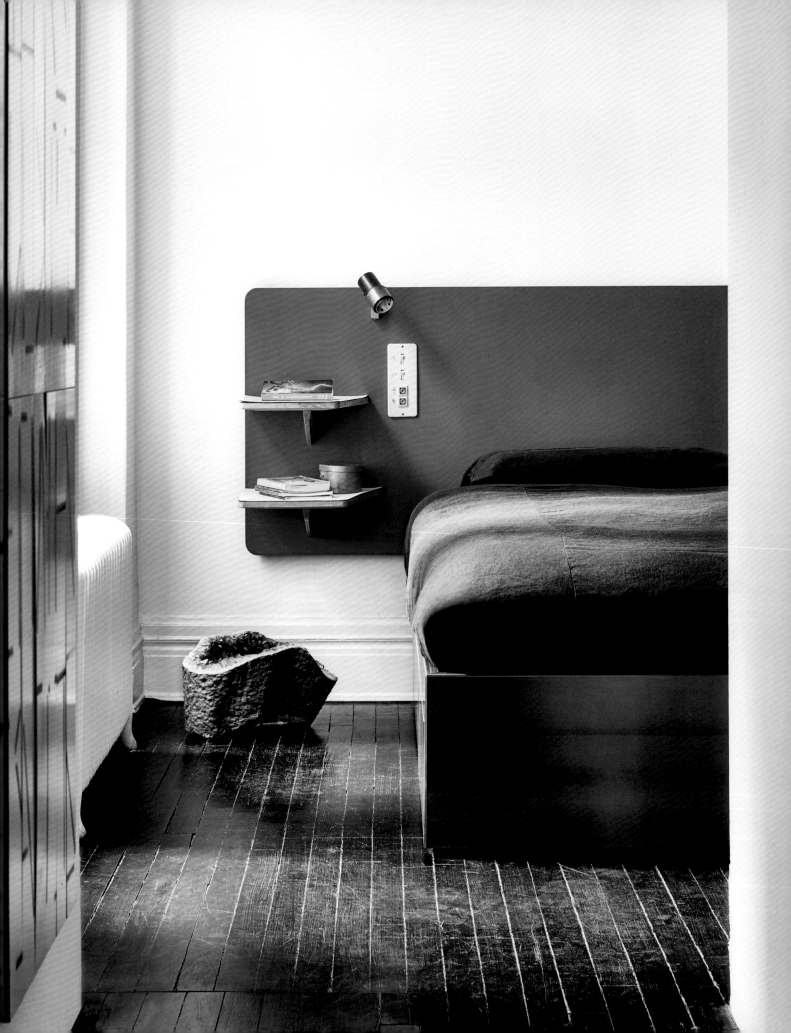

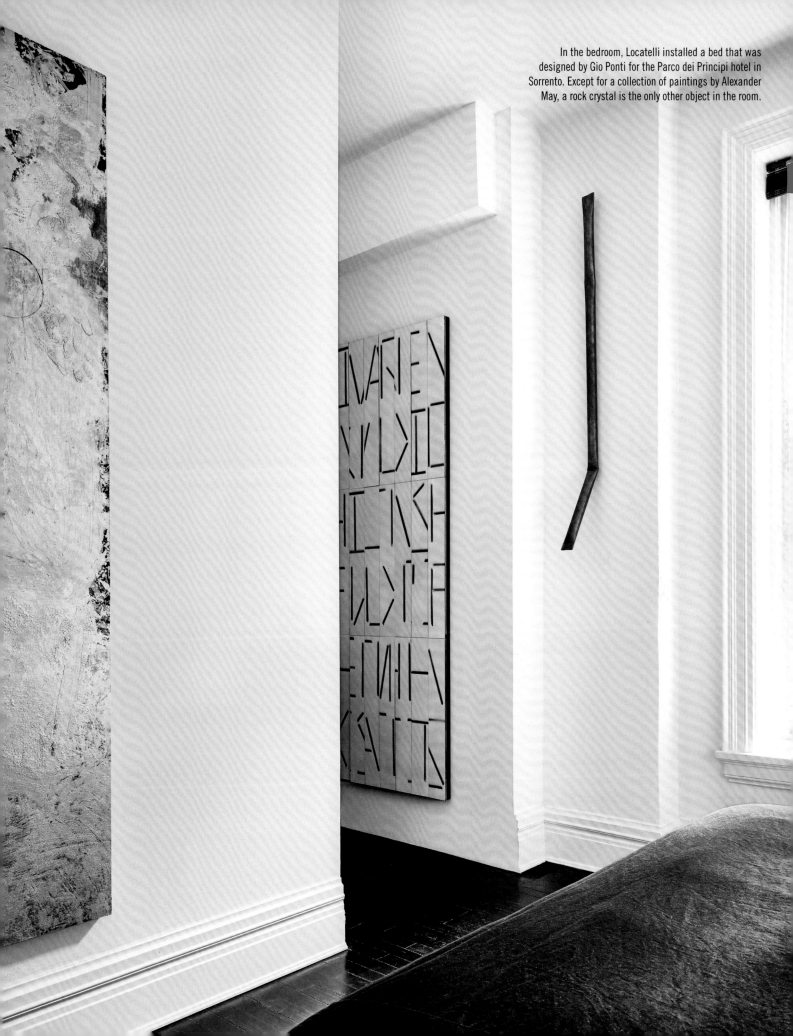

In the bedroom, Locatelli installed a bed that was designed by Gio Ponti for the Parco dei Principi hotel in Sorrento. Except for a collection of paintings by Alexander May, a rock crystal is the only other object in the room.

DAVID MANN

Architect and designer David Mann and his partner, Fritz Karch, a shop owner, author, and stylist, share this apartment at United Nations Plaza. After living in the heart of Greenwich Village for nearly thirty-five years, Mann and Karch became part of the migration uptown, in this case to a forgotten pocket of Manhattan that was one of the most glamorous places to live in the city not very long ago. The building they now live in was originally designed as offices for Alcoa, but it was converted into apartments before construction was complete in 1966. One would have expected this change of use to produce awkward layouts, but instead, the apartment Mann and Karch found was beautifully laid out and very thoughtfully planned, with great light and spectacular urban and river views.

Mann and Karch are only the second occupants of the half-century-old space. Despite nearly fifty years of wear and tear and some very bad decorative decisions by the first owners, the bones of the apartment were in excellent condition. The original owners had carpeted the entire apartment, with the exception of the kitchen and bathrooms, which meant that the original wood floors had basically been preserved. The floors became the foundation of Mann's renovation and a point of departure for an intervention that was more about elevating the space than transforming it.

Mann's design for the space set out to emphasize the clean, modernist lines of the structure while encouraging simple living and ease of use. In the library, for example, he painted the walls deep matte black and installed shelves, also in black, to mimic the relentless grid of the view of the adjacent building as framed by the room's large window. He also accentuated the horizontal quality of the apartment with low-slung furnishings. A black-and-white color palette is prominent throughout the home—Mann's subtle reference to the city's sophisticated past as portrayed by the likes of Fred Astaire and Ginger Rogers in a Hollywood re-creation of a New York ballroom, or the myriad other New York images from his childhood.

Although the building was originally built as "luxury" apartments, the hollow metal doors, marble tile, and inexpensive hardware gave the space a pedestrian feel. To counter this, Mann installed full-height, thick doors in the entrance gallery; the kitchen was renovated for function and aesthetics; and bold black-and-white marble, used in large slabs, lines the master bathroom walls and floors. Mann also added a layer of Sheetrock to the living room and gallery so that the wall could float above the floor, thus eliminating the necessity of a baseboard. With these interventions, Mann was not trying to transform the space into something it was not but rather to have the reality of the space match his fantasy of what it should have been.

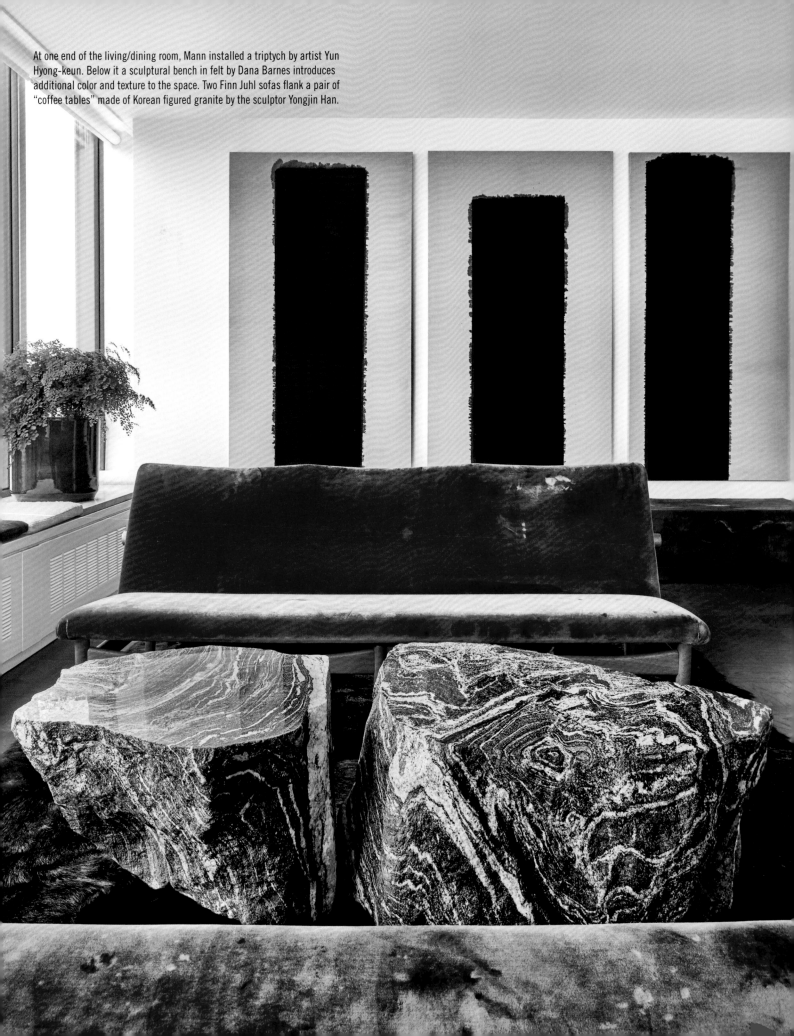

At one end of the living/dining room, Mann installed a triptych by artist Yun Hyong-keun. Below it a sculptural bench in felt by Dana Barnes introduces additional color and texture to the space. Two Finn Juhl sofas flank a pair of "coffee tables" made of Korean figured granite by the sculptor Yongjin Han.

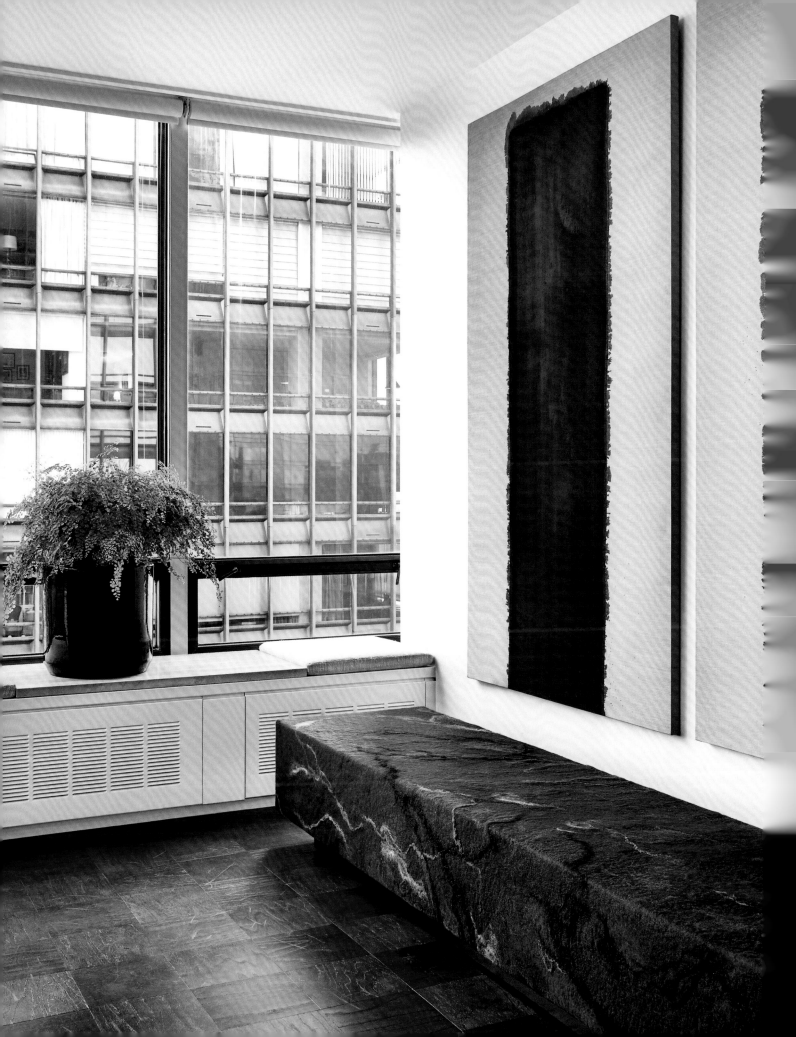

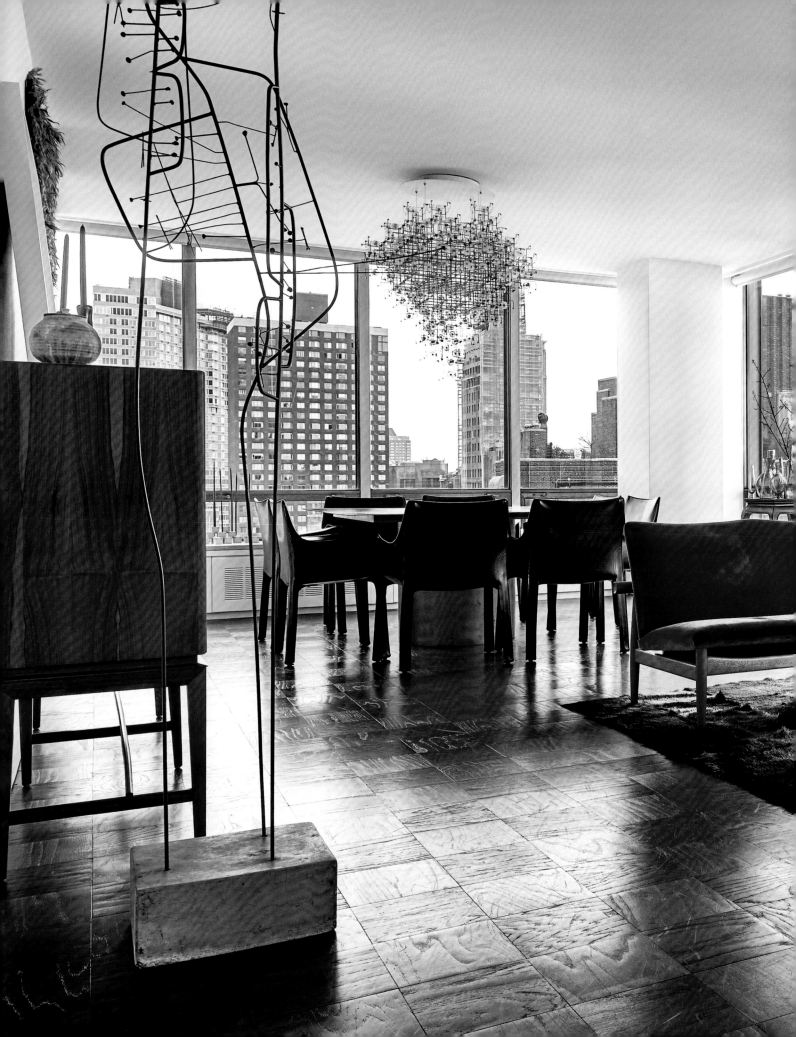

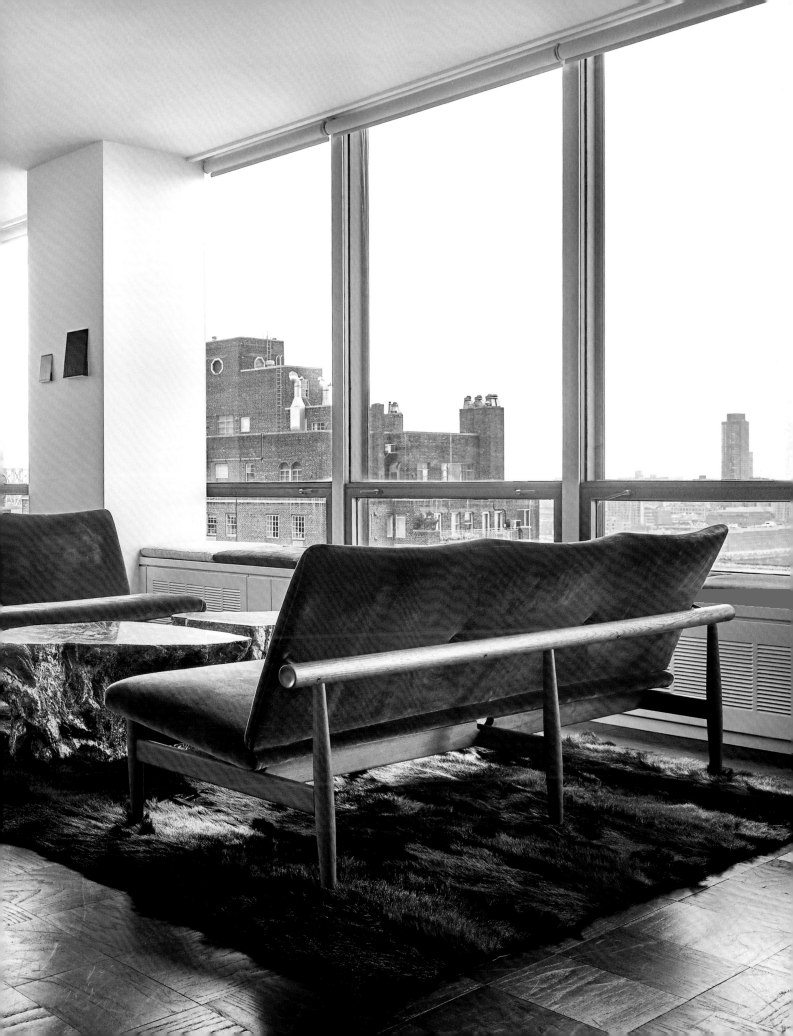

Mann designed the square dining table in unpolished brass. A Fragile Future chandelier by Studio Drift hangs over the table and commands attention. The chandelier is composed of bronze electrical circuits connected to LED lights, which are surrounded by real dandelion seeds that were picked by hand and glued, seed by seed, to the LED lights.

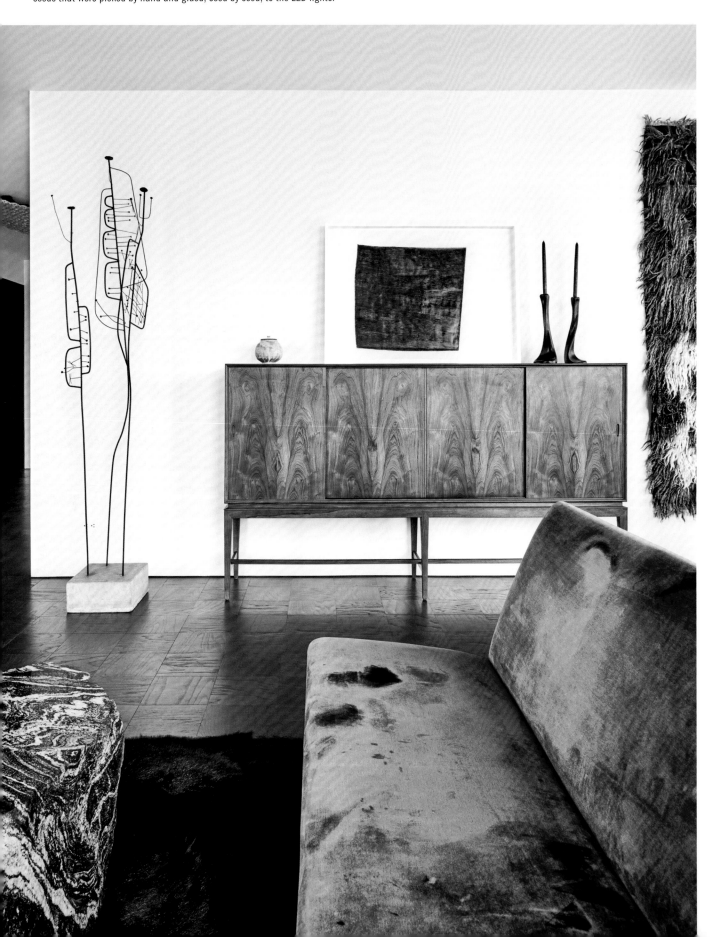

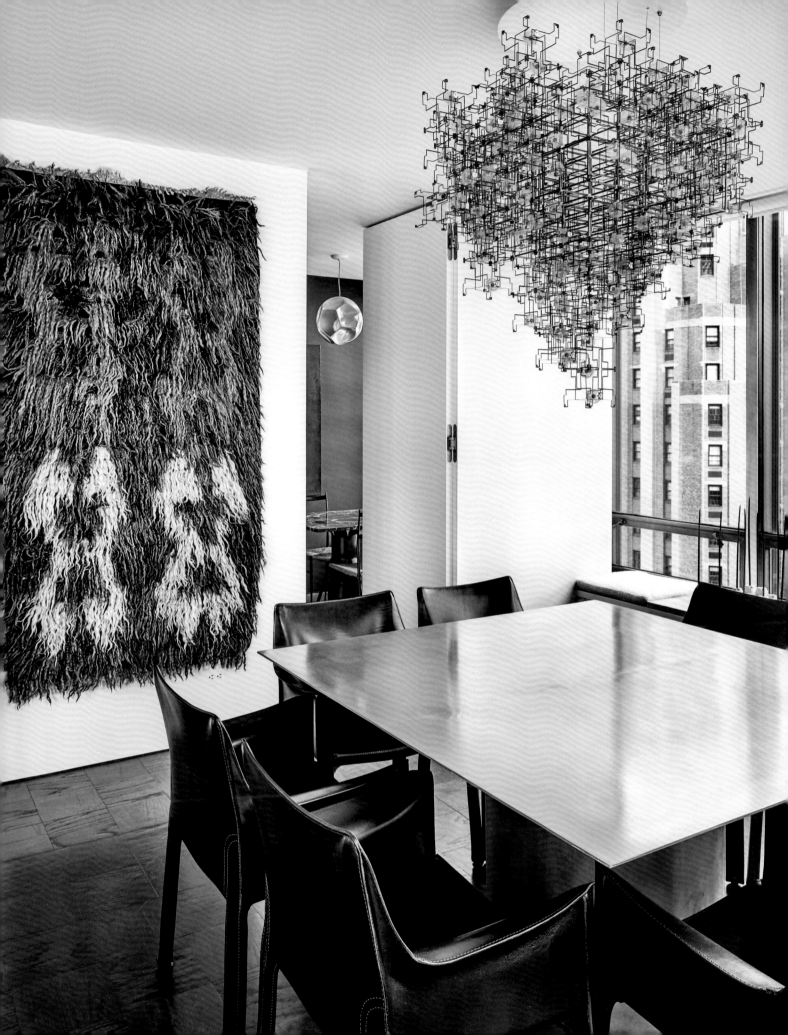

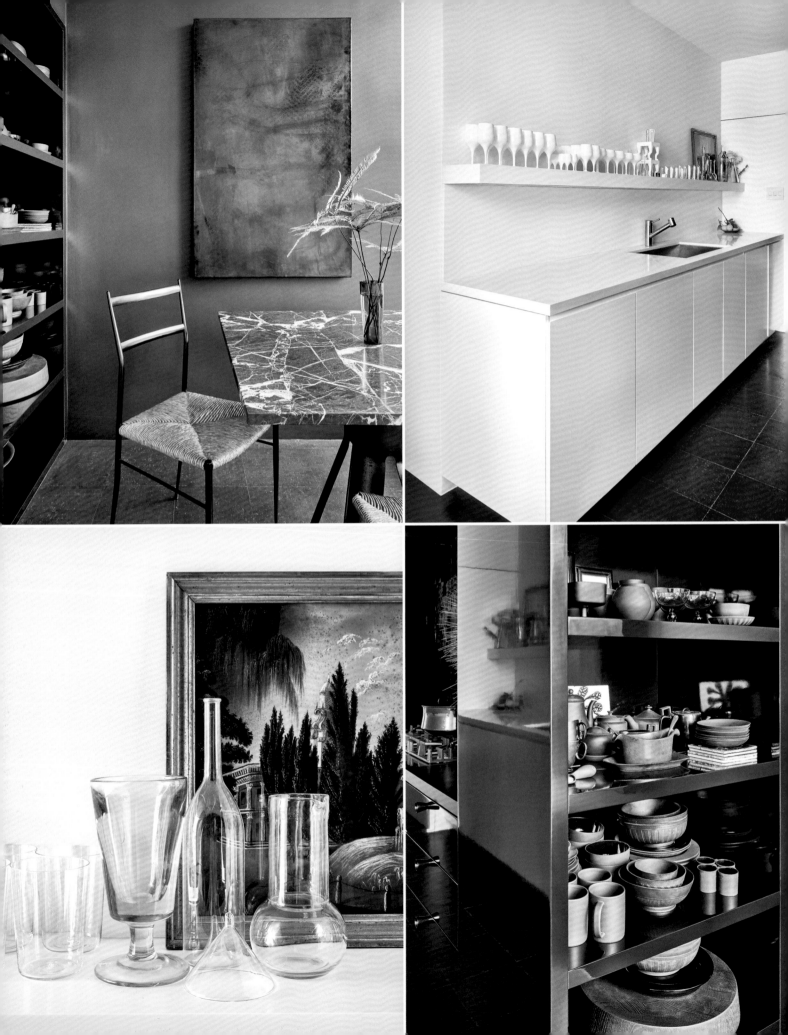

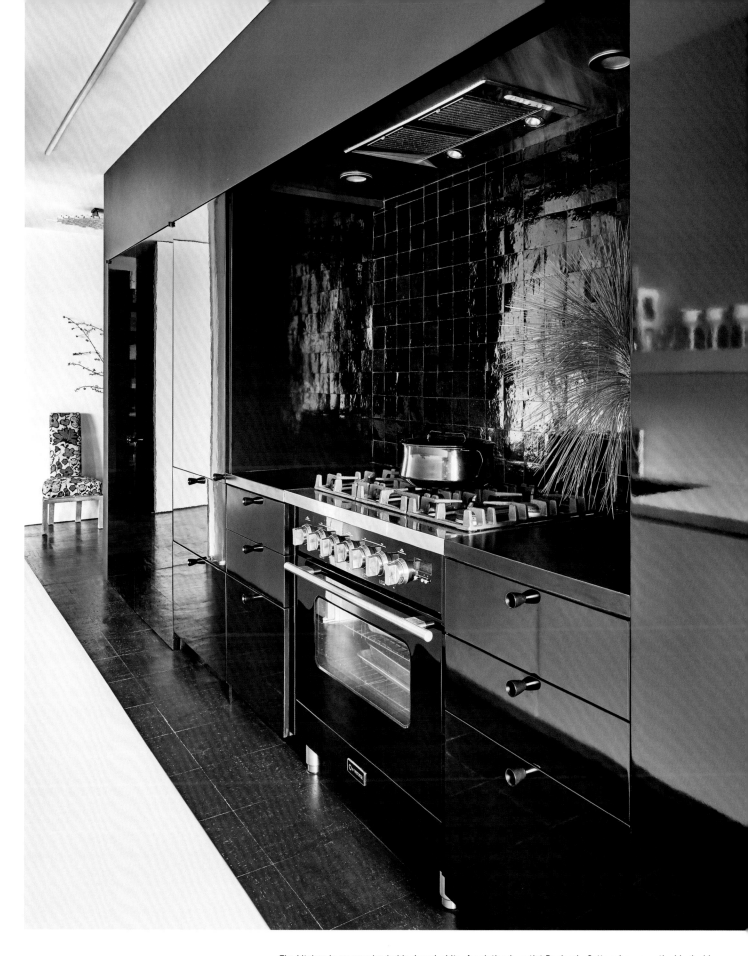

The kitchen is an exercise in black and white. A painting by artist Benjamin Cottam hangs on the black side along with Mann's collection of black dinnerware and serving objects. A chair by James Mont sits in the entry hall in the distance. The upholstery is worn, but Mann loved the pattern and color and decided to leave it as is.

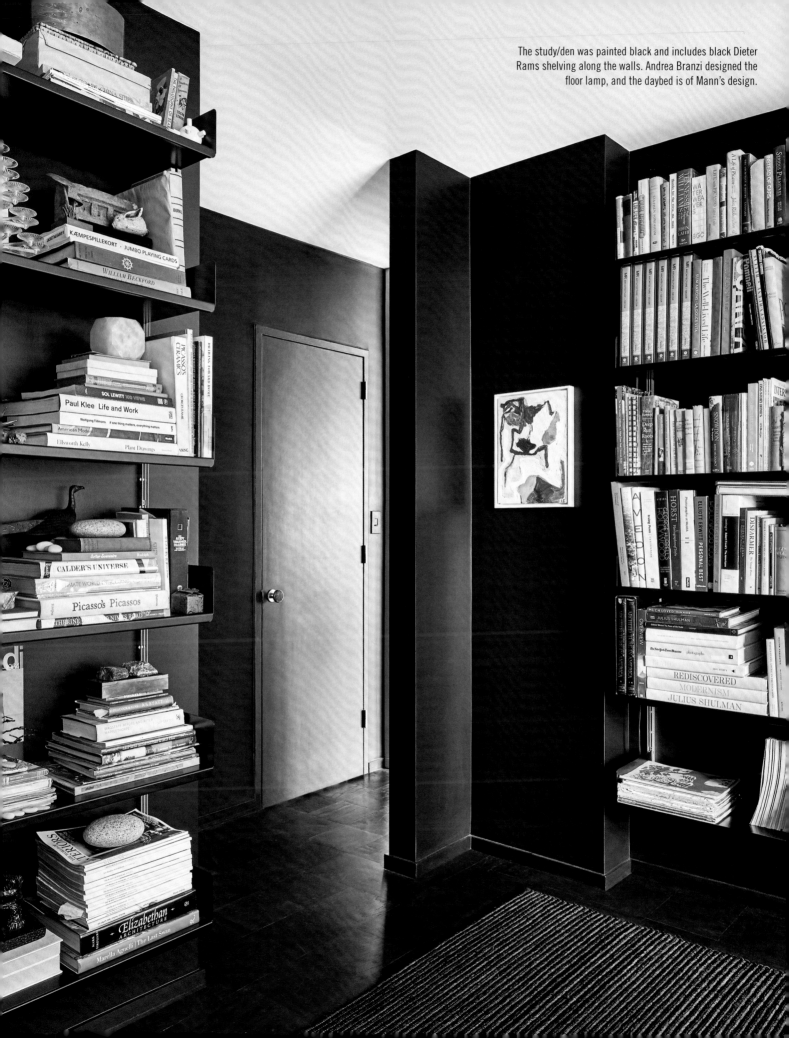

The study/den was painted black and includes black Dieter Rams shelving along the walls. Andrea Branzi designed the floor lamp, and the daybed is of Mann's design.

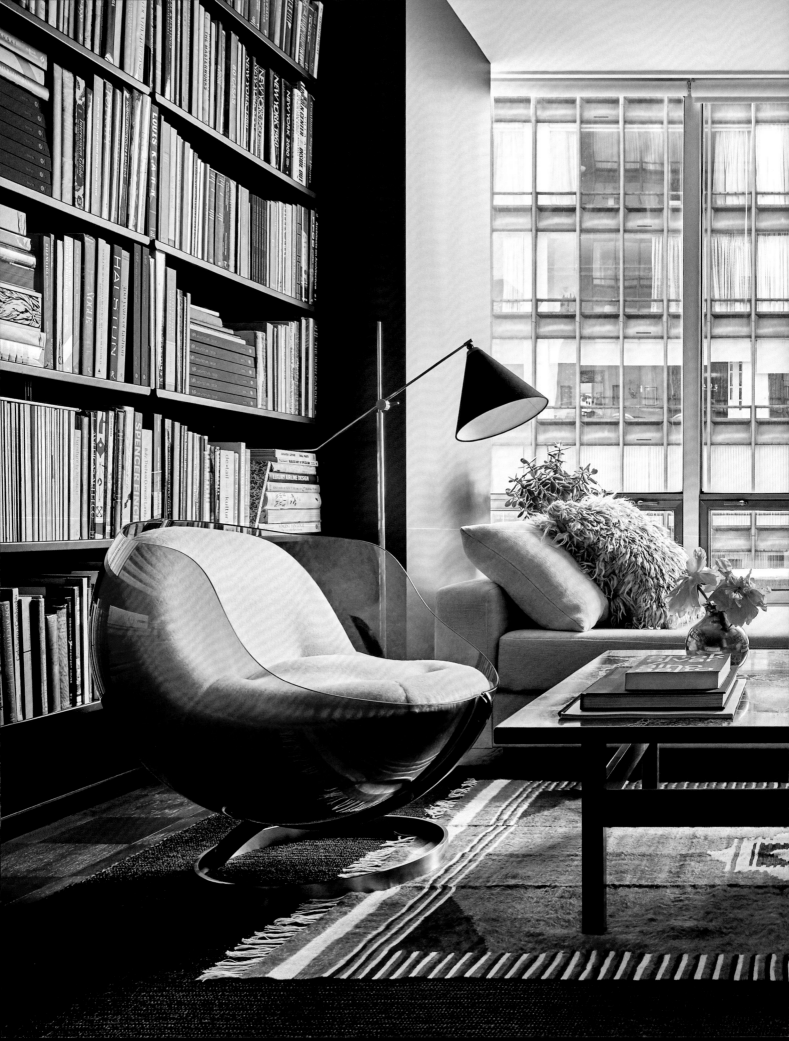

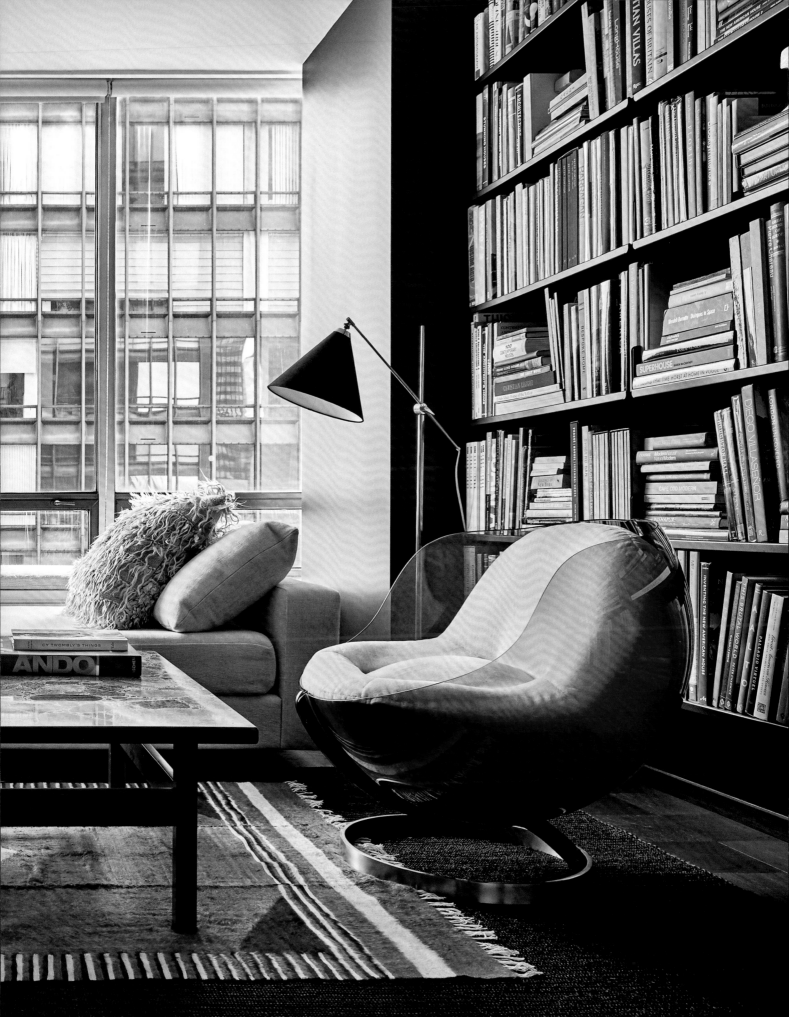

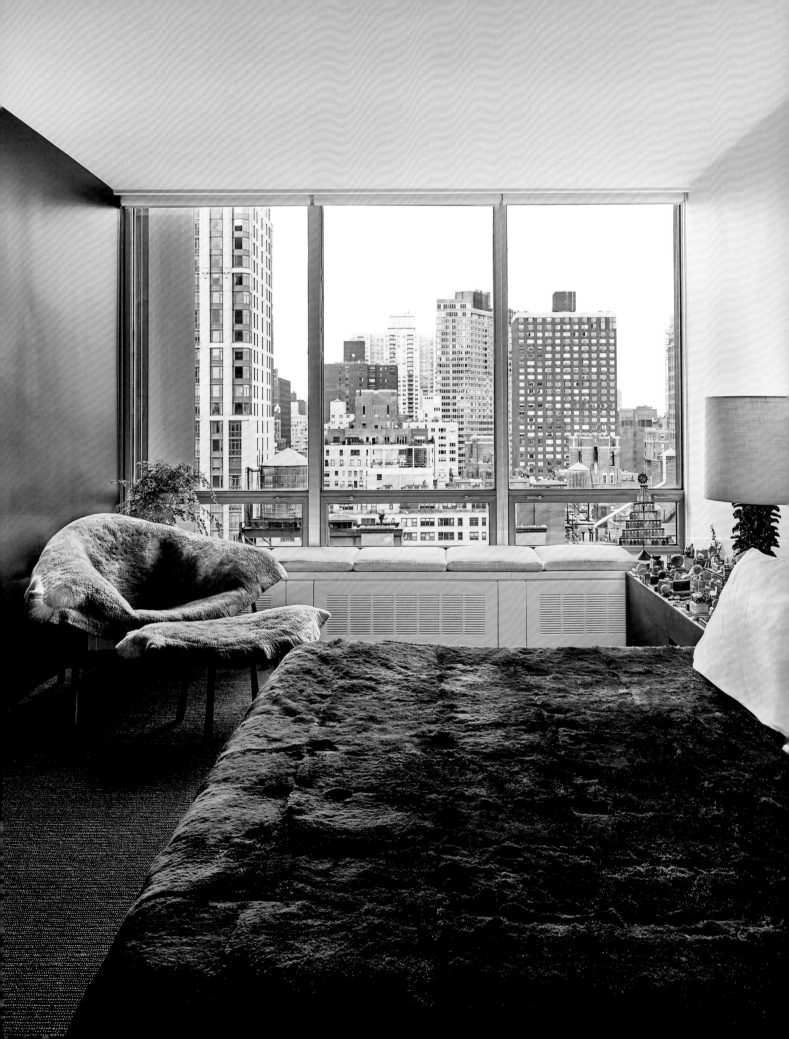

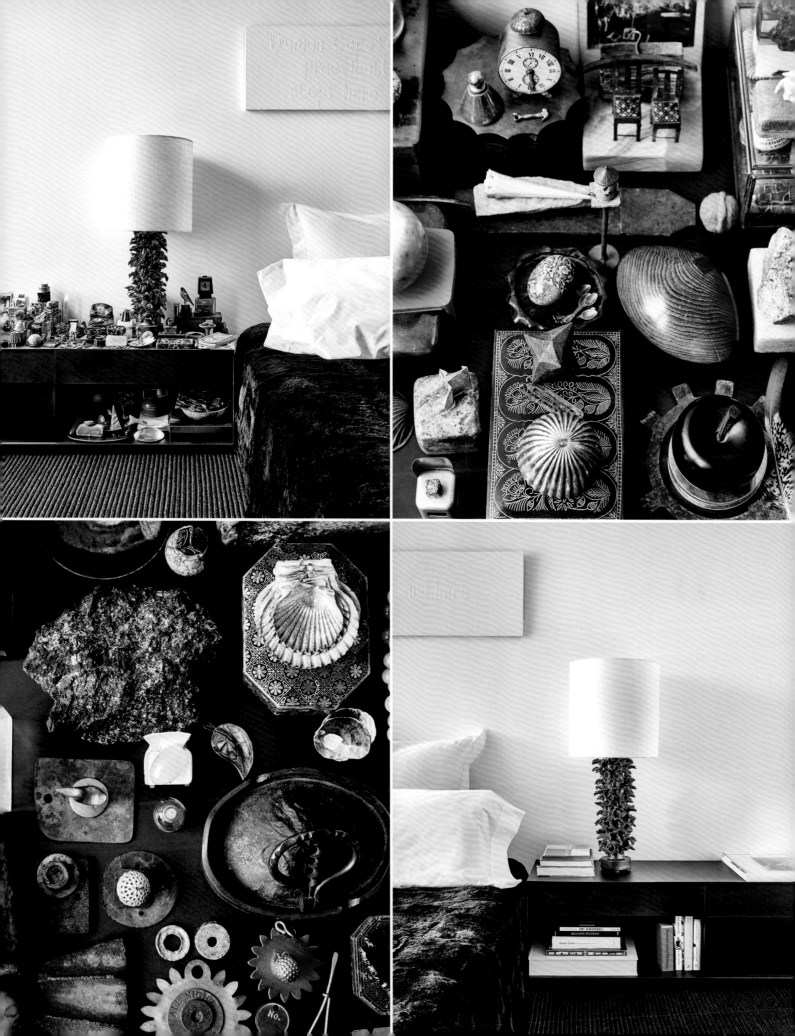

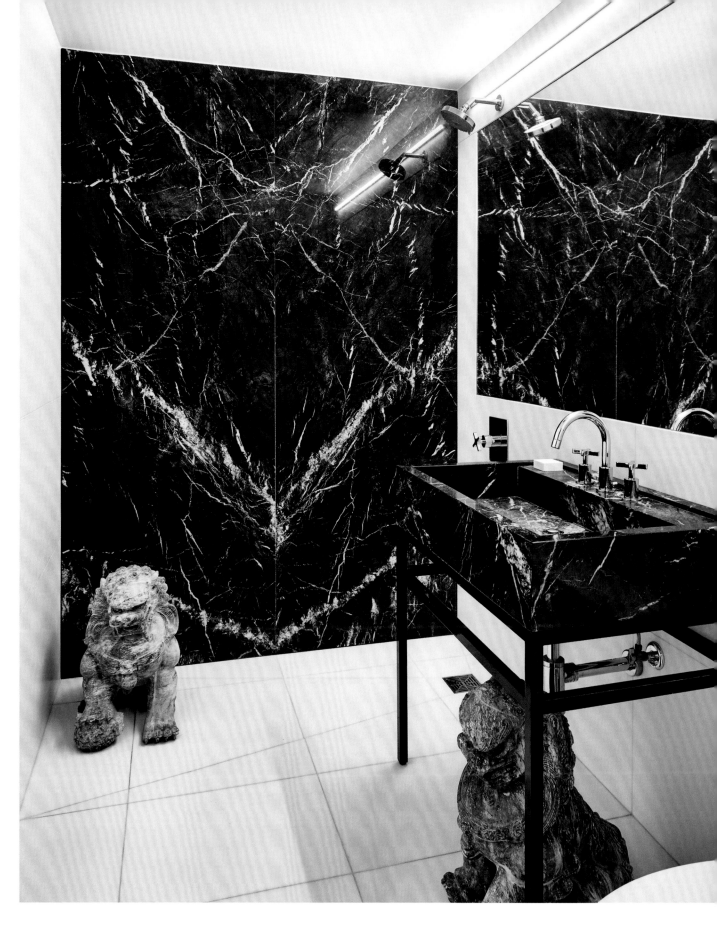

The black-and-white aesthetic continues in the bedroom (previous spread) and bathroom. The bedside cabinets were designed by Mann and reflect the character and interests of the apartment's two occupants. Designer Matthew Solomon made the lamps on either side of the bed, and Ayala Serfaty designed the armchair in the corner. Outside the bedroom is a black-and-white artwork, a collage of photographic materials, by Doug and Mike Starn. In the bathroom, the shower was simplified to only a floor drain, and a pair of Foo dogs guard the space.

ZACK MCKOWN & CALVIN TSAO

The appreciation of light and the balance between private and communal spaces seem to have been the driving forces behind the design of the duplex apartment the architects Zack McKown and Calvin Tsao share with their partner David Poma. The south-facing apartment overlooks the Museum of Natural History and its clean, minimalist spaces defy expectations as they create a stark contrast to the exuberance of the Emery Roth–designed building. The structure, with its Beaux Arts and Art Deco details, is an architectural testimony to the last moments of the Roaring Twenties. When McKown and Tsao found the apartment, all the original details and moldings had been removed, so, the space was a blank slate. The architects moved in and started to think about and experience how they would occupy the home before any renovation started.

Tsao said that observing the light at different hours of the day provided them with a set of tools they never would have acquired had a renovation started immediately. The light set the mood for the space and drove many of their design decisions. They moved the stairs and opened up the stairwell to allow more light to flow into the center of the space. In the living room, they created a wall of palladium-leaf cabinet doors that mimic the proportions of the windows and reflect morning light into the space. They also removed the wall between the dining and living rooms and incorporated three different shades of white in the area. An appreciation of light is also reflected in the architects' choice of art, as black-and-white photographs by Mitch Epstein and Hiroshi Sugimoto underscore this theme.

McKown and Tsao were also keen on striking the right balance between communal and private spaces. The opening of the stairwell and creation of the stair hall allowed for a greater sense of connection between the two floors while also creating common space for the three bedrooms on the upper floor. The kitchen, distinguished from the rest of the living space with a slightly lower ceiling and warmer shade of taupe gray, is an open, communal space; however, the architects ingeniously tucked a private pantry behind a wall of storage that runs the length of the lower floor.

The stark yet welcoming quality of the apartment encourages a reading of all the furnishings and objects through a lens of display. Here, objects, textiles, and furniture as distinct and varied as Venetian gondoliers' lanterns, nineteenth-century French Masonic stools, Javanese fabrics, and an antique Sicilian gilt cross not only remind McKown, Tsao, and Poma of their experiences but also invite visitors to look for the connections between these seemingly unconnected artifacts. These connections, whether formal, textural, or chromatic, create a tension from which beauty is born.

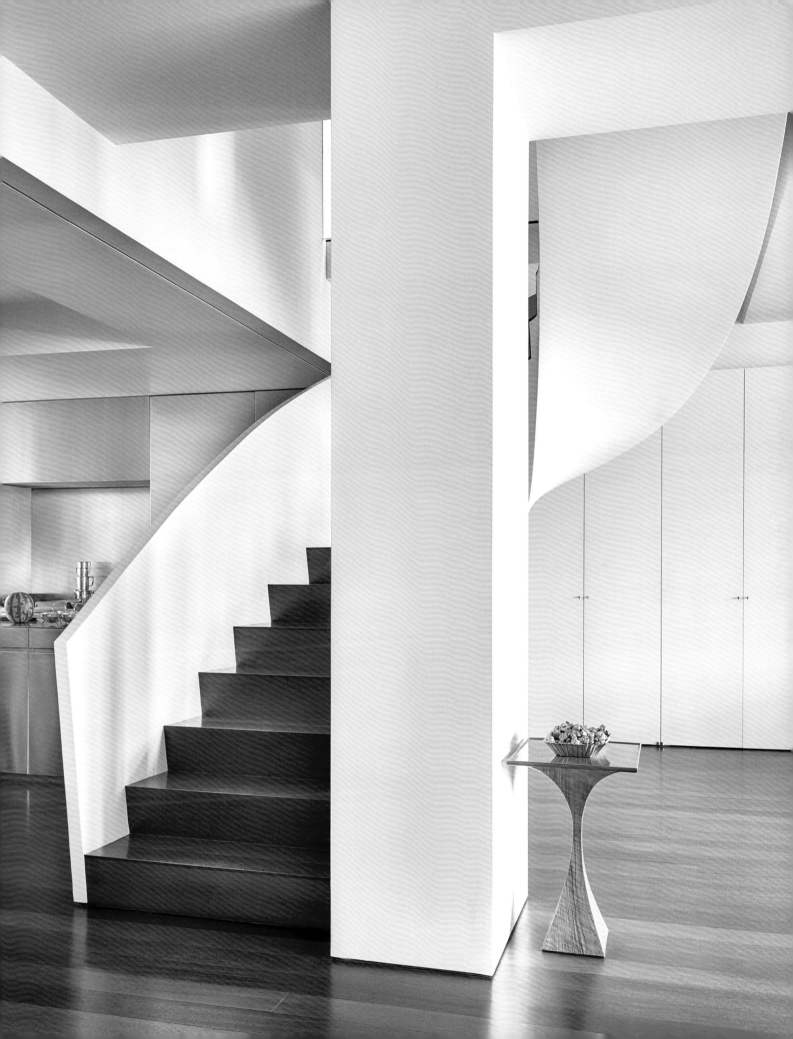

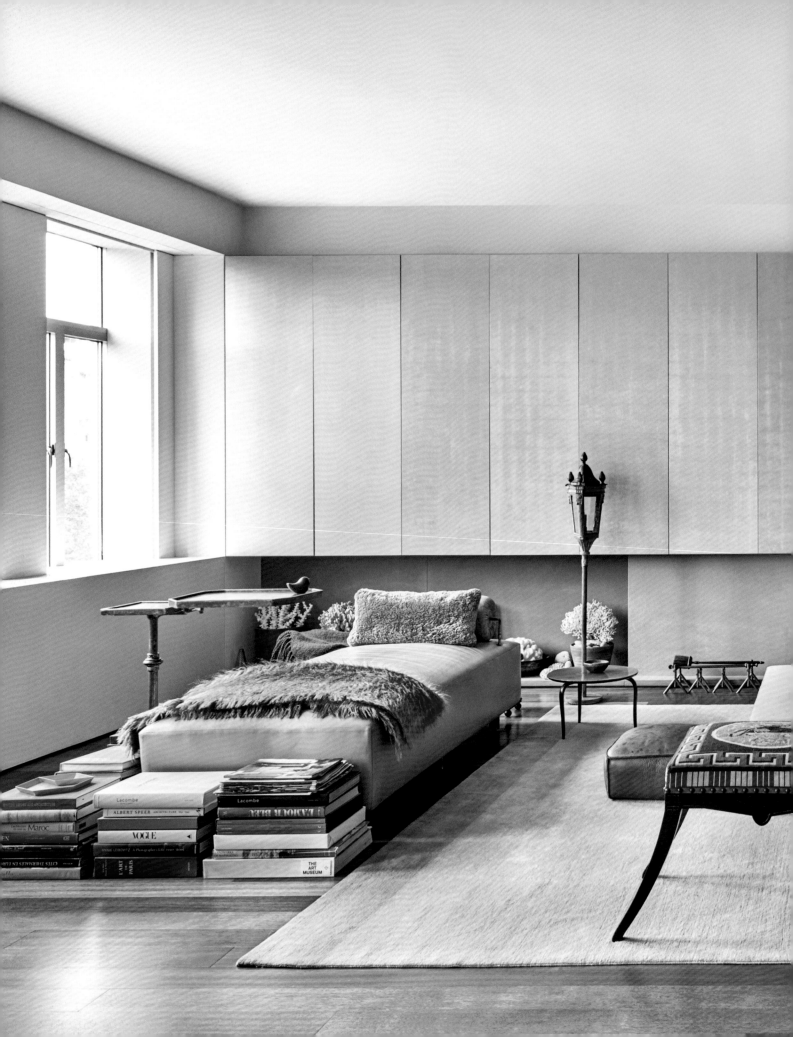

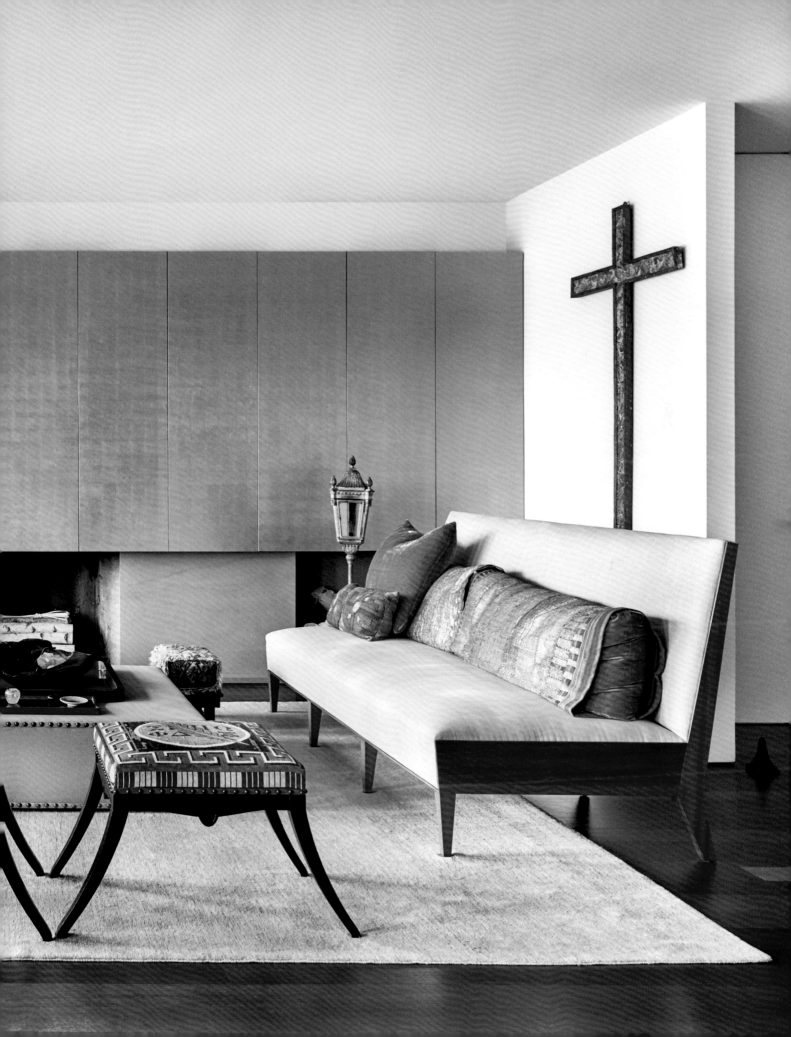

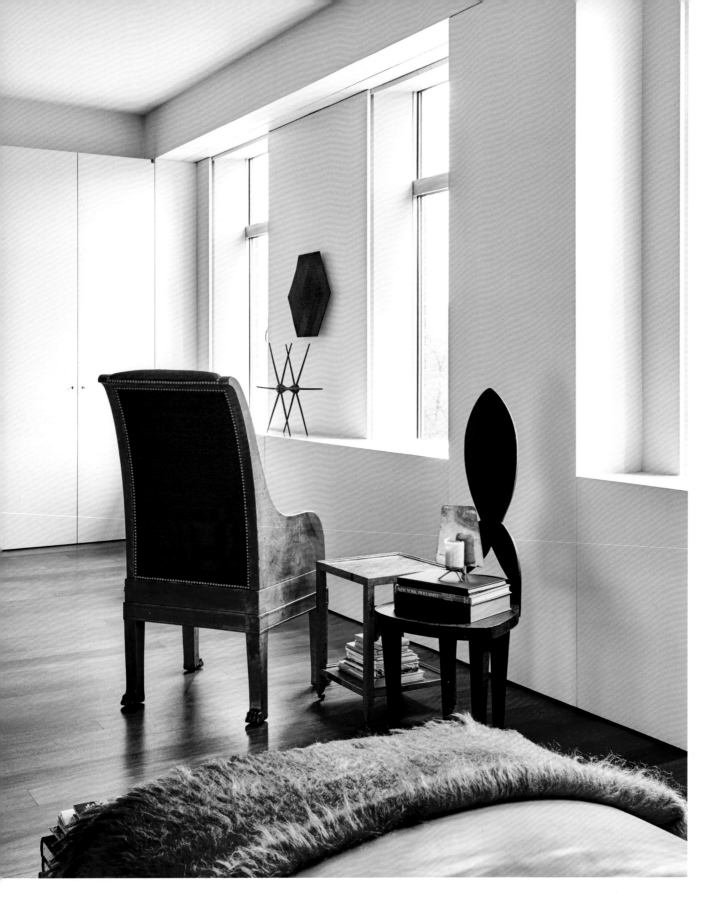

A wall of palladium-leaf cabinet doors reflect eastern morning light into the living room. Their form and position mimic the south-facing windows. A pair of gondoliers' lanterns were converted into floor lamps that flank the fireplace. The room also includes a pair of nineteenth-century French Masonic stools, Javanese textiles on cushions, and a Sicilian gilt cross. While not unique designs, the sofa and coffee table were scaled specifically for the room.

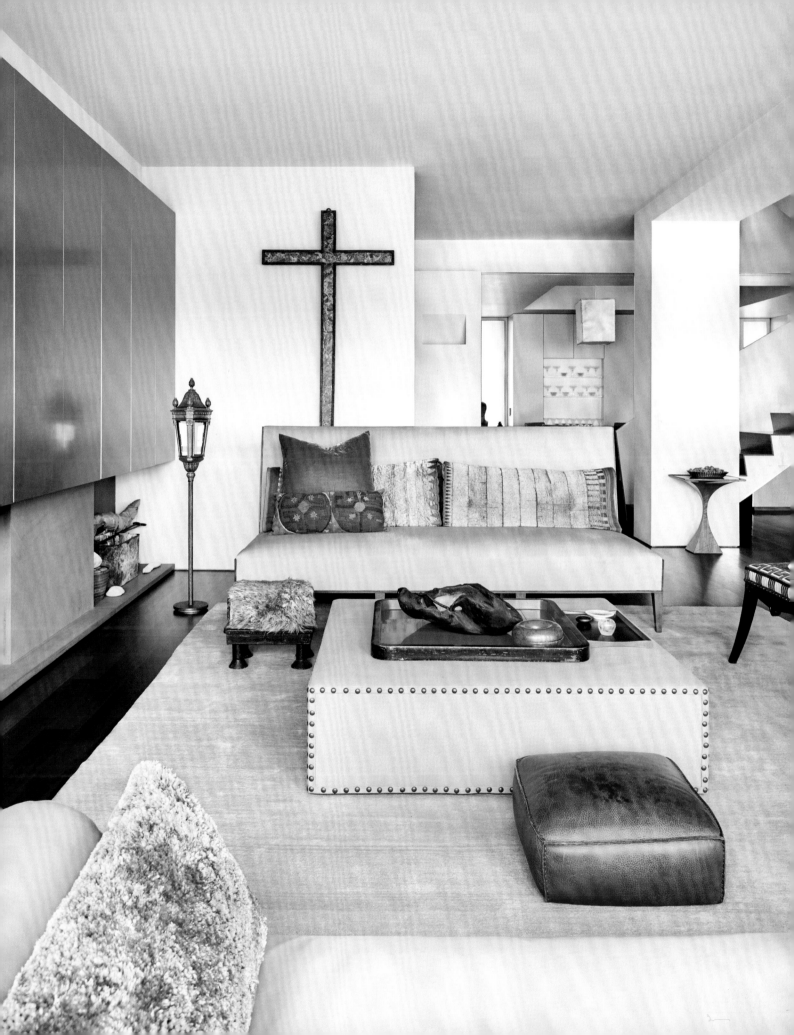

A sculptural stairway leads to the upper floor and visually separates the living/dining area from the kitchen. The dining table was designed by McKown and Tsao and made specifically for the space, and a wall of storage makes it easier to maintain the minimalist quality of the home.

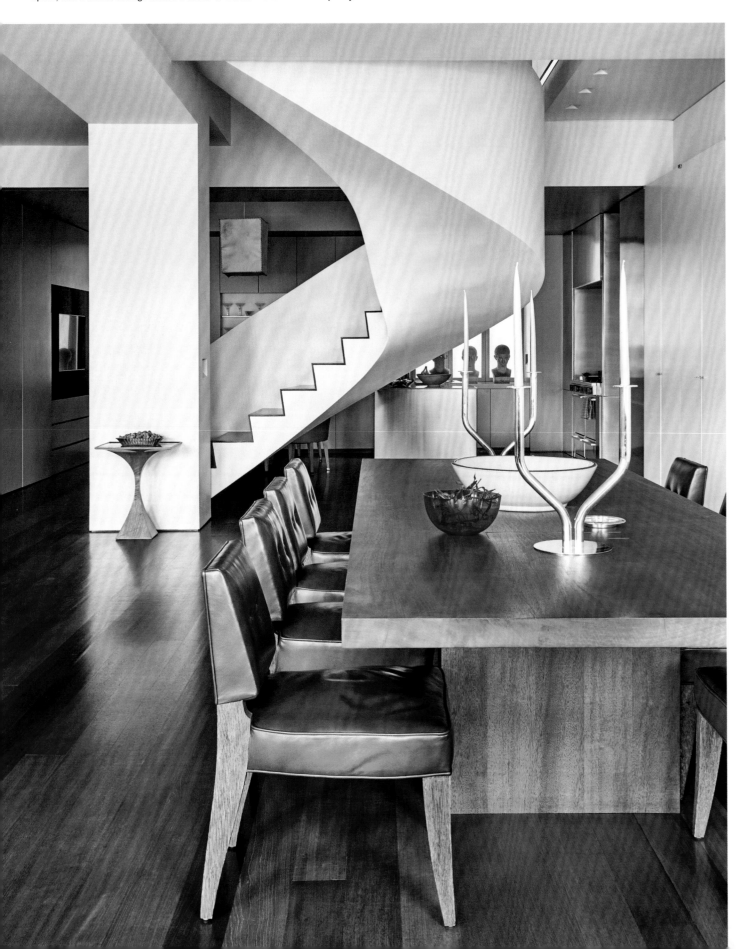

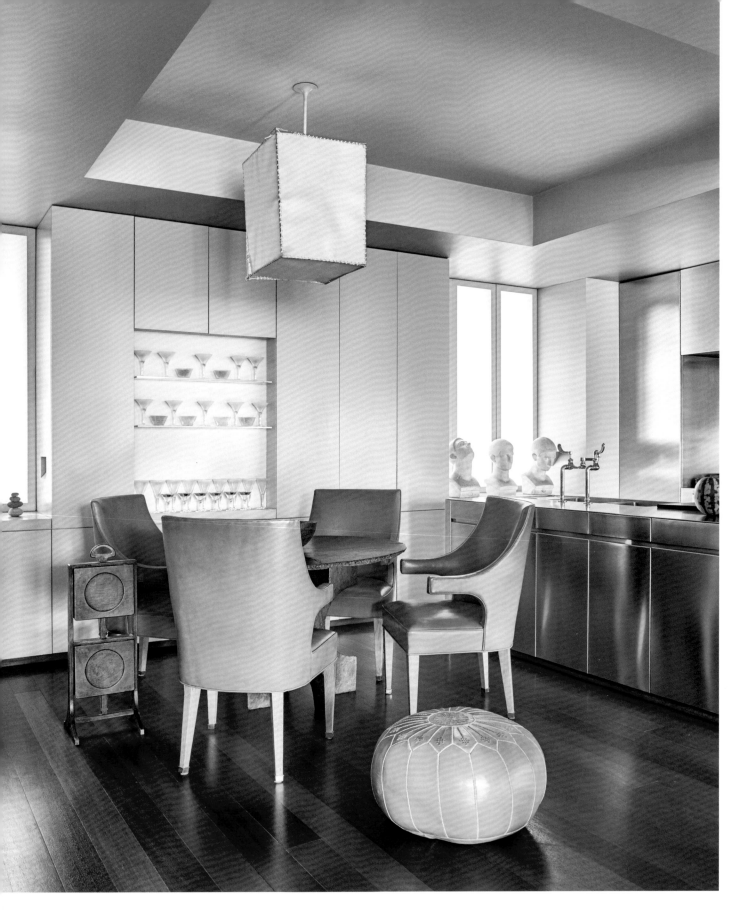

In the kitchen, the color shifts to a slightly warmer beige, and abundant storage lines the walls. The stainless-steel kitchen island and cooking area provide ample room to prepare meals in proximity to friends and family, and a butler's pantry concealed behind the storage wall allows for an additional work area.

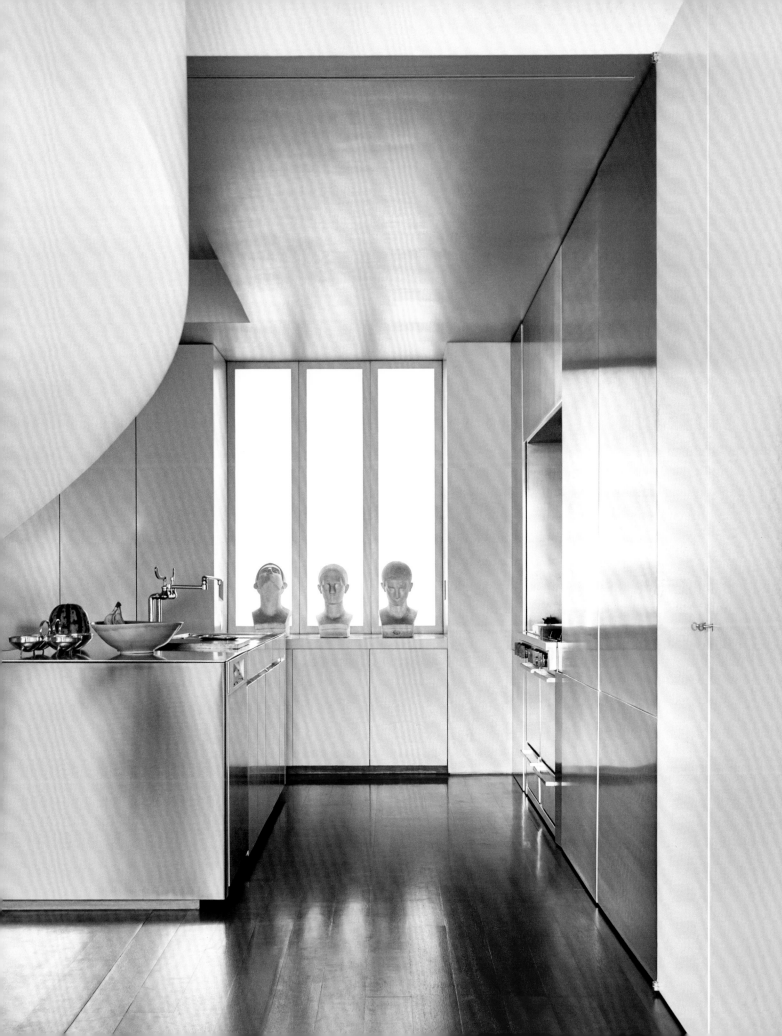

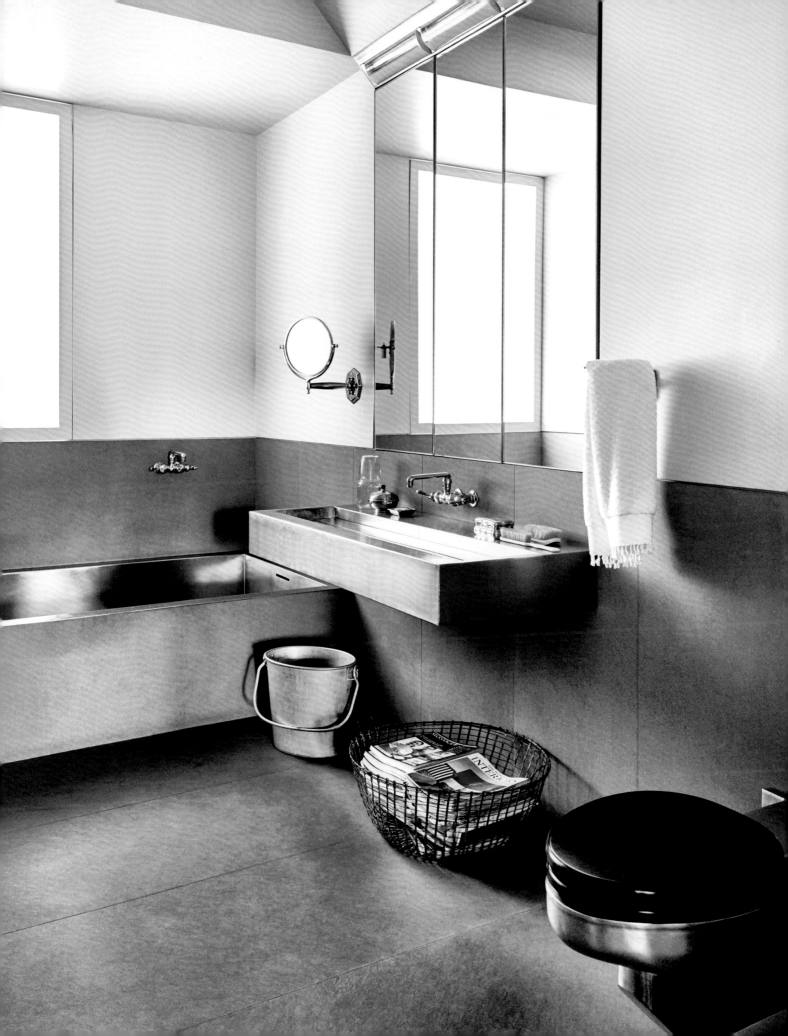

McKown and Tsao's major objective throughout their apartment was to create both communal and private spaces. The opening of the stair hall allows visibility and spatial connection between the two floors. The three bedrooms also provide a personal study area for each member of the family. One of the rooms includes a Parsons-style table that extends off the exterior wall and mirrors the dimensions of the window (page 236, top right).

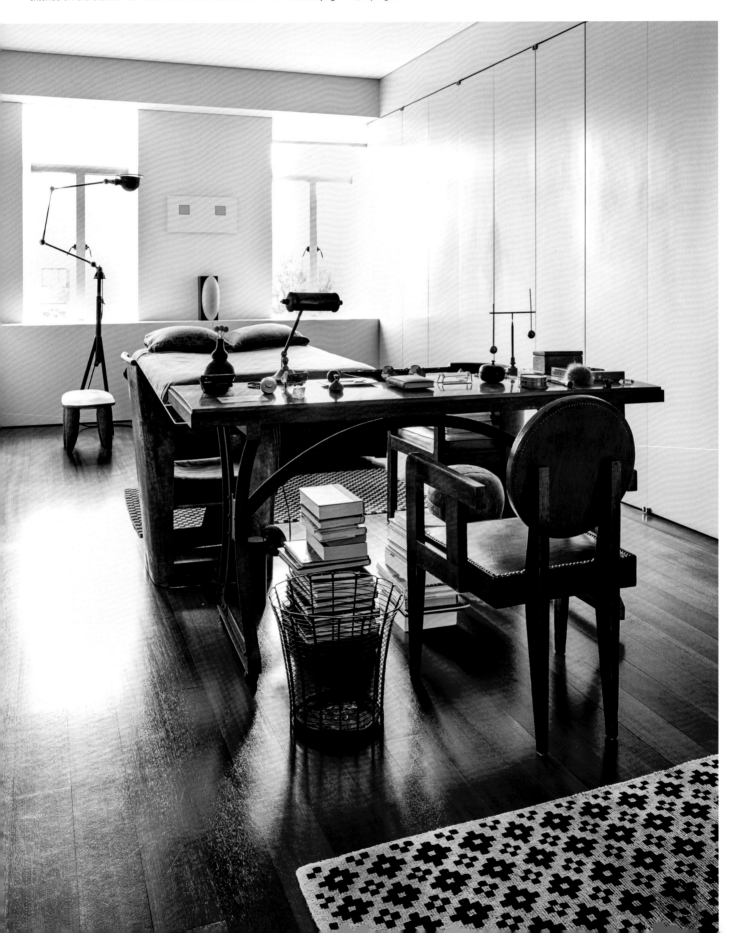

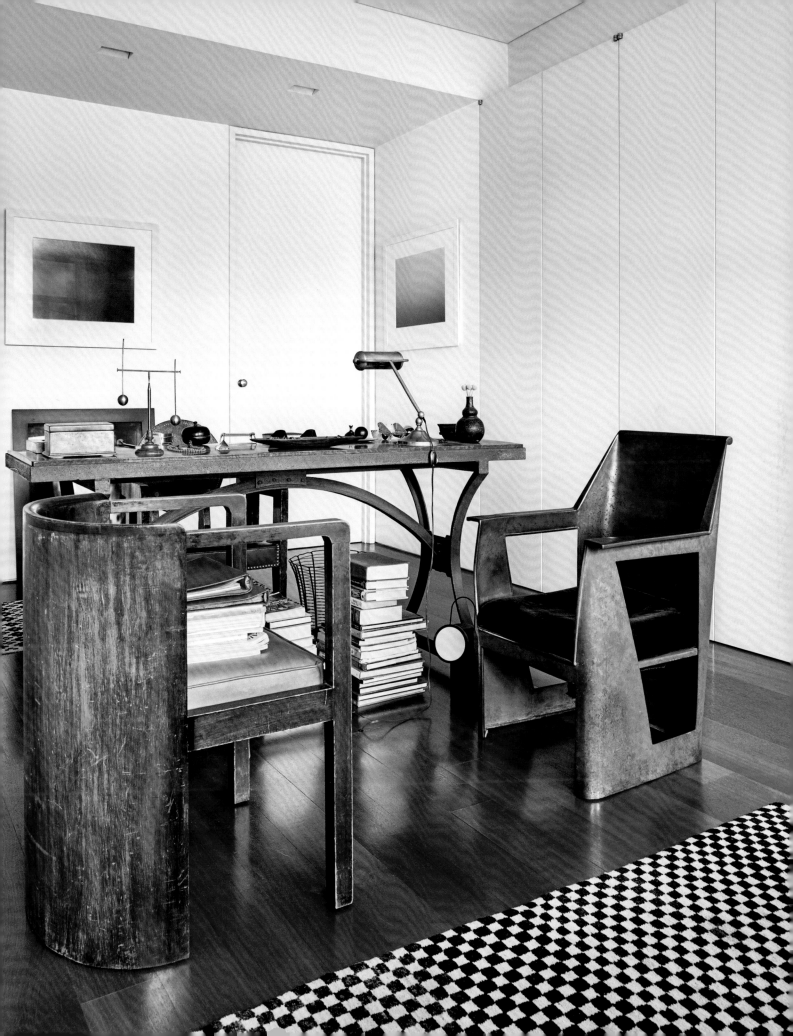

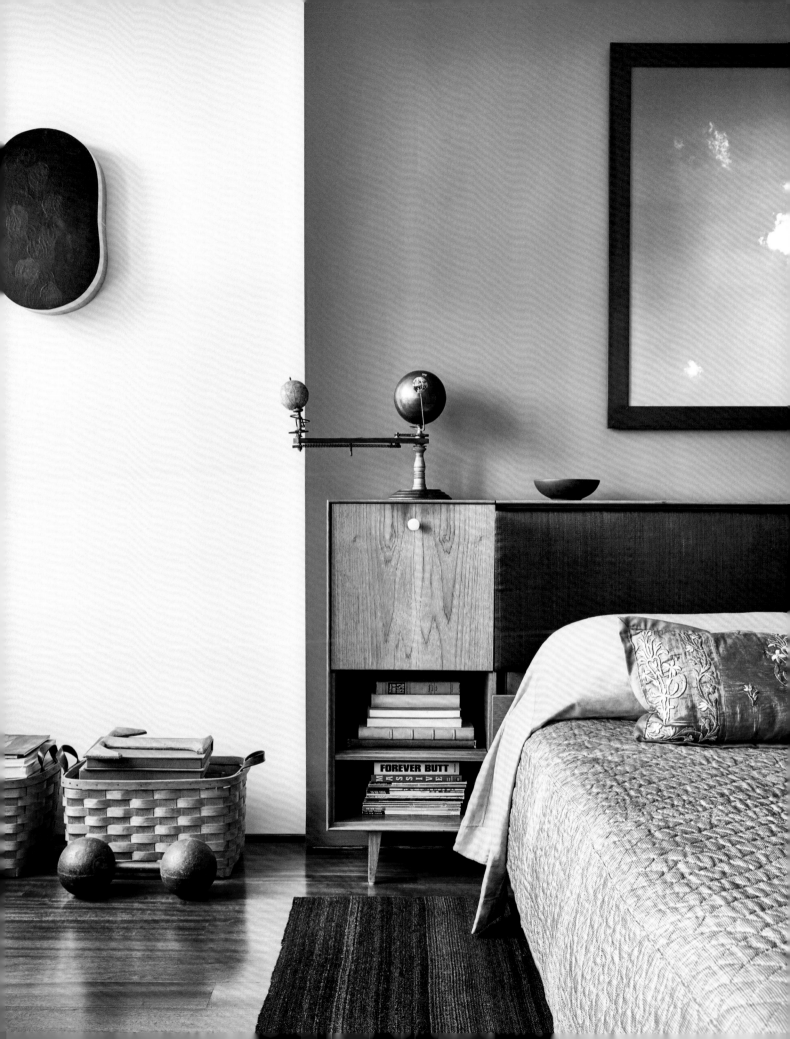

JAYNE MICHAELS

When Jayne Michaels and her husband found this apartment in Manhattan's Sutton Place neighborhood, they were immediately attracted to the classic, gracious proportions of the Art Deco–era space, the working fireplace, and the French windows in the living room. There were a few problems, though: The apartment offered only one bathroom, the ceilings were caved in, the kitchen had barely survived a fire, and the walls and moldings were encased behind several years of crumbling paint and plaster.

In her design practice, which she shares with her twin sister, Joan, Michaels is a devout modernist, so she wanted the apartment to maintain the same flavor it had when it was built in 1925, but with an end result that would be more Bauhaus than Deco. To accomplish this, she removed any superfluous detailing, retained the existing floors and windows, removed the crown moldings, and raised the door moldings to the ceiling to accentuate the ceiling height and infuse a more modern consciousness into the space. In lieu of transom windows above the doors, mirror panels were installed to reflect more light and create visual depth. The mantel they inherited with the home was, according to Michaels, "a Home Depot colonial something or other," and she initially searched for the perfect pre-war stone mantel, but none of them fit her requirement for a piece that would be both appropriate and modern. Instead, she decided to design something that would be simple yet dramatic, and chose a bluish-gray concrete to set the tone for the room.

The crumbling ceilings came down quite easily, and within the hidden ceiling joists, Michaels was able to fit in a few small art lights. The couple also needed a second bathroom, and carving the space out for it without destroying the integrity of the original layout was a challenge. The living room and den walls were moved by a few inches to accommodate the new bathroom and create a vestibule/closet area. To further increase the functionality of the space, Michaels enlarged the opening between the living room and den and removed a dumbwaiter in the corner of the kitchen.

By carefully retaining some of the original details and respectfully adding new ones, Michaels was able to create a fully functioning series of rooms that met her requirements and looked as though they had always existed in the current state.

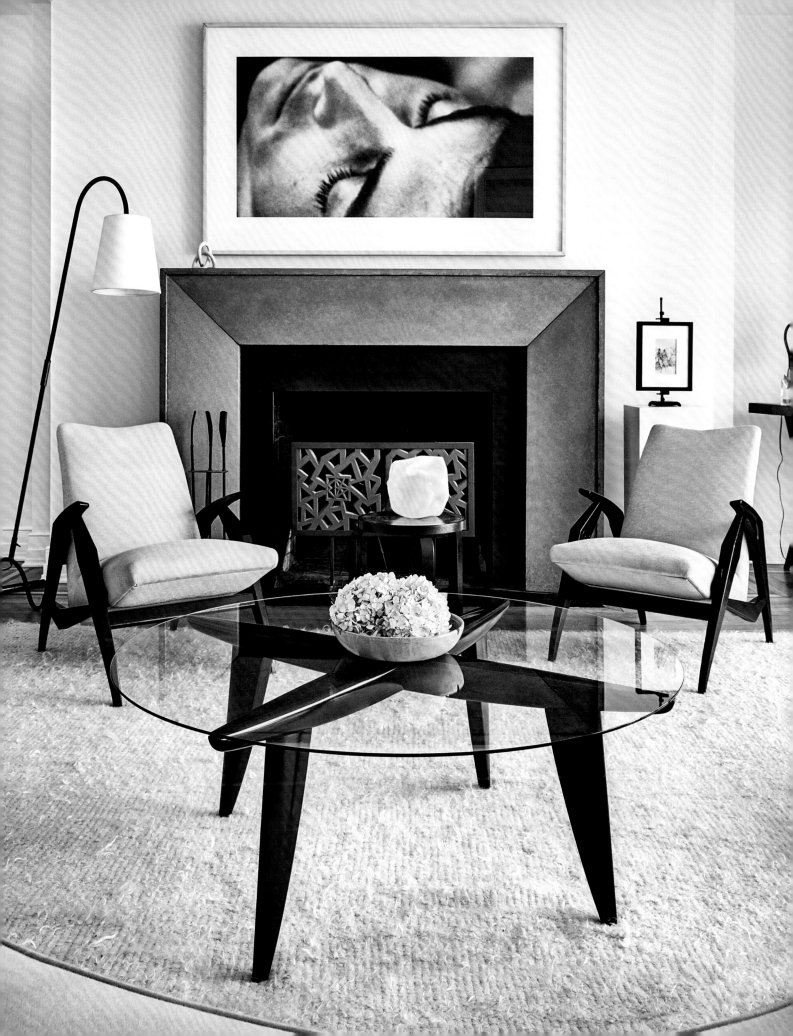

A handwoven mohair rug from South Africa creates a neutral backdrop in the living room, which hosts a collection of furnishings from various periods. The curving sofa is from the 1930s, the coffee table is by Gio Ponti and from the 1950s, and the blue chair is 1940s Swedish. A sculpture by Will Horowitz from 1963 sits in the corner, and black-and-white ink drawings by Irving Hayes, circa the 1960s, hang behind the sofa. A dining table by Hans Wegner with built-in leaves sits along the wall at the far end of the living room. When there are guests for dinner, the table can be moved into the space, be enlarged, and host up to six.

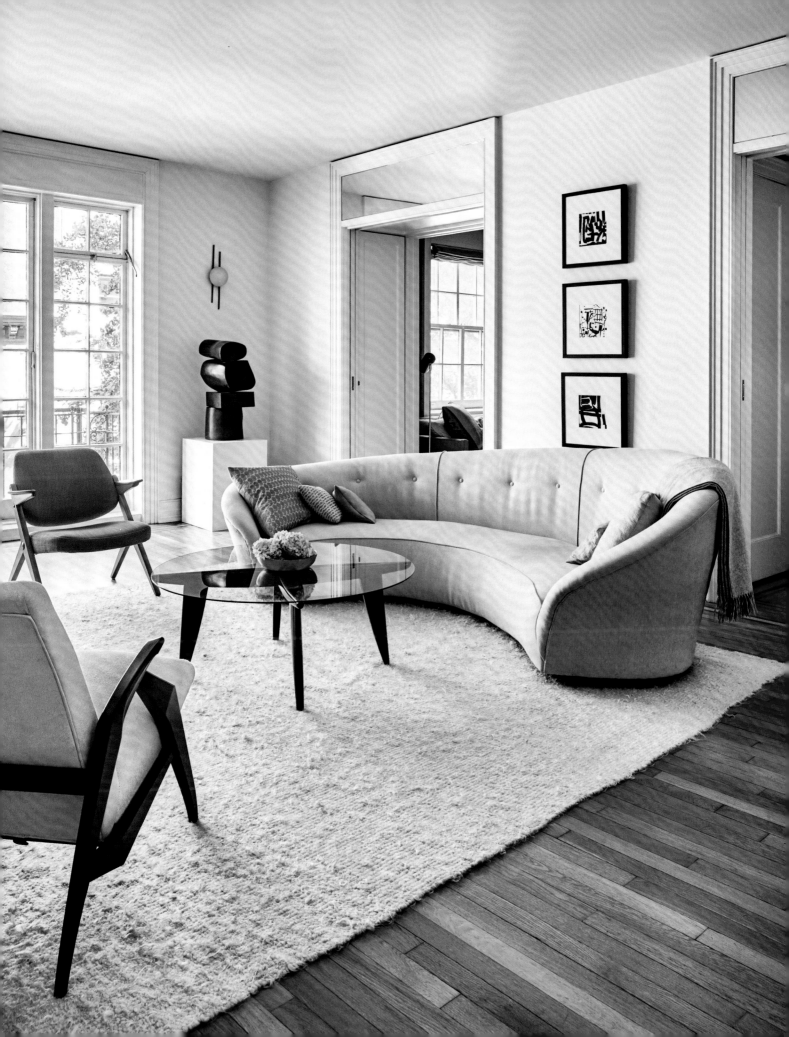

Michaels wanted the apartment to retain the same flavor from when it was built in 1925 but render it more Bauhaus than Art Deco. In order to meet these objectives, she removed the crown moldings, raised the door moldings to the ceiling and added a mirror to the transom space to reflect light.

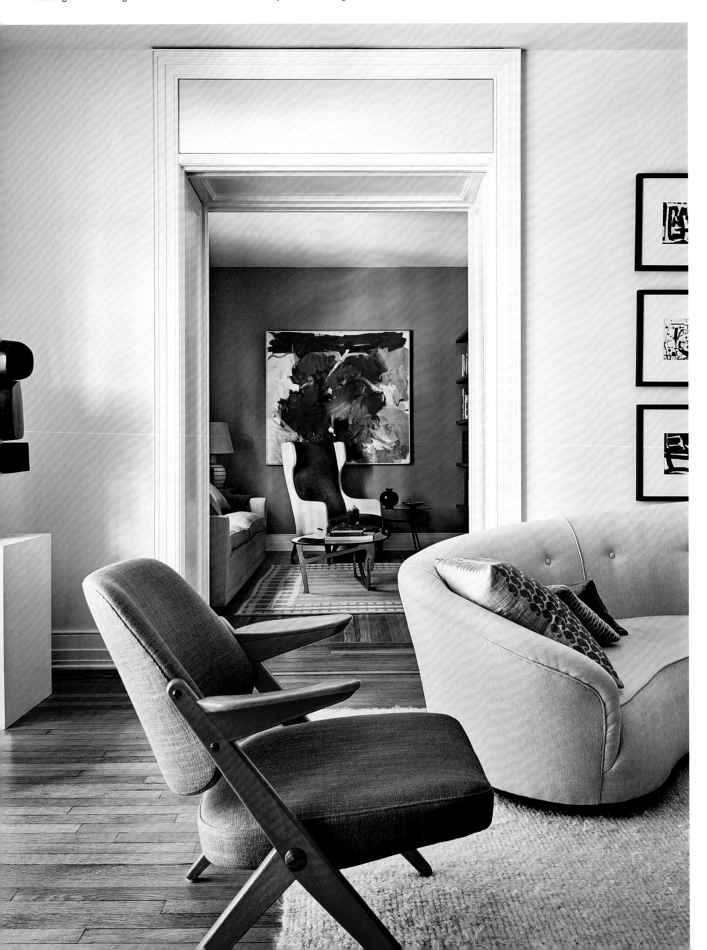

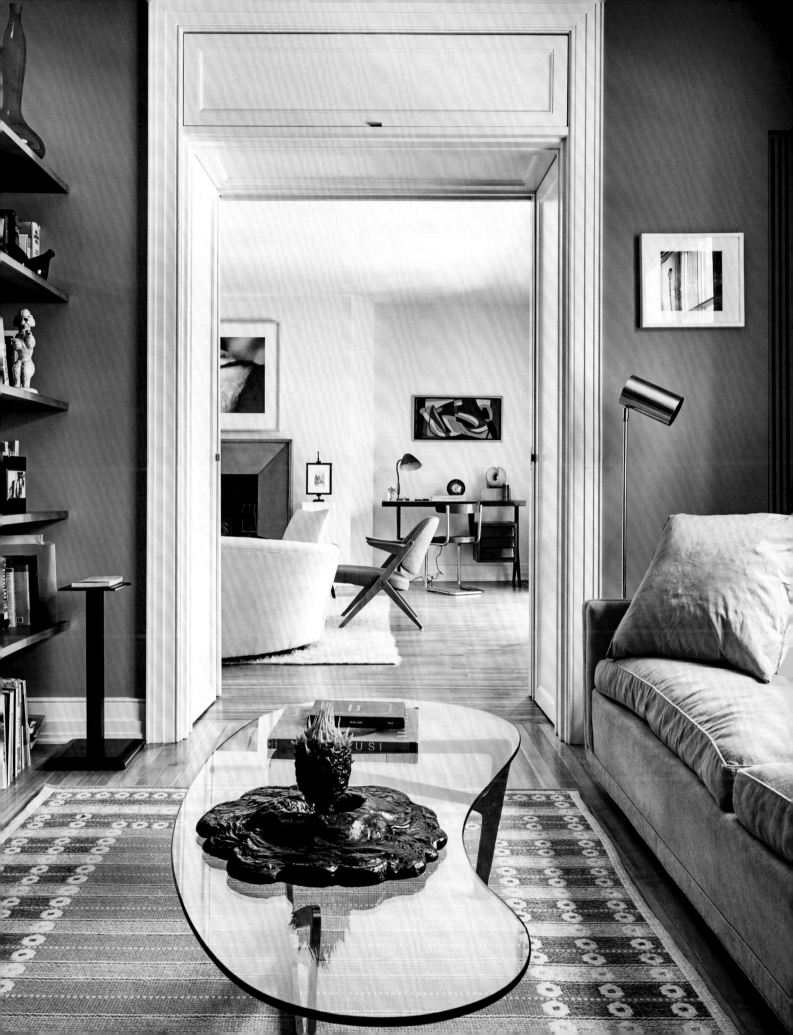

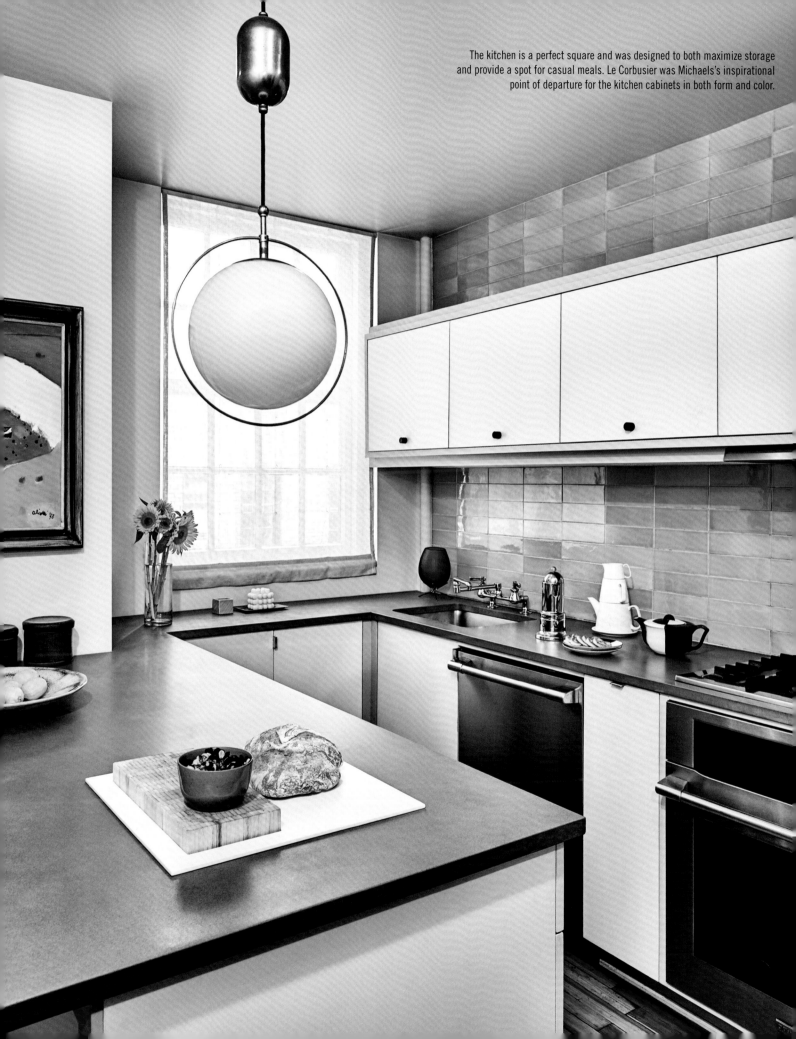

The kitchen is a perfect square and was designed to both maximize storage and provide a spot for casual meals. Le Corbusier was Michaels's inspirational point of departure for the kitchen cabinets in both form and color.

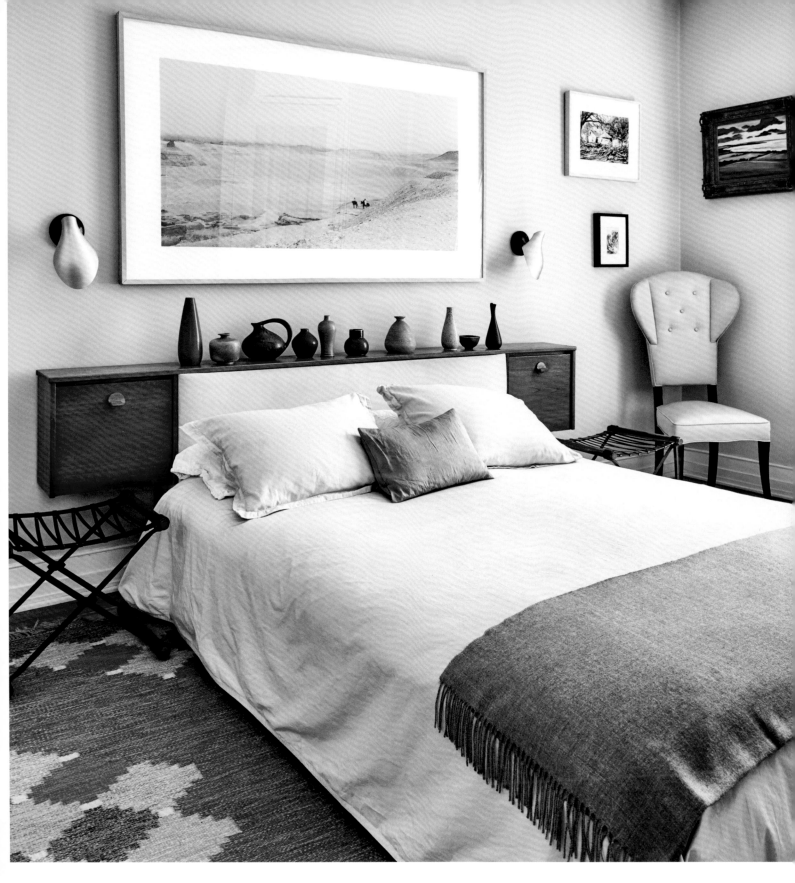

Calming hues continue in the bedroom. A mid-century
headboard provides additional storage as well as a spot
to display Michaels's collection of vintage ceramics.

JOAN MICHAELS

When interior designer Joan Michaels found this one-bedroom in a storied 1928 Upper West Side building designed by Rosario Candela and just steps from Central Park, it was in a state of overwhelming disrepair. The previous owner had lived there for decades and, unfortunately, died in the apartment. Maintenance had not been done in years. The floors were stained and worn, and the walls were a sea of peeling paint. But Michaels saw past the decay and was taken with the gracious layout with an ample foyer, the large eat-in kitchen, the windowed bathroom (complete with the original fixtures and tiles), and the ingenious circular flow that allowed one to access the bedroom from both the living room and the kitchen with an adjacent bath.

Michaels was also attracted to the southern exposure and light, the character of the building, and the interior details, like the moldings that she was able to bring back to life. The sunny quality of the space inspired her to incorporate light paint colors and refinish the original wood floors in a light but natural color. The relatively low ceiling heights encouraged Michaels to use low-slung furnishings wherever possible. Like in her design practice, which she shares with her twin sister, Jayne (page 238), Michaels was attracted to all things "slightly Scandinavian" for her own home. She appreciates the light, airy feel and commitment to materials in as natural a state as possible that are hallmarks of mid-century Scandinavian design, and hoped to infuse the apartment with that casual yet elegant feeling.

The centerpiece of the living room is a magnificent vintage French Art Deco carpet by Paule Leleu, which sets the tone both chromatically and stylistically for the entire space. The rich off-white, gray, and blue geometric patterns seem to introduce and frame all the other objects in the home, from the cream-colored Edward Wormley sofa to the buttery patina on the Florence Knoll console from the 1940s. Michaels is particularly fond of her photograph of a woman's eyebrow by Sam Samore. She has owned it for many years and claims to never tire of staring at it—"it's modern and mysterious." And for Michaels, those are qualities she seems to never exhaust.

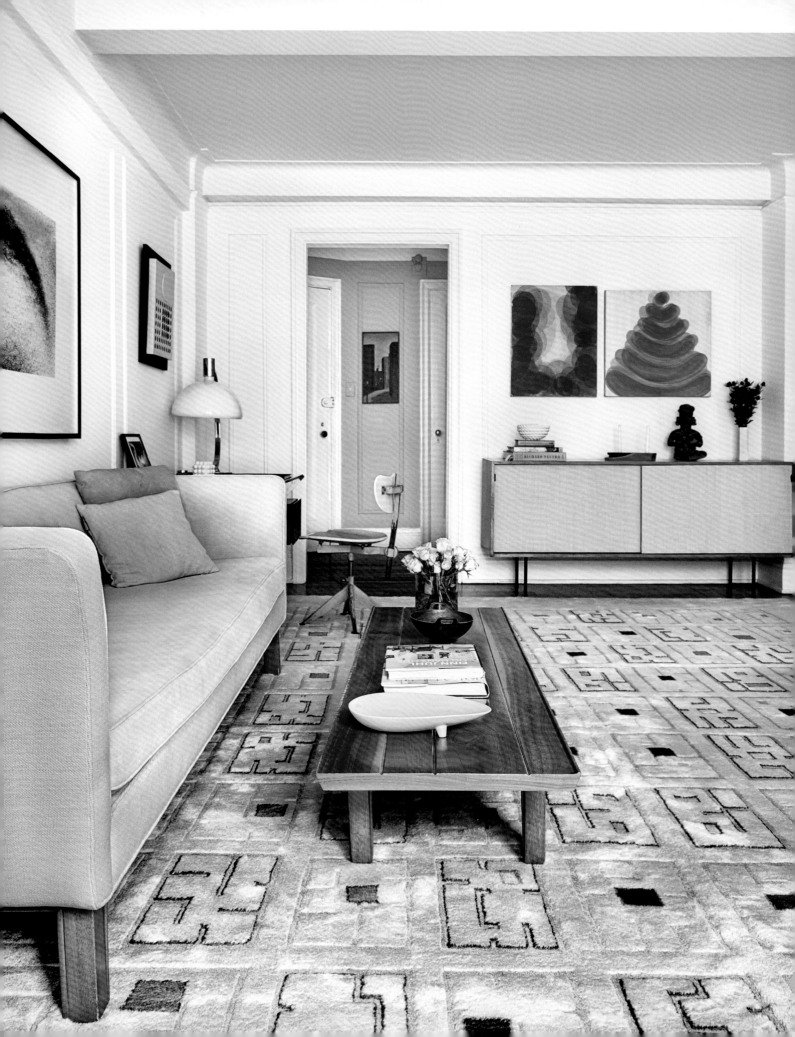

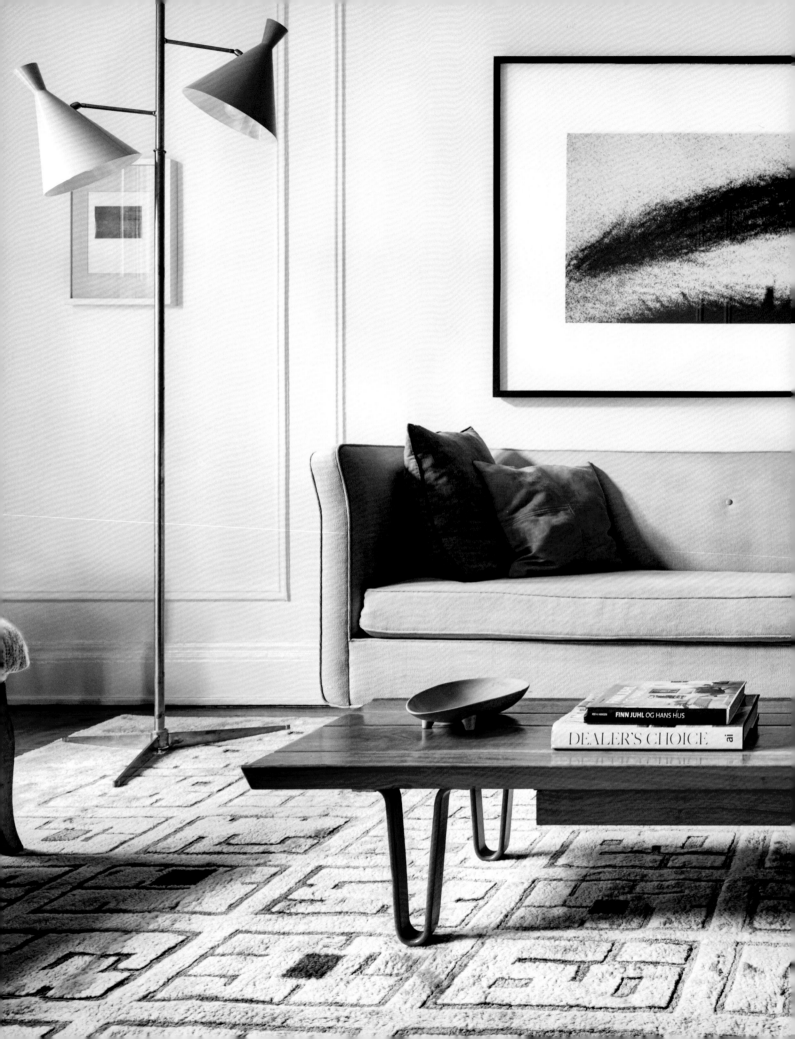

On the books on the coffee table: FINN JUHL OG HANS HUS · DEALER'S CHOICE ai

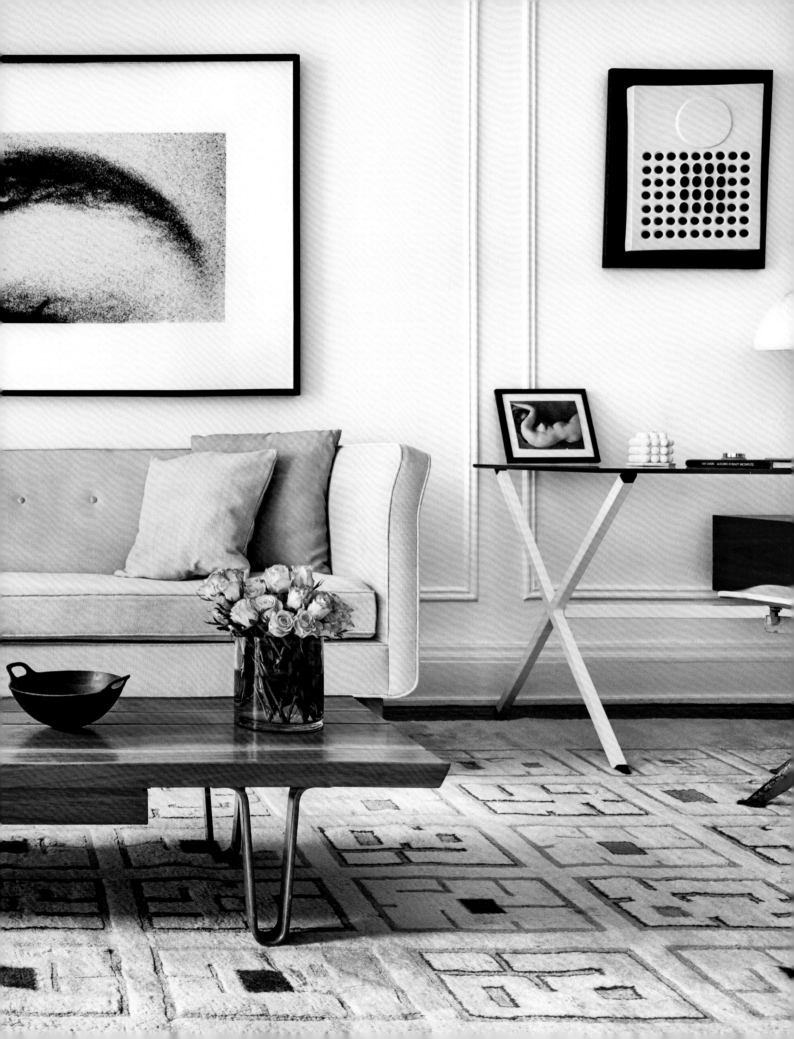

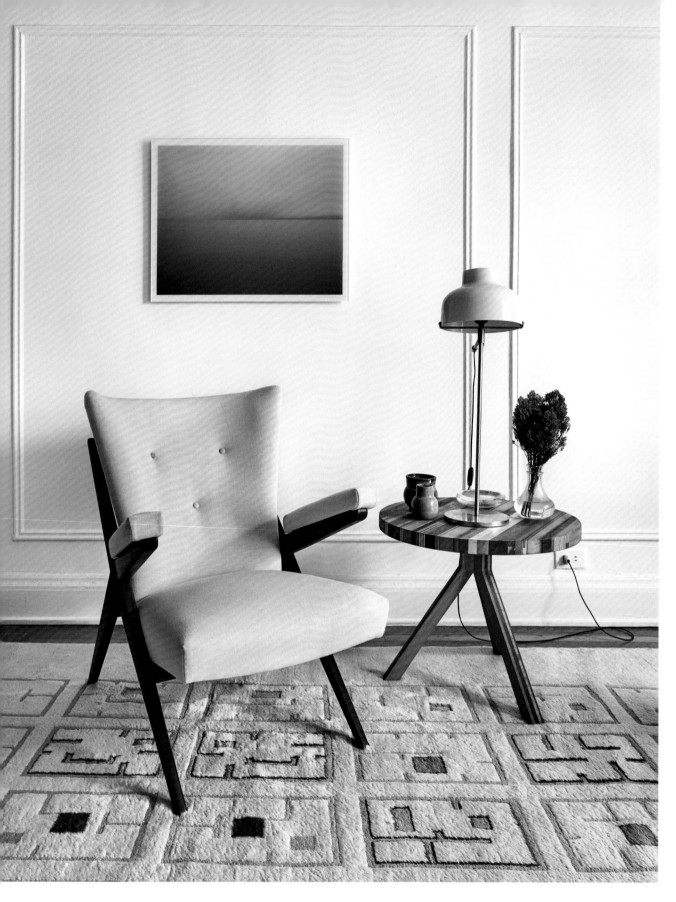

Michaels wanted the apartment to feel light and airy and slightly Scandinavian. She used furnishings sparingly and kept the colors light or reminiscent of the sky, which is seen in abundance from her south-facing windows. In the living room, a magnificent French Art Deco rug by Paule Leleu creates the perfect chromatic backdrop for Michaels's eclectic collection of American and European mid-century furnishings. An Edward Wormley sofa sits below a photograph by Sam Samore. The room also hosts a Florence Knoll console from the 1940s that has a buttery patina Michaels is very fond of.

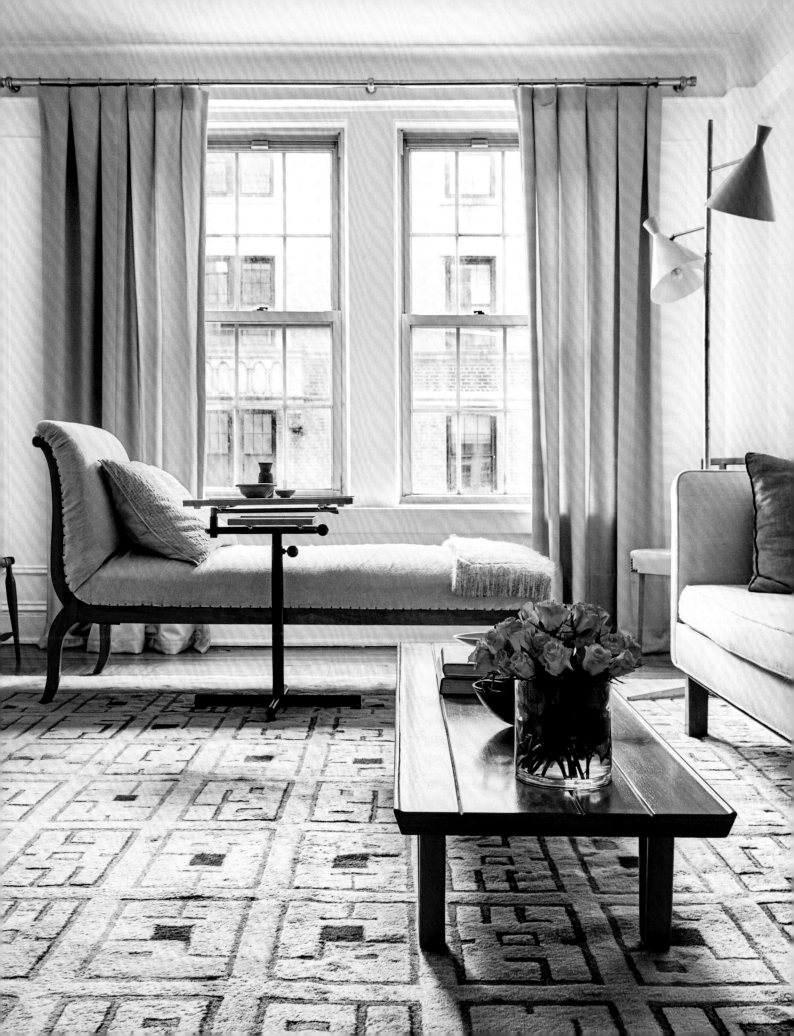

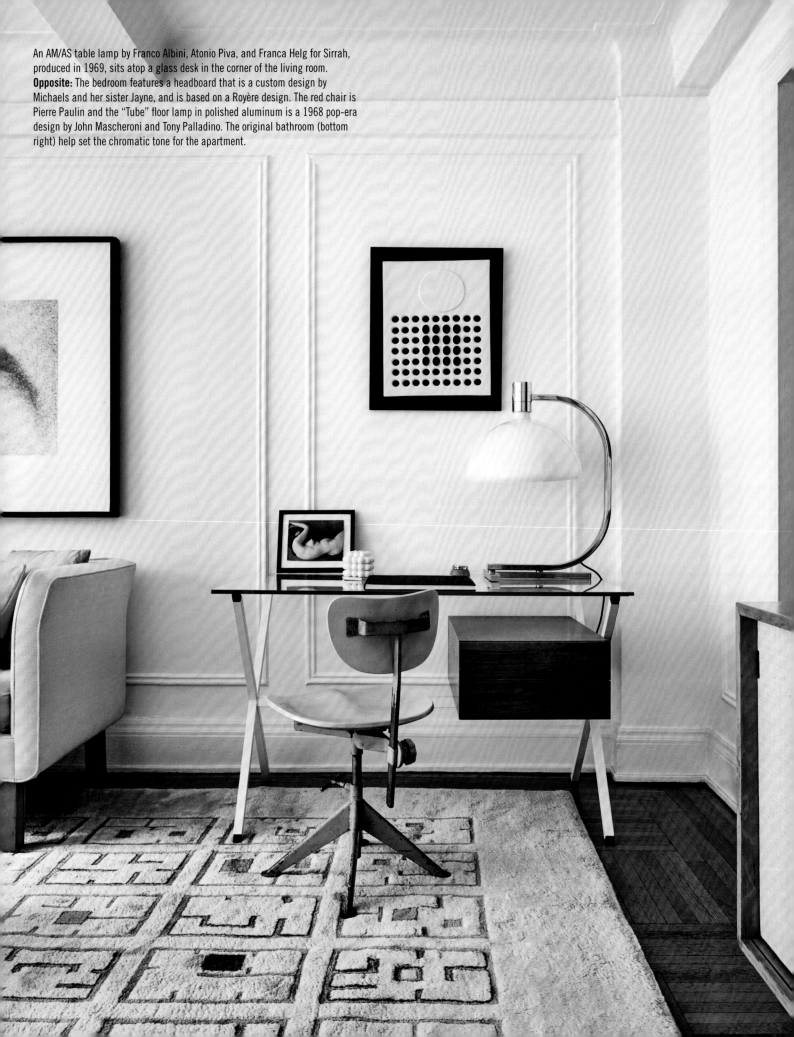

An AM/AS table lamp by Franco Albini, Atonio Piva, and Franca Helg for Sirrah, produced in 1969, sits atop a glass desk in the corner of the living room.
Opposite: The bedroom features a headboard that is a custom design by Michaels and her sister Jayne, and is based on a Royère design. The red chair is Pierre Paulin and the "Tube" floor lamp in polished aluminum is a 1968 pop-era design by John Mascheroni and Tony Palladino. The original bathroom (bottom right) help set the chromatic tone for the apartment.

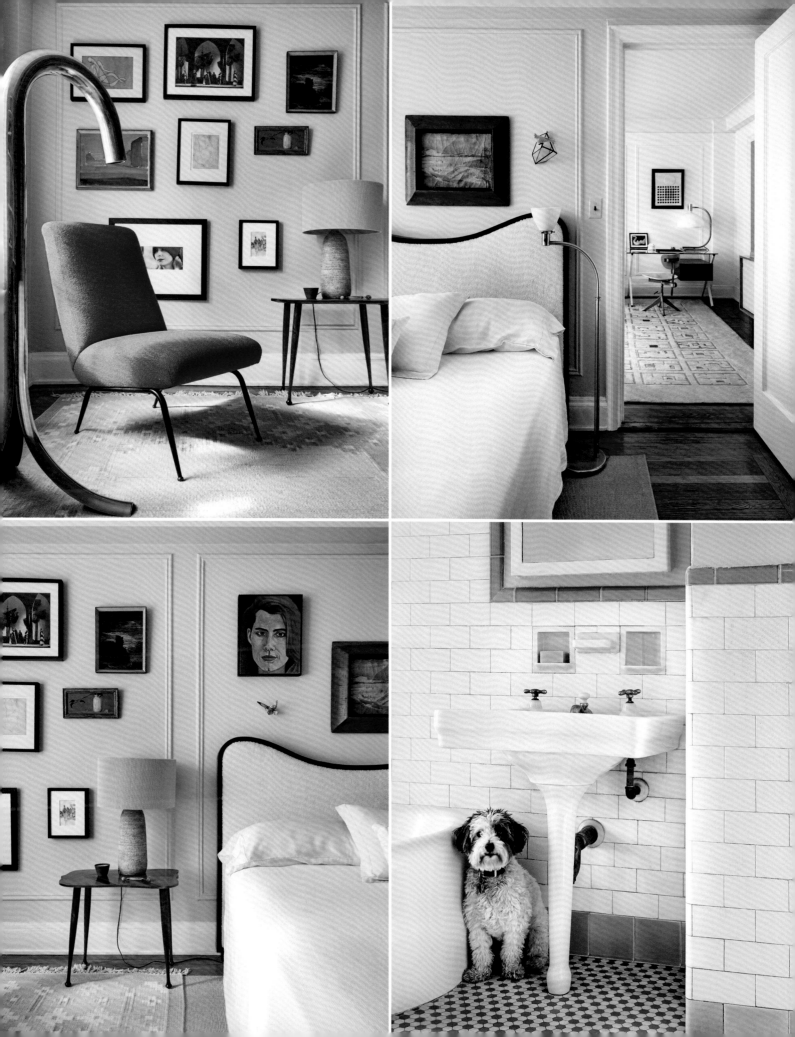

CARLOS OTERO

I t is hard to believe that the elegant Anglo-Italianate row house that now hosts Carlos Otero's duplex apartment had been boarded up for decades before a group of pioneering New Yorkers reclaimed the West Chelsea building and converted it into a series of apartments in the 1970s. Otero himself is no stranger to change. He was born in Argentina and studied architecture in his homeland before moving to New York; most recently, he has shifted away from architecture and interior design to working with ceramics. His home exists as a sort of laboratory for both of his interests.

The duplex was in a state of disrepair and neglect when Otero first encountered it, but the space, which occupies the original parlor floor—the level with the highest ceilings and largest windows—and part of the floor below, spoke to him. Otero renovated the entire space, taking full advantage of the fourteen-foot ceiling heights, returning the rooms to proportions in line with the size and scale of an 1850s row house, and celebrating the abundant light and views. At the back of the duplex, a single window and door led to a terrace overlooking the rear garden. Otero opened up the area with large French doors, allowing for more light to enter what he now uses as a library and home office. Otero installed the kitchen at the front of the space and maintained the remainder of the floor as a singular living and dining area, with the bedroom and bath below.

In an attempt to restore some of the original splendor, Otero researched the building's history to learn as much as he could about the earliest details. Crown moldings, chair rails, door frames, mantels, and baseboards were replaced or reinstalled, and the entire home was painted a single rich ecru. The choice to neutralize the details with one color imbues the space with a modern, almost minimalist feeling, a feeling that Otero fully embraces in the kitchen, bathrooms, and bedroom. In his research, Otero discovered that gold was often used around door frames, crown moldings, fireplace mantel mirrors, and chair rails in this type of town house. While his approach was decidedly modern, he applied a soft gold leaf around some of the door frames to provide the space with extra depth, visual interest, and light, and to tie the original details to some of the modern brass touches around the apartment. The end result is a refined balance between embracing the history of the space and creating a modern, vibrant home and workspace.

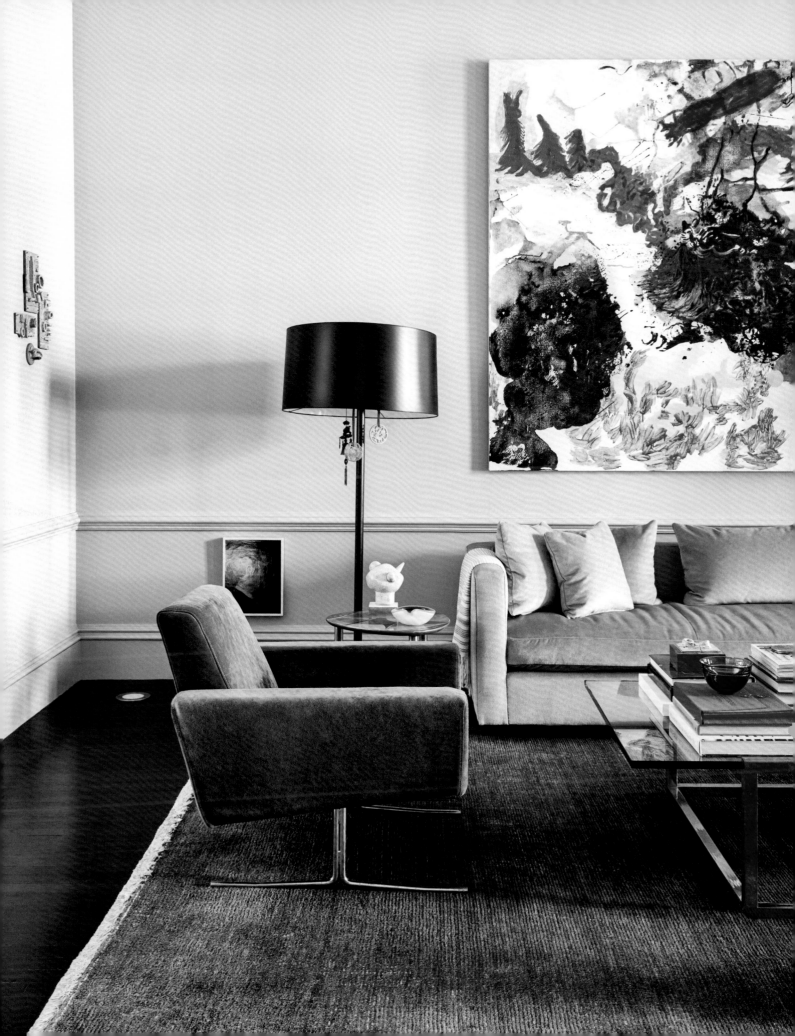

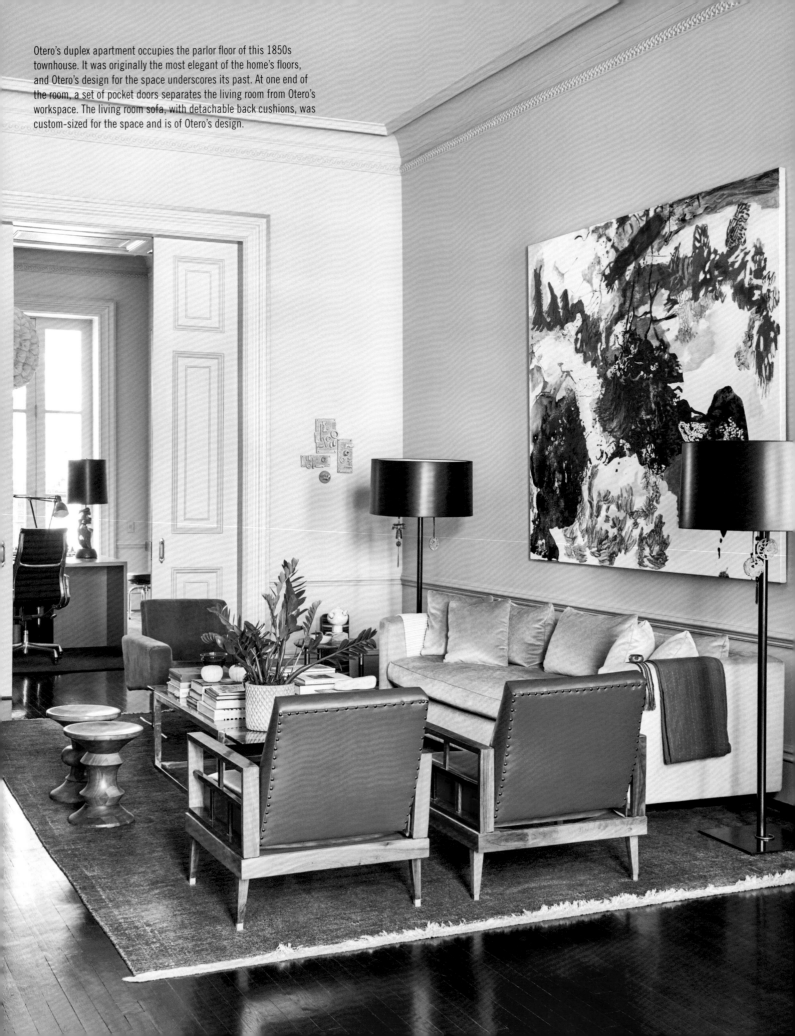

Otero's duplex apartment occupies the parlor floor of this 1850s townhouse. It was originally the most elegant of the home's floors, and Otero's design for the space underscores its past. At one end of the room, a set of pocket doors separates the living room from Otero's workspace. The living room sofa, with detachable back cushions, was custom-sized for the space and is of Otero's design.

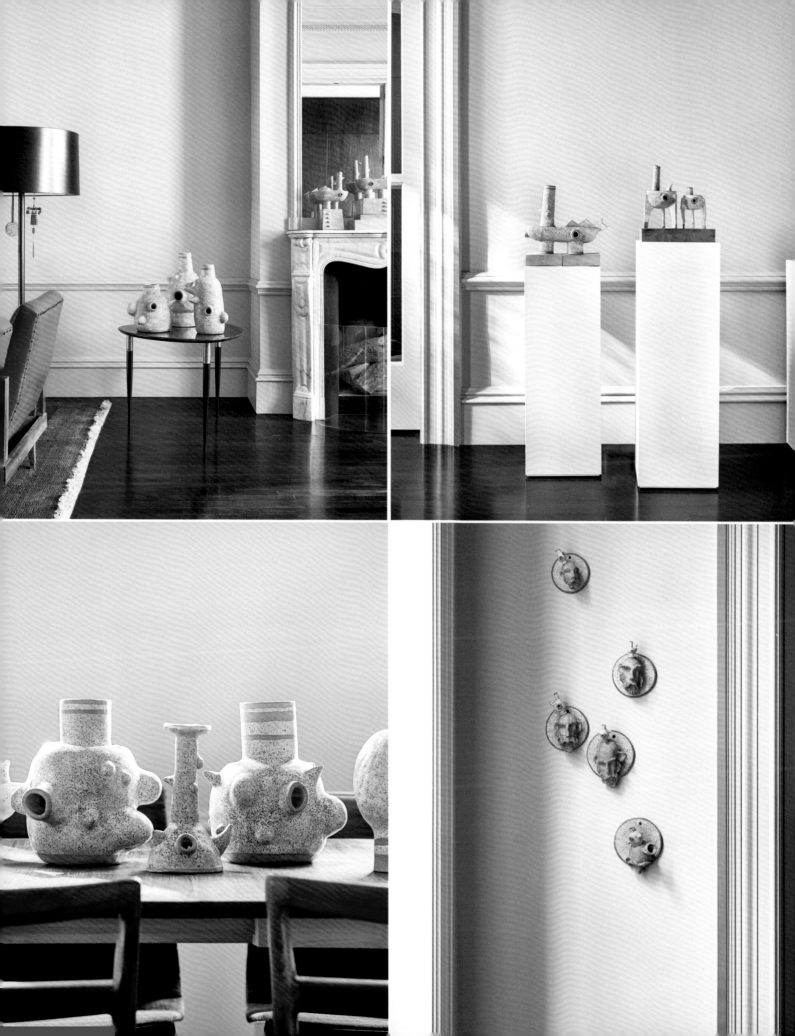

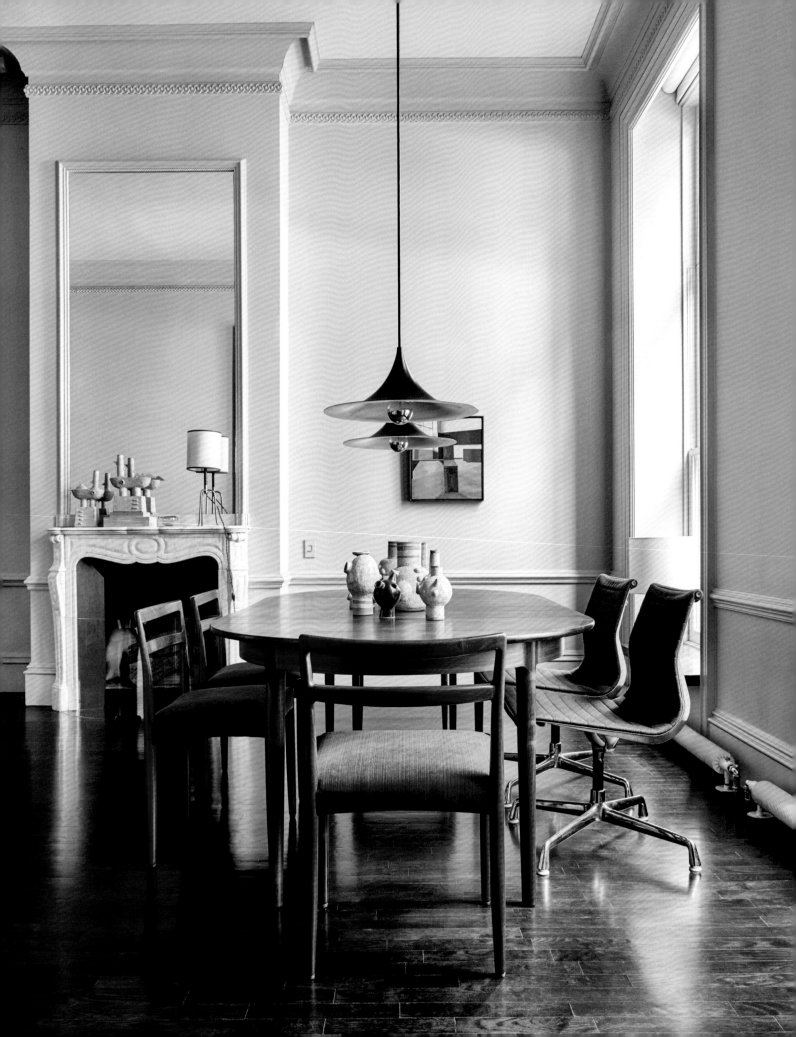

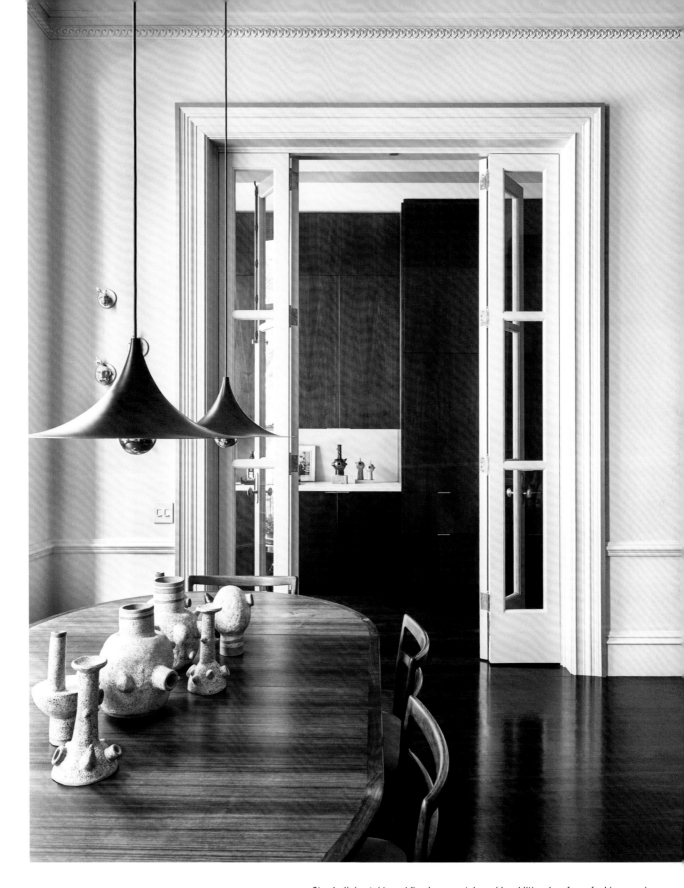

Otero's dining table and fireplace mantel provide additional surfaces for his ceramic works, which are displayed throughout the space. The kitchen, located off the dining area, features walnut cabinets designed by Otero that he stained as dark as possible while still showing the walnut grain. The counters and backsplashes are Corian.

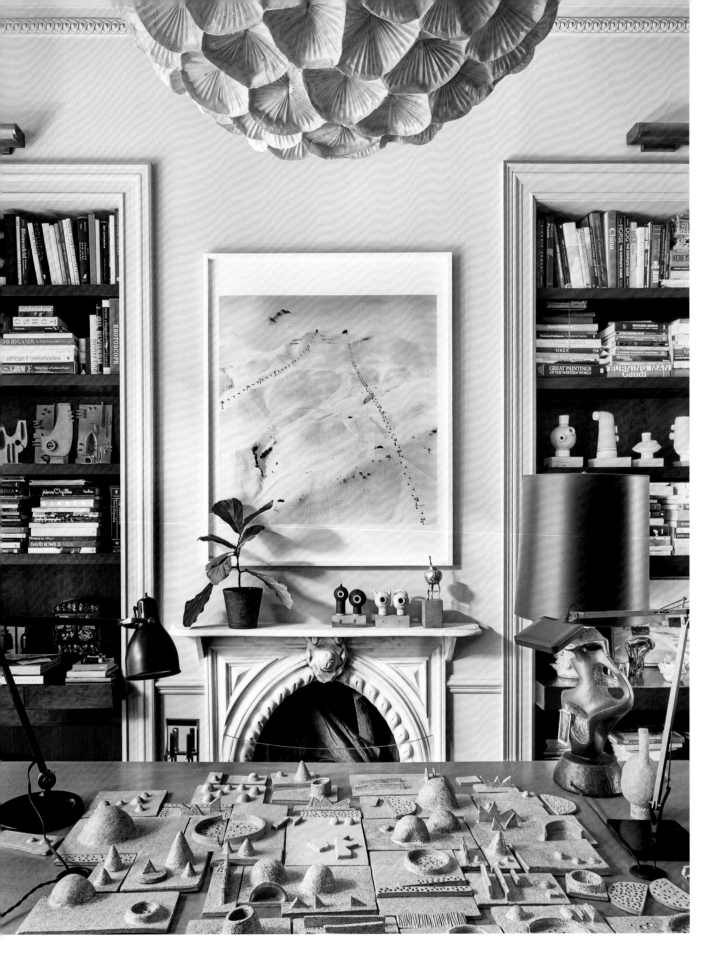

A beautifully proportioned room at the back of the parlor floor serves as Otero's home office.
Here, the tabletop is covered with ceramic tiles of Otero's own design and production,
which he was experimenting with before they eventually became part of a wall installation.

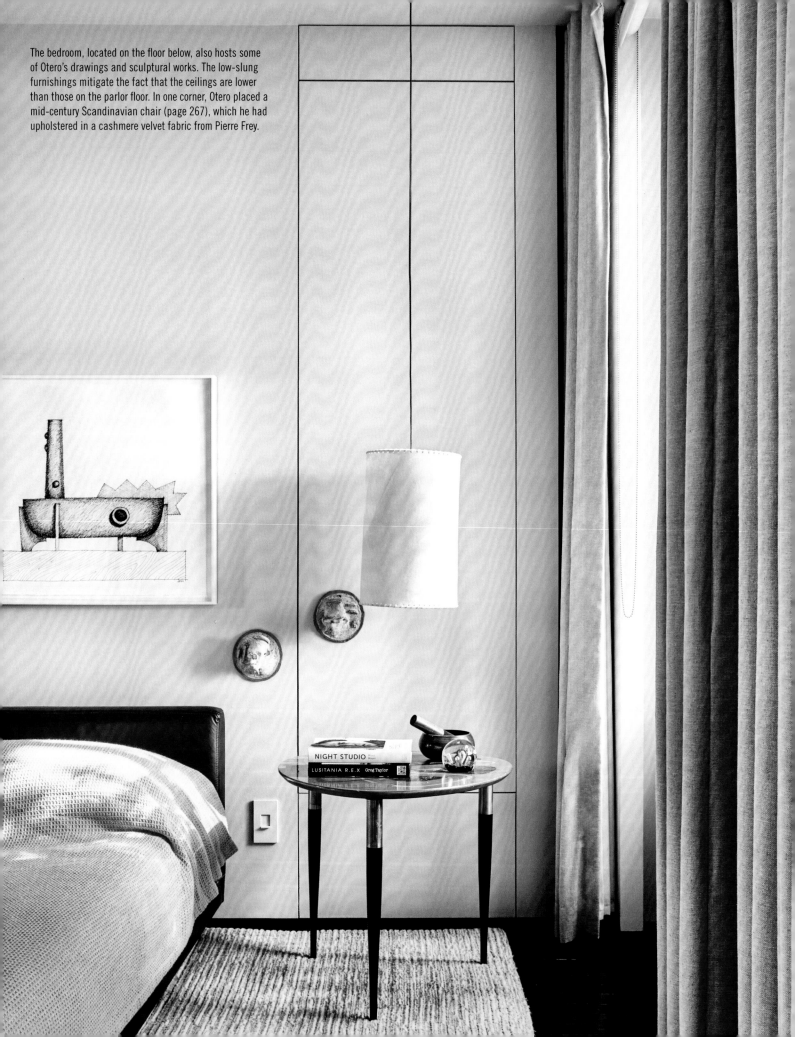

The bedroom, located on the floor below, also hosts some of Otero's drawings and sculptural works. The low-slung furnishings mitigate the fact that the ceilings are lower than those on the parlor floor. In one corner, Otero placed a mid-century Scandinavian chair (page 267), which he had upholstered in a cashmere velvet fabric from Pierre Frey.

NIGHT STUDIO

LUSITANIA R.E.X Greg Taylor

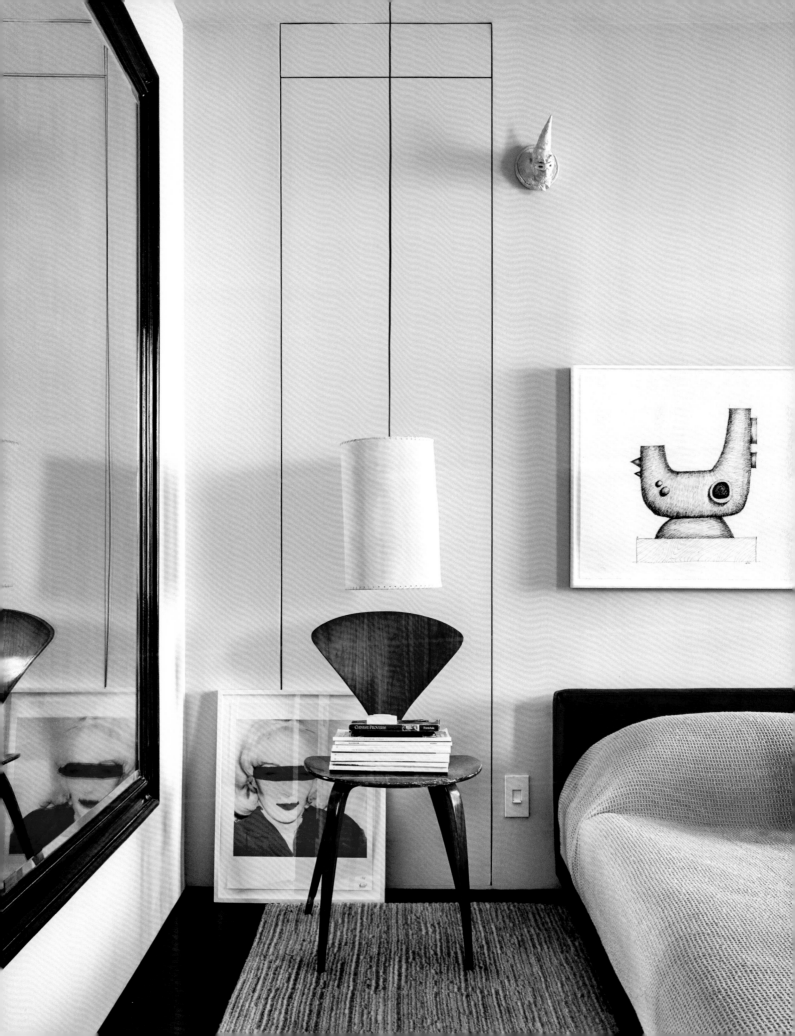

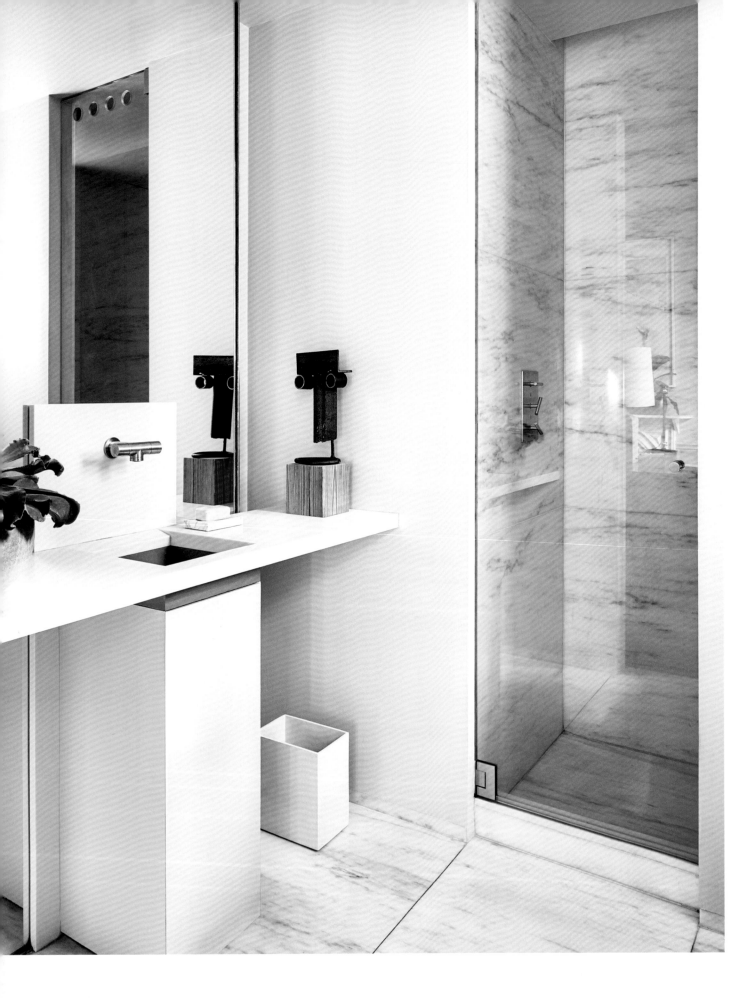

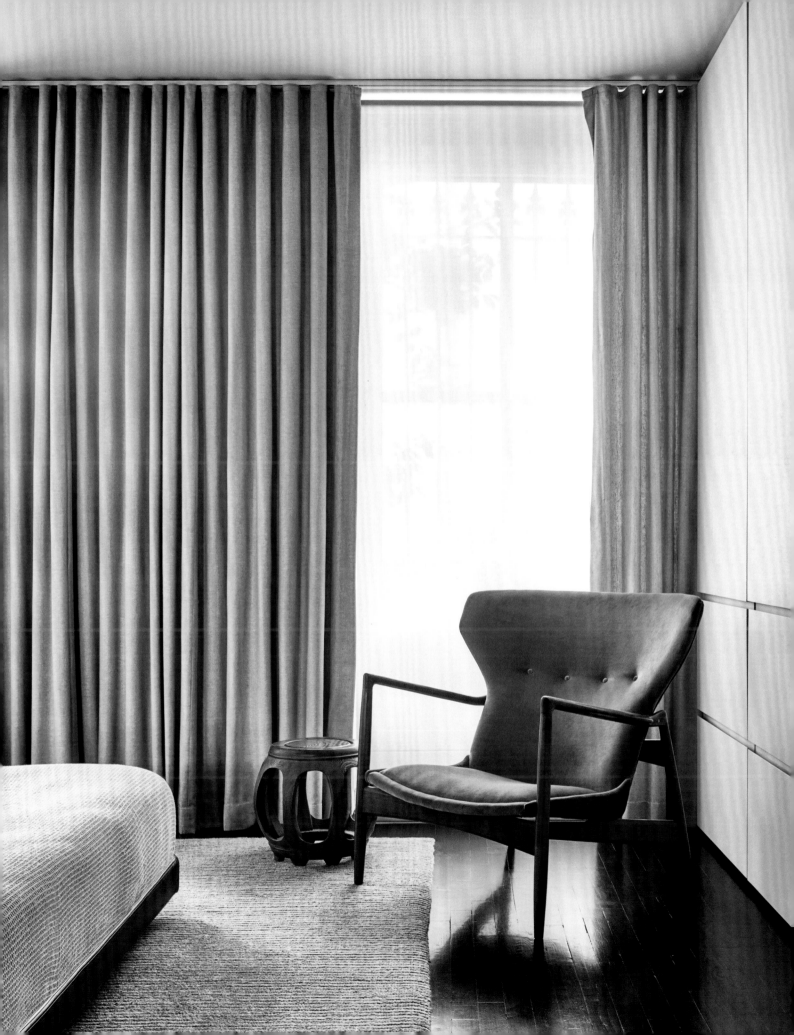

CHARLES RENFRO

Before moving into this Garment District manufacturing building, which was converted into housing in the early 1980s, Charles Renfro lived in a sprawling Williamsburg loft with giant industrial windows, concrete floors, high ceilings, and no interior walls. Renfro, in a spirit he has since incorporated into some of his important architectural commissions, made a giant rolling door, eighteen feet long and ten feet high, that traveled from one end of the loft to the other, establishing several spaces in the process. It was made of the cheapest, most durable material he could find: plywood. But Renfro didn't just want to expose the face of the plywood—Frank Gehry, he believes, had forever stripped the material of its ability to be neutral—so instead, he cut 1½-inch-wide strips and painstakingly glued them together to make the whole surface feel like an impossibly thick chunk of plywood. There were more than one hundred laminations in the door. When the time came for Renfro to move, he couldn't stand to leave behind the giant door that had given his loft so much character, so he cut it into several pieces to bring with him.

The new space was a classic early-1980s conversion plagued with inappropriate and inexpensive materials and a bedroom created with a curved, glass-block wall that cut into the space and eliminated any hint of its lofty past. Renfro removed the glass-block wall and made every effort to return the space to its open, industrial past so that light from the twelve windows would be everywhere. He even worked in the door from his old apartment. The plywood is now a screen that conceals the bed and the kitchen counter in his new home. Carrying the material with him provided a certain connection to his past and also solved some problems within the apartment.

Renfro thought that the combination of the industrial and the custom was right for the space and the neighborhood. He designed a Pullman-style kitchen with custom cabinets and used vintage steel-and-glass barrister cabinets to create an island. When it came to the bathroom and closet suite, he made a long, interconnected space: A full bath leads to a half bath, which leads into a laundry room, which connects to a large walk-in closet. All of these spaces were designed so they can be independently closed off or opened to one another. Guests are able to access the wet suite without disturbing the master sleeping area, and the owners can also flow undetected from one side of the apartment to the other if needed. Renfro is drawn to the playful, and the Pigro sink by Mary Ellen Carroll in the half bath provides some whimsy, as does his collection of art and furnishings. Renfro's apartment is a palimpsest of his life: There are pieces of furniture from his first dorm room, objects of value paired with Dumpster finds, contemporary art, and new and vintage design objects. They are all put together to create an intimate and personal space that seems to celebrate both New York and Renfro's creative spirit.

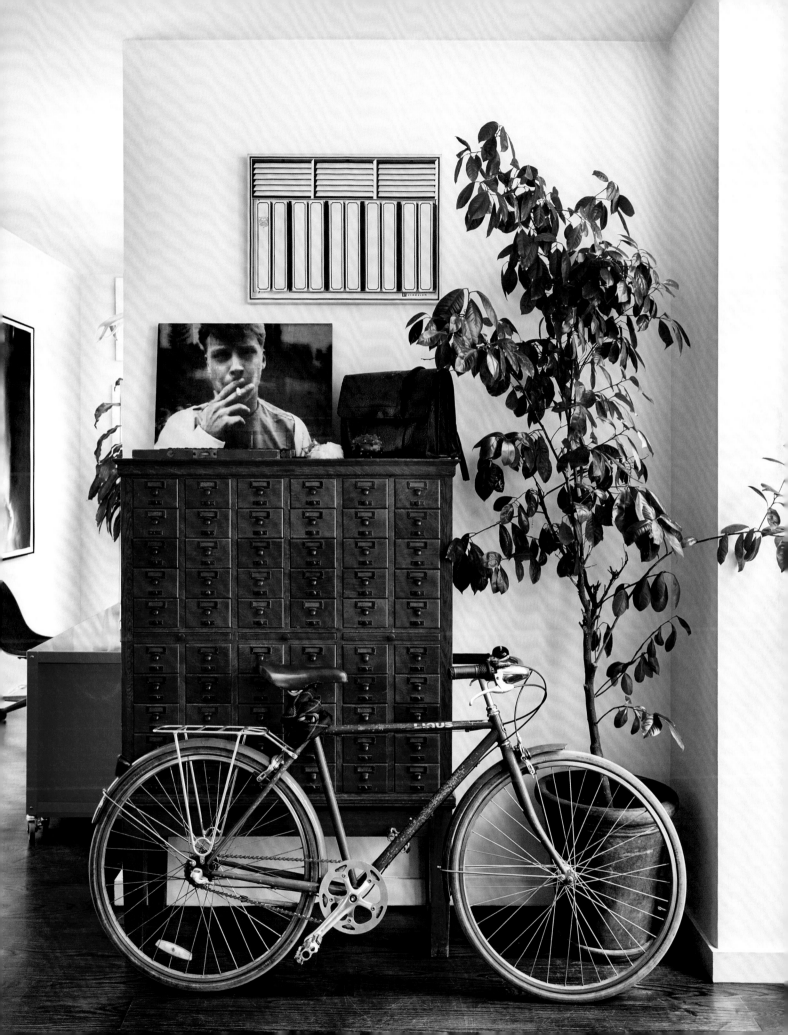

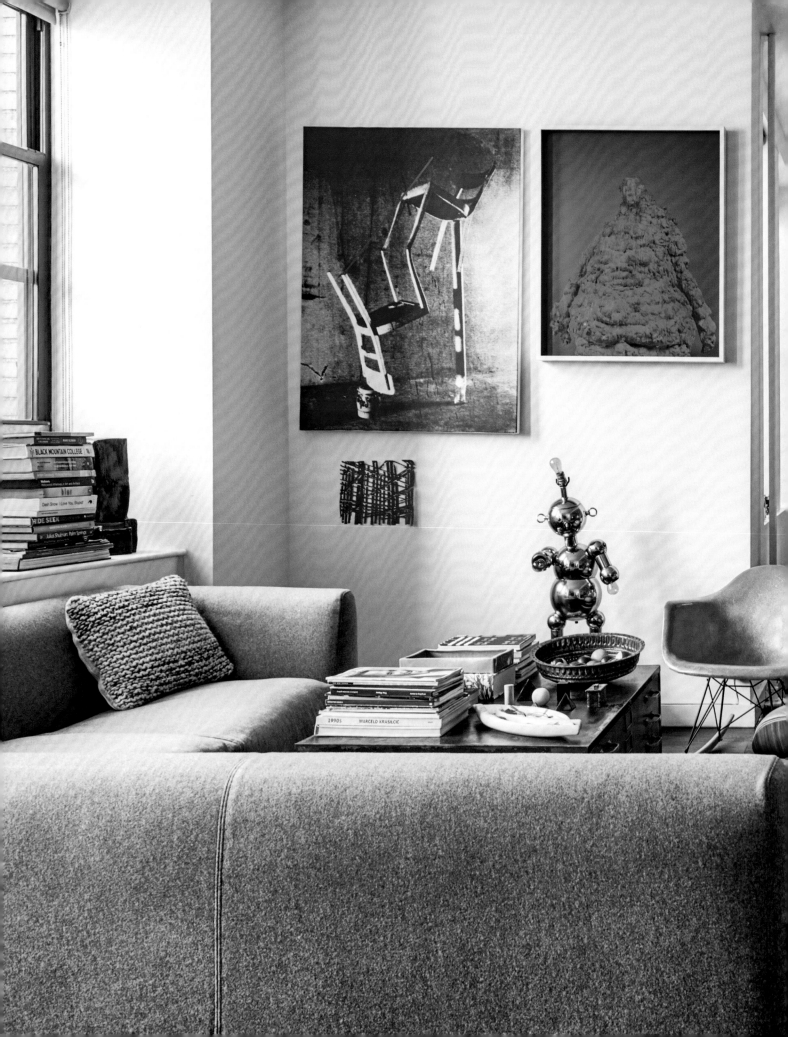

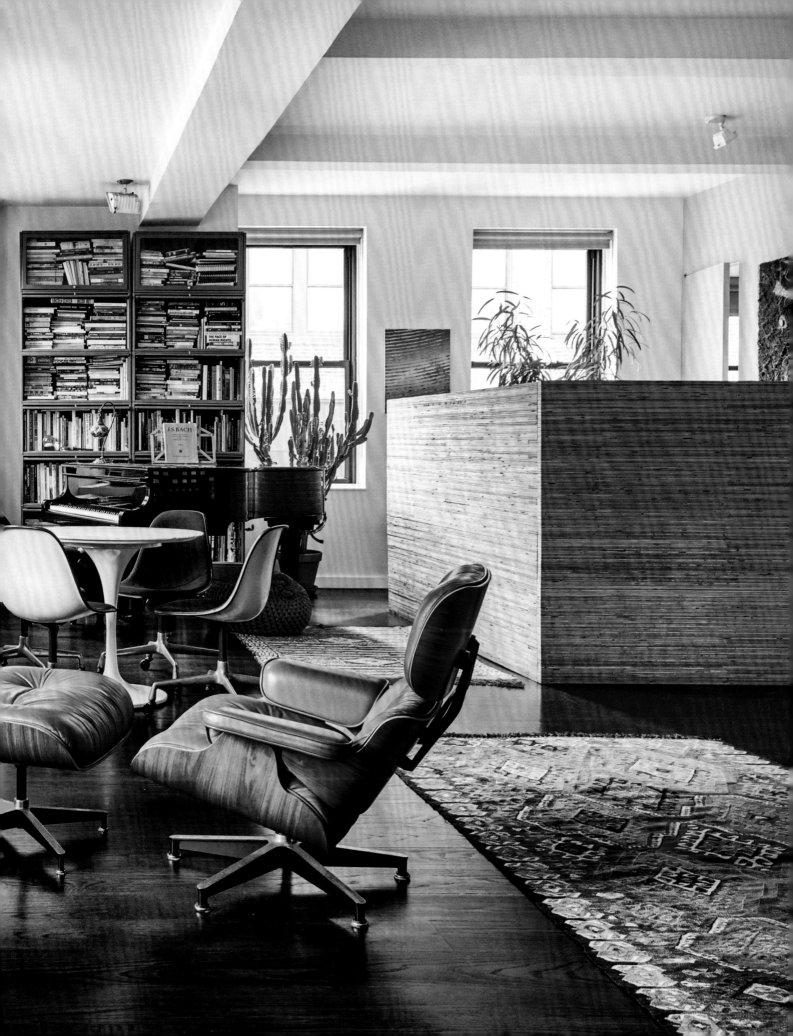

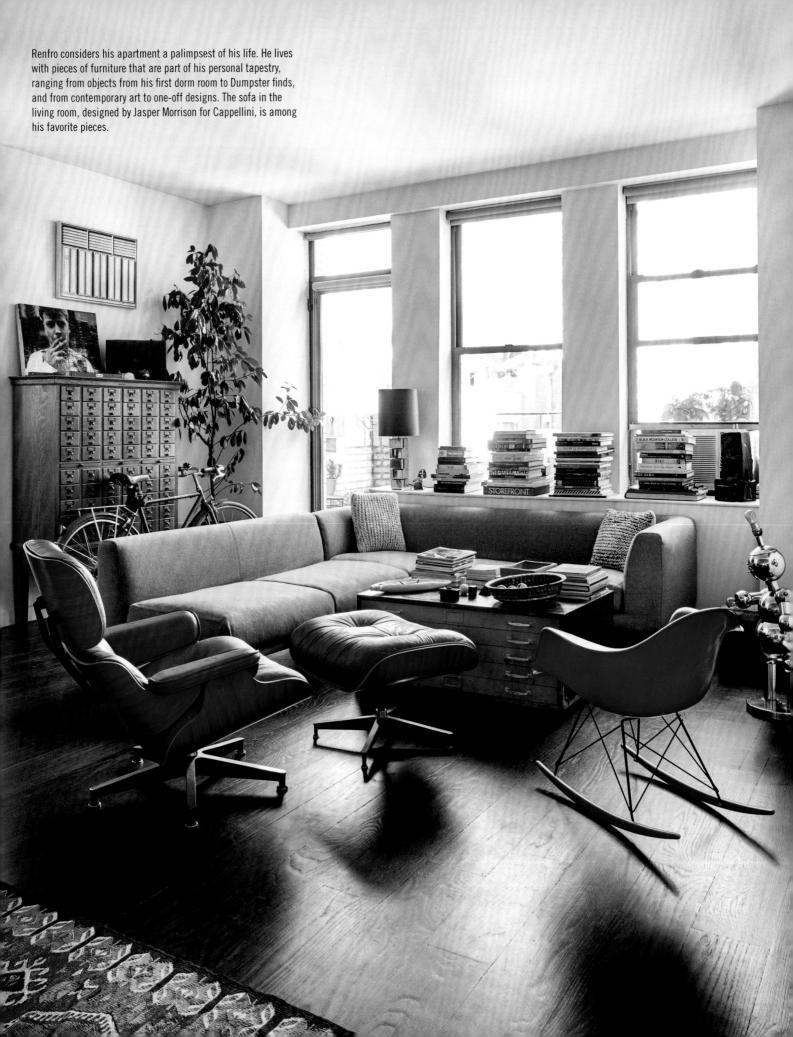

Renfro considers his apartment a palimpsest of his life. He lives with pieces of furniture that are part of his personal tapestry, ranging from objects from his first dorm room to Dumpster finds, and from contemporary art to one-off designs. The sofa in the living room, designed by Jasper Morrison for Cappellini, is among his favorite pieces.

THE BROAD AN ART MUSEUM DESIGNED
DILLER SCOFIDIO + RENFRO

Alan Cumming / Grant Shaffer The Adventures of HONEY & LEON Random House

Чувство города Sence of the City
СЕРГЕЙ КУЗНЕЦОВ SERGEY KUZNETSOV MAMM 20
АРХИТЕКТУРНАЯ ГРАФИКА ARCHITECTURAL GRAPHICS

TESTING TO FAILURE
DESIGN AND RESEARCH IN MIT'S DEPARTMENT OF ARCHITECTURE

DAVID LEVENTI OPERA DAMIANI

WOLVES LIKE US Portraits of the Angulo Brothers by Dan Martensen DAMIANI

DESIGN | ART | ARCHITECTURE CULTURED CULTUREDMAG.COM FALL 2015

Jenni Olson THE QUEER MOVIE POSTER BOOK

SURFACE "I KNOW EXACTLY WHAT I WANT: SIMPLICITY AND ELEGANCE" —PETER MARINO SURFACEMAG.COM

PETER PRAN of NBBJ realizations

axel vervoordt wabi inspirations Flammarion

ESOPUS SPECIAL COLLECTIONS 20

ARTISTS' Handmade HOUSES

LISA D. FREIMAN AZIZ + CUCHER

ASOCIACIÓN DE OFICINAS DE ARQUITECTOS CHILE

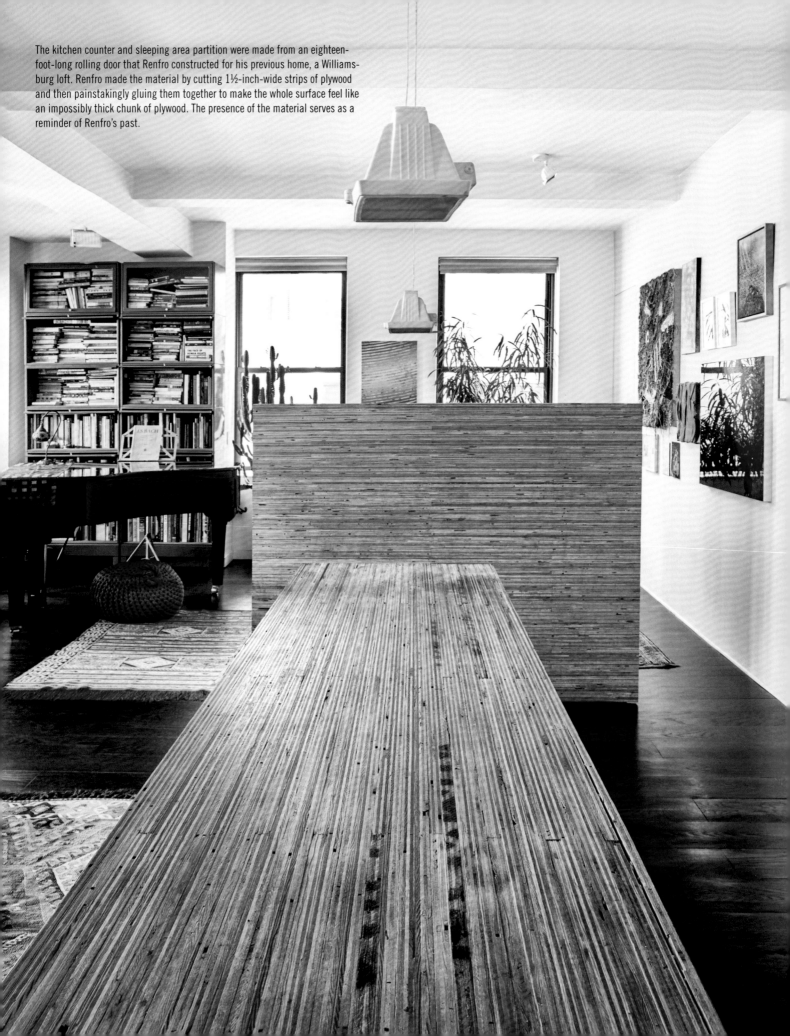

The kitchen counter and sleeping area partition were made from an eighteen-foot-long rolling door that Renfro constructed for his previous home, a Williamsburg loft. Renfro made the material by cutting 1½-inch-wide strips of plywood and then painstakingly gluing them together to make the whole surface feel like an impossibly thick chunk of plywood. The presence of the material serves as a reminder of Renfro's past.

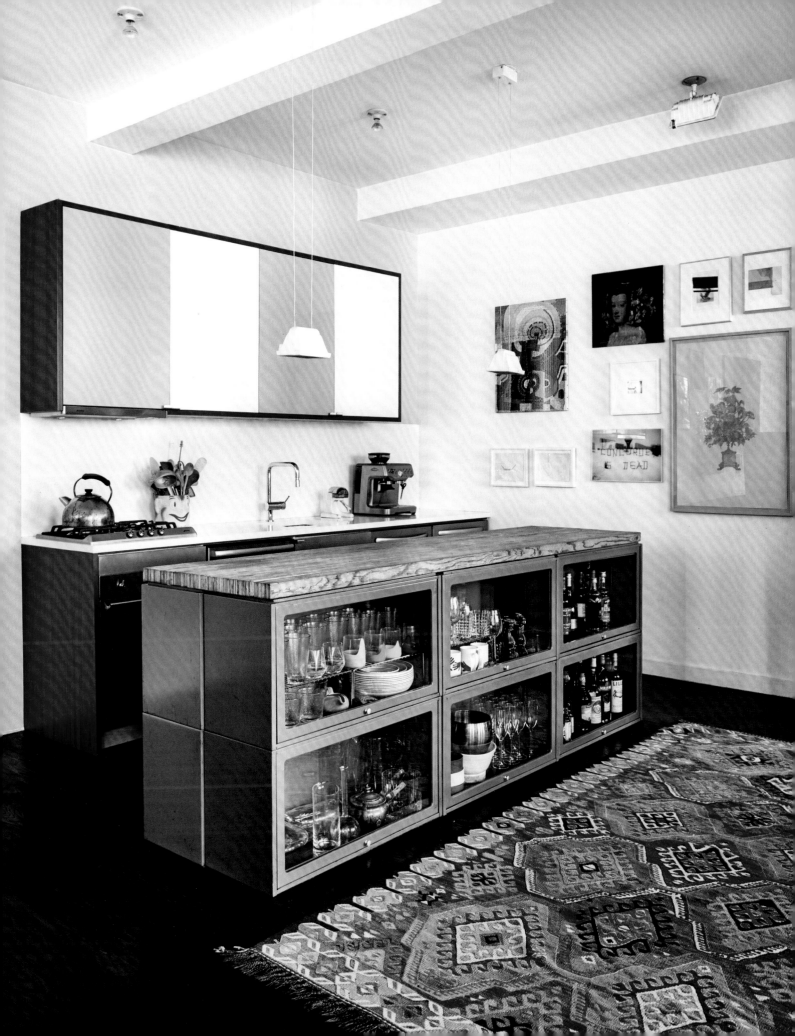

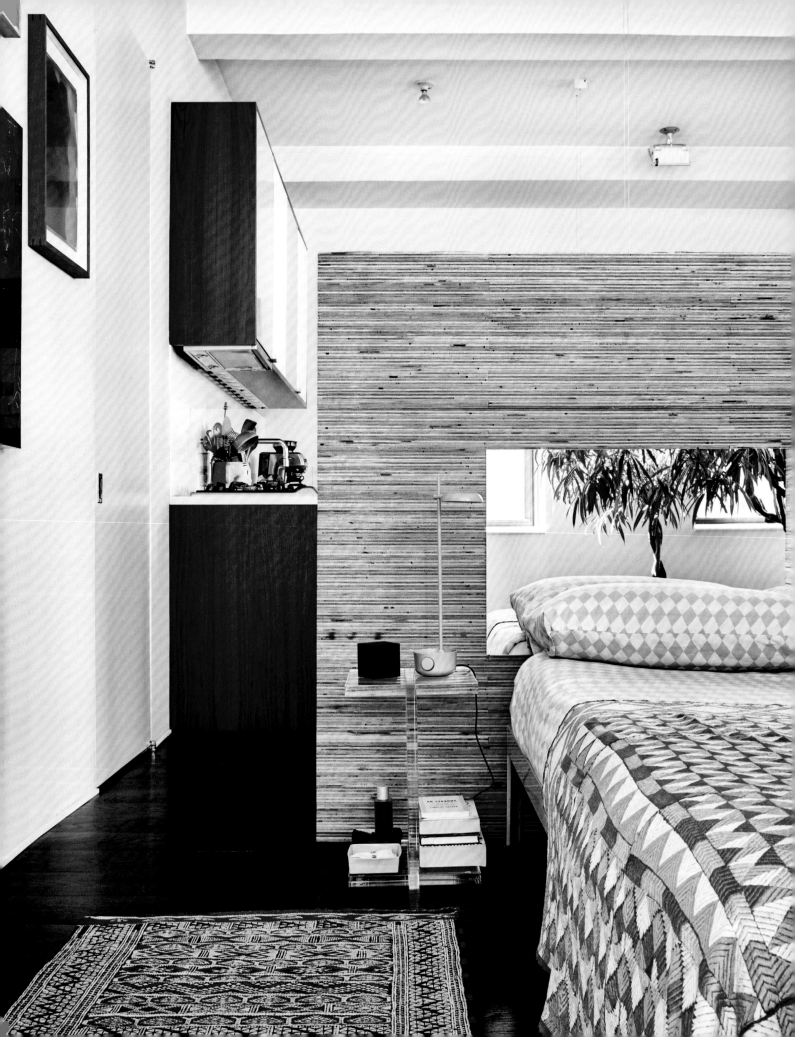

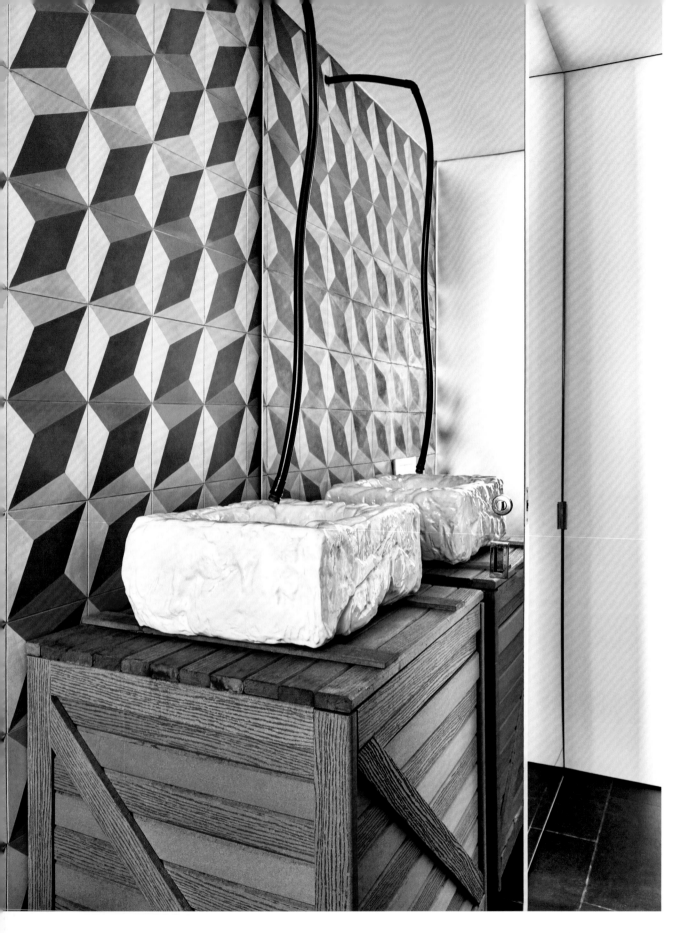

The centerpiece of the half bath is Mary Ellen Carroll's Pigro sink. Renfro chose it for its playful and surprising quality. The flow of water is activated by a foot pedal, and the water simply comes out of a garden hose hanging off the wall.

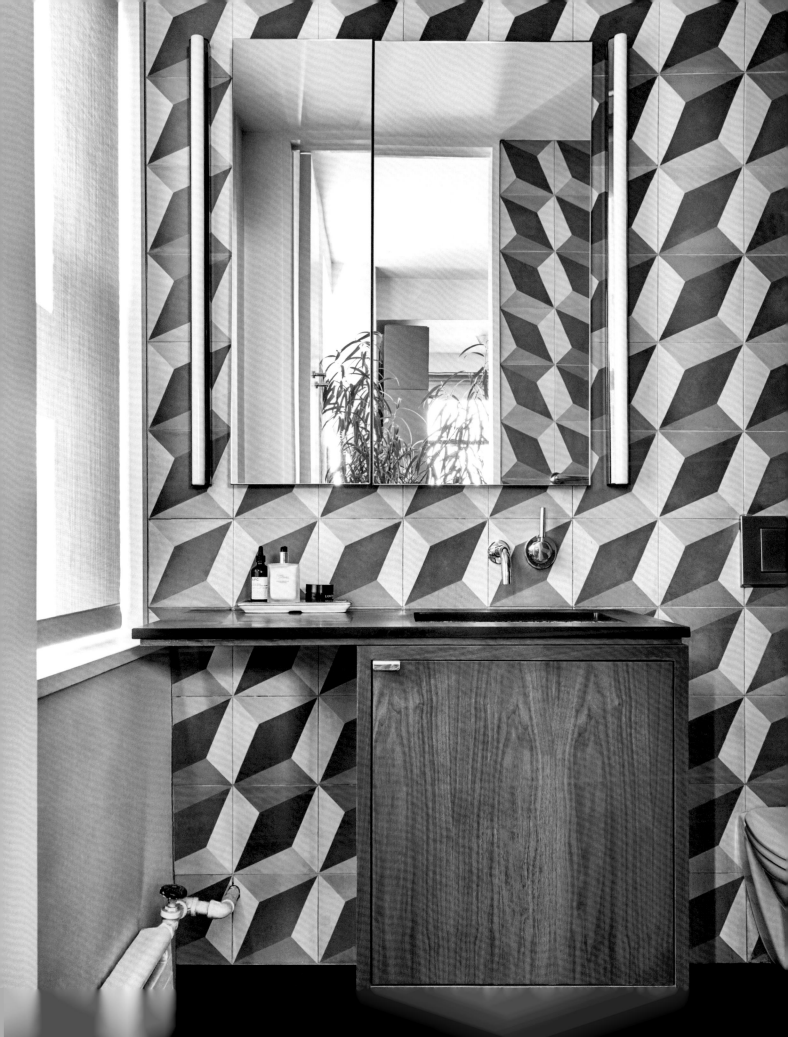

FRANKLIN SALASKY

When Franklin Salasky and his partner, Billy Gallo, found this late nineteenth-century town house in the Bedford-Stuyvesant neighborhood of Brooklyn, they fell in love with the historic streetscape, which seemed undisturbed since the neighborhood's establishment more than one hundred years ago. The midblock location and size and scale of the house also appealed to the couple. However, the home displayed a heavy, gloomy quality that Salasky found awkward and saw as reflecting poorly on the late Victorian era. It was also not in good condition. The couple did not want to take on a period restoration, but they were happy to leave any historical elements in place that could be polished up, especially if saving an existing piece meant not having to spend money, time, and resources on a new one. The renovation became a balancing act between appreciating the unique architectural character of the building and Salasky's passion for modernism.

For some inspiration, the couple turned to the approach of artists and designers converting lofts to residences in SoHo during the 1970s. After all, many of those loft buildings were from the same late Victorian period as their new home, albeit built for different purposes. They hoped to infuse the home with a sense of the improvisational and innovative design that governed the choices of loft dwellers some forty years earlier. In the kitchen, for example, plaster was removed to expose the underlying brick, which was then painted a deep blue. The plaster was also removed from the ceiling to expose the joists and ducting and conduit, tapping into a certain nostalgia associated with late 1970s loft living.

Prior to Salasky's renovation, there had been one of dubious quality during the 1960s or 1970s. Elements of that period's detailing remained, but these features were visibly compromised. Every mechanical device or system was very old, if not original, and in need of replacement. Budgets soared, and plywood, which entered the mix as an inexpensive material, introduced a great deal of improvisation and creativity into the renovation. In the living room, plywood was cut into "tiles," painted, and used as flooring. It was also white-washed and hung from the 10½-foot-high ceilings with a reveal at the wall that creates the illusion of an even higher ceiling; it was stained a dark blue and used to frame the windows; and it was laminated together for shelving. In the bath and powder room, plywood lined the walls; in the bedroom, it was used for the headboard. Salasky believes that interior detailing benefits from a few common denominators in the selection of materials. Plywood becomes that material here, and like the late Victorian details that remain, he chose to celebrate rather than hide its origins.

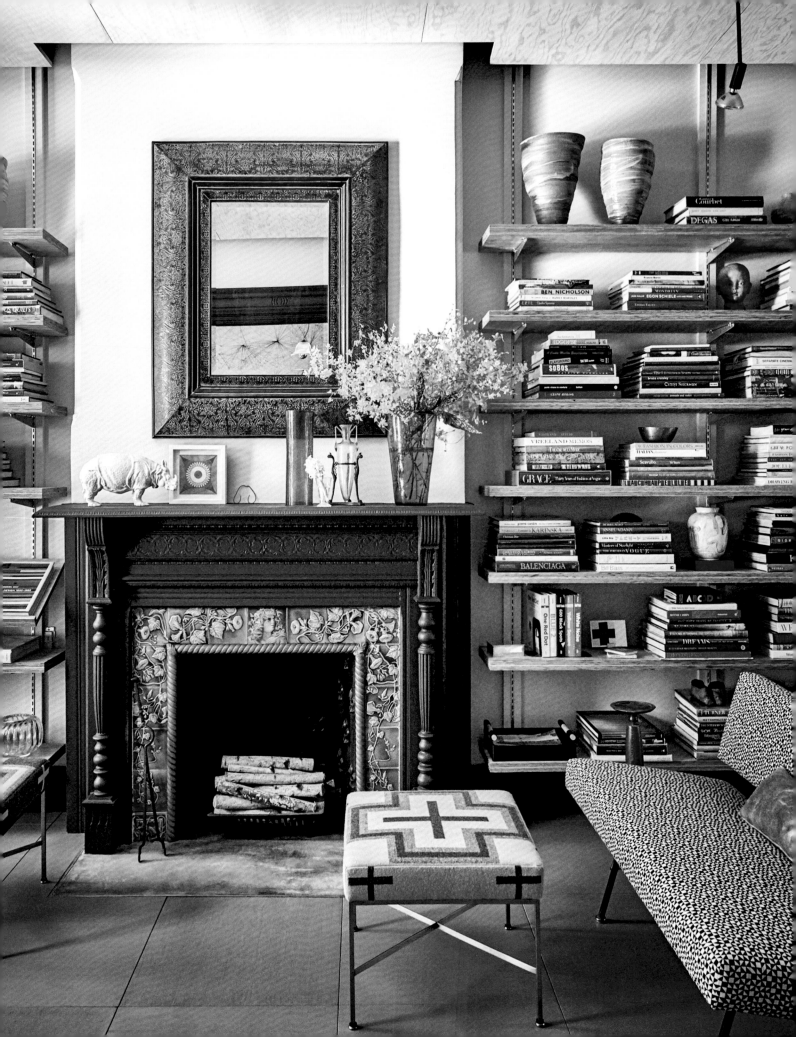

Throughout the house, Salasky balances original elements with his design choices. In the living room, for example, the floors and ceiling were replaced but the original pocket doors and fireplace surround were kept as is.

Salasky channeled the approach artists and designers took in the 1970s when converting lofts to residences. Those buildings were from the same period as his town house and shared some of the same clumsy, heavy, and dark details that were original to his home, such as the staircase, door frames, pocket doors, and paneling in the hallway. He eventually decided to paint them nearly black. The tile floor in the entry extends to the back of the house and into the kitchen. In that room, Salasky stripped the space down to the bricks and structural beams leaving it with a raw, loft-like feel.

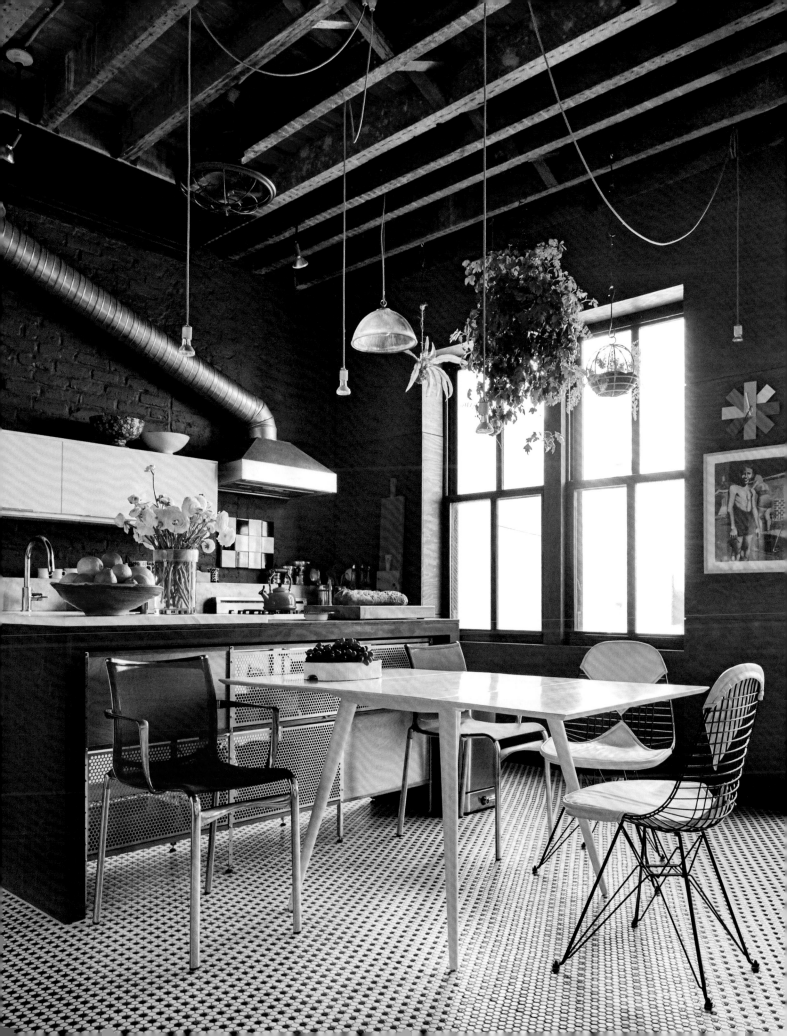

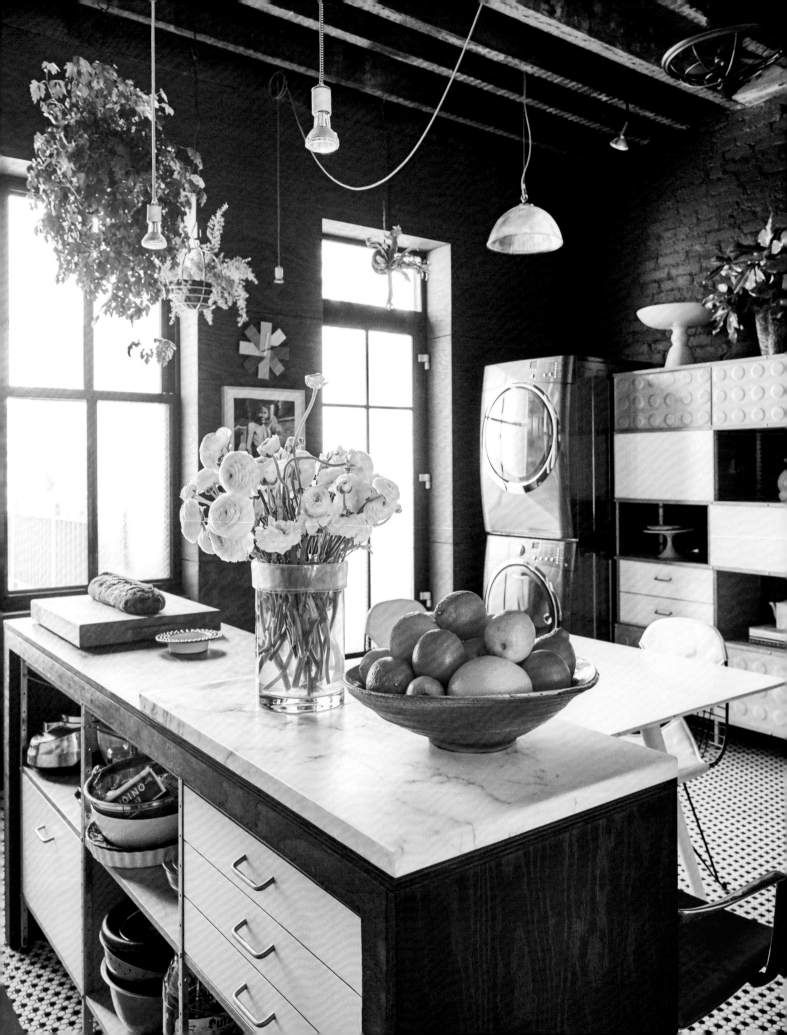

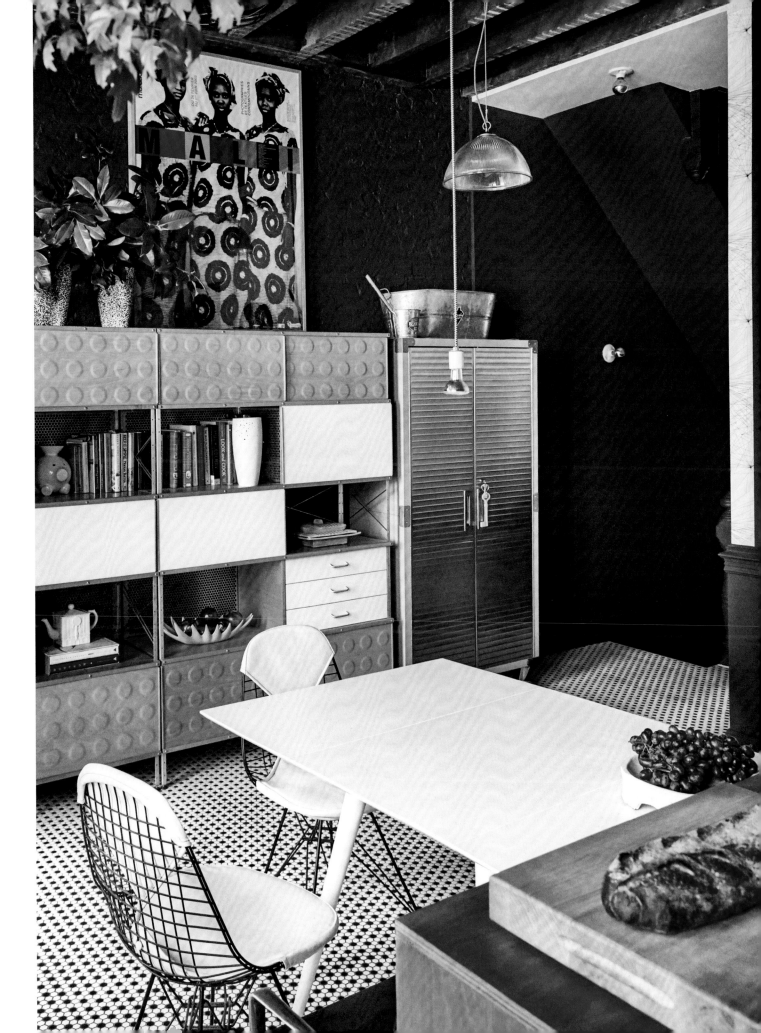

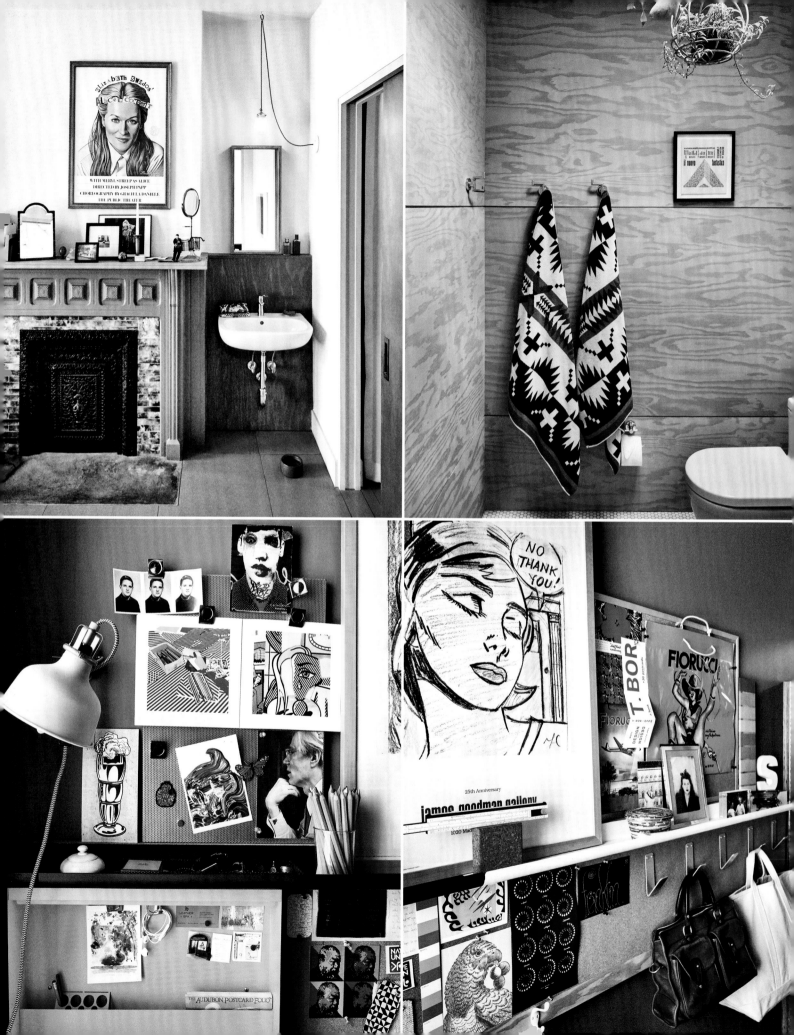

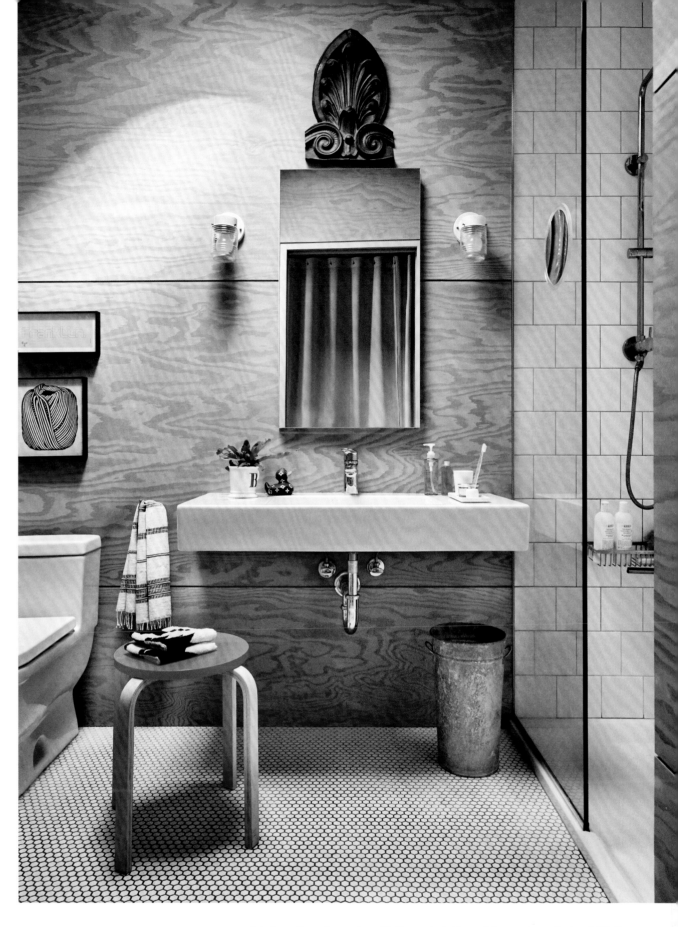

Salasky continues to use plywood in the master bathroom (above and opposite, top right). Here, gaps between the horizontal sections of the material extend the grout lines in the shower's tile. The simple gesture elevates the humble materials and the light from a skylight above bathes the room with a jewel-like importance. A bulletin-board was installed in the dressing room (opposite, bottom), and a sink in the guest room (opposite, top left) is a nod to conveniences of another period.

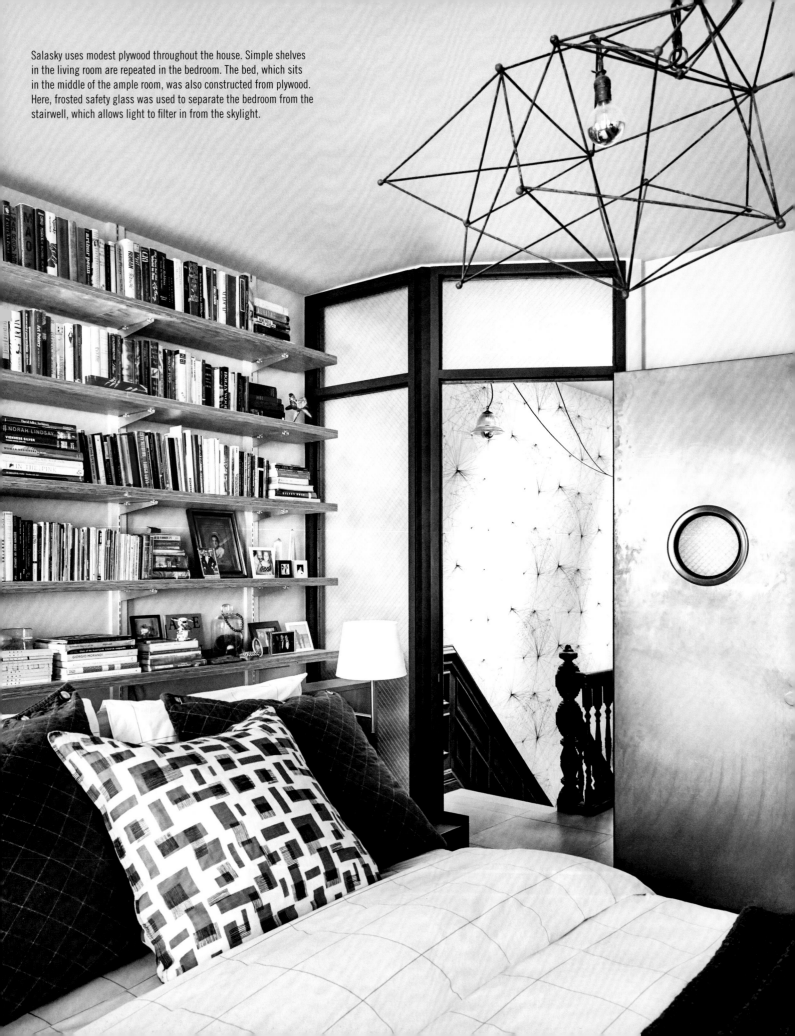

Salasky uses modest plywood throughout the house. Simple shelves in the living room are repeated in the bedroom. The bed, which sits in the middle of the ample room, was also constructed from plywood. Here, frosted safety glass was used to separate the bedroom from the stairwell, which allows light to filter in from the skylight.

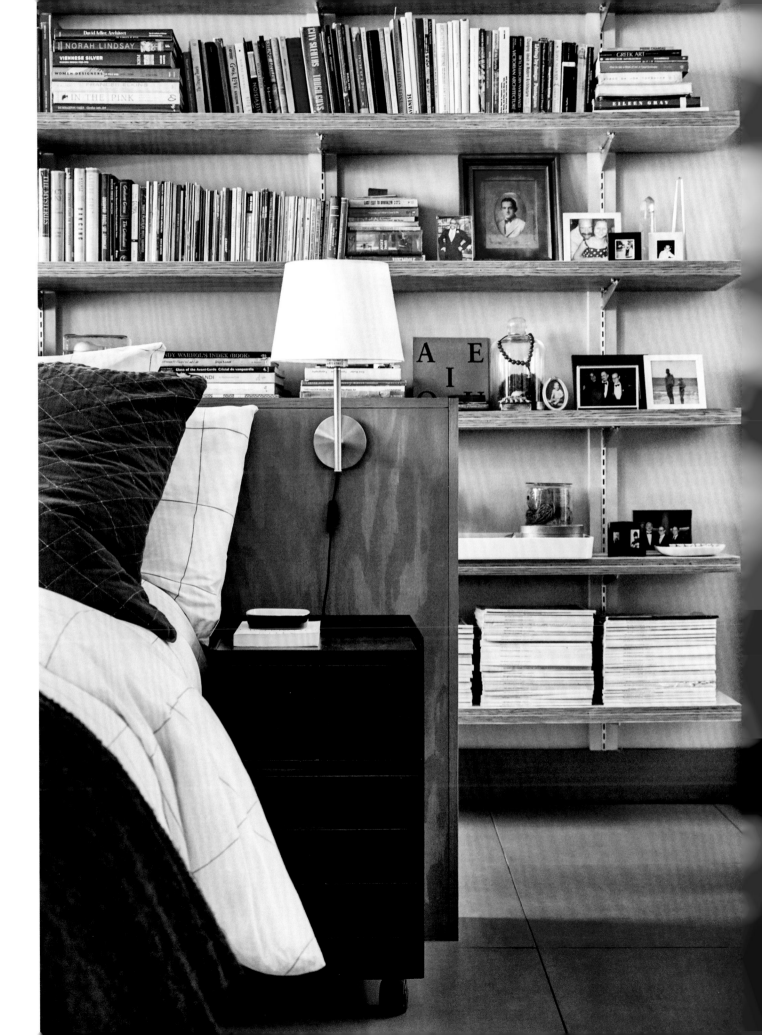

BRIAN SAWYER

At the time of this Greenwich Village building's construction in the late nineteenth century, the neighborhood had a reputation as an artistic center with galleries in storefronts and artists' studios often in the top floors of many of the town houses. The building's developer wanted to capitalize on the neighborhood's artistic vibe and installed a large skylight in the living room as a tribute to the studios that peppered the area. When Brian Sawyer first saw the apartment, it was in terrible condition. A fire had ravaged the adjacent unit, and the space was dripping with water. But it had two working fireplaces and was full of light, in part, because of the massive skylight that dominated the front, street-facing room.

Sawyer was eager to restore and emphasize the architectural history and style of the apartment. His intervention sought to preserve this narrative of an art-filled, creative life that the space originally promised to foster. Before completely gutting the space, he carefully inventoried all of the period details, and where they were missing, he painstakingly researched other apartments in the building and structures of the period for the correct profile or condition. He then went about creating new architectural features based on these details. In the dining room Sawyer installed paneling, for example, for which there was no precedent in the building; an office he visited in SoHo, which was built in the 1870s, inspired his choice. And while the ceilings were high to begin with, he was able to raise them to just beneath the roof framing of the building. Sawyer then reduced the size of the kitchen and concealed it behind a secret panel while restoring the dining room to its original plan.

While Sawyer made many efforts to restore the space to its original condition, there were some elements that did not seem appropriate. For example, the living room fireplace mantel was carved wood, which seemed more suitable for an artist's studio or other workplace, so Sawyer replaced it with a more formal antique black marble mantelpiece from the same period. The apartment also suffered from the lack of a proper entry; to fix this, Sawyer created a small vestibule with a marble mosaic floor, which he modeled after the one at Bigelow's Pharmacy, dating back to 1902 and located just around the corner.

Sawyer chose a dark color for the dining room and designed the table based on one by Maison Jansen that he had seen in Paris. The living room with its large windows and commanding skylight, demanded a lighter treatment. Drama and curiosity seem to have driven many of Sawyer's design choices. The bedroom ceiling hosts a depiction of a partially cloudy sky painted by Tom Borgese, and the bathroom ceiling is covered with a reproduction of a painted ceiling by Caravaggio in the Villa Aurora in Rome. The desire to create a home that sets the stage for a creative life is nothing new, and Sawyer seems to take comfort in that.

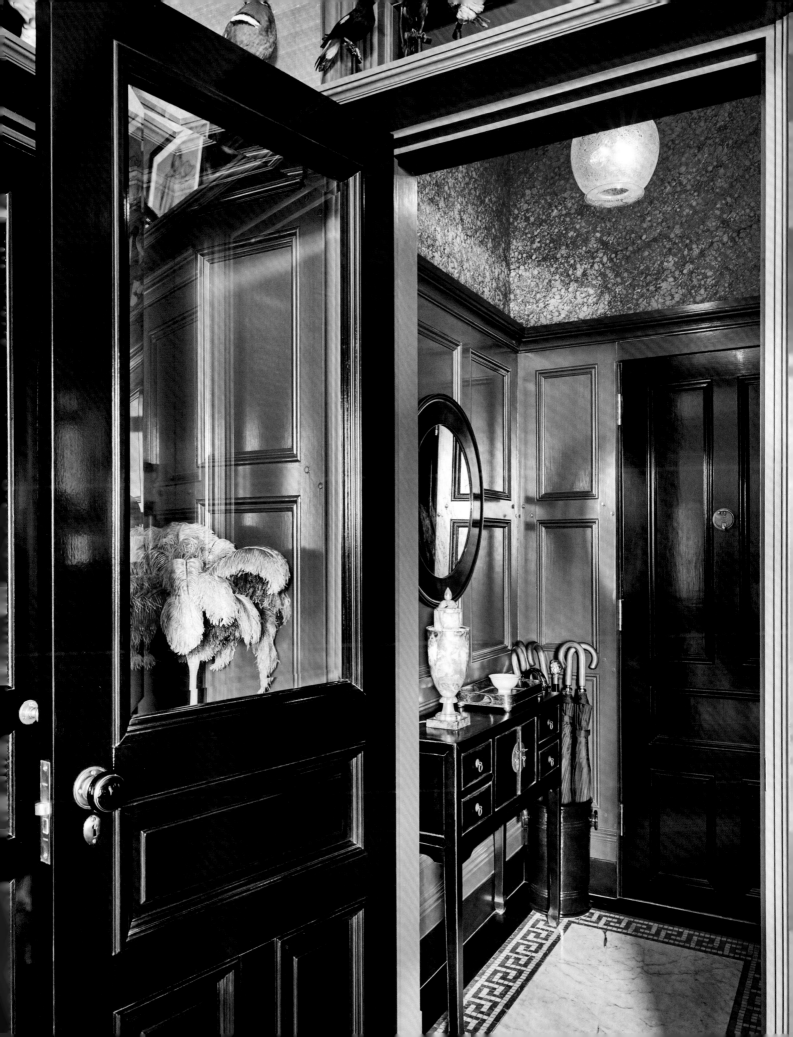

Sawyer was inspired by an 1870s SoHo office when he decided to panel the dining room. In this space, he was able to raise the ceilings to just beneath the roof framing. This meant that the plaster crowns he had seen in other apartments in the building were now too small, so he used a larger cove molding to accommodate the new scale. The dark color provides a perfect backdrop for the collection of taxidermy he inherited from his great-uncle.

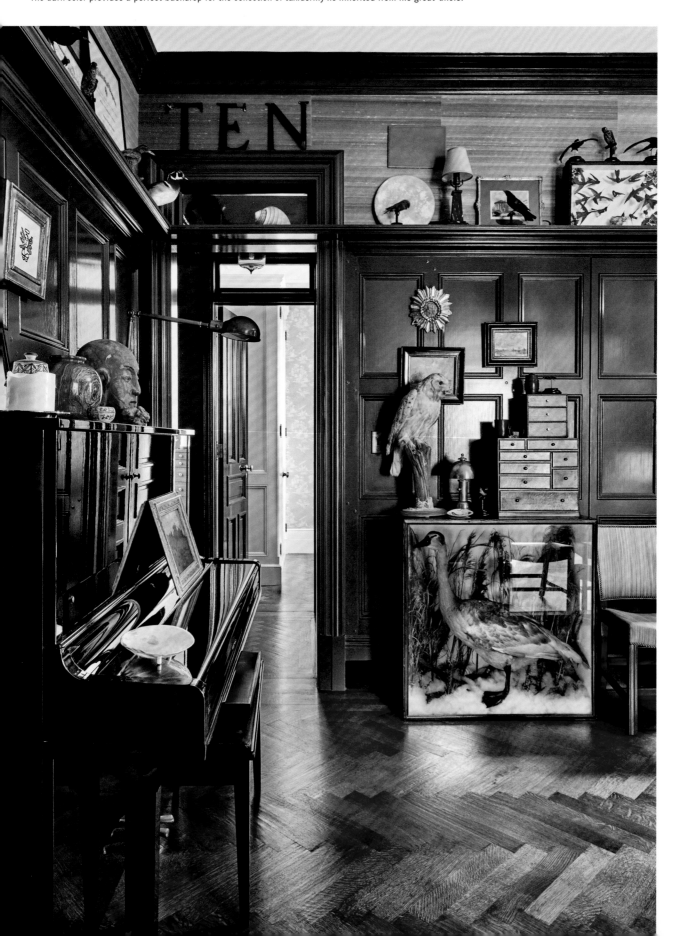

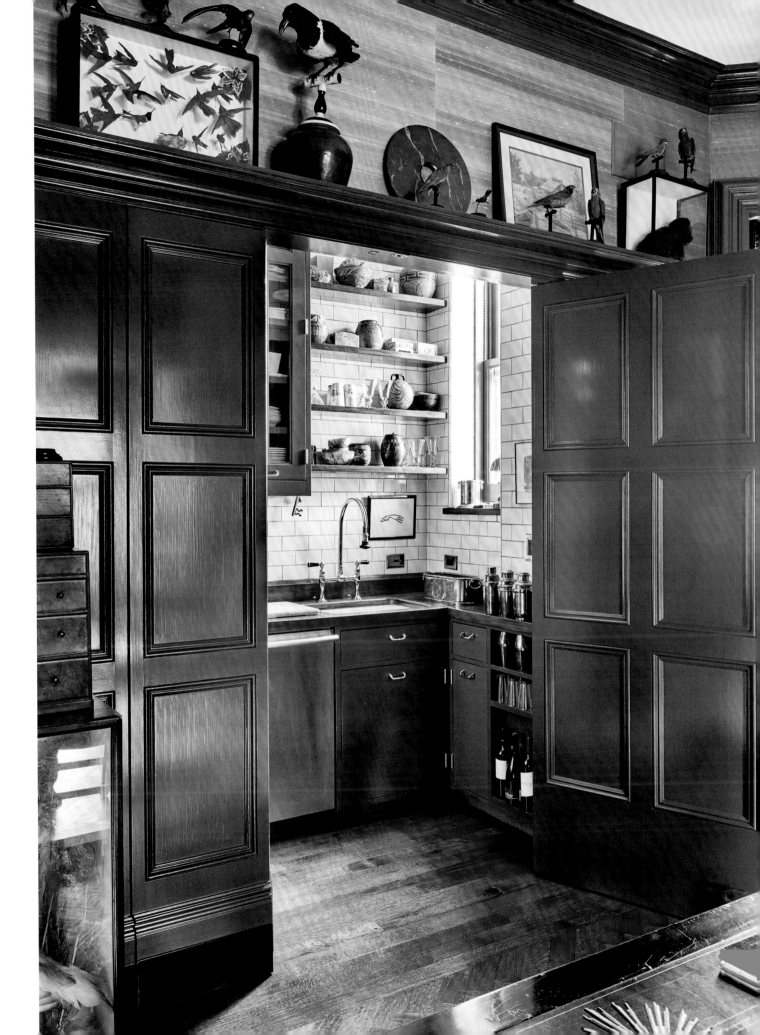

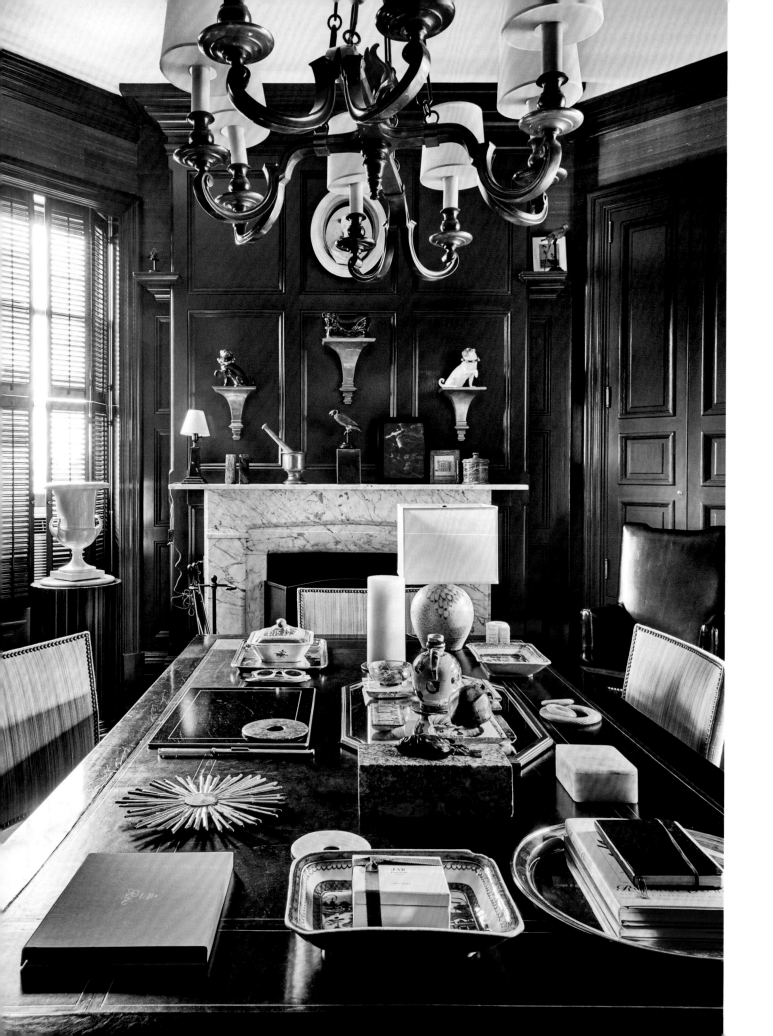

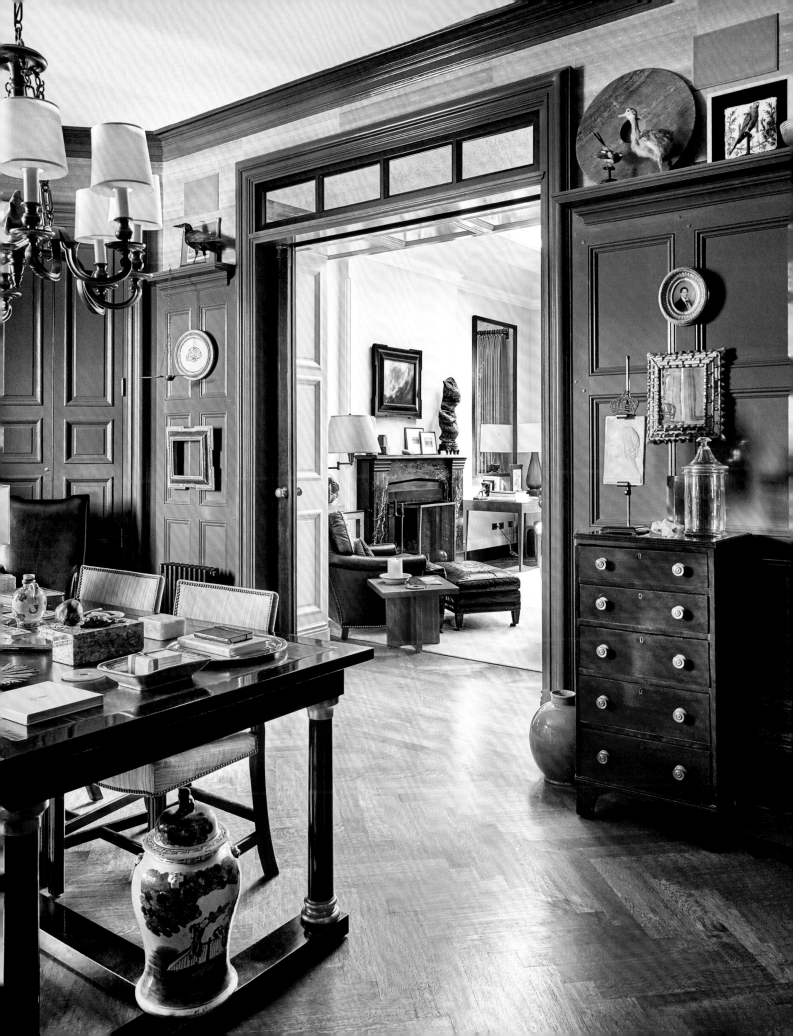

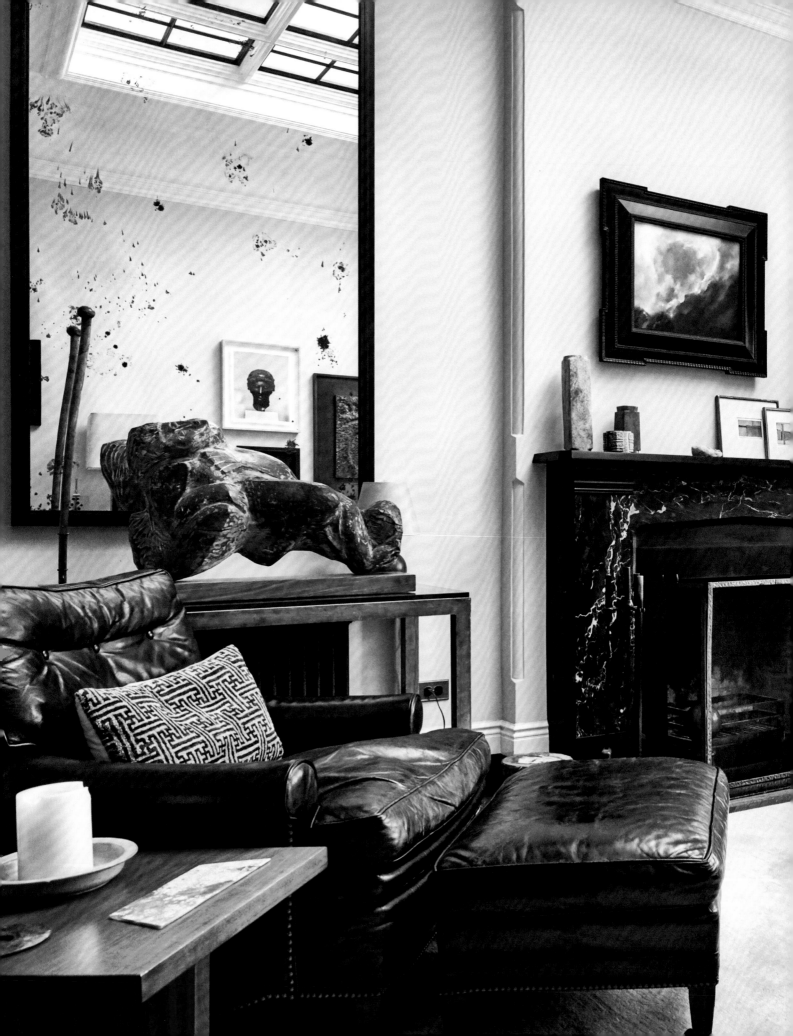

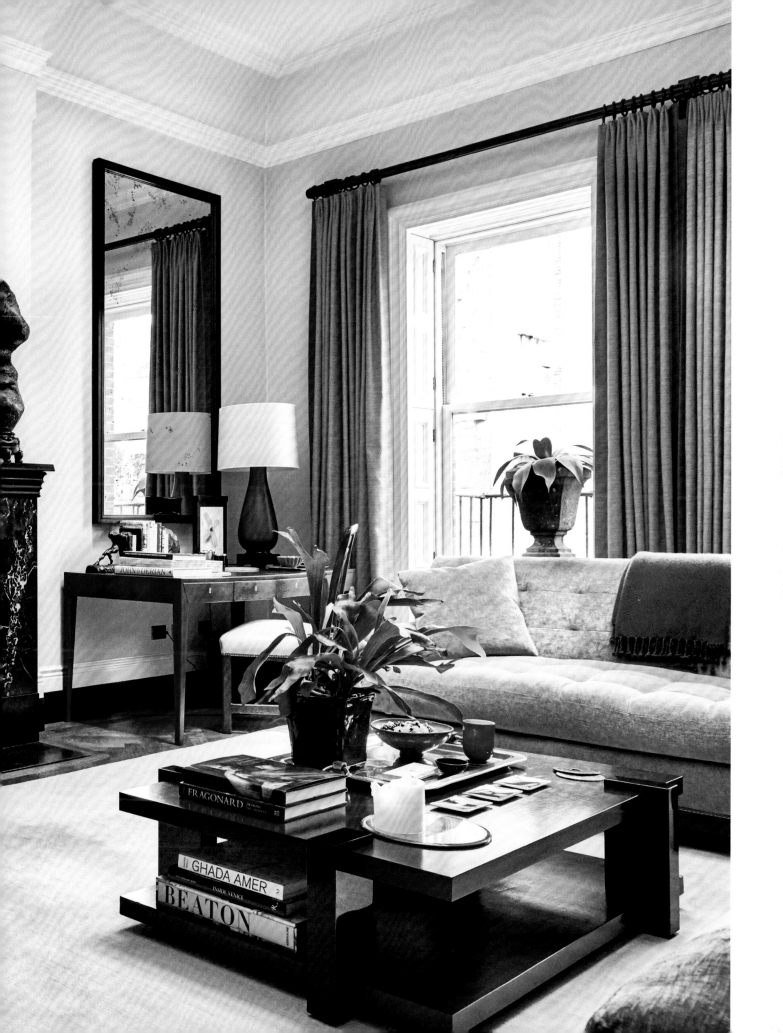

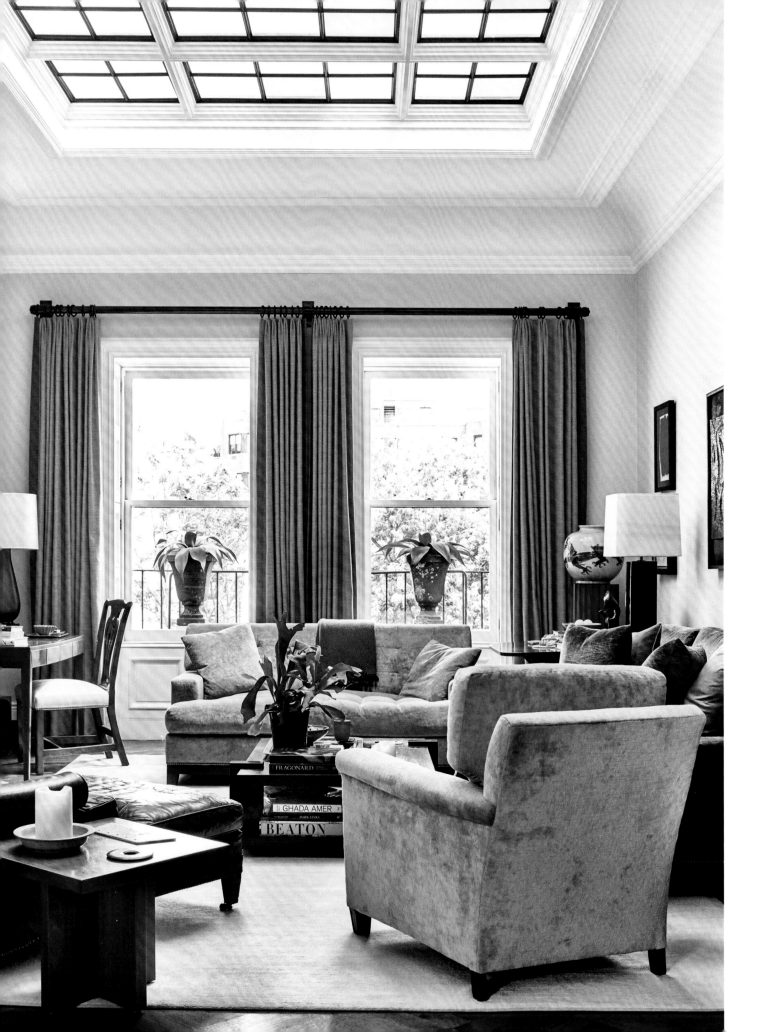

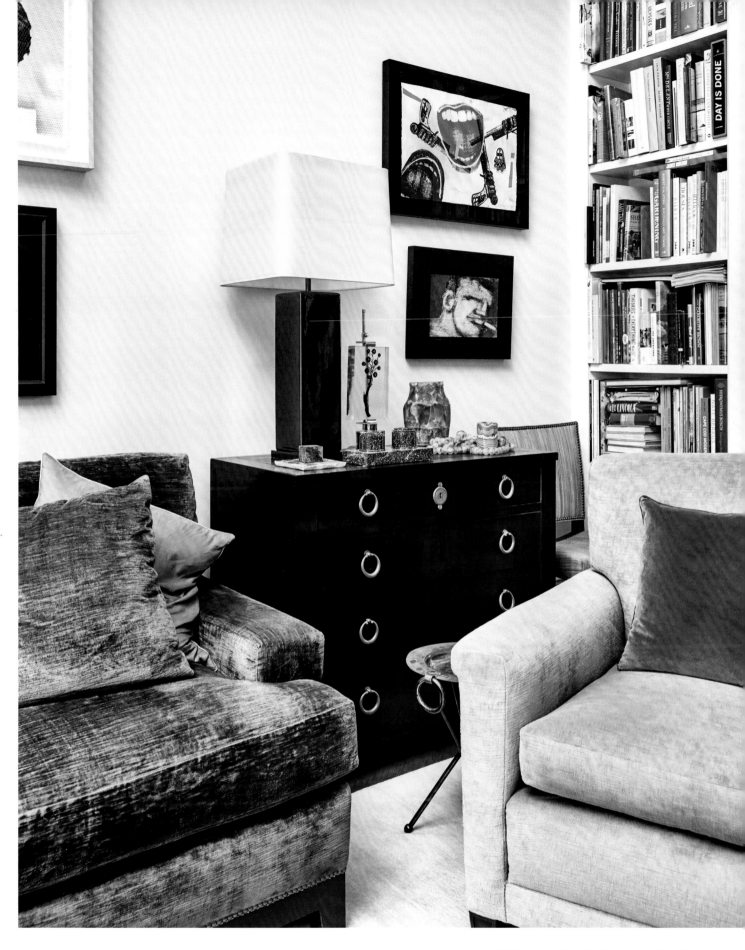

Sawyer prefers dark colors in rooms with little natural light; the living room, with its two large windows and big skylight, demanded a lighter treatment. The room also includes sofas and a coffee table that Sawyer designed specifically for the apartment.

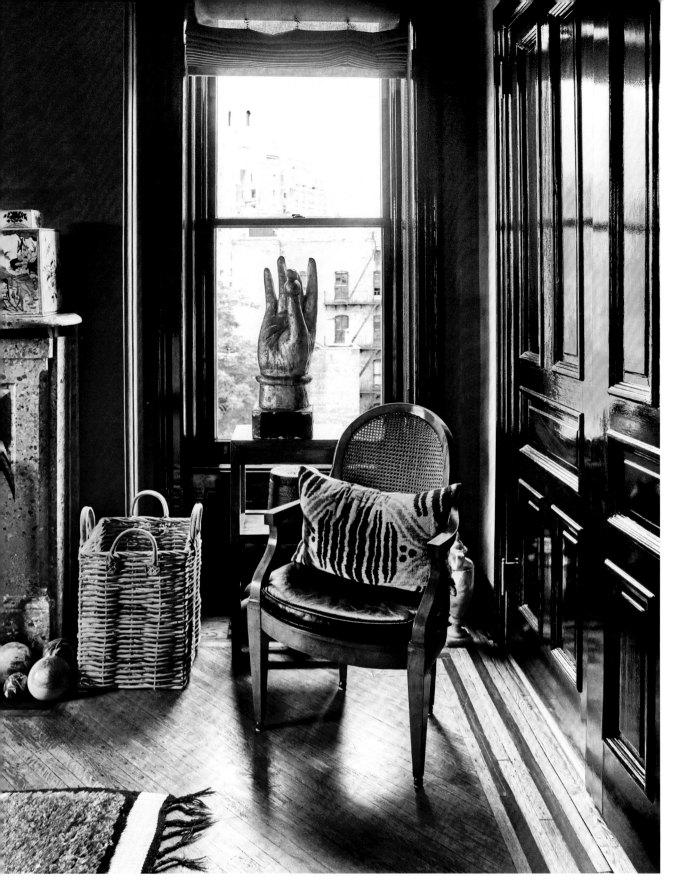

In one of the bedrooms, Sawyer covered the walls in a light-absorbing, chocolate-colored Ultrasuede. The ceiling hosts a painting of a partially cloudy sky by Tom Borgese. To paint the ceiling, Borgese replicated the colors and the cloud pattern from the bathroom ceiling, which is a reproduction of a painted ceiling by Caravaggio in Rome's Villa Aurora that was printed on adhesive photo paper. The trim, doors, and moldings were painted in a high-gloss black. Here, as throughout the apartment, Sawyer mixes objects and art from an array of periods and styles.

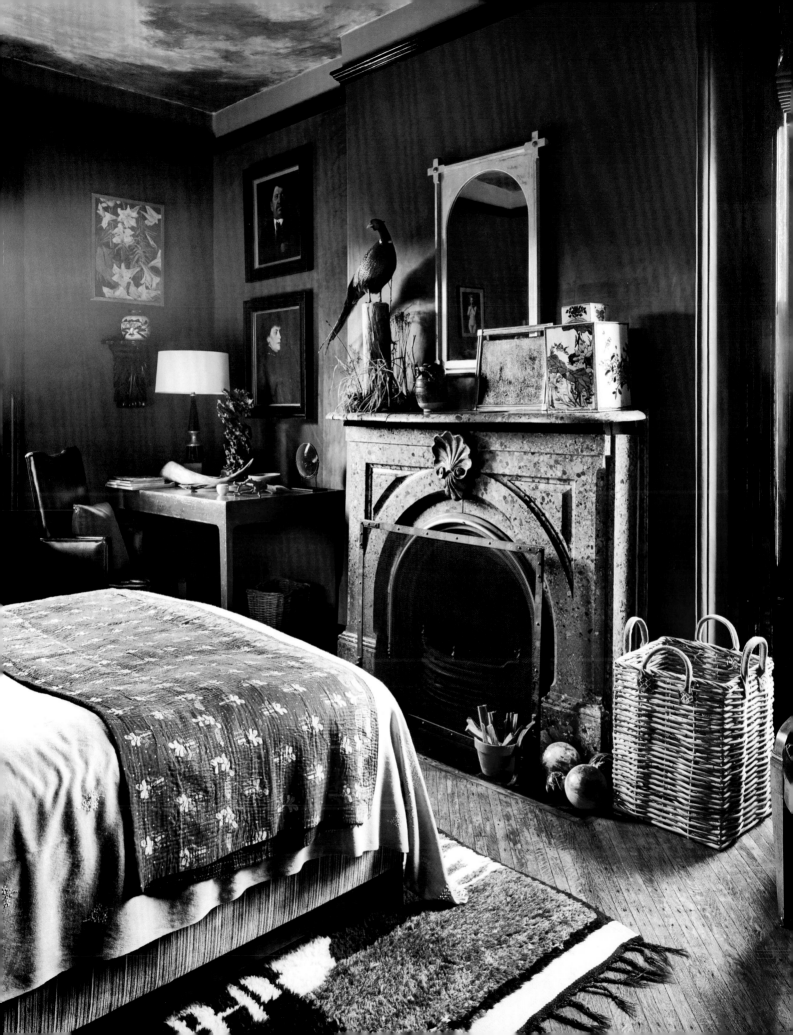

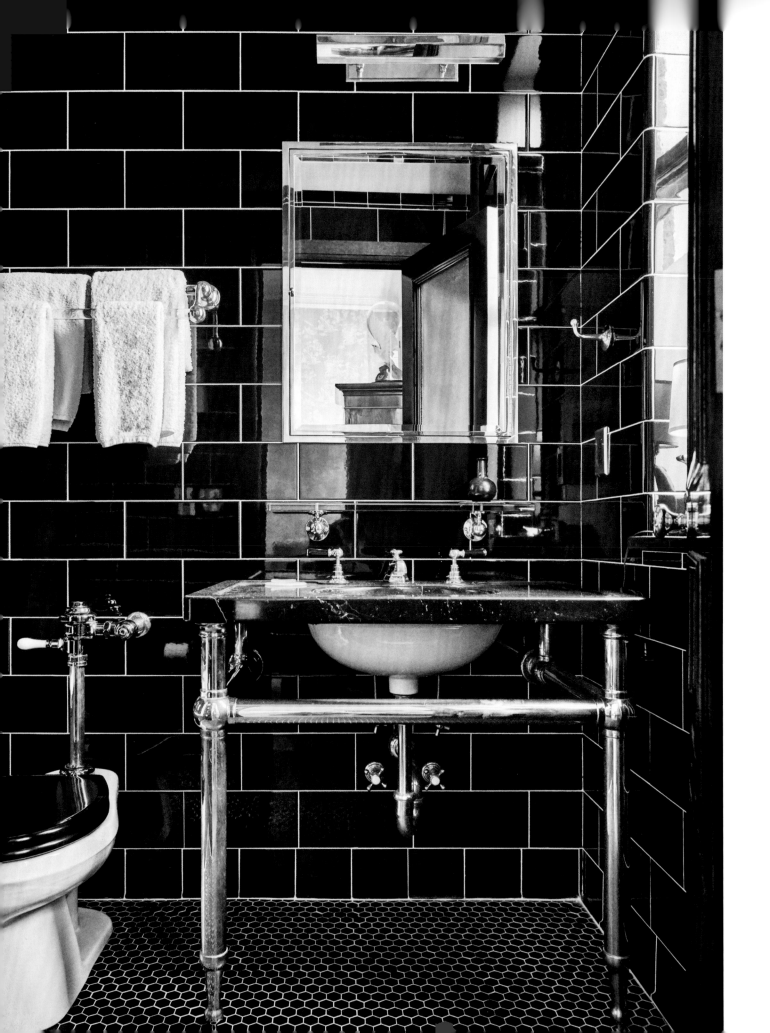

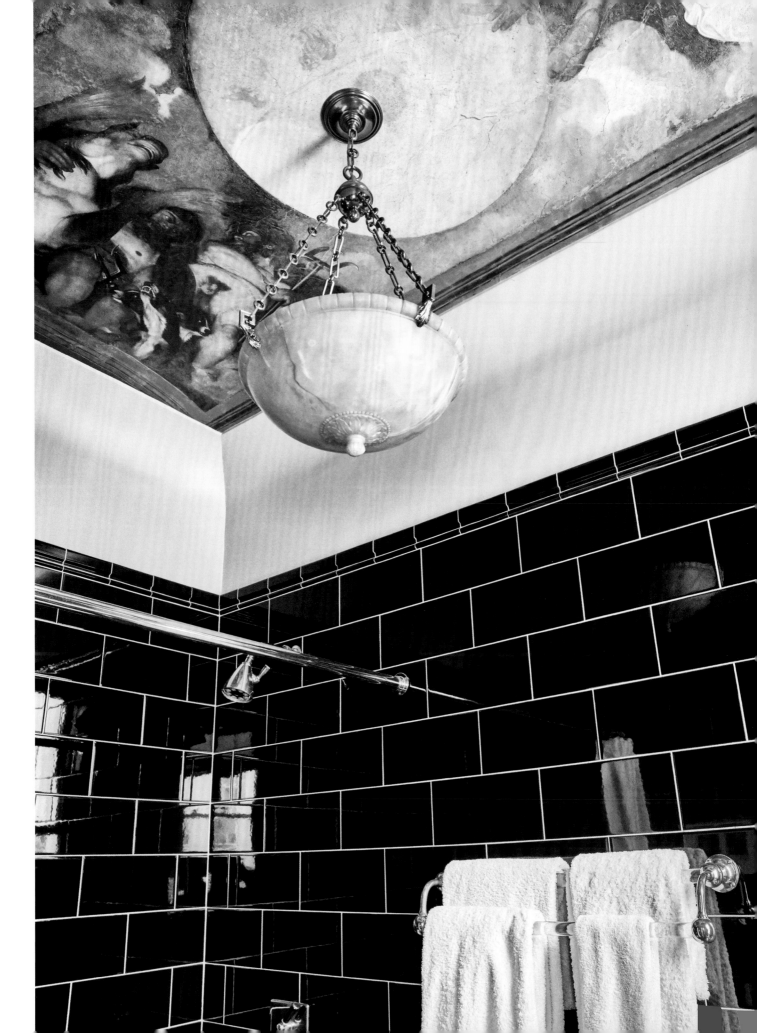

MICHELLE R. SMITH

While Michelle R. Smith was fully renovating this late Victorian-era Brooklyn town house, she was concerned that the intervention would distance the house from what had originally attracted her to it. When she found the space, it was, as she describes it, "perfectly untouched," which also meant that it was uninhabitable. She was drawn to the history of the building and understood that the doors, moldings, plasterwork, and any other details she could preserve from the original structure would serve as vibrant reminders of that past; one of Smith's greatest challenges was to make certain that the contractors did not "fix" anything that was already perfect to her eye.

Smith is originally from southern Louisiana and went to college in New Orleans, and her partner is a documentary filmmaker from Florence, Italy, so the couple has some experience living with history, and, perhaps even more, an appreciation for the casual elegance that can be obtained from controlled decay, where every surface of the historically significant—from furnishings to buildings to works of art—has not been restored to look and feel like "new" but rather given the opportunity to express its patina, wear, and age.

With those objectives in mind, Smith set out to reconfigure the functionality of the space. The kitchen was moved from the garden floor to the center room of the parlor floor. A room at the back of the garden floor was transformed into a screened-in porch, and what was once a bedroom at the back of the parlor floor became the dining room, a natural extension of the newly positioned kitchen. A closet off the hall to the new dining room became the butler's, or "coffee," pantry, as Smith calls it. The closed-off pantry, complete with a sink, allows Smith to keep much of the clutter normally associated with the kitchen off the counters and out of sight. The kitchen hosts a massive island, which Smith designed in black lacquer with subtle gold accents and decorations to recall a favorite chinoiserie table. Smith left the ceiling in this room as she found it, and the patina and wear provide the space with a majestic quality often associated with centuries-old grand European villas.

Smith made gallant efforts to avoid the trappings of contemporary renovations: Recessed lighting was never used, and elements like switch plates, custom millwork, and AC vents were chosen to seamlessly embrace the building's history. Smith also designed some of the furnishings with this in mind. She was not going for a period renovation, but rather made these choices so that they would disappear into the structure. She wanted the space to feel "un-done, un-themed, and certainly not 'decorated.'" In keeping with these guidelines, she incorporated an impressive array of whites. The walls of the home subtly move from slightly green to slightly pink. This is a testament to Smith's love for "non-colors," which she also used on the custom upholstery that, like many of her other choices, seems perfectly at home here without screaming for attention.

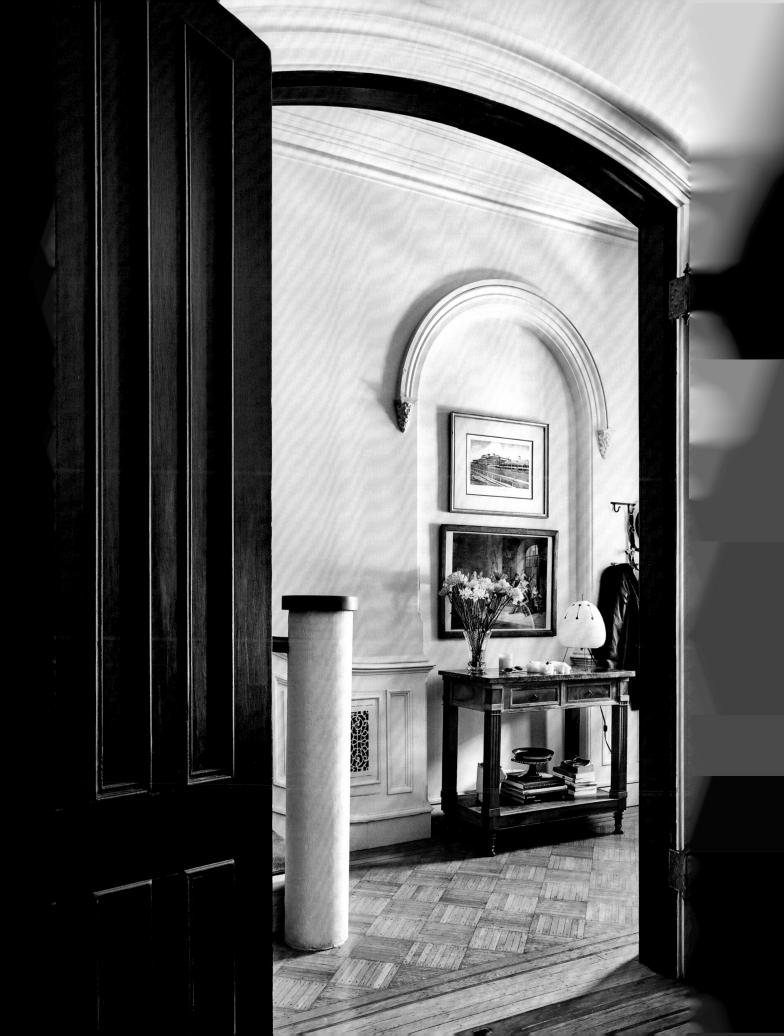

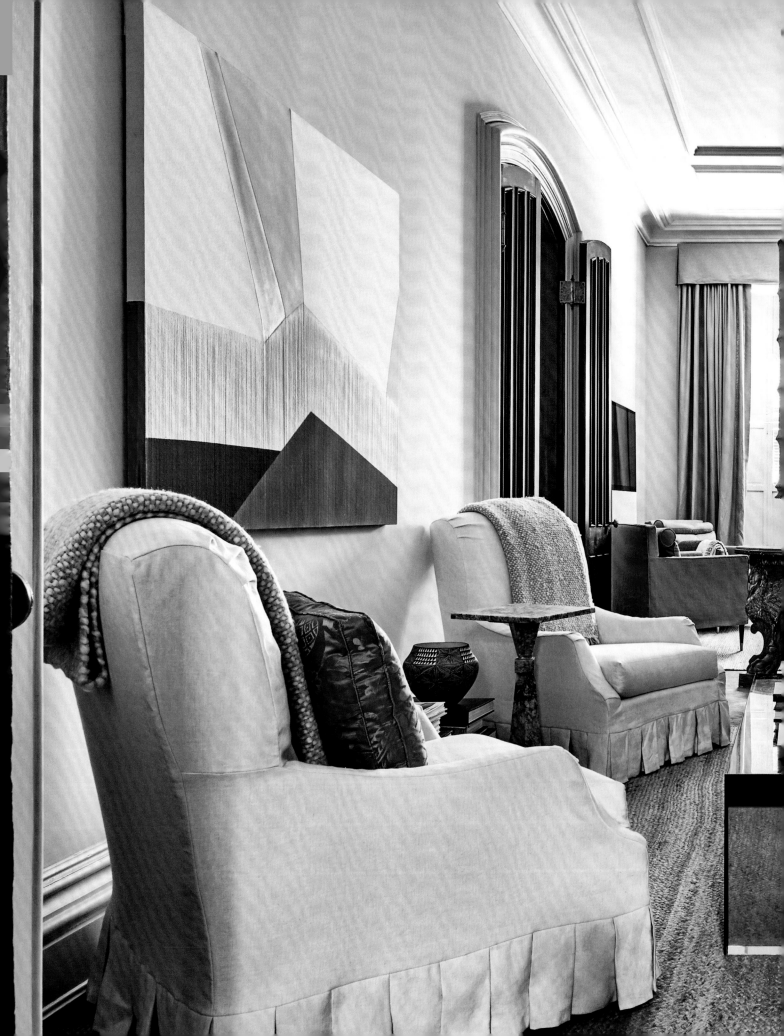

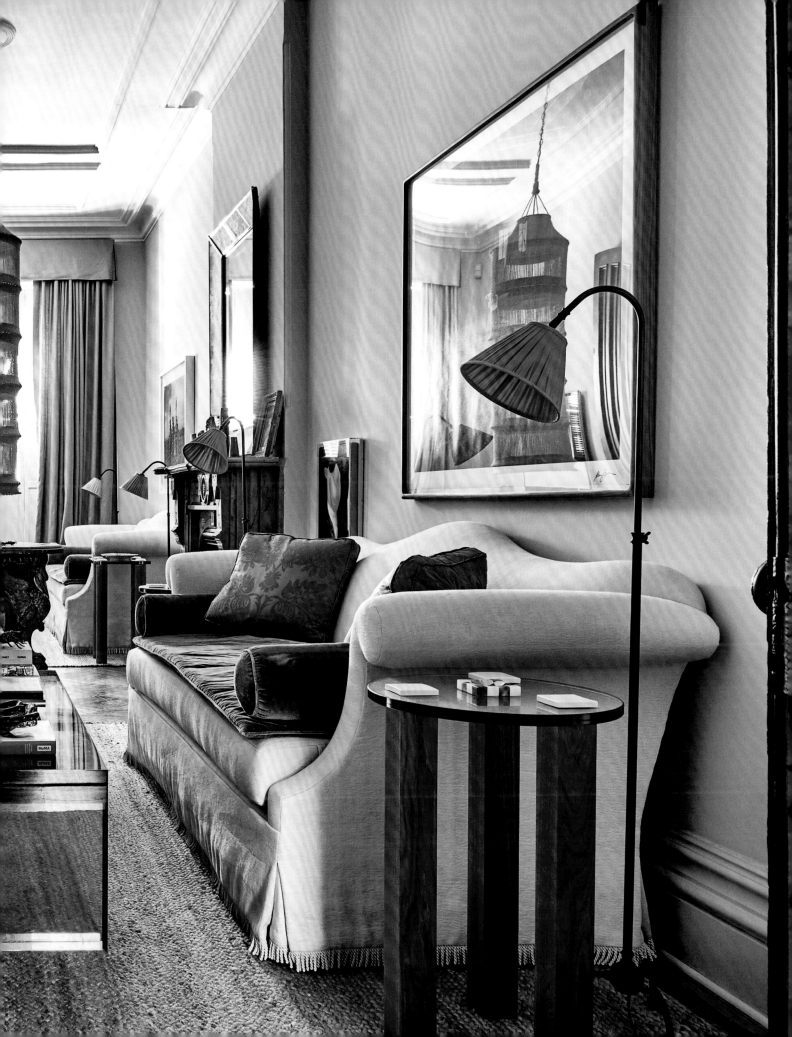

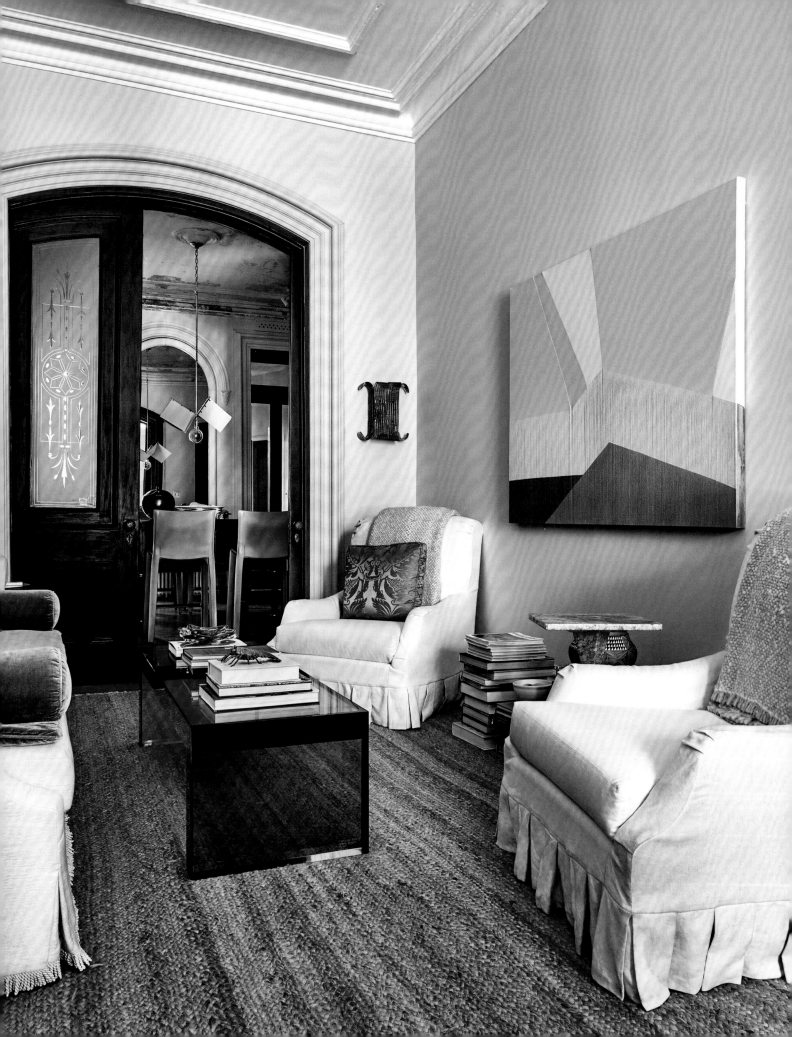

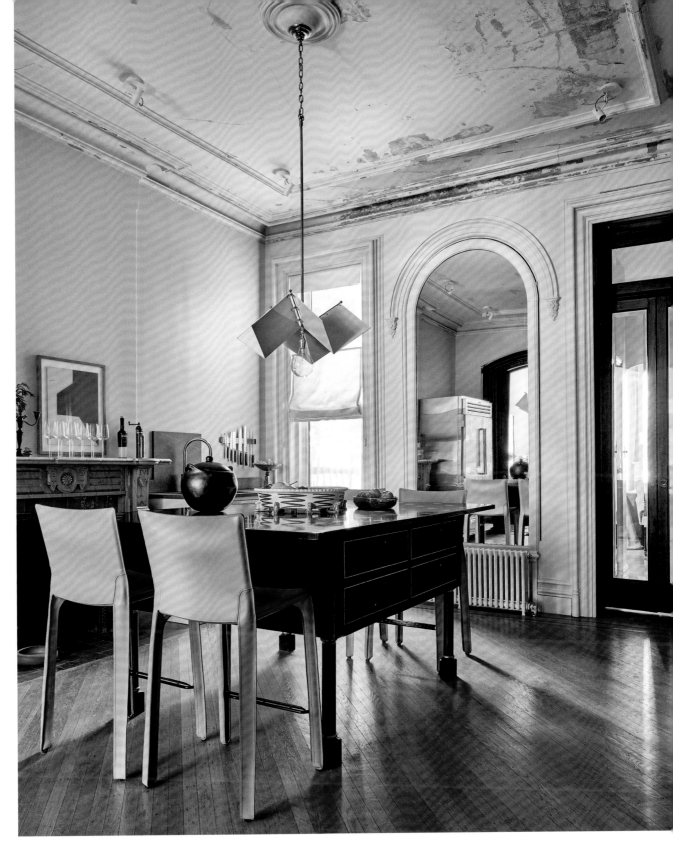

Previous spread and opposite: Smith followed the lead of the architecture and set the long, narrow living room up as two distinct seating areas, with the fireplace, entry table, and hanging fixture separating the areas. Here, Smith designed the camelback sofas and chairs, as well as the side tables that flank the sofas—circular tops with square legs and square tops with circular legs—to work with the height of the sofas.

Above and following spread: Smith was immediately attracted to the decaying ceiling in what would become her kitchen. The room is a collection of freestanding appliances with minimal cabinetry. The island, which also serves as a table for casual meals, is of her own design. A "coffee pantry" down the hall from the dining room provides a place for extra kitchen storage.

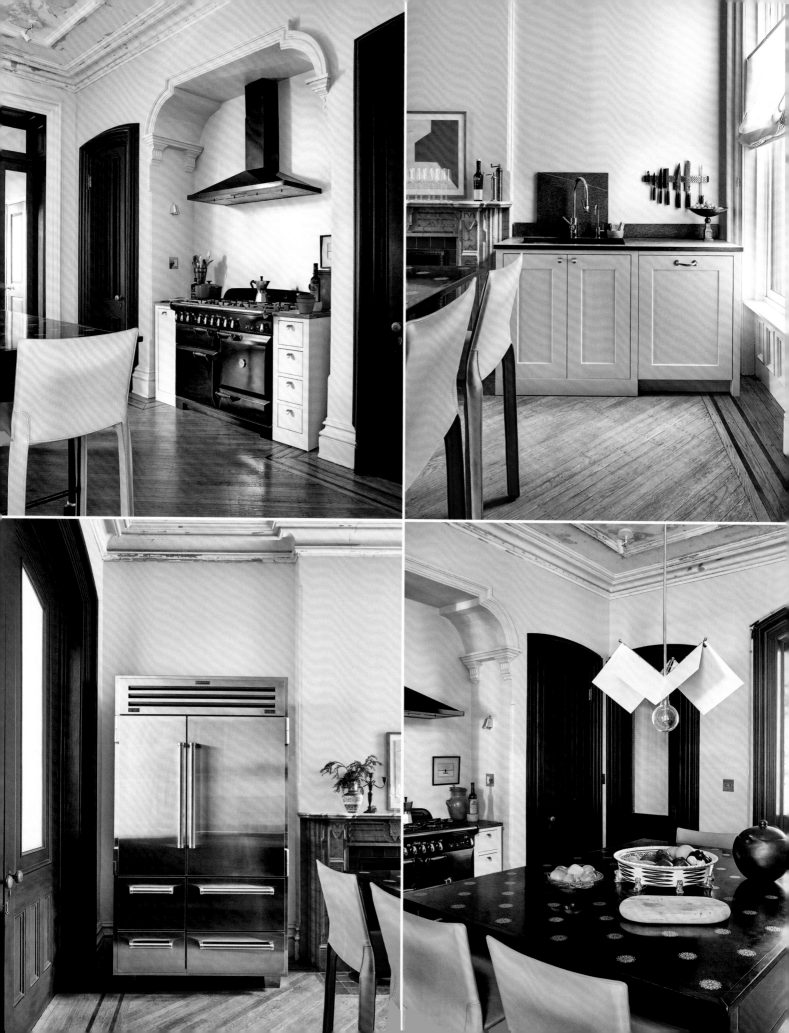

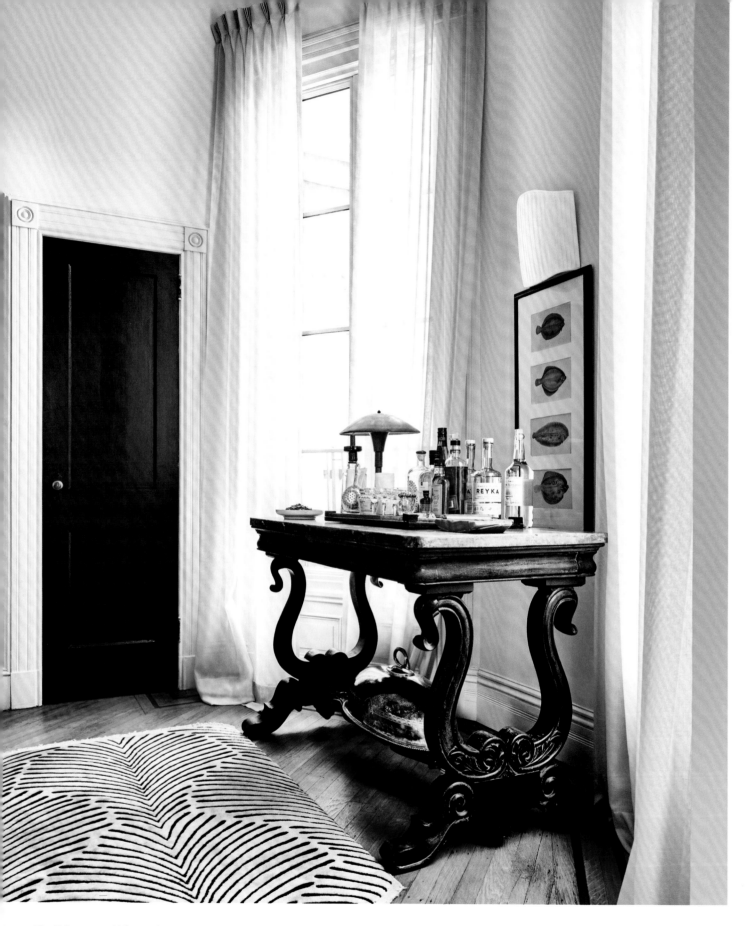

The dining room, which occupies an extension to the original structure, offers multiple exposures. The table is of Smith's design but is often kept under linen wraps. The host chairs, a vintage find, were originally covered in green vinyl.

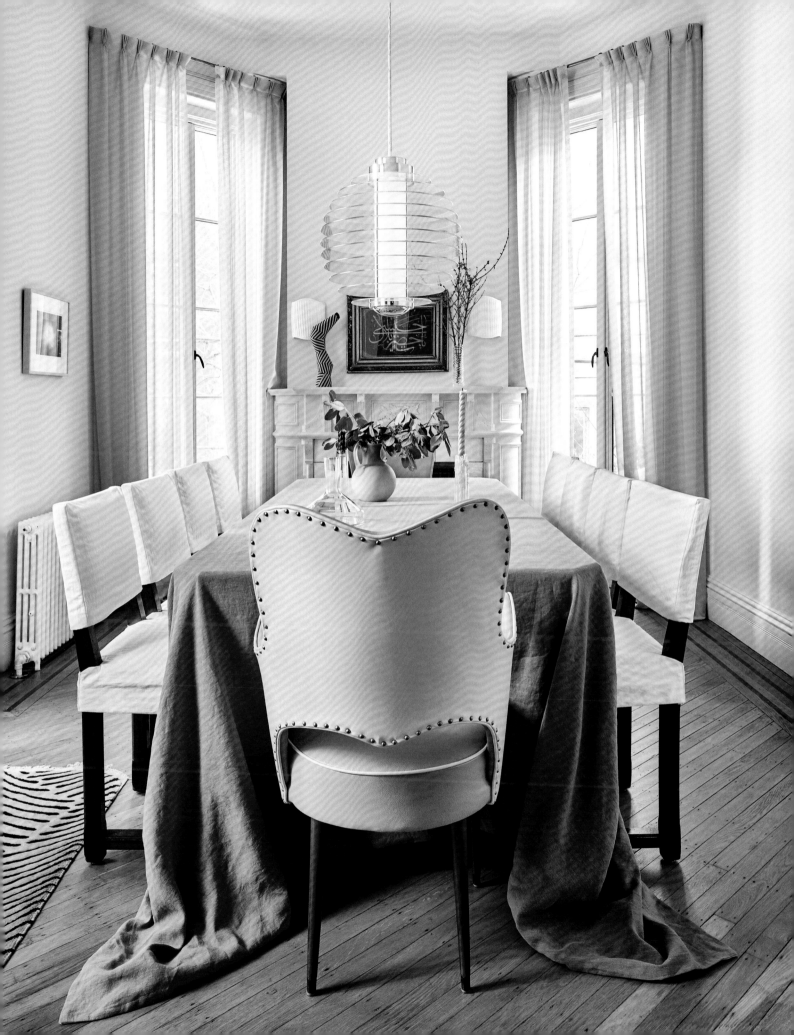

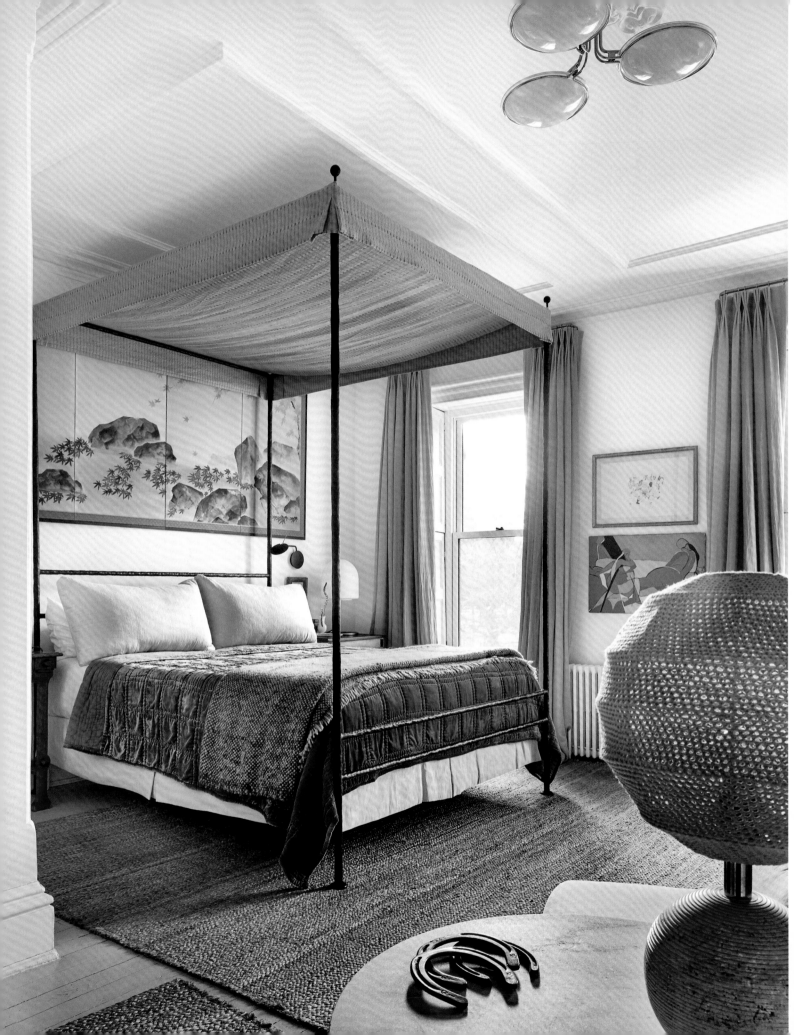

Smith loves color, but her partner longed for white walls. The couple struck a compromise with an assortment of whites that move from tints of green to pink. These choices were then underscored by the subtle use of colored textiles and fabrics. In the living room, the green in the walls is echoed in the velvet seat cushions on the camelback sofas. Here in the bedroom, the beige/pink quality of the walls is accentuated by upholstery fabrics and bed linens.

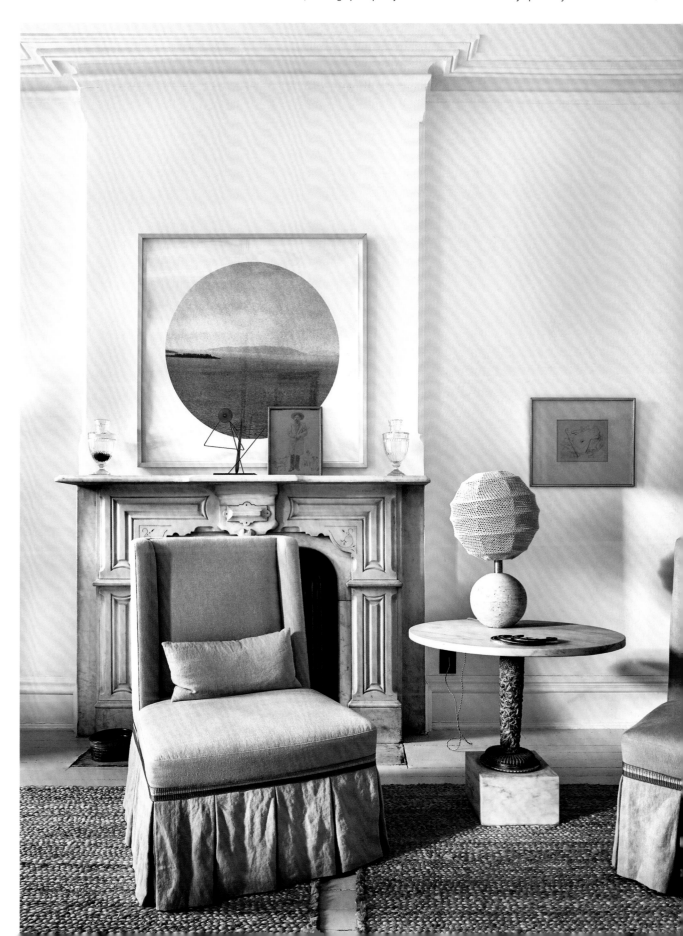

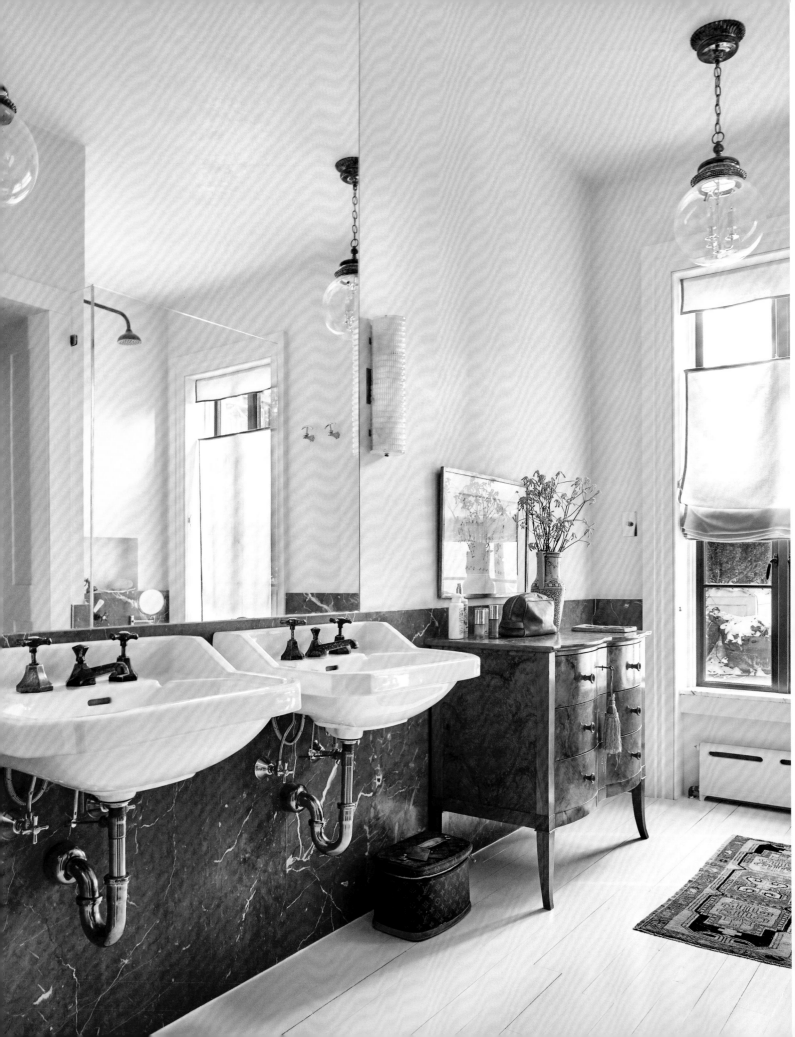

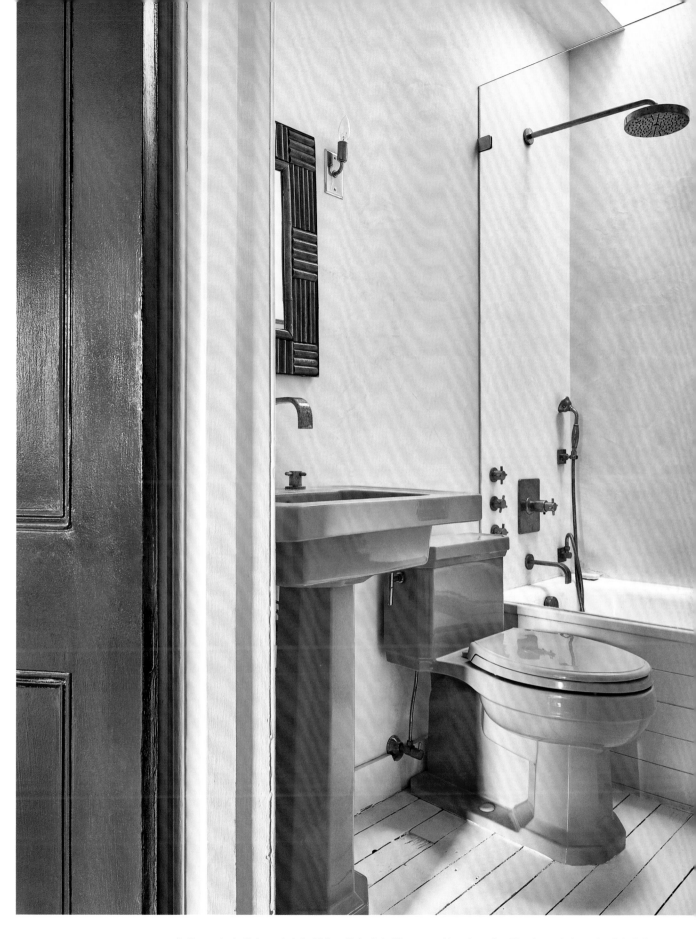

In the master bath (opposite), Smith installed a Rojo Alicante marble wainscoting. The chromatic intensity of the Rojo is reflected in the choice of copper fittings and exposed plumbing. The antique cabinet has followed Smith from two prior apartments. Smith created a monochromatic space for the guest bathroom (above). The tan plumbing fixtures are paired with a custom plaster color on the walls, painted floors in a similar shade, and California Faucets in brass.

BILL SOFIELD

Bill Sofield understands how an interior space can reinforce an identity or even create one; he is well known for the elegant retail environments he has created for fashion houses, including Gucci, Yves Saint Laurent, and Tom Ford. For each of these brands, Sofield crafted theatrical narratives that not only dovetail seamlessly with the brand's aesthetic mission but also help establish it within a controlled environment.

Known for his clear and precise designs, Sofield did not abandon his ability to craft identity within a space when he considered his own home. If anything, it was put into overdrive. Sofield's SoHo loft occupies the top floor of a historic seven-story building. When he first encountered the space, much of its industrial character was hidden behind dropped ceilings of poorly installed Sheetrock. The previous owner had attempted to conceal the many steam and sprinkler pipes that crisscross the loft, which meant lowering the ceilings by two feet in most places and as much as five feet in others. Sofield removed the ceilings to accentuate the space's wonderful height and celebrate its industrial past. In addition to the ceiling heights, Sofield was attracted to the loft's multiple exposures at the building's rear corner. Monumental arched windows provide views of the Brooklyn Bridge, the Woolworth Building, and the area's many period buildings. Sofield said, "If New York came in an aerosol, this would be it." He clearly has found his home.

There were no moldings or beautiful finishes in the home, so Sofield used the window arch as an organizing theme for his design, incorporating an abundance of sensual materials like hand-rubbed lacquer, pigmented waxed plaster, bleached maple, cashmere, and handsome stone. He repeated the beautifully proportioned arch for the interior doors and windows and added lacquered shutters to control the light and views and provide privacy where needed. The space originally lacked distinct rooms and therefore had no sense of progression. He gave the loft an air of formality by creating an entry, a bedroom suite, and a private study. For the apartment's color, Sofield was interested in harmonizing it with or, in some cases, matching it to the trim of the surrounding buildings, a device he hoped would extend the visual space beyond the perimeter walls.

Sofield also liberated a large wooden beam and column that were mostly concealed and consumed by unnecessary built-ins. In fact, Sofield was not interested in storage in his own home; things here seem to spill over one another as if in a collage. Functionality of space takes on the same fluid position. Is it the living room or the gym, the hallway or the closet? Sofield has taken the wisdom of one of his most cherished clients to heart. "The point," he says, "of having beautiful things is to be inspired by them. If you can't see them, they can't inspire you and you shouldn't have them."

When Sofield found the apartment, it resembled what he described as a first-class lounge for Swiss Air, perhaps too "done" for him and too removed from the industrial past of the building. He loved the curved windows, though, and the arch became the organizing theme of the apartment, which he repeated in the interior doors and windows.

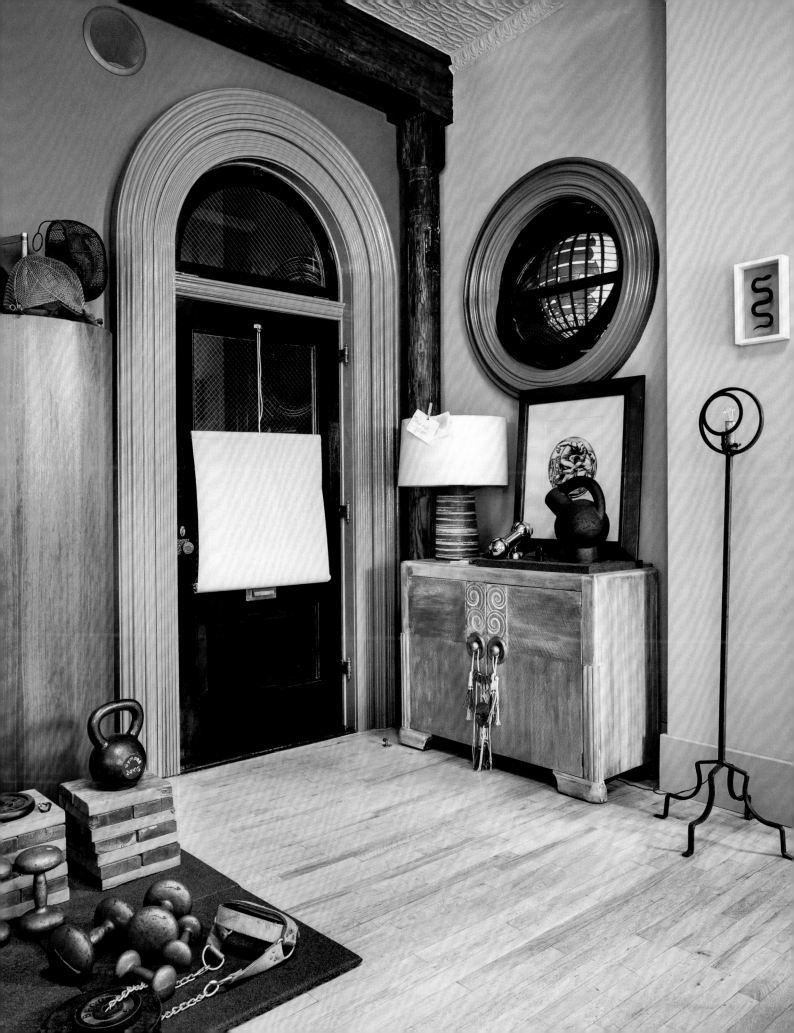

In the living and dining area, lacquered shutters control the light and views perfectly. The dining table and chairs are of Sofield's design, and he's incorporated humorous elements throughout the apartment, like the imposing sculpture, the elephant in the room, by Cyrille André.

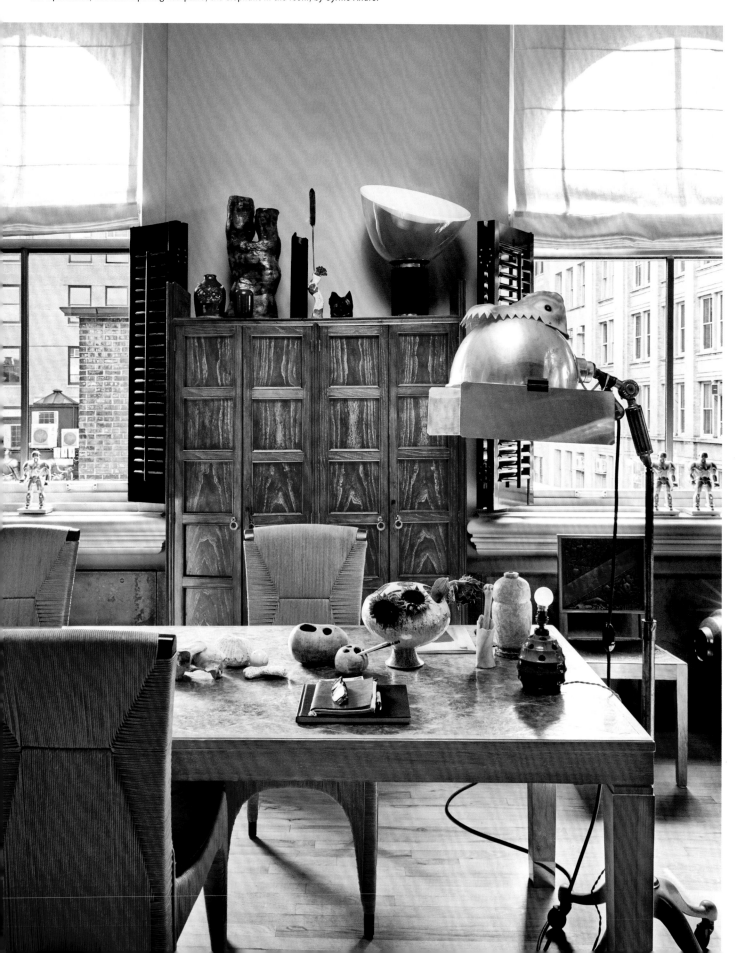

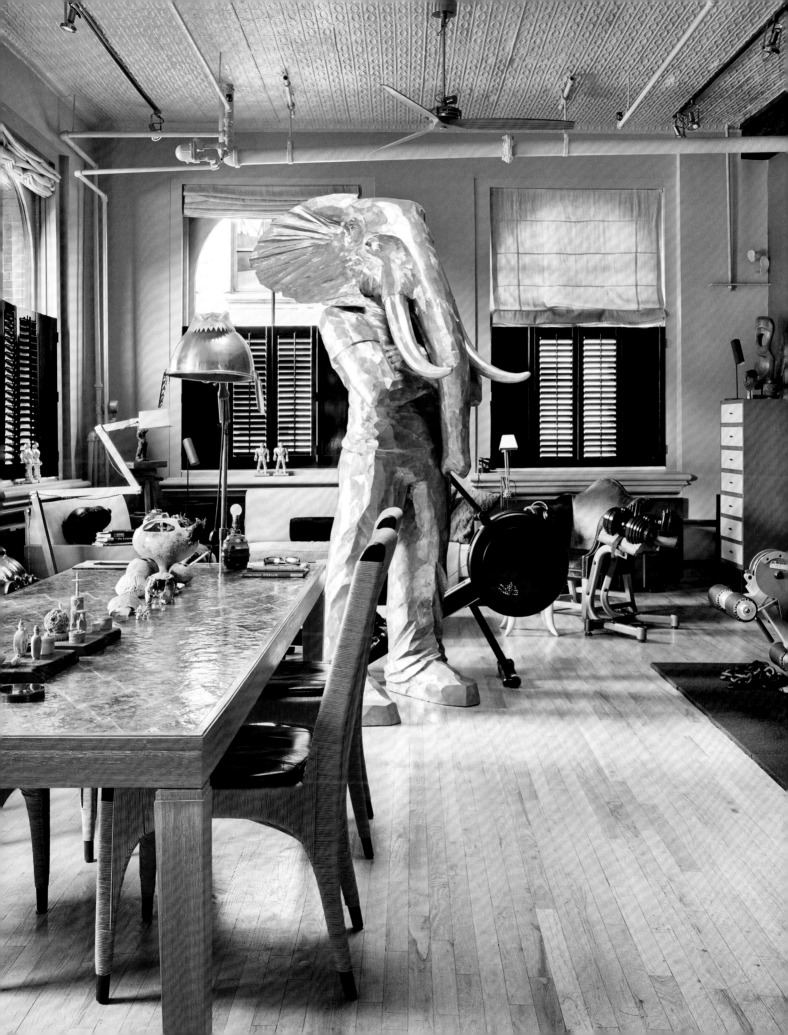

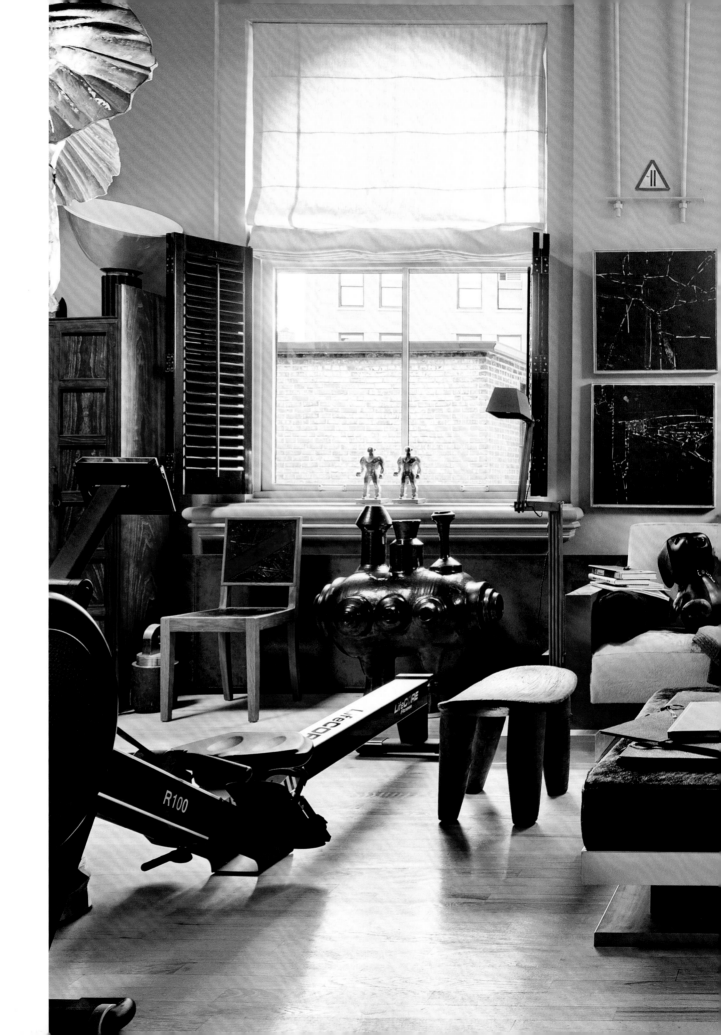

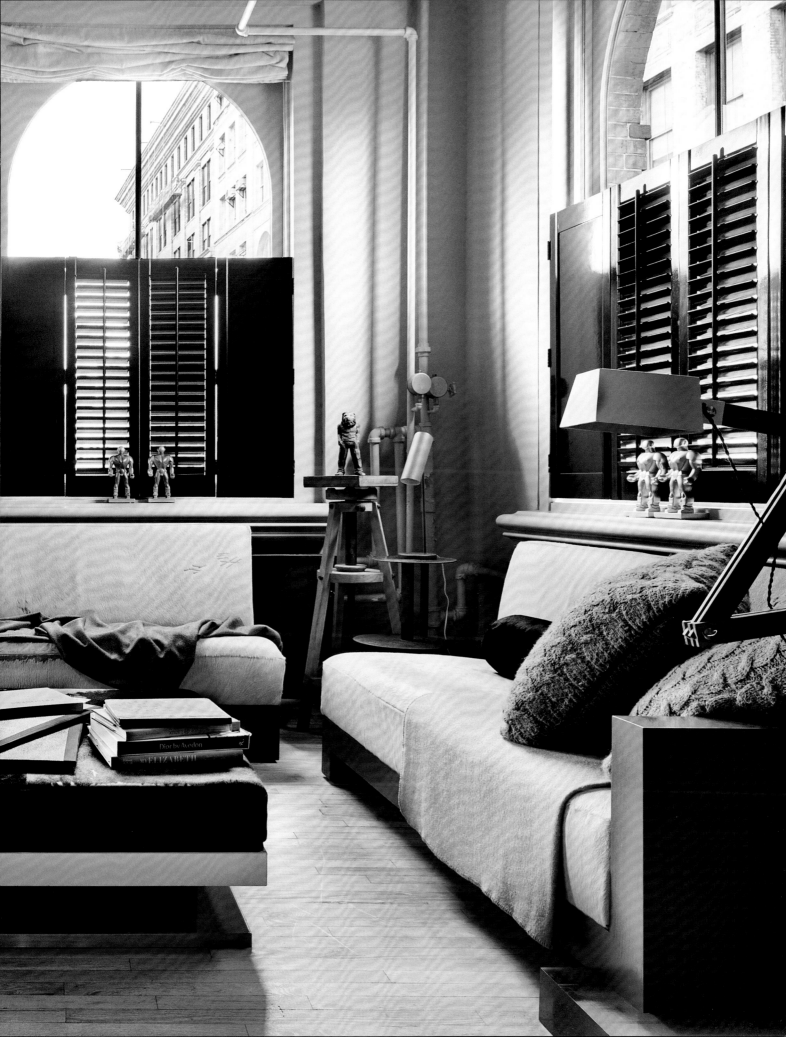

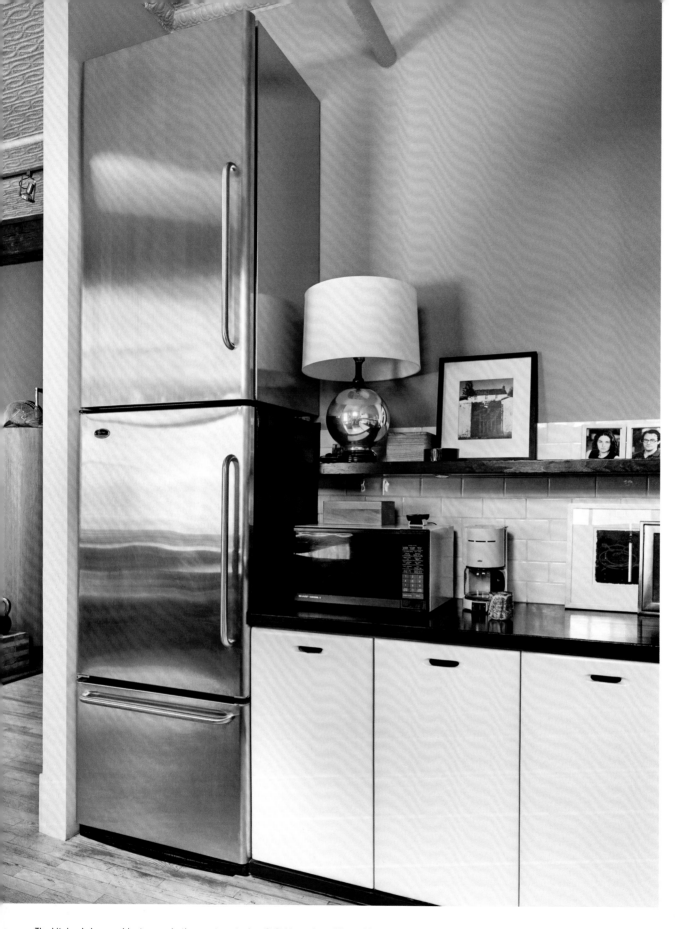

The kitchen's base cabinets were in the apartment when Sofield purchased it, and he added a vintage hanging cabinet by Florence Knoll above the sink. A stainless-steel cabinet, which duplicates the form of the refrigerator, was designed and installed above the common appliance, exalting both objects to new levels.

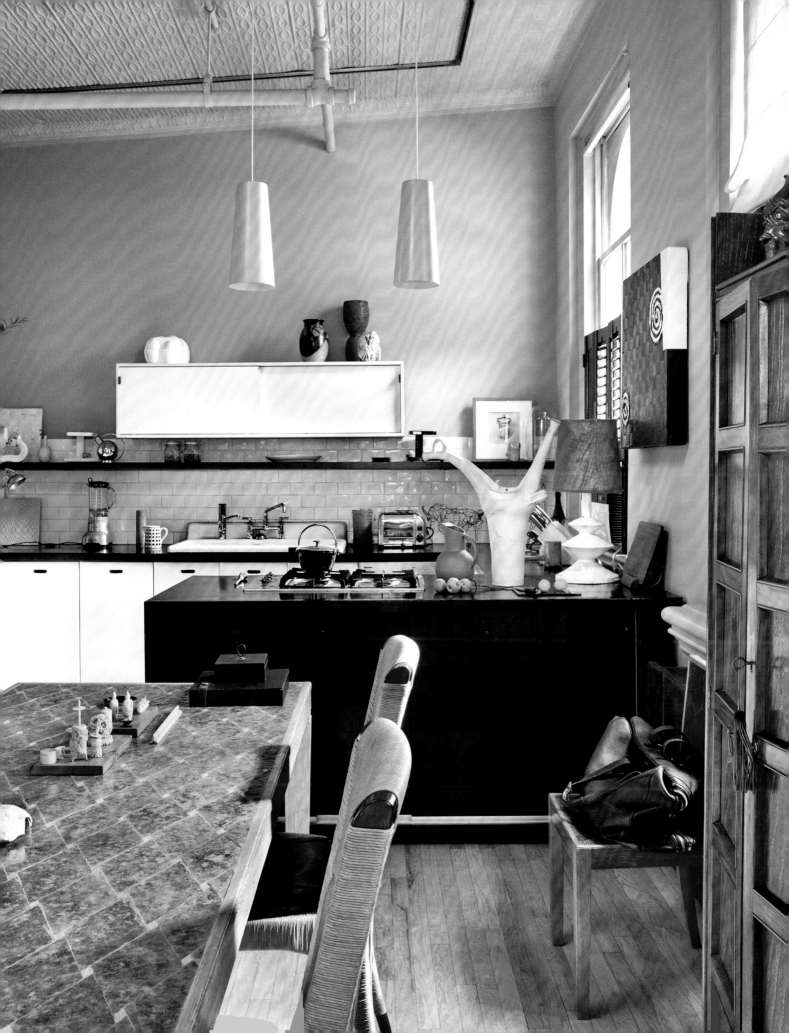

The windowless study counterintuitively incorporates a black-on-black color scheme. Light, besides the hanging fixture—which was recuperated from a theater—and a few lamps, is celebrated by the many glossy or reflective surfaces.

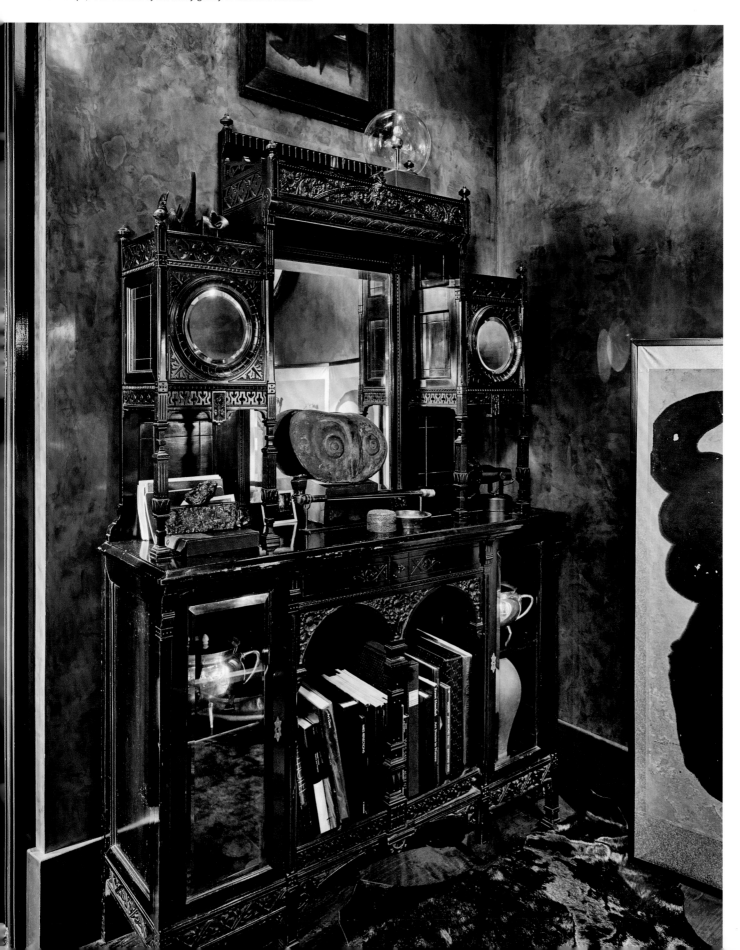

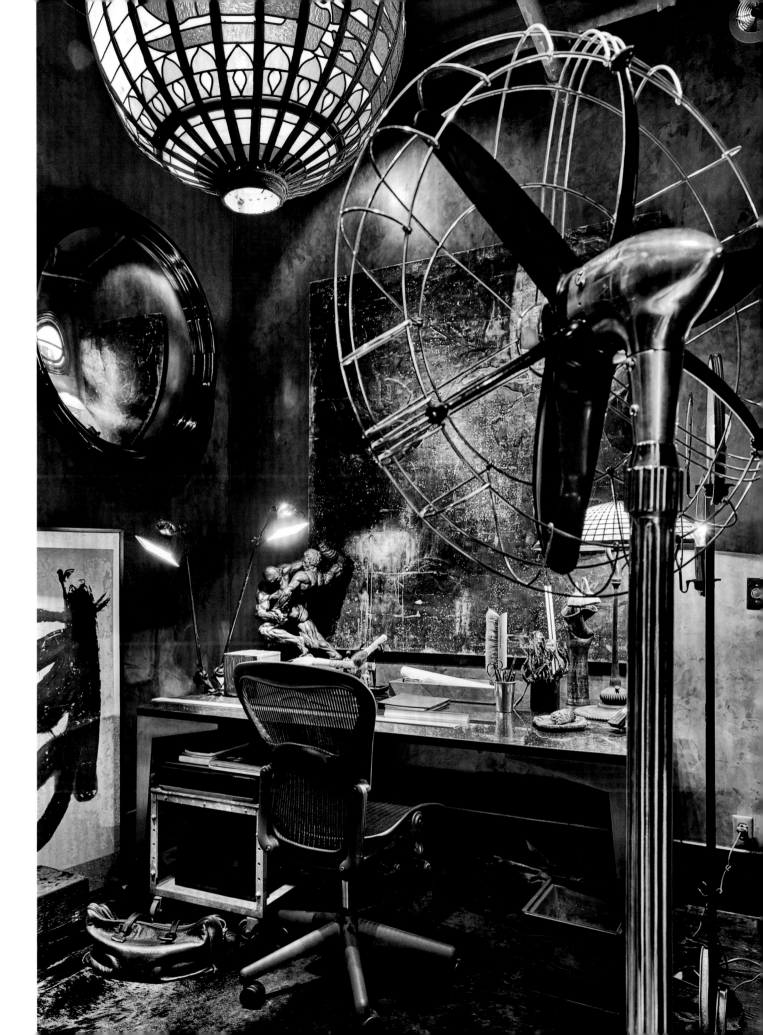

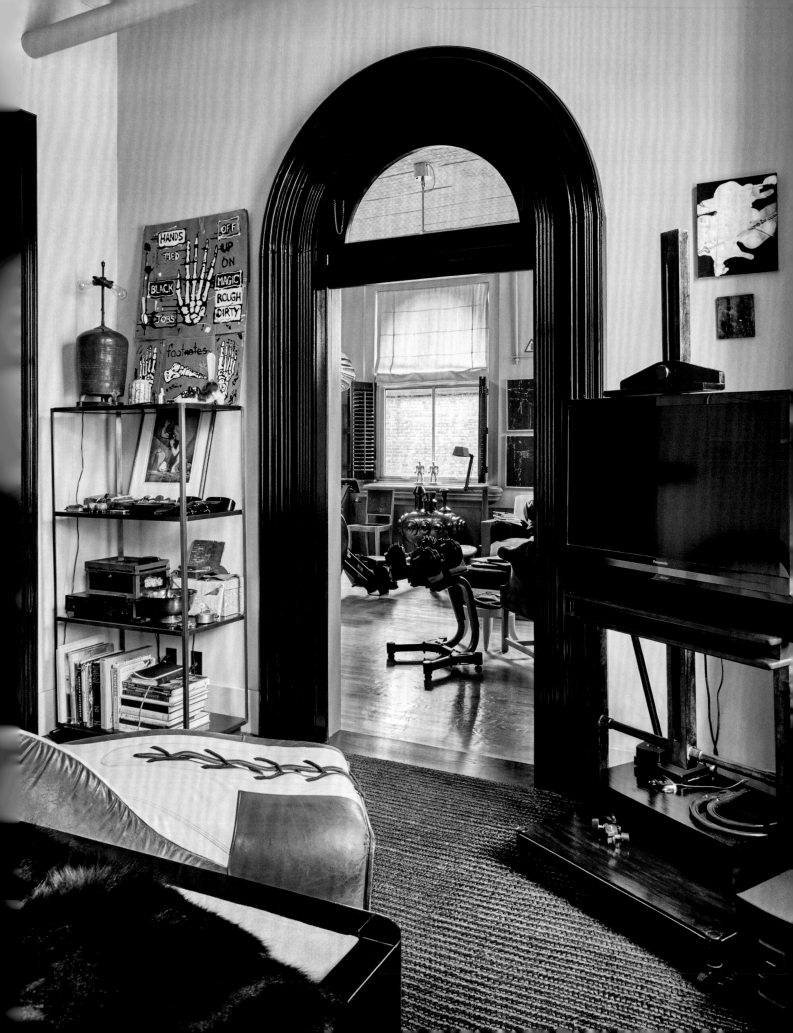

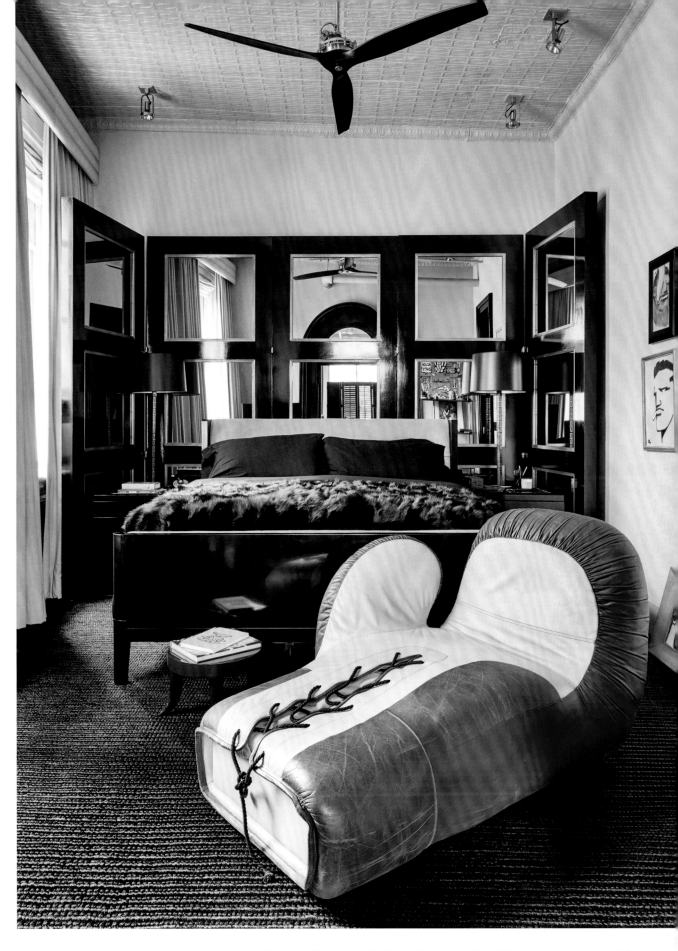

In the bedroom, a flat-screen TV sits on a painter's easel and an oversized, vintage boxing glove chair by de Sede in beige-and-brown leather is positioned at the foot of the bed. Both add an element of levity. The mirrored surround behind the bed and the cashmere window coverings supply the elegant contrast that resonates throughout the space.

The bathroom includes wildly veined black marble and features Sofield's Jeton faucet, which he designed for Kallista. The wastebasket is by Robert Kuo.

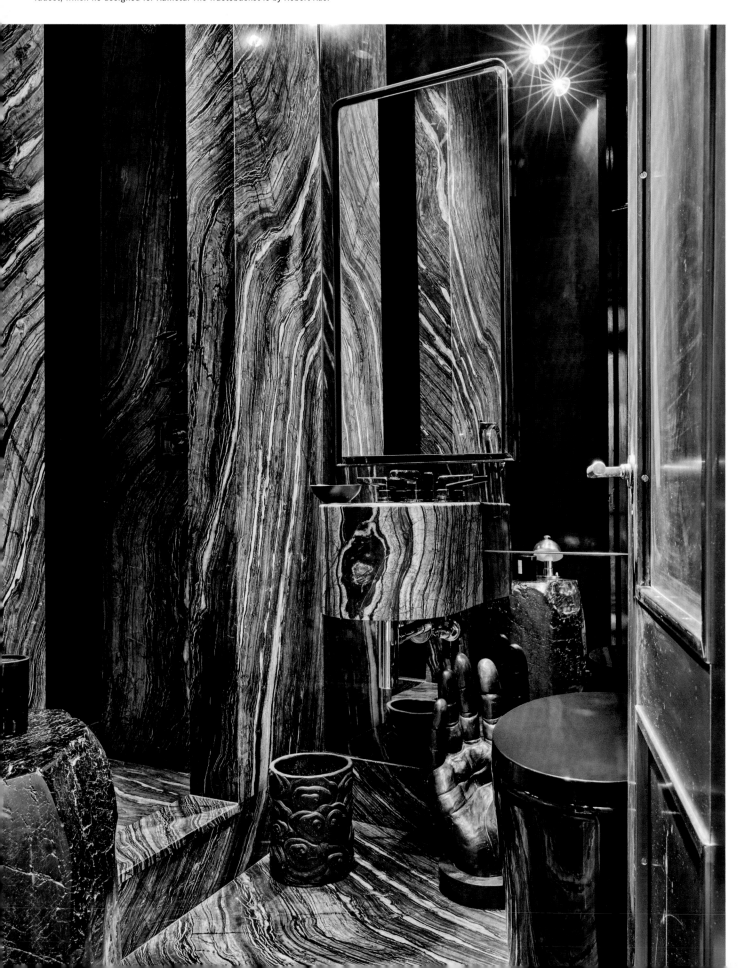

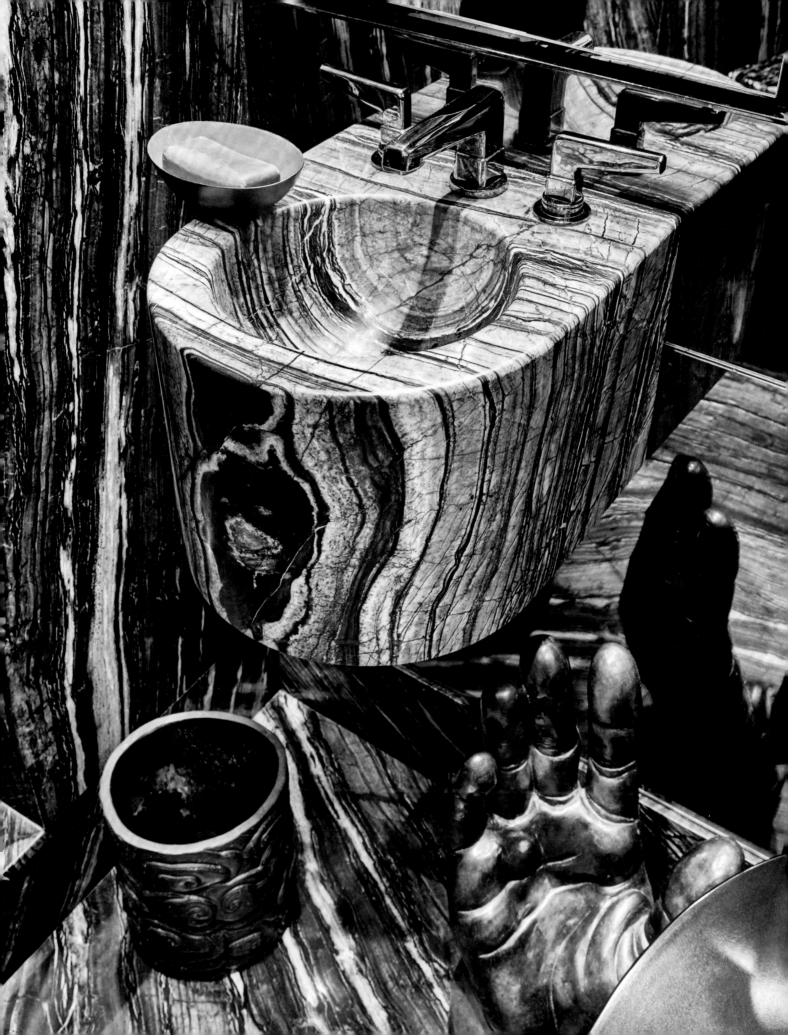

ROBERT STILIN

In addition to his practice as an interior designer, Robert Stilin has spent many years buying and selling antiques and vintage furniture and objects. It is nearly impossible to consider his work, and above all the design of his own home, without acknowledging this aspect of Stilin's professional life. Stilin is a collector at heart, and his own home is a highly curated and intricate collage of art, books, furniture, objects, textiles, and rugs—a world of curiosities and wonder. Stilin applies the same celebratory abundance to his art and furniture, and this is brilliantly contrasted by the pristine shell of his apartment, which is in a newly constructed building in SoHo designed by Charles Gwathmey of Gwathmey Siegel Kaufman Architects.

Stilin was drawn both to the idea of living in SoHo, surrounded by the neighborhood's historical buildings and beautiful streets, and to the big, open modern spaces and walls of windows that the new construction provided. Because there was little to no work needed before moving in, Stilin focused his efforts on layering art, furniture, luxurious fabrics, and rugs to create warmth and infuse character into his home. The layering and accumulation of objects in his dining area, for example, invite visitors to question the function of the space. Books and periodicals are stacked everywhere—across the entire surface of the table, on a vintage library cart, and atop stools and shelves. Throughout the apartment, larger pieces of art appear to anchor the rooms; the many smaller pieces are either hung in a salon style or simply propped up against the wall.

Stilin relies on his collection of objects to infuse the space with not only character and function but also color. He has left the walls white not only to unify the space but also to become a neutral backdrop for the layering he is so fond of. In his living area, Stilin installed a sofa of his own design in a Loro Piana cashmere. A large round coffee table occupies the space in front of the sofa and is surrounded by a collection of four different armchairs and nearly the same number of stools. The armchairs are in an array of vastly different styles and origins, yet all are rendered homogenous by a unified yet varied collection of fabrics. Like his ample collection of books, this diverse collection, this study in layers, which continues in the bedroom, has the capacity to foster curiosity. What better way to maintain interest in a home?

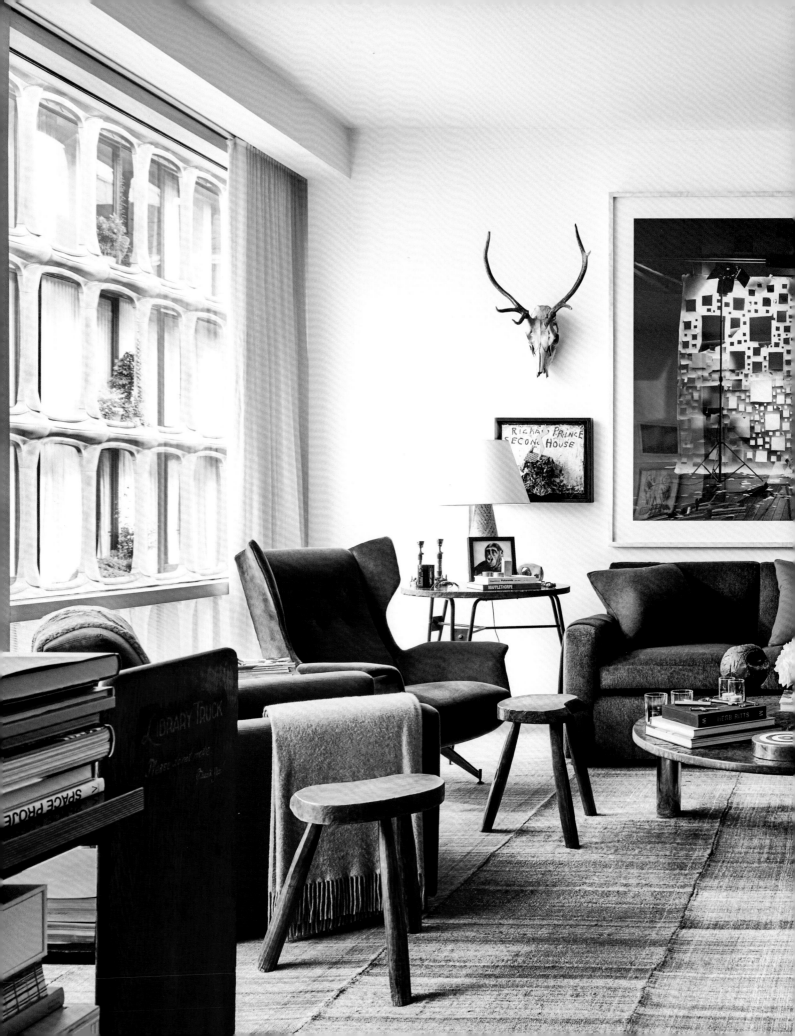

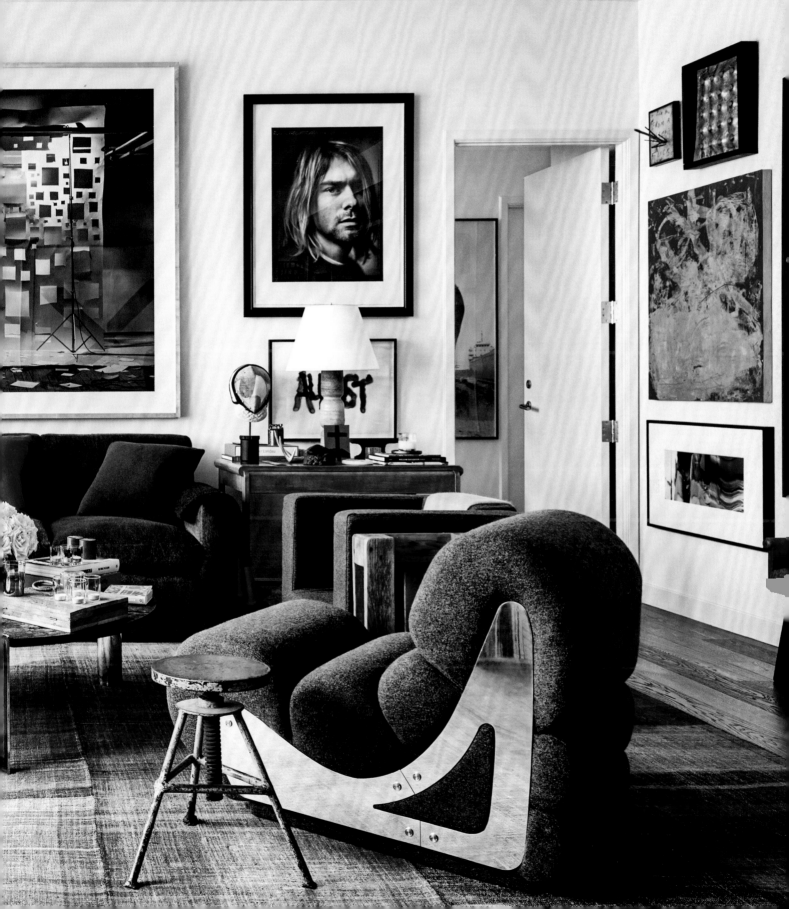

Stilin loves books, and they are piled and scattered throughout the apartment. In the living room, the sofa is of his custom design and upholstered in Loro Piana cashmere. Among his favorite possessions are the portrait of Kurt Cobain by Mark Seliger and the vintage Swiss pallet chair. The architectural form of the piece and its construction from humble wooden pallets speak to Stilin's interest in simple materials that manage to be luxurious.

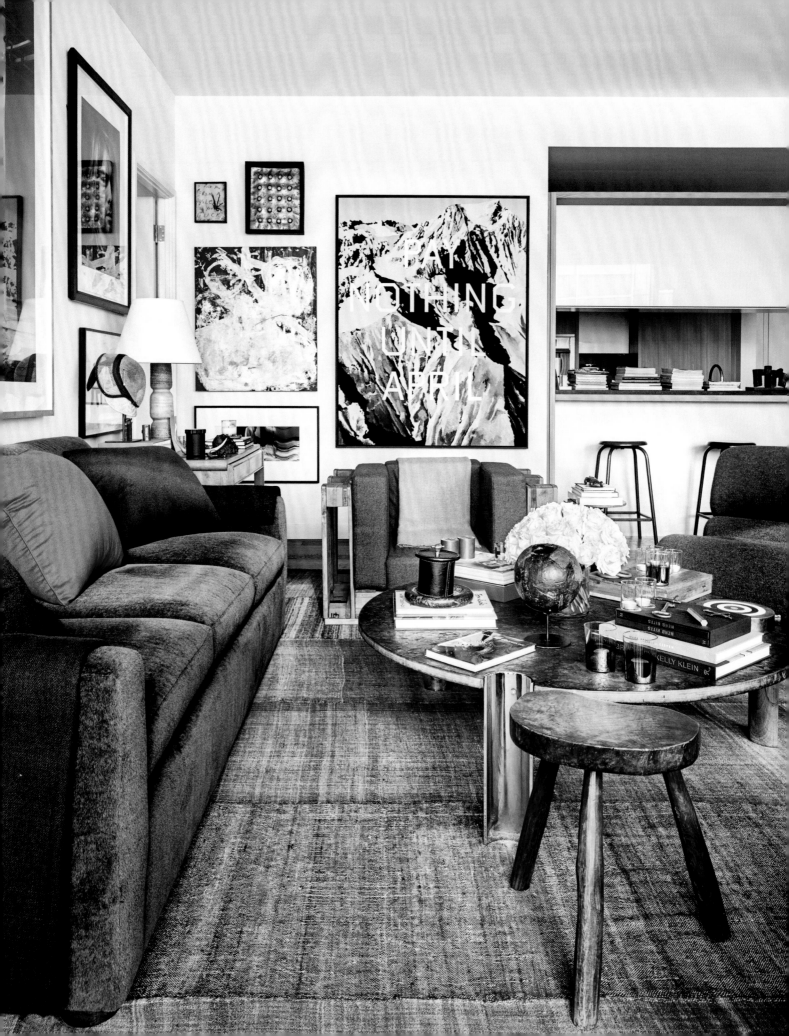

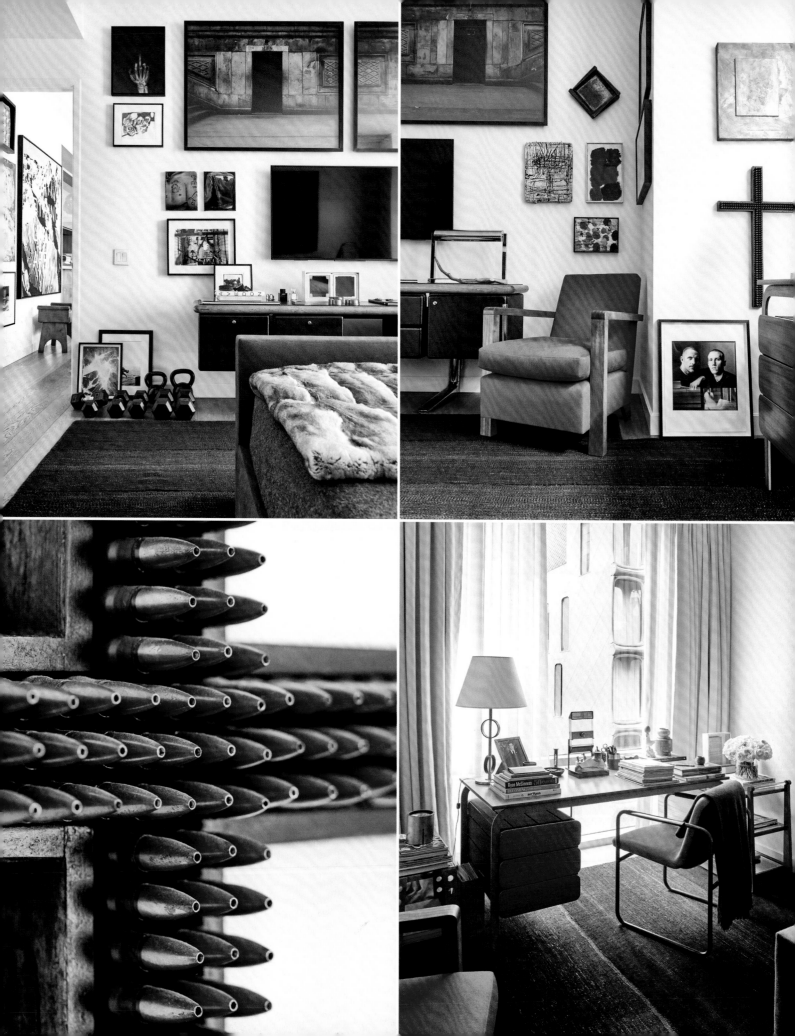

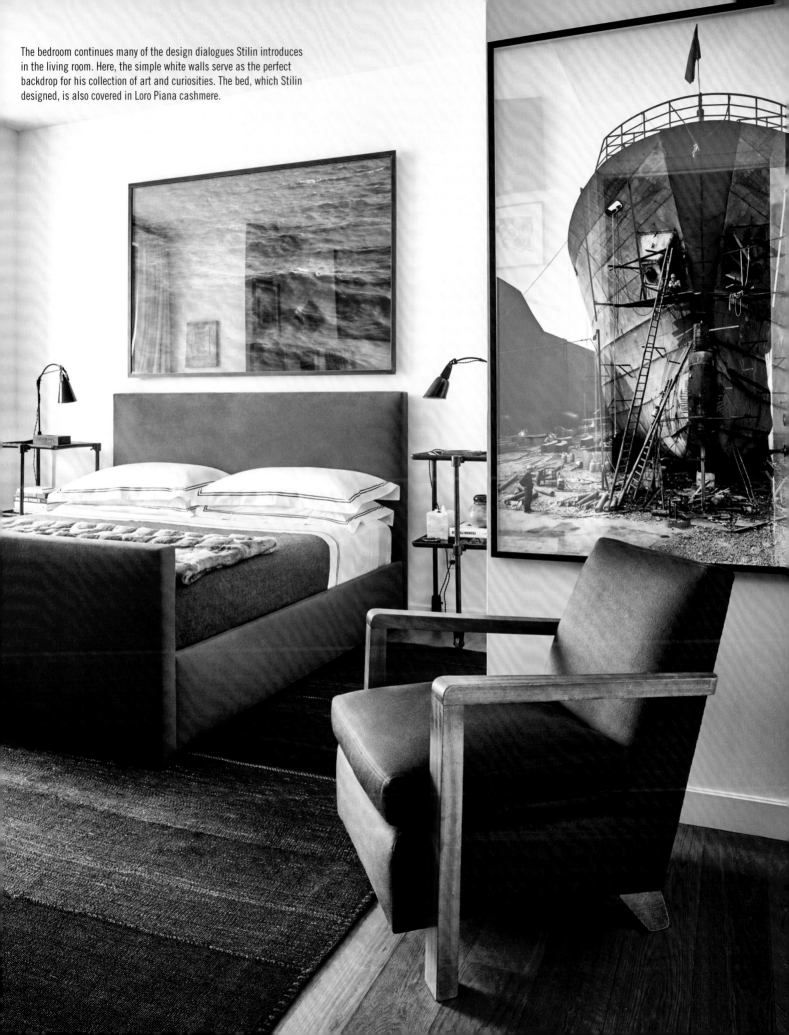

The bedroom continues many of the design dialogues Stilin introduces in the living room. Here, the simple white walls serve as the perfect backdrop for his collection of art and curiosities. The bed, which Stilin designed, is also covered in Loro Piana cashmere.

JUNIPER TEDHAMS

When Juniper Tedhams and her sister found this Italianate townhouse in Chelsea, it had been used as an SRO, or Single Room Occupancy, for some time. With shared bathrooms and kitchenettes on every floor and a drop ceiling of acoustic tile in the parlor and on the top floor, the structure had lost much of its original 1901 splendor. Tedhams chose the parlor and garden level for her home, and her sister settled into the two upper floors. Despite the home being carved up into three or four apartments per floor, once Tedhams started to peel back the vestiges of the SRO, she discovered that most of the original details had barely been touched. The dropped ceilings, for example, protected the original moldings, which were intact, along with the original fireplaces and overmantel mirrors. She quickly realized that her work here would be more about taking away details than adding.

There is a major jump in scale from the elegant and intentionally showy parlor floor to the once-utilitarian garden level, but Tedhams wanted to make the two spaces feel like part of the same home. Despite being somewhat averse to decorative moldings, she could not imagine removing this kind of decoration. To manage this, she underplayed the ornate plasterwork and arches of the parlor floor by adding a uniform coat of white paint and infused as much character as possible to the garden level. Here, thick plaster walls were left intact, and black cattle-yard bricks were installed as flooring in the back of the space, where Tedhams placed a lounge area and the floor's bathroom. Throughout the renovation, Tedhams was interested in the history of the place. She wanted to make certain, for example, that the kitchen was where the hearth had been and that the walls were thick where they were supposed to be. Additionally, these two floors were never designed to host bedrooms in the traditional sense because those were delegated to the upper levels; Tedhams gave up on the idea of carving out yet another small room and instead designed a walnut "shelter bed" that would establish a sleeping area in the rear of the parlor floor.

As in most townhomes, the lower two levels can be quite dark, so Tedhams wanted to give the walls a reflective quality without being too shiny or new feeling. Her limited budget was also a factor, so she created a skim coat of plaster with marble dust and joint compound, and then applied a coat of beeswax with a trowel as a sealer/finish. Tedhams kept the furnishings to a minimum. Most of the large items, like the sofas, bed, kitchen table, and credenza, are of her own design. This minimalist approach both focuses attention on the backgrounds, which include a dynamic ceiling mural by Dean Barger, and allows the few vintage items and artworks to be fully appreciated. Her goal for the space was to transform it into a comfortable, modern home, but more importantly, she wanted to let it breathe and hoped her intervention would be seen as something that had naturally evolved over time.

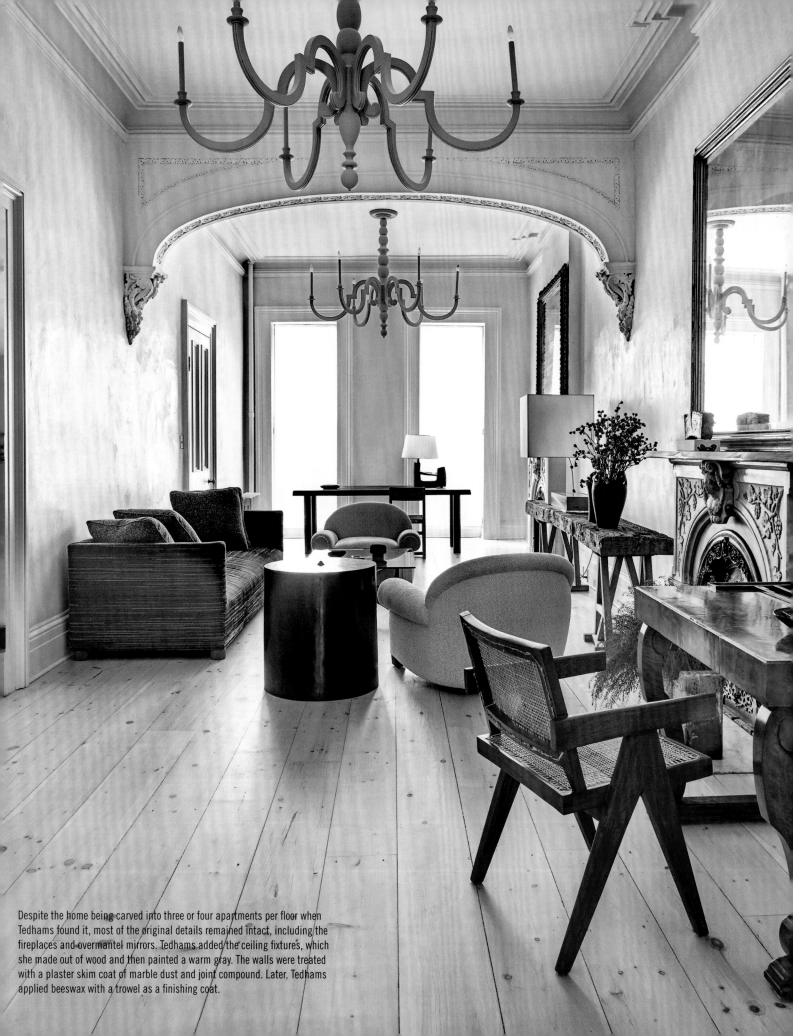

Despite the home being carved into three or four apartments per floor when Tedhams found it, most of the original details remained intact, including the fireplaces and overmantel mirrors. Tedhams added the ceiling fixtures, which she made out of wood and then painted a warm gray. The walls were treated with a plaster skim coat of marble dust and joint compound. Later, Tedhams applied beeswax with a trowel as a finishing coat.

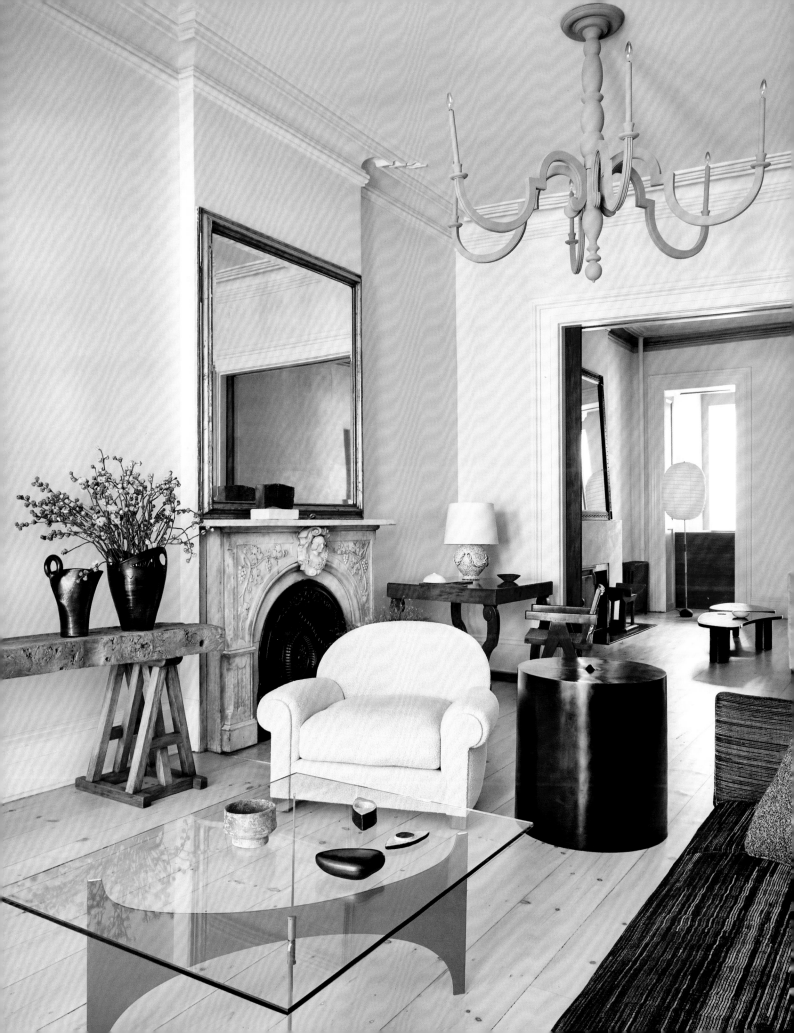

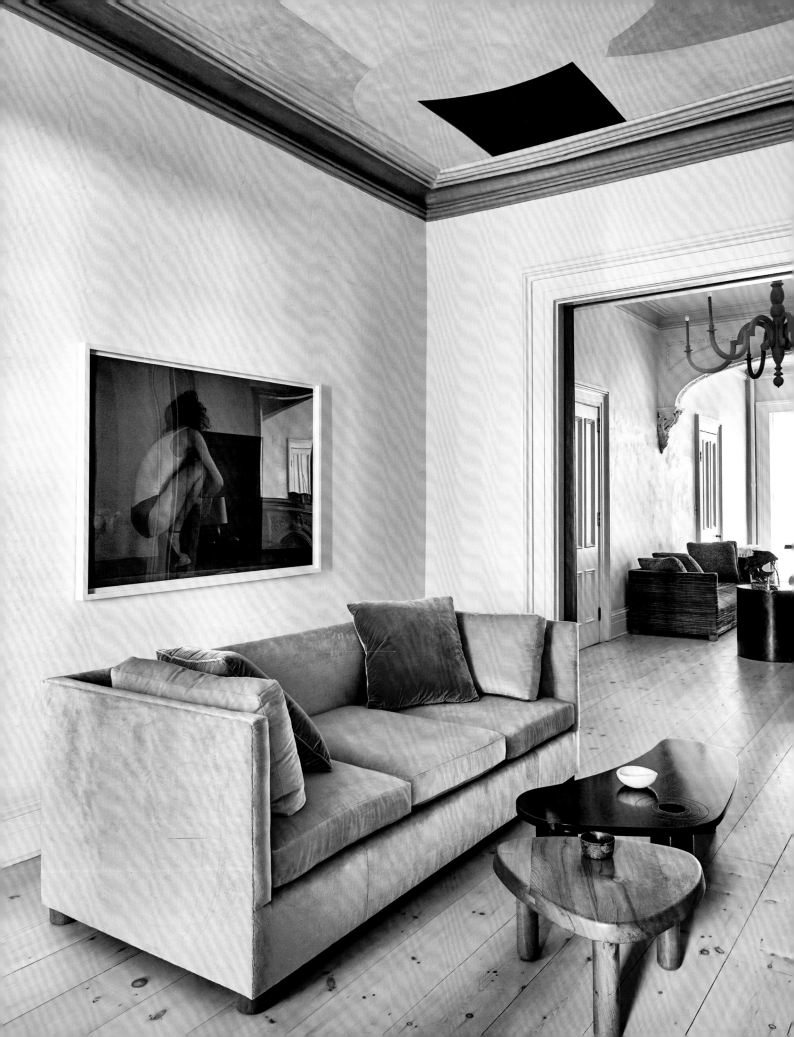

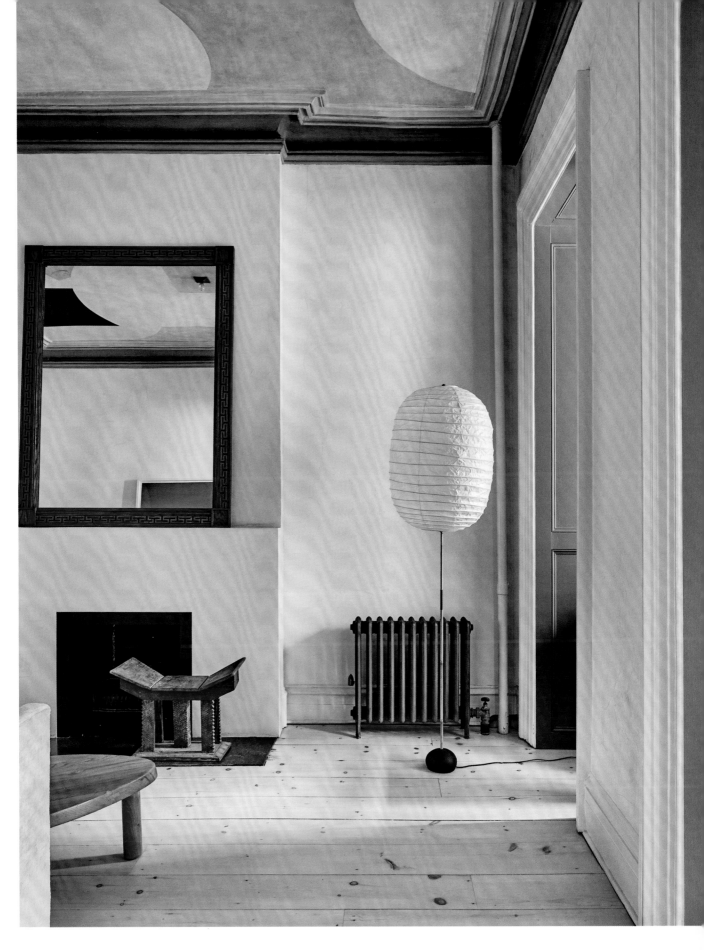

Tedhams designed the three sofas in the apartment as well as the walnut "shelter bed" in the back of the parlor floor. In this middle room, she commissioned Dean Barger to paint the ceiling, hoping to give the space a more intimate scale, as it had none of the ornate plasterwork of the front parlor.

Tedhams's walnut bed was inspired by both Donald Judd's daybed and English Knoll sofas. She had designed other furniture like this and calls the pieces her "Shelter Furniture," as they are designed to encase and create a sense of privacy. Just off this room, Tedhams installed a custom tub. To achieve the desired design, she found an Art Deco bookbinding with a pattern that appealed to her. She made a photocopy, gave it to Dean Barger, and asked him to duplicate and enlarge the pattern and then paint it on her tub.

Tedhams replaced the floors throughout the space and was able to copy the original floors from elsewhere in the building. Her solution was simple: Use flat-sawed pine boards finished in simple white oil. The steel kitchen table is of her design; the chairs are vintage and by Pierre Jeanneret.

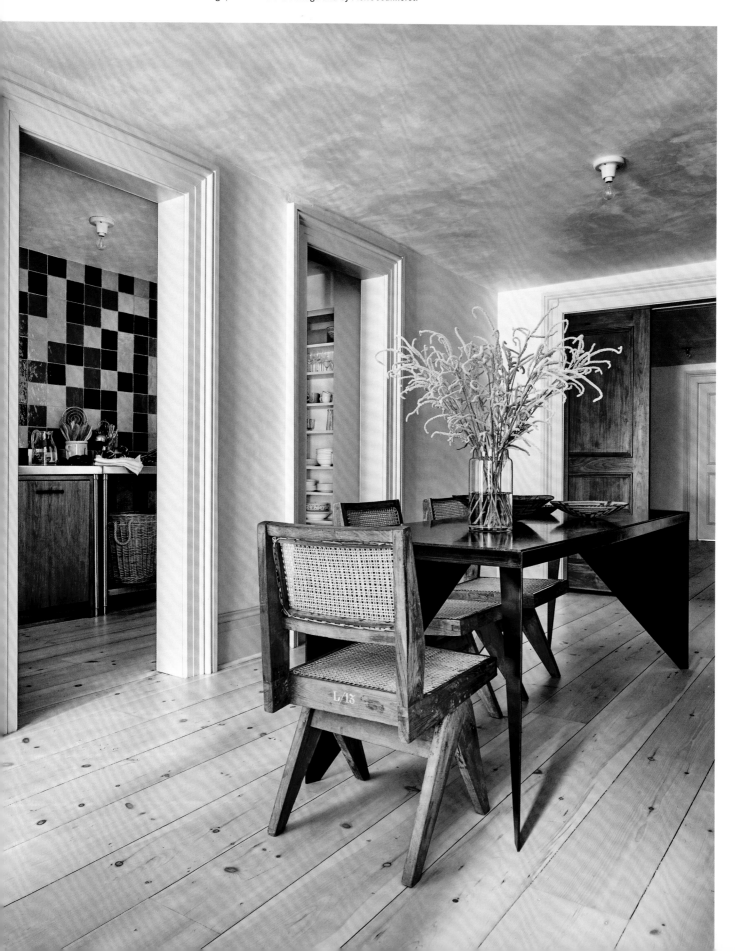

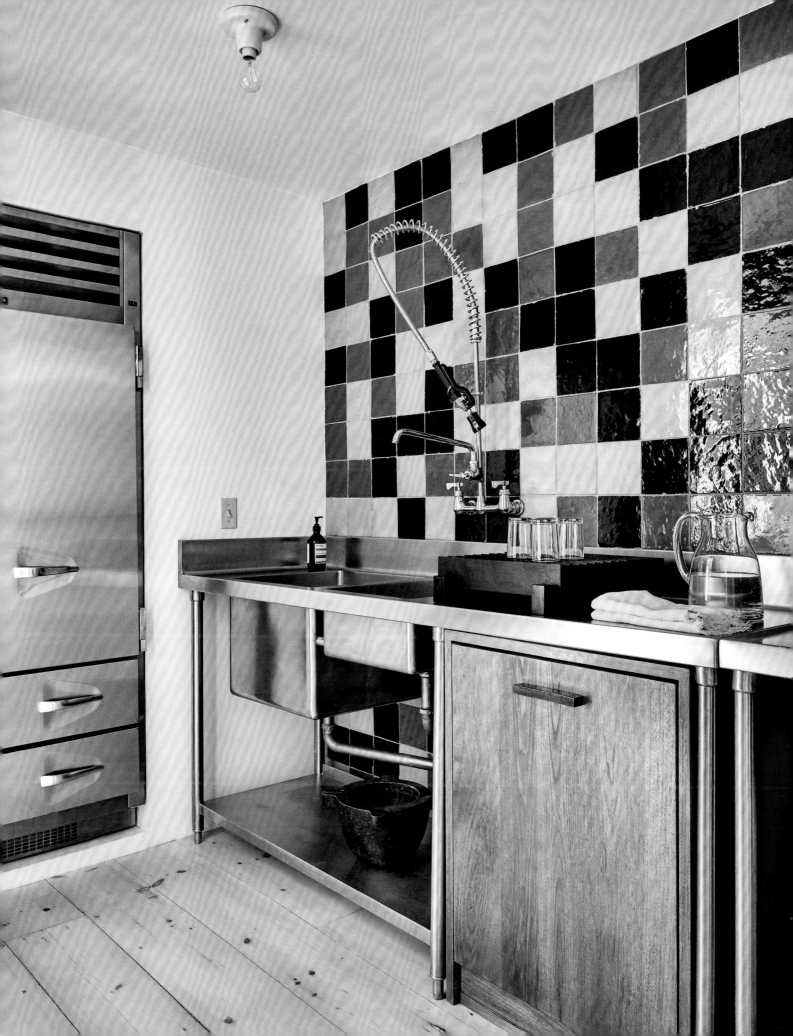

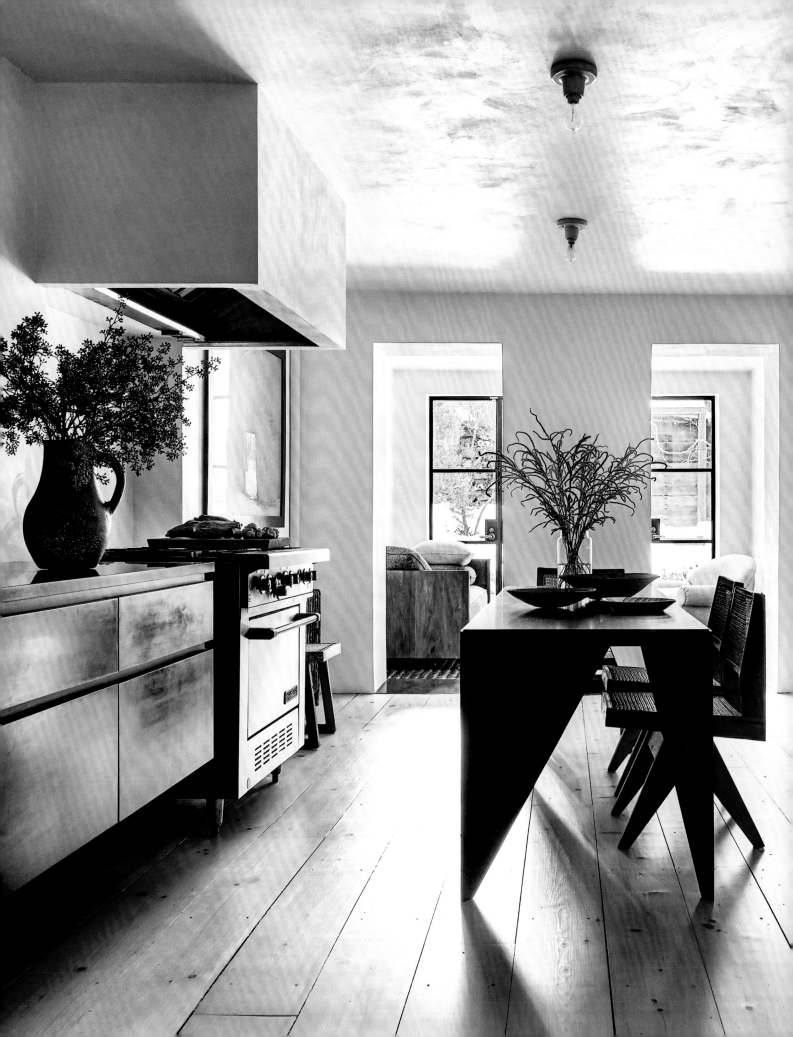

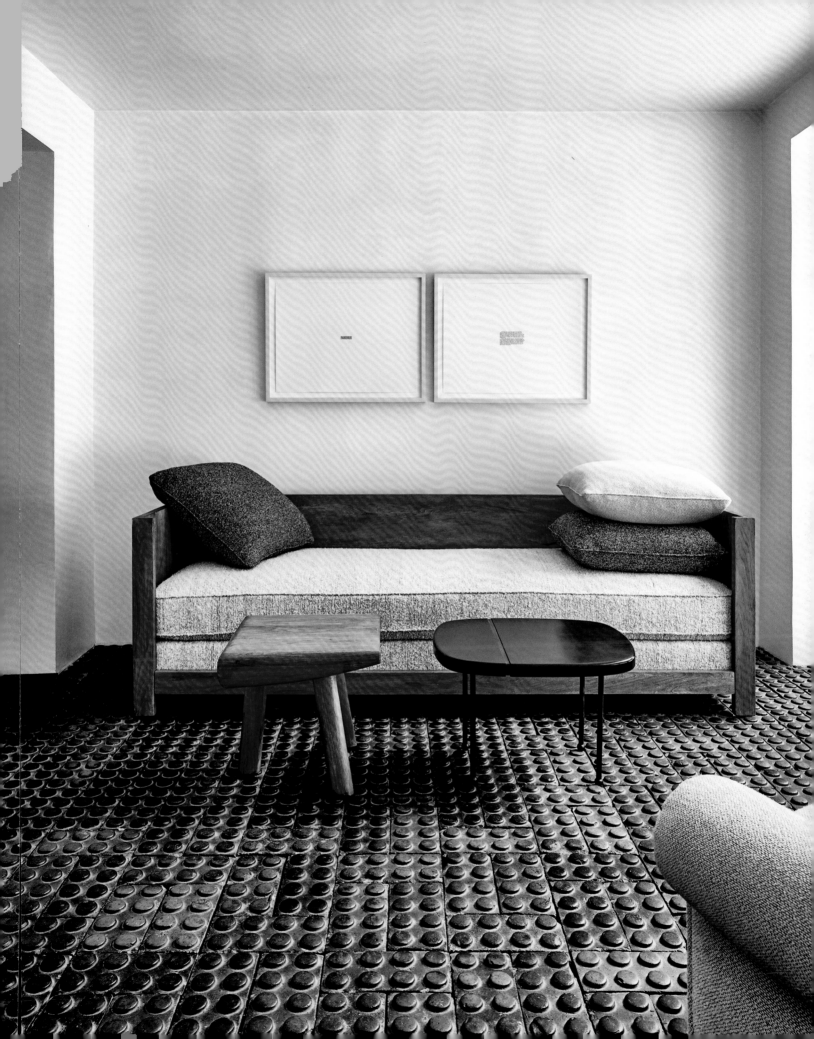

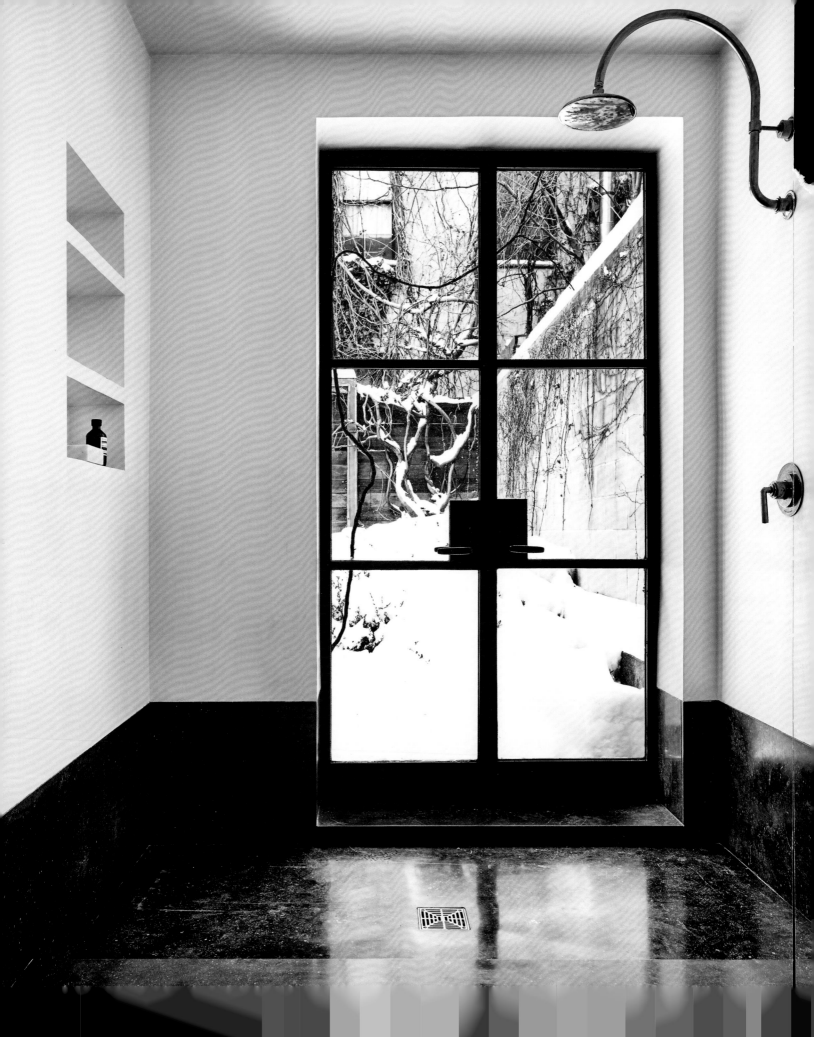

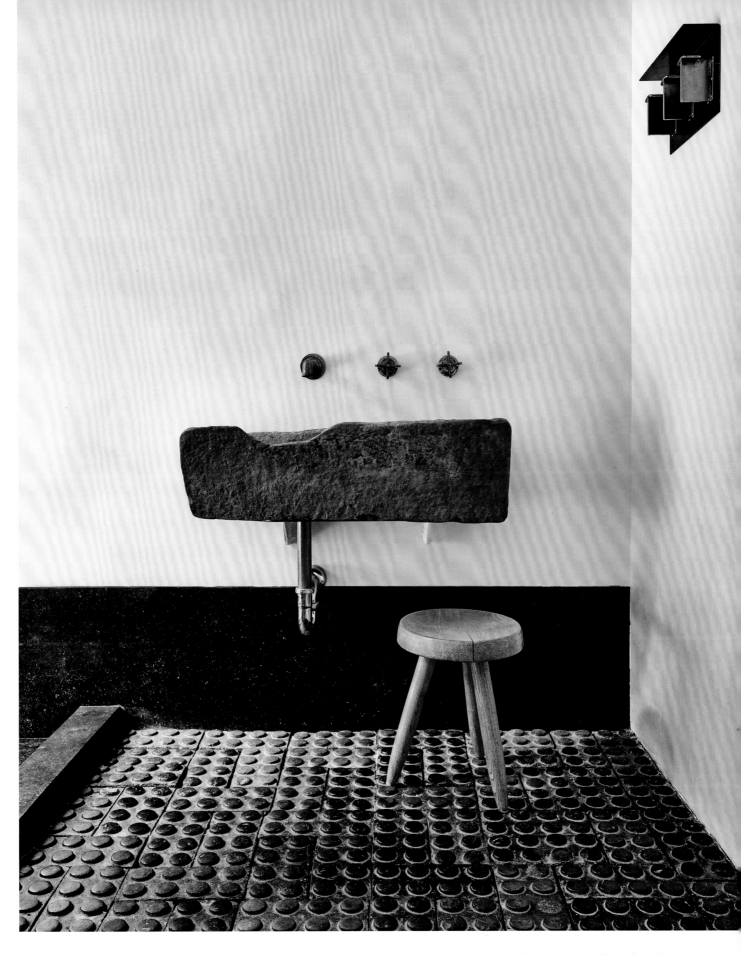

Black cattle-yard bricks, which Tedhams found in the UK, were used on the floor in the kitchen seat-ing area (previous spread) and bathroom, both located just off the rear garden. While everything on the garden level is new, Tedhams hoped it would feel as if it had been around for some time.

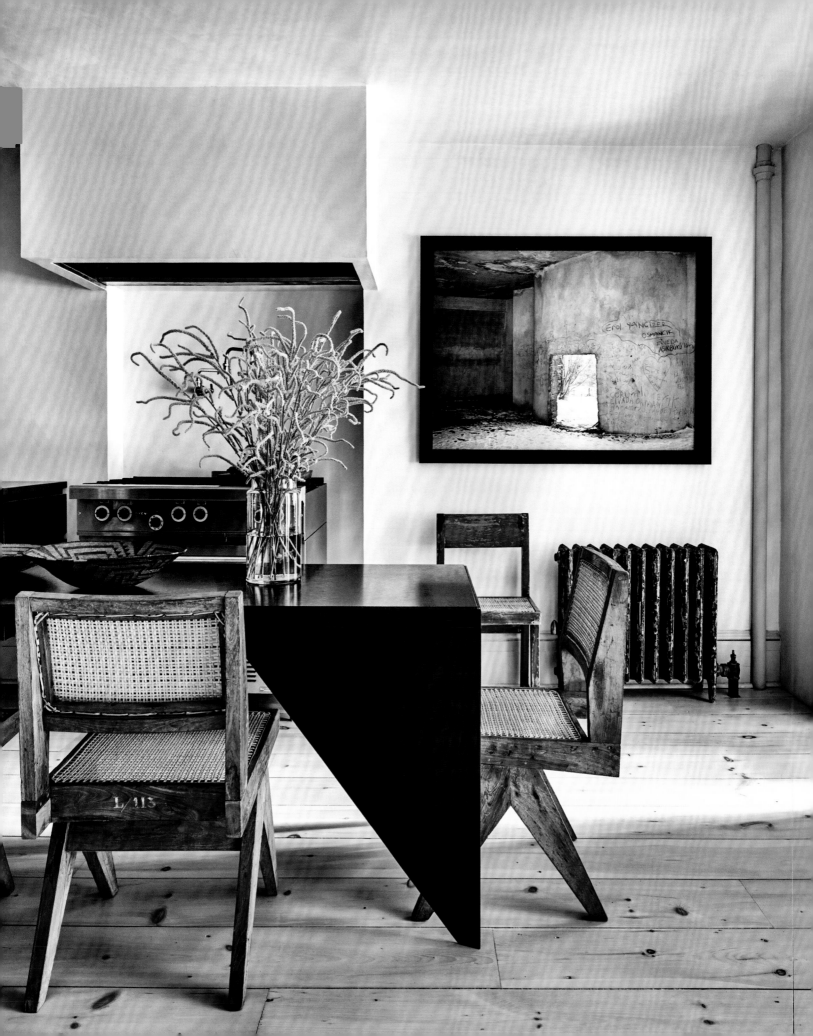

CREDITS

Jeremy Anderson
Apparatus Studio

Ariel Ashe
Ashe + Leandro

Neal Beckstedt
Neal Beckstedt Studio

Will Cooper
Ash NYC

Billy Cotton
Billy Cotton

Lan My Do
Tamarkin Co.

Tom Flynn
Tom Flynn Inc.

David Gresham
David M. Gresham Design

Ellen Hanson
Ellen Hanson Designs

Steven Harris
Steven Harris Architects LLP

Michael Haverland
Michael Haverland Architect

Shawn Henderson
Shawn Henderson Interior Design

Gabriel Hendifar
Apparatus Studio

Tony Ingrao
Ingrao Inc.

Randy Kemper
Ingrao Inc.

Reinaldo Leandro
Ashe + Leandro

Massimiliano Locatelli
CLS Architetti

David Mann
MR Architecture + Decor

Patrick McGrath
Patrick McGrath Design

Zack McKown
TsAO & McKown

Jayne Michaels
2 Michaels Design

Joan Michaels
2 Michaels Design

Carlos Otero
Carlos Otero Design

Benjamin Pardo
Knoll

Lucien Rees Roberts
Rees Roberts + Partners LLC

Charles Renfro
Diller Scofidio + Renfro

Franklin Salasky
Kellie Franklin Interior Design

Brian Sawyer
Sawyer Berson

Michelle R. Smith
Studio MRS Interiors

Bill Sofield
Studio Sofield

Robert Stilin
Robert Stilin

Cary Tamarkin
Tamarkin Co.

Juniper Tedhams
Juniper Tedhams

Calvin Tsao
TsAO & McKown

ACKNOWLEDGMENTS

I would like to thank Eric Himmel and Sarah Massey at Abrams for providing me with a vehicle to explore this subject and for all their help and guidance along the way. I would also like to thank Carrie Hunt, the graphic designer of this book and a long-time collaborator; I must thank Carrie for her exquisite work on this volume and also for introducing me to our photographer, her husband, Noe DeWitt. Noe and I worked side by side on each and every photograph we present here. Noe's beautiful images fill me with pride. To say it was a joy to work with Noe would be an understatement of enormous proportions. His love of photography and intellectual curiosity inspired me on every shoot.

Special thank-yous go to Jeremy Anderson and Gabriel Hendifar, David Gresham and Benjamin Pardo, and Tom Flynn, as they allowed Noe and me to photograph their homes before we even knew if this book would become a reality. I will forever be grateful for their trust in me. I must thank Billy Cotton for introducing me to Will Cooper and Will Cooper for introducing me to Massimiliano Locatelli and Michelle R. Smith. I would like to thank Shawn Henderson for introducing me to Juniper Tedhams, and Dan Scheffey for introducing me to Ellen Hanson.

Lastly, I must thank each and every one of the designers whose homes are featured here. They let us into their personal spaces and shared part of their lives with us. For that I will be forever grateful.

— ANTHONY IANNACCI

Thank you to my partner in crime, my friend, true mentor, and author of *New York Design at Home*, Anthony Iannacci, for inviting me on this incredible journey. I couldn't have asked for a more creative and focused work partner in the hundreds of hours spent together making this book come alive.

Thank you to Carrie Hunt, my wife and the designer of this book, for keeping me on track whenever I derailed. Your patience and astute eye for imagery always astounds me.

I'd like to give a special thank you to the team at picturehouse + thesmalldarkroom for their tireless and masterful work in finalizing all the imagery: David Hazan, Claudia Galindo, Bob Whitmore, Fernando Reyes, Jesse Koechling, Laurent Le Moing, Laura Garcia-Serventi, Christina Martinez, Geoff Thomas, and Conan Thai.

— NOE DEWITT

Editor: Sarah Massey
Production Manager: Katie Gaffney
Photographer: Noe DeWitt, www.noedewitt.com
Designer: Carrie Hunt, www.skylarkstudiosny.com

Library of Congress Control Number: 2018936263

ISBN: 978-1-4197-3446-5
eISBN: 978-1-68335-513-7

Printed and bound in China
10 9 8 7 6 5 4 3 2 1

Abrams books are available at special discounts when purchased in quantity
for premiums and promotions as well as fundraising or educational use.
Special editions can also be created to specification.
For details, contact specialsales@abramsbooks.com or the address below.

Abrams® is a registered trademark of Harry N. Abrams, Inc.

ABRAMS The Art of Books
195 Broadway, New York, NY 10007
abramsbooks.com